Ben Shahn's New York

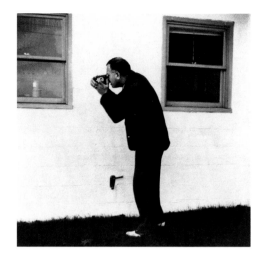

Deborah Martin Kao, Laura Katzman & Jenna Webster

Fogg Art Museum, Harvard University Art Museums *Cambridge* Yale University Press *New Haven & London*

Ben Shahn's New York The Photography of Modern Times

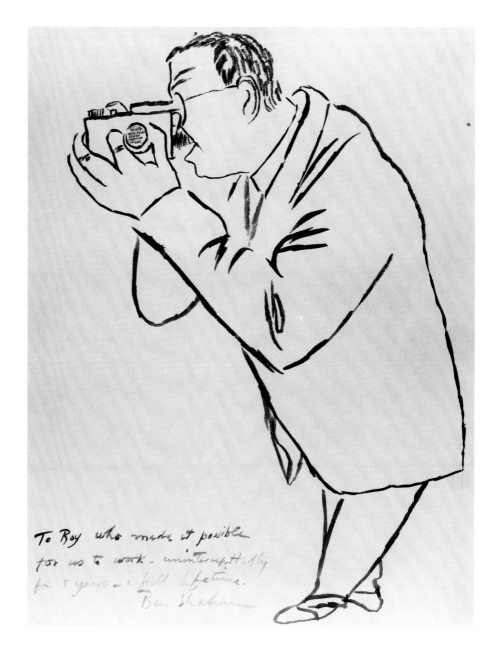

To Roy who made it possible
for us to work - uninterruptedly
for 5 years - a full lifetime.
Ben Shahn

This catalogue is published in
conjunction with the exhibition
*Ben Shahn's New York: The Photography
of Modern Times*.

Harvard University Art Museums

 5 February–30 April 2000

The Phillips Collection, Washington, D.C.

 10 June–27 August 2000

The Grey Art Gallery, New York University

 14 October 2000–27 January 2001

David and Alfred Smart Museum,

 University of Chicago

 19 April–17 June 2001

Illustrations: (half-title page) Unknown photographer, *Untitled
(Ben Shahn, Jersey Homesteads)*, c. 1936–39, fig. 41; (title page) Ben Shahn,
Self-Portrait with Angle Viewfinder, c. 1939, Ink on paper, 20.5 x 25.6 cm,
Fricke Leica Collection.

NATIONAL ENDOWMENT FOR THE
HUMANITIES

The National Endowment for the Humanities provided major support
for this exhibition. This publication has been made possible in part by a grant
from the Andrew W. Mellon Foundation.

Designed by Richard Hendel and set in Monotype Garamond type by Eric M. Brooks.

Printed in Hong Kong by Palace Press.

Library of Congress Cataloging-in-Publication Data
Shahn, Ben, 1898–1969.
Ben Shahn's New York: the photography of modern times / Deborah Martin Kao,
Laura Katzman, Jenna Webster; Fogg Art Museum, Harvard University, Cambridge.
 p. cm.
Includes bibliographical references and index.
ISBN 0-300-08315-7 (cloth: alk. paper)—ISBN 1-891771-12-4 (pbk.: alk paper)
1. Documentary photography—New York—New York—Exhibitions. 2. Shahn, Ben,
1898–1969—Exhibitions. 3. New York (N.Y.)—In art—Exhibitions. I. Kao, Deborah
Martin. II. Katzman, Laura. III. Webster, Jenna. IV. Fogg Art Museum. V. Title.
TR820.5.S4797 2000
770'.92—dc21 99–053647

A catalogue record for this book is available from the British Library.

The paper in this book meets the guidelines for permanence and durability of the
Committee on Production Guidelines for Book Longevity of the Council on Library
Resources.

10 9 8 7 6 5 4 3 2 1

Contents

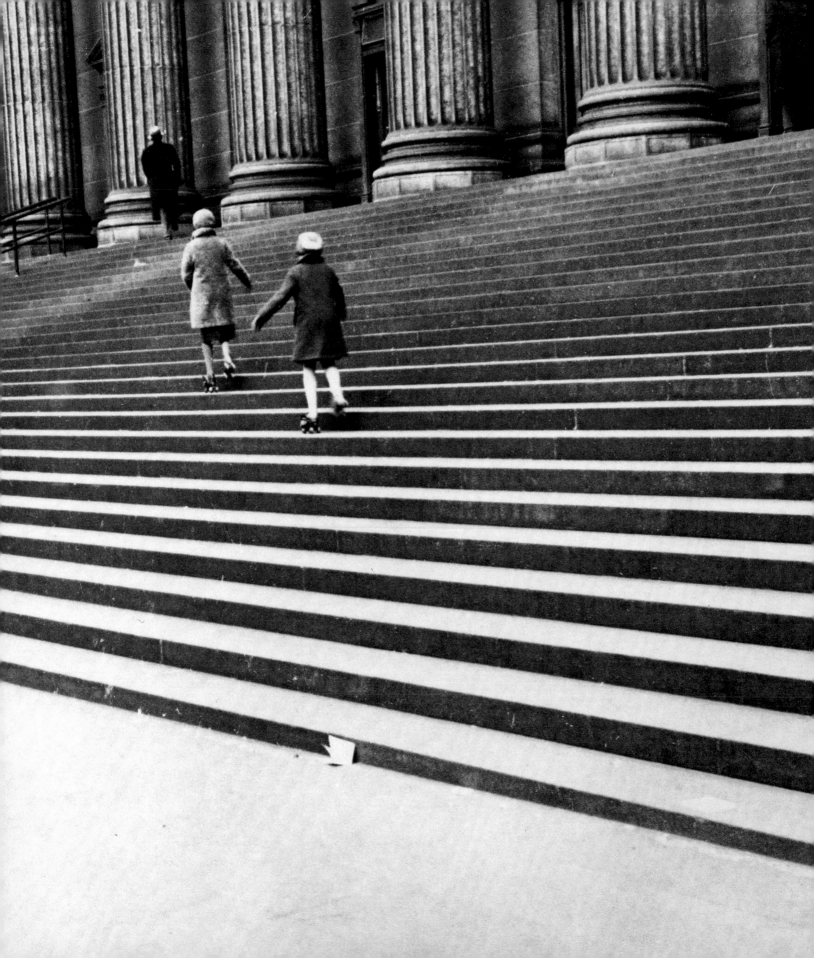

Foreword

Harvard University and the Fogg Art Museum have enjoyed a long connection with the art of Ben Shahn. In October 1932 the Harvard Society for Contemporary Art, a student-run enterprise, assisted and advised by the Fogg's director and associate director, Edward Forbes and Paul Sachs, exhibited twenty-three gouaches from Shahn's controversial series *The Passion of Sacco-Vanzetti* and ten watercolors from *The Dreyfus Case*. In 1956, at the height of Shahn's career, Harvard invited the artist to give the Charles Eliot Norton Lectures, the university's most distinguished lecture series in the humanities. That year Shahn also occupied a studio on the top floor of the Fogg as artist in residence, and the museum organized and presented two exhibitions of his work. The following year Harvard University Press published Shahn's Norton lectures as *The Shape of Content,* which became one of the most influential mid-century art treatises. Finally, in 1967 Harvard acknowledged Shahn's contribution to the arts in America by awarding him an honorary Doctor of Arts.

Shahn died in 1969, yet the Fogg continued to explore the richness of his art. That fall Davis Pratt, the first curator of photography, and William S. Johnson of Harvard's Fine Arts Library mounted *Ben Shahn as Photographer,* the first important exhibition of Shahn's photographs. Pratt continued to promote Shahn's photography, publishing in 1975 *The Photographic Eye of Ben Shahn,* with an introduction by the poet Archibald MacLeish, a longtime admirer of the artist's work.

In 1970, in appreciation of Harvard's decades-long support of her husband and his work, Bernarda Bryson Shahn gave the Fogg his collection of his own photographs, comprising prints, negatives, and contact strips—some five thousand images in all. In 1999 this photographic archive was enhanced by Dolores Taller's gift to the Fogg and the Fine Arts Library of an extensive research and graphic collection focusing on the art and times of Ben Shahn. The two collections, the Shahn photograph collection and the Stephen Lee Taller Ben Shahn Archive, make Harvard a resource of international significance for scholars and students of Shahn and his contemporaries.

Ben Shahn's New York: The Photography of Modern Times, a major touring exhibition examining Shahn's earliest work in photography, was conceived six years ago through discussions between Deborah Martin Kao, the Fogg's Richard L. Menschel Curator of Photography, and Laura Katzman, assistant professor of art and director of the museum studies

program at Randolph-Macon Woman's College in Lynchburg, Virginia, who at that time was researching her doctoral dissertation for Yale University on Shahn's photography. Jenna Webster, curatorial assistant in the department of photographs at the Fogg, joined the exhibition team as a research assistant when she was a Harvard undergraduate; since 1997 she has been a collaborator on all aspects of the project.

I would like to acknowledge a number of people who made this groundbreaking exhibition possible. First, of course, I thank its organizers, Deborah Martin Kao, Laura Katzman, and Jenna Webster. Special credit must also go to Bernarda Bryson Shahn, whose generous gift provided the impetus for this exhibition; to the late John Coolidge, who first promoted Shahn's work while a student involved in the Harvard Society for Contemporary Art and who supported the museum's Shahn exhibitions as director of the Fogg in the 1950s and 1960s; and to the late Davis Pratt, Shahn's early champion. I should also like to acknowledge Richard L. Menschel, who has been a constant supporter of photography at Harvard as well as one of the medium's most acute and inspiring critics. Richard always encourages us to push our scholarly mandate further, and I trust that this exhibition and catalogue have met his challenge.

The exhibition was made possible by the early and ongoing support of the National Endowment for the Humanities, which provided substantial financial assistance and allowed us to gather a group of notable advisers, including Beverly W. Brannan, Lawrence Levine, Frances K. Pohl, and Alan Trachtenberg. In addition, Susan H. Edwards, an important Shahn scholar and member of the Fogg's Collections Committee, gave unstintingly of her time and expertise throughout the planning of the exhibition. The curators acknowledge the many other scholars and colleagues whose advice was invaluable to the success of the exhibition and catalogue.

In addition to the Fogg, the Phillips Collection in Washington, D.C., the Grey Art Gallery at New York University, and the David and Alfred Smart Museum at the University of Chicago will host the exhibition *Ben Shahn's New York*. On behalf of my colleagues at these institutions, I want to express my gratitude to all those who enabled Deborah Martin Kao, Laura Katzman, and Jenna Webster to use their passion for Shahn's work and their high regard for the academic mission of the Harvard University Art Museums to create *Ben Shahn's New York*.

James Cuno
Elizabeth and John Moors Cabot Director
Harvard University Art Museums

Abbreviations

Block Papers
> Lou Block Papers, Margaret M. Bridwell Art Library, University of Louisville, Kentucky

Leyda Papers
> Jay Leyda Papers, Tamiment Institute Library, New York University

MoMA
> Museum of Modern Art, New York

PWAP
> Public Works of Art Project, December 1933–June 1934

Shahn Papers
> Ben Shahn Papers, Archives of American Art, Smithsonian Institution, Washington, D.C.

RA/FSA
> Resettlement Administration/Farm Security Administration. The RA existed between April 1935 and December 1936; it was taken over by the FSA in 1937 and subsumed under the Office of War Information (OWI) in 1942. The FSA remained active until 1943.

Taller Archive
> Stephen Lee Taller Ben Shahn Archive, Fine Arts Library, Harvard College Library, and Fogg Art Museum, Cambridge, Mass.

TERA
> Temporary Emergency Relief Administration, September 1931–December 1935

TRAP
> Treasury Relief Art Project, July 1935–June 1939

WPA/FAP
> Works Progress (later Projects) Administration's Federal Art Project, August 1935–June 1943. Although the WPA officially began on 14 October 1935, the nucleus for the agency took over New York City's Emergency Work (later Relief) Bureau as early as August 1935.

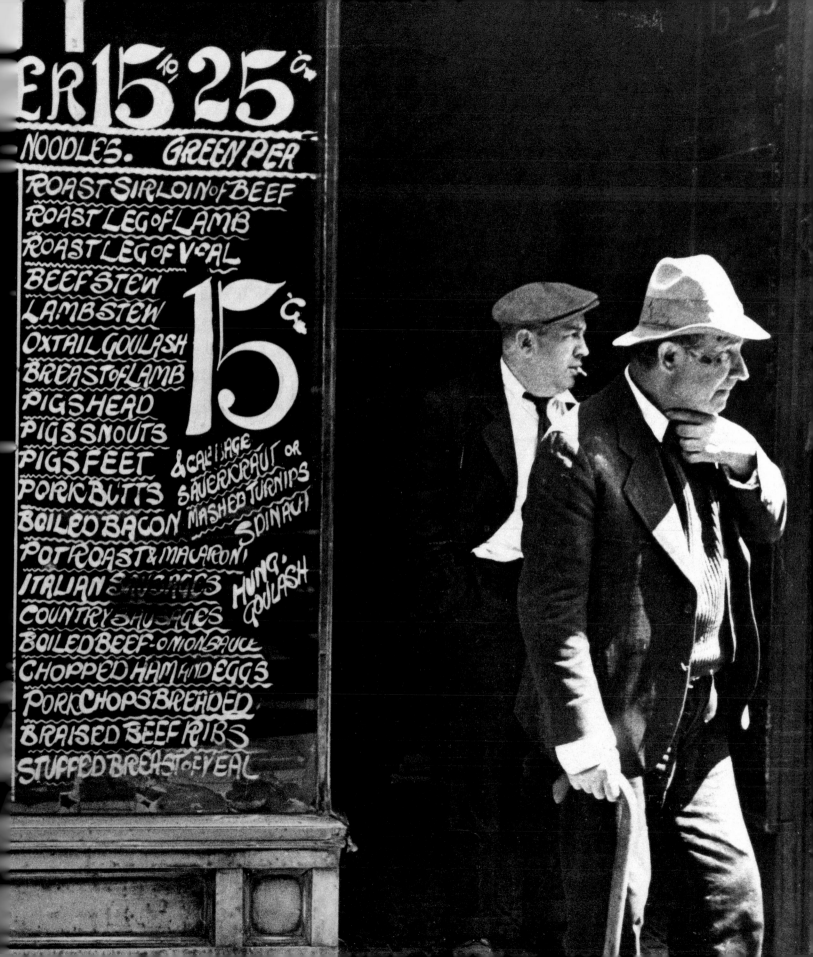

Introduction

Tremendous social and political upheaval engulfed America during the Depression. Among the disruptions were a surge in radical political movements, efforts at social reform, and attempts by diverse populations to establish a national identity. In response to the crisis President Franklin D. Roosevelt inaugurated dozens of New Deal relief programs; and for the first time in the nation's history, the government instituted public art projects. Many artists who were radicalized during this period became involved in these programs, including Ben Shahn (1898–1969), an immigrant whose socialist Jewish family had fled czarist Russia in 1906 and settled in Brooklyn. In the early 1930s, as Shahn and his first wife Tillie (Ziporah) Goldstein struggled to support themselves and their young children, Judith and Ezra, the artist sought work on public art projects.

As the decade began Shahn abandoned his interest in European modernism in favor of incisive social-realist art that addressed the issues dominating public debate. Critical acclaim for his 1931–32 gouache and tempera series on the trial and execution of Sacco and Vanzetti, as well as for his 1933 paintings on labor leader Tom Mooney, propelled him to the forefront of the American art scene. Although he became widely known as a painter, muralist, and graphic artist, Shahn was also making formidable photographs, work which received little public or critical recognition. *Ben Shahn's New York: The Photography of Modern Times* uncovers Shahn's substantial contribution to the emerging field of social documentary photography and illustrates how the medium became essential to both his political activism and his artistic practice.

Discussing his art in 1946, Shahn commented: "I am a social painter or photographer. . . . I find difficulty in making distinctions between photography and painting. Both are pictures."[1] Yet in the postwar era Shahn himself acquiesced in the downplaying of his prolific work in photography in favor of his paintings, murals, and graphic art. In fact, Shahn's photographs were not presented in a monographic exhibition until 1969, when Davis Pratt and William S. Johnson organized *Ben Shahn as Photographer* at the Fogg Art Museum. The next year Shahn's widow, Bernarda Bryson Shahn, donated her husband's photograph collection to the museum, where it now forms a permanent research archive, containing more than five thousand prints, negatives, and contact strips. This archive documents the artist's lifelong interest in the medium and provides the basis for the current exhibition.[2]

Shahn first became interested in photography at a time when rotogravure reproductions of photographs in newspapers and magazines served as essential source material for

Detail of catalogue 49

his polemic paintings and satiric caricatures. News photographs enabled Shahn to imbue such works as his famous gouache series *The Passion of Sacco-Vanzetti* and *The Mooney Case* with a quality of seemingly uninflected reportage, an effect favorably noted by many of his contemporaries. Between 1932 and 1935, he joined the vanguard of the social-documentary movement, making hundreds of street photographs that defined life in New York City through the prosaic activities and expressive gestures of ordinary people (cat. 1).

In addition to photographing activity on the sidewalks of lower and midtown Manhattan, Shahn documented demonstrations for expanded work-relief programs and protest marches against social injustice in and around Union Square and City Hall. In preparation for one of his earliest murals he photographed inmates and prison officials at Blackwell's Island Penitentiary and the New York City Reformatory. Shahn's New York photographs address such topical issues as unemployment, poverty, immigration, and social reform and their connection to race and class. They constitute a singular vision of urban life during a period in which many diverse and influential photographic interpretations of the modern metropolis appeared, including projects by Berenice Abbott, Walker Evans, Lewis Hine, Helen Levitt, and members of the New York Film and Photo League. Shahn's experimental New York photographs also laid the foundation for his work as a government photographer. Between 1935 and 1938, Shahn, a vocal proponent of Roosevelt's New Deal policies, produced thousands of documentary photographs of the rural southern and midwestern United States for the Historical Section of the Resettlement Administration/Farm Security Administration (RA/FSA). It is these photographs, which unlike those made in New York exist in the public domain and have received moderate exposure since they were created, that have defined the limited understanding of Shahn's camerawork. The occasional photographs Shahn made at midcentury await further study.

Eschewing the large-format, formal aesthetic of many artist-photographers of his day, Shahn, like hoards of amateurs, embraced the handheld thirty-five millimeter Leica camera. This tiny, lightweight apparatus allowed him to move unobtrusively through the crowded immigrant neighborhoods of New York City, documenting daily life. Shahn oriented his camera horizontally and tended to photograph at eye level at fairly close range, thereby placing the viewer in the midst of the urban scene. Walker Evans, who shared several Greenwich Village studios with the painter in the early 1930s, encouraged Shahn's interest in photography and instructed him in basic technical matters. In later years Evans heralded Shahn's photography as "exciting," "pioneering documentary" and reminisced about what it was like to work with Shahn, recollecting that the two of them "used to hang around a great deal . . . getting the atmosphere of life in the Lower East Side." He also marveled at "what a witty eye Shahn had to whip out . . . the camera and to sort of shoot from the hip in a second." Indeed, Shahn found that by affixing a miniature periscope-style attachment known as a right-angle viewfinder to his camera, he could capture passersby unaware. The artist could thus present his subjects "immersed in a private world," as Bernarda Bryson

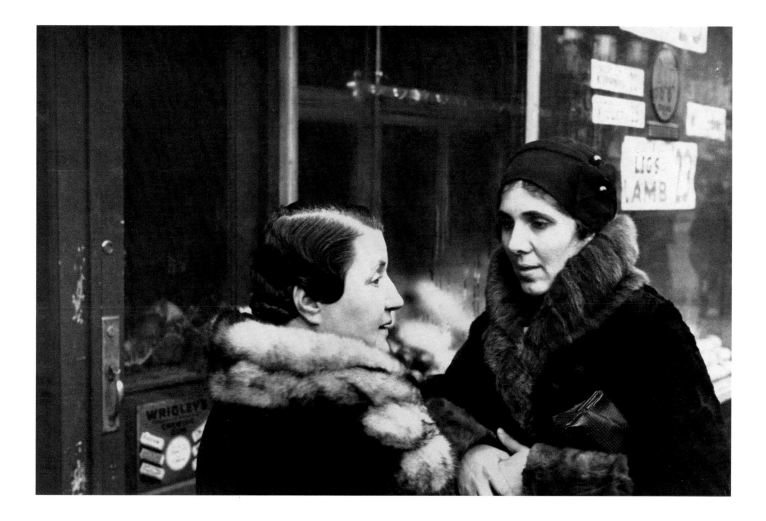

1. *Untitled (New York City),* 1932–35, 15.4 × 23.6 cm
Fogg Art Museum, gift of Bernarda Bryson Shahn, P1970.1066

Shahn observed. This "arresting of unconscious mood," she affirmed, constituted "one of the distinguishing marks of all of Shahn's photographic work."[3]

From the outset Shahn regarded content as the most important element of his photographs, and he employed standard darkroom techniques to achieve the effects he desired—exaggerating or subverting information in his negatives through cropping, dodging, and burning (figs. 1–3).[4] Like other photographers of his era, Shahn frequently mounted, signed, and titled prints he wished to designate "finished." He also sought a mass audience for his New York photographs and submitted them to leftist magazines like *New Theatre* as well as to mainstream publications like *U.S. Camera Annual.* Moreover, as an editor of *Art Front,* the organ of the radical Artists' Union and the Artists' Committee of Action, Shahn reproduced his photographs of political demonstrations to show how organized protest could effect social change. In spite of the seriousness with which Shahn pursued photography, he did not seek technical perfection in his prints beyond the degree needed to reproduce and disseminate them. Shahn held that for him, "the function of a photograph was to have it seen by as many people as possible, and newspapers and magazines are one of the best ways. Naturally things printed in a magazine won't have the photographic quality of the photograph itself. But I felt that the image was more important than its print quality." In fact, he poked fun at photography clubs preoccupied with technical matters, and he even sent misleading technical data to a popular camera annual publishing his photographs.[5]

Compelling examples of social-realist art in their own right, Shahn's early New York photographs also inspired many of his most important paintings, murals, and drawings, establishing a photographic aesthetic that would characterize his work for decades. In preparation for his large-scale mural at the Rikers Island Penitentiary (1934–35) (cat. 122), a project on which he worked with the painter and photographer Lou Block, Shahn made striking photographic studies of young men confined in correctional institutions. To photograph life behind bars Shahn had to secure permission from prison officials, wardens, and inmates, making him perforce a conspicuous presence. He encountered the inmates directly, imparting a distinct character to his prison photographs. The artist reveled in the nuances of form and expression present in these images, qualities he translated into his mural studies.

Photography became so integral to Shahn's identity during the 1930s that he portrayed himself with a Leica and angle viewfinder in his witty tempera *Myself Among the Churchgoers* (1939) (cat. 2), which was based on a number of the artist's RA/FSA photographs. The painting is Shahn's incisive response to accusations by religious officials that aspects of his and Bernarda Bryson's mural in the Bronx General Post Office (1938–39) were "irreligious," and it depicts the artist in jaunty apparel photographing dour churchgoers without their knowledge. Despite Shahn's spirited posturing here, the work testifies to his identification with photography as a powerful artistic and political tool. Shahn's longtime admirer

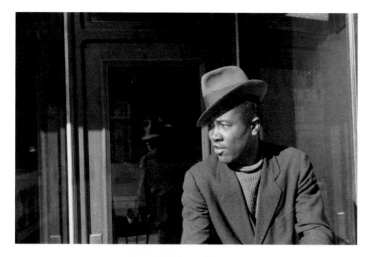

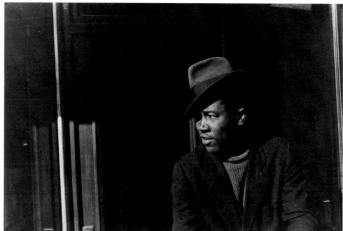

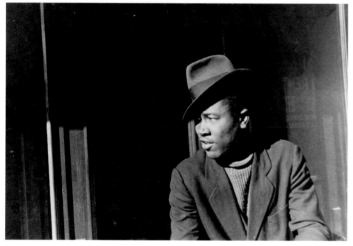

Archibald MacLeish commented that for him, this painting represented the artist's unique manner of engaging with the world: "[Shahn] was not that private painter who stands outside his picture and looks in. He was that rarer artist who is himself a figure in the scene." MacLeish well understood how photography gave Shahn perpetual access into the social "scene," and he suggested that by extension the photographs could be described as "Myself Among the Living."[6]

Ben Shahn's New York: The Photography of Modern Times explores how the artist's first foray into documentary street photography provided him with a fundamental means of interpreting contemporary life in the urban milieu. Although the term "modern times" is most often associated with Charlie Chaplin's comic 1936 film, it was in use throughout the era. The 1934 anthology *Art in America in Modern Times,* edited by Holger Cahill and Alfred H. Barr, Jr., for example, contains an essay by Shahn's friend Lincoln Kirstein summarizing trends in American photography and identifying the distinctive qualities of contemporary documentary camerawork: "Then there are art-photographs of a slightly different nature,

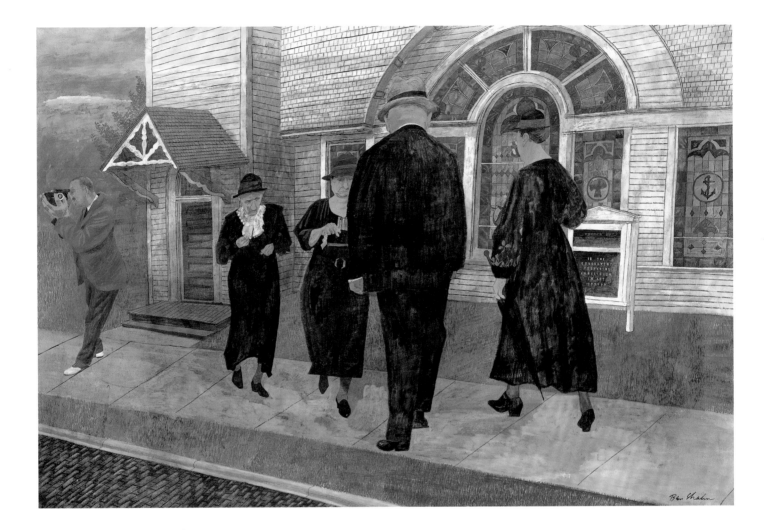

2. *Myself Among the Churchgoers,* 1939, Tempera on masonite, 50.8 × 74.9 cm
Curtis Galleries, Minneapolis, Minn.

scenes of human interest caught in the passage of time and events, scenes which by their tragic or comic typicality summon up a whole world of related reference. . . . [They are] keys to an epoch."[7] Kirstein's passage perfectly describes the character of Shahn's New York photographs, images that helped shape a highly influential documentary aesthetic with far-reaching social implications.

The development of Shahn's social-realist vision was infused by his commitment to leftist politics and his interest in the cultural force of mass media during the 1930s—news photographs and film in particular. *Ben Shahn's New York: The Photography of Modern Times* situates the artist's earliest activities as a documentary photographer within these wide-ranging interests. The book is organized in three sections: text, catalogue of the exhibition, and an appendix of writings and visual resources. The abbreviation "fig." identifies the illustrations to the text and the appendix, while "cat." indicates works that appear in the exhibition.

The text builds outward from a consideration of the immediate social history of Shahn's New York photographs to their broader cultural significance. Laura Katzman's "Ben Shahn's New York: Scenes from the Living Theater" provides readers with an essential introduction to Shahn's New York street imagery, demonstrating how the photographs speak eloquently to many pertinent issues of the day, such as unemployment, poverty, and race relations. Deborah Martin Kao's "Ben Shahn and the Public Use of Art" places Shahn's New York protest, prison, and street photographs in the context of his involvement in the radical artists' movement and leftist critical responses to his reportage-inspired aesthetic. Jenna Webster's "Ben Shahn and the Master Medium" uncovers how Shahn's unique relation to film and film culture in the 1930s informed his thinking and his aesthetic sensibility. Laura Katzman's "The Politics of Media: Painting and Photography in the Art of Ben Shahn," asserts the importance of analyzing Shahn's paintings and photographs together, explaining why the connections between the two have received little interpretive analysis heretofore. Written in 1993, it is republished here in revised form.

The exhibition catalogue is organized thematically and intersperses Shahn's photographs with his related paintings, prints, and drawings as well as relevant ephemera. The appendix consists of contemporary documents and later commentaries on Shahn's work. Together, the sections of the book offer a diverse range of materials that speak to the pervasive impact of Shahn's New York photographs and their relevance to American culture of the 1930s.

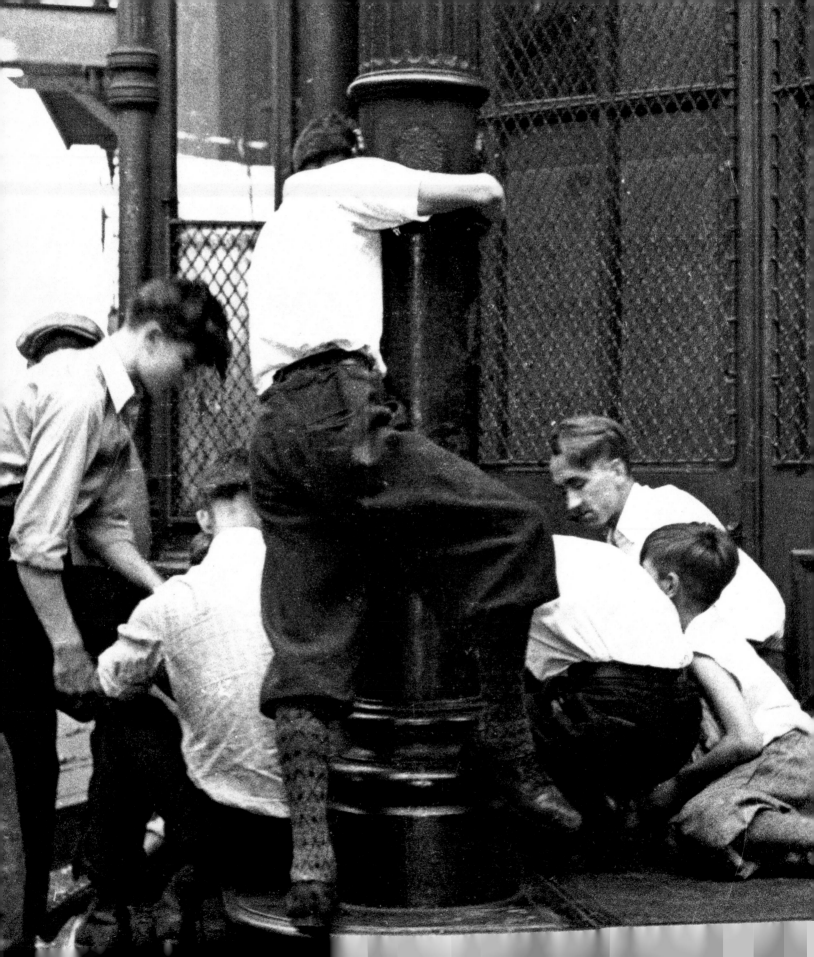

1. Ben Shahn's New York Scenes from the Living Theater

Laura Katzman

East Side, West Side, all around the town, boys and girls together hanging around shop doors; whispering, giggling in tenement hallways, in courtyards smelling of backhouses. The world's most populous Italian city outside of Italy spends the sultry night on doorsteps, standing, sprawling on sidewalks of broken cement. So with the world's third Irish city. The world's Negro metropolis is the most crowded of all. Home has scarcely room to hang one's hat, which instead is hung in churches, club rooms, rent parties . . . and among the thousand already asleep on the Lower East Side will be a large number of old timers who have never seen Broadway.

—Federal Writers' Project, *New York City Guide,* 1939

In November 1934 twelve of Ben Shahn's photographs of New York were reproduced as a spread in the radical cultural magazine *New Theatre* (fig. 4). These remarkably candid images depict elderly immigrant women sitting stolidly on tenement stoops, a lone black woman eying a "for rent" sign, a worker in a peacoat and cap at rest, and middle-class men almost dapper in their fedoras. From Harlem's Willis Avenue Bridge to Bowery restaurants, in Greenwich Village apartments and Union Square bargain shops, Shahn captured his subjects off guard and unposed, their gestures arrested. Yet this unsuspecting, seemingly arbitrary cast of characters reflects the rich ethnic, racial, and economic diversity described by the *New York City Guide*. As the title of Shahn's spread suggests, these documents of street life—his first published photographs of the city—constitute "scenes from the living theatre" that was New York.[1]

The *New Theatre* spread introduces us to Shahn's distinctive documentary approach to the lives of ordinary people on the "sidewalks of New York." Restless and freewheeling, Shahn wielded his Leica with its right-angle viewfinder in service of a matching aesthetic. He often achieved a loosely cinematic effect, though, significantly, he rarely stayed with a subject for more than three frames. The results are fresh, gritty, and immediate, with dynamic framing, striking juxtapositions, off-balance composition, and truncated figures.[2] The publication of the pictures in *New Theatre* also attests to Shahn's social commitment and leftist political stance: the magazine was the organ of the Communist-backed National Film and Photo League, which promoted Soviet-inspired film, theater, and dance about class struggle in America. Shahn was in fact involved with the Communist Party, his values

9

Detail of catalogue 3

Scenes From The Living Theatre — Sidewalks of New York

Photographs by BEN SHAHN

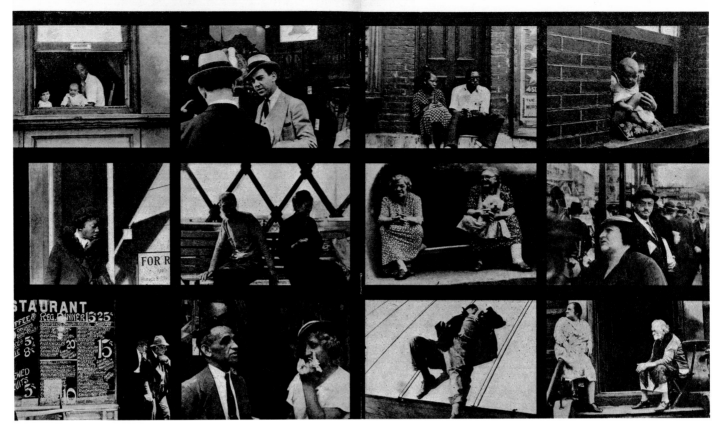

FIGURE 4

"Scenes from the Living Theatre:
Sidewalks of New York"
In *New Theatre* 1
(November 1934): 18–19
31 × 47 cm
Taller Archive

having been influenced from an early age by the socialism of his father, a Lithuanian Jewish craftsman. As a radical the artist believed deeply in the social and political functions of camerawork.[3]

Shahn used his Leica to photograph New York during the worst years of the Great Depression, making vivid studies of working-class people and immigrant neighborhoods. In addition, he undertook two related projects: documenting demonstrations by the Artists' Union and photographing prisoners in local reformatories and penitentiaries for a Rikers Island mural commission. In all, he produced hundreds of photographs of New York City that capture the unique energy and celebrated diversity of the metropolis at a troubled time.[4]

But compelling as these images are, they have not been closely studied, in part because they remained largely a private resource for Shahn during his lifetime and as such received limited public exposure, appearing in only a few publications in the 1930s and 1940s.[5] Although the photographs became more accessible to scholars in 1970, when Shahn's widow

donated his archive to the Fogg Art Museum at Harvard University, they did not become fully available to the public until 1994. Despite efforts by the Fogg's first photography curator, Davis Pratt, to promote Shahn's camerawork, the New York photographs have never been comprehensively exhibited or published.[6] Examination of the New York pictures as sociohistorical documents has been hampered by the general impression (perpetuated in part by Shahn) that the photographs served mainly as source material for the artist's work in other media—"grist to his mill," in the words of Walker Evans.[7] To the extent that they have elicited attention in their own right, the New York works have been overshadowed by Shahn's more famous documentation of rural poverty and small-town life for the RA/FSA project, which has undergone a resurgence of interest since the 1970s.

Shahn did use the camera to assist his other art—to record fleeting actions and revealing details and as a research aid for mural projects. However, the sureness of his painter's eye, coupled with an amateur photographer's freedom to experiment, give his New York photographs aesthetic value that transcends their status as either snapshots or sources and makes their social statements all the more powerful. Such intrinsic value, along with the lifelong impact these photographs had on his social outlook and his work in other media, render these images worthy of serious attention. In this chapter, I focus on Shahn's candid street scenes, exploring representative subjects in his portrayal of the disenfranchised—workers, vagrants, and children—and considering how Shahn employed the language of humanist documentary (the burgeoning photographic style of the day) to comment on the city's social conditions at a time of severe economic hardship. I also examine Shahn's particular construction of New York in the context of certain popular commercial views of the city and the work of better-known street photographers of his generation.[8] The photographs, despite their seemingly casual creation and their practical purpose, are acute observations of the urban scene that reflect the artist's active engagement in radical politics, complex feelings about his ethnic identity, and keen responsiveness to the cultural climate in which he worked.[9]

EARLY INFLUENCES

Ben was a born graphic artist and craftsman. It wasn't very difficult to teach anyone as bright and gifted as that—a very gifted artist—really a poet.
—Walker Evans, in Davis Pratt, *Ben Shahn as Photographer,* 1969

Shahn's friend Walker Evans introduced him to photography around 1932, when both were struggling to make ends meet. Shahn and his first wife, Tillie Goldstein, had just moved with their young daughter, Judith, from Brooklyn Heights to a Greenwich Village apartment building, where Evans used a street-level room as a studio (see fig. 54). Evans taught Shahn how to print his negatives and reportedly gave him his first and only lesson in making exposures: "F/9 on the sunny side of the street, F/4.5 on the shady side of the

street. For a twentieth of a second hold your camera steady."[10] Together the gregarious Shahn and the reserved, fastidious Evans toured the city with their handheld Leicas, drawn in particular to the visually rich atmosphere of the immigrant neighborhoods on the Lower East Side.

Although Evans's middle-class Christian upbringing differed from Shahn's poor Jewish background and they disagreed intensely on politics, they shared a mischievous sense of humor and a rebellious attitude toward both bourgeois convention and avant-garde pretension.[11] Aesthetically, Shahn and Evans reacted against the artifice of soft-focus pictorialism, preferring instead to freeze the flux of urban life. Their work is quite close stylistically during these years, as is evident in a comparison between images like Shahn's *14th St. (New York City)* (1932–34) (cat. 26) and Evans's *Girl in Fulton Street, New York* (1929) (fig. 5), which shows a striking face singled out from an anonymous crowd and framed by the prominent architecture.[12] Yet even in their thirty-five millimeter photographs, subtle distinctions emerge, as Shahn's vision appears warm and compassionate, Evans's exacting and detached. Evans's New York compositions, while at times as rough and off-kilter as Shahn's, often display clarity, symmetry, and a sensitivity to abstract patterning. These qualities are especially pronounced in Evans's urban architectural scenes (c. 1928–29) made with 2 ¼ by 4 ¼ roll film and inspired by the international modernism of such figures as Man Ray and László Moholy-Nagy, as well as in his later work with an eight-by-ten large-format view camera. The formalist deliberation in Evans's Depression-era photography makes him seem, in the words of cultural historian Alan Trachtenberg, "less like a social critic and more like a disinterested observer."[13]

Shahn came to the New York photography world at a time when the medium had reached unprecedented levels of popular and critical recognition, as evidenced by increased exposure in museums, galleries, and publications. Amateurs abounded, experimenting with the newly available faster films and small cameras, whose portability and convenience were transforming photojournalism. Among the significant figures with whom Shahn came in contact were the painter-photographer Hans Skolle, the architect-photographer Paul Grotz, and the film theorist Jay Leyda, all friends of Evans's. Shahn was also acquainted with Paul Strand, Ralph Steiner, Leo Hurwitz, and Herbert Kline, radical photographers and filmmakers affiliated with the New York Film and Photo League and related organizations. He was drawn to the gritty detail and raw textures of Strand's early street photography, which appeared in *Camera Work,* and to the human dignity in the work of Lewis Hine, whose photographs Shahn could have known from the liberal journal *Survey Graphic* and the Empire State Building project (1931), which resurrected Hine's reputation.[14] Shahn also felt a deep affinity with Eugène Atget's unadorned lyricism in view-camera pictures he may have seen at two exhibitions in the Julien Levy Gallery in December 1931 and January 1932, shortly after Berenice Abbott had transferred Atget's Paris archive to New York. Shahn would certainly have encountered Atget's surrealistic street

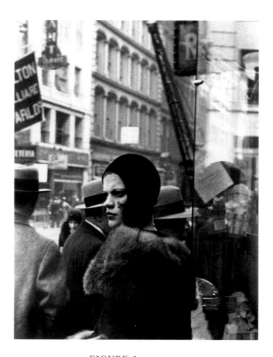

FIGURE 5
Walker Evans,
Girl in Fulton Street,
New York, 1929
17 × 13.6 cm
The J. Paul Getty Museum,
Los Angeles

scenes and August Sander's clinical German working-class portraits in a book review Evans wrote in 1931 celebrating both.[15] Of profound interest to Shahn was the "ambivalent," "accidental," anti-narrative aesthetic of the young Henri Cartier-Bresson, whom he met in New York in the mid-1930s, having first seen his photographs at Levy's gallery in October 1933. In a 1947 article Shahn praised Cartier-Bresson for his "genuine sympathy for people" and his ability "to find the extraordinary aspect of the ordinary."[16]

Shahn was one of many socially engaged painters who took up photography in the 1930s. Lou Block, Reginald Marsh, Lucienne Bloch, and Yasuo Kuniyoshi, like Shahn, used the Leica to connect to lived experience in new ways and to record images that inspired a broadly communicative art. Yet Shahn was not an ordinary Leica enthusiast. In 1934 the *New Masses* critic John Boling, bemoaning "the tragic case of our camera men" who were embracing commercial advertising, romantic aestheticism, or surrealist abstraction, singled Shahn out with two other painters who were "many steps ahead of our photographers in recognition of the camera as a powerful medium of [social] expression." And by the mid-1930s, Shahn's Leica shots were being published in both commercial and artistic venues—by Leica promoters Willard D. Morgan and Henry M. Lester and by editor T. J. Maloney of *U.S. Camera,* the popular, lavish annual of distinguished professional and amateur photography. Years later, Evans, in his 1969 Harvard lecture on Shahn, asserted that Shahn's work represented "pioneering documentary photography," adding: "Now you've all seen oceans of it, but this is one of the early examples, and Shahn had that kind of eye and enthusiasm and energy about it."[17]

Although Shahn's talent was clearly recognized in the early 1930s, even before he

began working for the RA/FSA, Shahn himself made ambivalent if not contradictory statements about photography. He was often indifferent to technique, which he saw as subordinate to content. He claimed in 1940 that he had "never taken a picture for photography's sake, but always for my own use" and in 1964 that photography "is a mind, an eye, but not an art."[18] Yet close analysis of Shahn's photographic archive challenges such statements and reveals his deeper engagement with the medium. Not only did he experiment in the darkroom, burning, dodging, and cropping images, but he also printed variants and reversals of pictures and prepared many of the New York photographs as "finished" prints (cats. 26, 27, 29, 30). From extant contacts, negatives, and "work" prints, it is evident that the images Shahn selected for mounting tended to be the strongest technically and compositionally or the most iconic in a particular series. In a number of cases, such discrimination is also apparent in what he chose to print. He mounted, titled, and signed many pictures that were not used for paintings, which means that he saw the photographs as documents that stood on their own.[19] And despite Shahn's informal and carefree stance, his street photography reflects a remarkably consistent vision of the social and physical character of New York in the 1930s.

THE FACE OF A CITY

NEW YORK—home of the world's . . . most stupendous structures . . . veritable center of our country's wealth, culture, and achievement! NEW YORK—!!! What visions of magnitude, variety and power the name New York conjures up for human comprehension. . . . Buildings that house whole cities . . . keep going up in almost every part of the huge city.
—W. Parker Chase, *New York: The Wonder City,* 1932
The New York we knew [in the 1930s] was not just a vital metropolis brimming with politics and confusion; it was also brutal and ugly, the foul-smelling jungle Céline would evoke in Journey to the End of the Night. New York was frightening . . . as a social vortex into which you might be dragged down, forever beyond rescue.
—Irving Howe, *A Margin of Hope: An Intellectual Autobiography,* 1982

Shahn's special relationship with New York encompassed the city's contradictions. As a precocious child he had explored the streets of his Williamsburg, Brooklyn, neighborhood and led friends on escapades into Manhattan. He stood in awe of the Brooklyn Bridge, a tour de force of human ingenuity and physical beauty. As a teenager removed from school to be an apprentice at a lithography shop on the Lower East Side, Shahn quickly made the area his surrogate classroom. Although he could express a youthful disdain for New York and its art world when he lived in Paris in 1929, just three years later he was writing his dealer Edith Halpert from Truro, on Cape Cod, that he "yearned for my beloved city."[20] After all, New York was the nation's cultural capital and since the late 1920s had been replacing Paris as the world's. It was also, for many leftists of Shahn's im-

migrant background, "the powerhouse of capitalism and the crucible of socialism," in the words of the social historian Irving Howe.[21] Even though Shahn's later trips through the United States for the RA/FSA led him to recognize the provincial attitude of many New Yorkers who like himself had not traveled "as far as Hoboken," he would always miss the tempo, the vitality, and the noises of the city. New York remained the center of his professional world even after he moved to the town of Jersey Homesteads in 1939, and he often returned to the city "to see my reflection in the windows and rub elbows with the crowd . . . [and to] take in all the newsreels too."[22]

Shahn took his New York photographs primarily in lower Manhattan, as is apparent from the locations he gave as titles to many of them. He focused on ethnic, working-class neighborhoods in Greenwich Village, Union Square, the Middle East and Middle West Sides, South Street Seaport, and especially on the Lower East Side. Shahn's images present both crowds and empty alleys. The weather is mild in his metropolis, and the bulk of the photographs were taken outdoors in full daylight. Although Shahn captured certain physical realities that conveyed a recognizable 1930s ambience—the soon-to-be-dismantled elevated train tracks darkening the streets with their heavy grillwork, for instance (cats. 71, 72, 74)—major architectural sites are conspicuously absent. Shahn began photographing New York at a time when the Depression had brought construction and demolition projects almost to a halt. Still, some of Manhattan's most renowned skyscrapers, including the Empire State Building, emerged during this period, and by the middle of the decade, under New York's indefatigable parks commissioner Robert Moses, the city was even witnessing a building boom.[23]

Shahn, however, ignored New York's status as the skyscraper capital of the world. His photographs reveal the character of each particular neighborhood more through the signage and displays of its storefronts than through famous sites, aerial views, or wide-angle cityscapes.[24] When such notable landmarks as Radio City Music Hall, the Washington Square Arch, or even his cherished Brooklyn Bridge filtered into Shahn's viewfinder, they served solely as a backdrop for human activity (cat. 65).[25] In a rare cityscape seen from a South Street pier, Shahn, with characteristic wit, stunted the verticality of the Wall Street towers by presenting those "cathedrals of commerce" in a horizontal format that cropped them, and he shifted the scene's focal point to the International Workers of the World (IWW) sign (cat. 64). When bridges appear in his work, they tend to be modest structures like the Willis Avenue Bridge, opened in 1901—a swing bridge that connects Manhattan and the Bronx. Shahn used the bridge's girders to reinforce the starkness of urban existence, as they frame and separate a shabbily dressed couple waiting on a bench.

Shahn's photographs differ dramatically from those in popular books like *This Is New York* (1934) (fig. 6), a romantic celebration of the city's most outstanding sites that the editor, critic Gilbert Seldes, called "the first modern photographic book of New York." Seldes declared his intention of showing readers "how to see" New York—"the startling

beauty and impressive grandeur of the metropolis of the New World." Shahn's subject choices are more personal than those of Frederick Lewis Allen and Agnes Rogers in *Metropolis,* a comprehensive, sociological study that, the authors explained, was "devised to suggest . . . the [diverse] complexion of human life in a metropolis—the ways in which people live and work and play."[26]

Shahn's portrayal of New York equally contrasts with the precise modernist visions of Alfred Stieglitz, Charles Sheeler, Ralph Steiner, Margaret Bourke-White, and Berenice Abbott, some of whom were represented in the Seldes book. Their work reinforced the magnificent presence of skyscrapers and bridges as a way of evoking the technological ambitions of the Machine Age (fig. 7). Although Shahn's photographs share a social concern with Abbott's Works Progress Administration (WPA) project *Changing New York* (1939), a decade-long effort that documented the transformation and development of the city, their sensibilities are worlds apart. Where Abbott juxtaposed old and new architecture to accentuate both the enduring strength of the past and the ascendant forces of the future, Shahn emphasized provocative relations between human subjects and their physical environments to highlight social or economic conditions.[27]

Shahn's peopled, street-level view of New York's poor and working-class districts aligns closely, however, with the work of photographers in the Photo League, an outgrowth of the more militant Film and Photo League. A member, though not an active one, Shahn supported the social and aesthetic principles of the Photo League, New York's most vital organization (and school) for responsible documentary practice at the time.[28] Like Walter Rosenblum in his *Pitt Street* series of 1938 (fig. 8), Shahn illuminated the characters and vibrancy of local hangouts as well as quieter moments of introspection on a crowded East Side block. Shahn's work was never as focused in technique or as extensive in its coverage and research as the league's "photo-documents" of the city.[29] Still, Shahn too captured the Lower East Side with candor and somber reflection, recording a time of change, when older immigrant generations were dying off and their children were becoming Americanized and moving out of the area.

Shahn's work also shares the more radical vision of the modern city expressed by Ilya Ehrenburg, the Russian Jewish novelist and international correspondent renowned as "the master of reportage in the U.S.S.R." Respected by Shahn and his colleagues in the Artists' Union, Ehrenburg's articles were published in *New Theatre,* including the issue that featured Shahn's 1934 photo spread. Shahn was especially taken with Ehrenburg's *Moi Parizh* (*My Paris*), a 1933 documentary book that he encountered through Evans.[30] Shahn was so excited about the book that it may have inspired his own photographic approach to New York. Ehrenburg, armed with a Leica and a right-angle viewfinder, had rejected the glamorous, romanticized image of Paris, presenting instead the poverty and decay of a capitalist city (see fig. 53). *My Paris* presents what Boling, writing from the left, called a "cross-section of the little joys and large miseries of the middle-class and labor population."[31] We

FIGURE 6
Gilbert Seldes, ed., *This Is
New York: The First Modern
Photographic Book of New York*
(New York, 1934), 5
24.3 × 19 cm

"New York is a great city to visit, but I wouldn't live there if you gave me the place."—Old Saying.

WELL, WE GIVE YOU NEW YORK. It isn't exactly ours to give, but it is yours to take. And it is a fine city to visit.

We give it to you so that you can see it. The ordinary "book of views" tells you, well enough, what to see. Our purpose here is to suggest *how* to see, and for that reason we have collected the work of the men and women who know best how to see —the most expert modern operators of the camera, the artists in photography. All of them are masters of their work; they know how to take pictures which are beautiful to see; but their real greatness is that they know how to look at buildings, bridges, monuments, land, water, and people. Like great painters, they make us see what they see; what their eyes find, the camera records; and for ever after, we are helped to see with our own eyes.

Before the city could be photographed, it had to be built. We have taken the trouble to record, for the first time in a book of this kind, the names of the architects responsible for the startling beauty and the impressive grandeur of the metropolis of the New World. Silly books, stupid movies, pretty

bathtubs, and ugly motor cars may all be known by the names of the men who made them; but the buildings of all our great cities have been, so far, virtually anonymous. We are grateful enough to the artists who created New York to resent their obscurity. So we publish their names.

Now this is the place to launch into a rhapsody about New York; its splendors and miseries, its towers that rise to the sky and its caves that lie deep in the earth, its kindness and cruelty, its hardness and sweetness; here New York ought to figure as the city of dreadful night, the spider at the center of the web, the golden gleam, the magnet which pulls men and women remorselessly to itself and either makes them wonderfully rich and famous or throws them out again, like a spent electric bulb. In short, this is the place to grow romantic.

As they say in the movies, "skip it." (It might be a good idea to skip this page altogether and go directly to the pictures which, like good wine, need no beating around the bush.) New York isn't quaint or odd; it is nothing to be romantic about. You might well say that New York is itself too much a romance

5

Fortieth Street Between Sixth and Seventh Avenue, From Salmon Tower, 11 West 42nd Street, Manhattan; December 8, 1938.

● Fortieth Street, Sixth Avenue and Broadway mingle in the architectural cascade seen from the Salmon Tower. The historic Bryant Park Studio Building at the left and the World Tower Building at the right frame modern setback skyscrapers of a later generation, the Bricken Casino and 1400 Broadway. The low structures in the foreground on Sixth Avenue are about a century old, typical of the changing city.

134

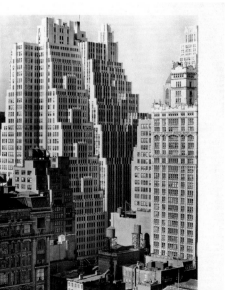

FIGURE 7
Berenice Abbott, *Fortieth Street
between Sixth and Seventh Avenue,*
5 December 1935
In Berenice Abbott, *Changing
New York* (New York, 1939),
plate 134
28.5 × 43 cm
Although Abbott dated this picture 8 December 1938 in *Changing New York,* Bonnie Yochelson, in her authoritative *Changing New York,* claims that this image is from 1935; in 1938 Abbott returned to the site.

see weary workers in stained clothing standing in front of rundown buildings, unkempt children playing on the pavement, and crippled men and slovenly drunkards sleeping unprotected on park benches. This grim portrayal is tame compared to Ehrenburg's more virulent attacks during the 1930s on the deceptions of Western democracy and the evils of fascism that demonstrated what many regarded as his loyalty to Joseph Stalin.[32] Ironically, such an exposé of social ills would have been impossible in Ehrenburg's own country, given the brutal repression of the Stalinist regime. Today Ehrenburg may seem to have been a mouthpiece for Stalin's government and *My Paris* to resemble Communist propaganda, but in 1934 Shahn and his comrades could still embrace a Soviet model for their own critiques of American capitalism and attempts to come to terms with the U.S. stock market disaster.[33]

Shahn admired Ehrenburg's unflinching eye and his skill with the anglefinder. Both men shunned the merely pictorial, the tricks of photomontage, and didactic contrasts between the privileged and the poor. Boling, who wrote, with some exaggeration, that Ehrenburg's work displayed "only . . . the life-withered faces and figures in their off hours, the burdened carriage of body and mind, the broken spirit of infinite despair," in the same review praised Shahn for his progressive use of "document pictures" for social purposes.[34] Yet Shahn's photographs are never as coarse as Ehrenburg's; the American artist's eye tended to be more selective, finding greater appeal in people as individuals and showing sensitivity to their ethnic and racial specificity. Shahn conveyed a stronger sense of affirmation in the ordinary lives that came into view as he paced the pavements of New York.

LABOR

The working class was part of the dream. . . . The casting out of old identities; communion with the workers; life in a future world that the workers would build in America as they were building it in Russia; all those religious elements were present in the dream of those years. It made everything else seem unimportant, including one's pride, one's comfort, one's personal success or failure, and one's private relations.

—Malcolm Cowley, *The Golden Mountain: Remembering the 1930s,* 1964

Given the widespread idealization of Russian proletarian culture among the American left in the 1930s, it is no surprise that images of workers pervade Shahn's photographic oeuvre. Artists in Shahn's circle, feeling consigned to society's margins, identified with the laboring classes and modeled their unions and their protests on those of manual workers. Yet Shahn was careful not to present oppressed laborers as heroes or capitalists as villains; perhaps his own experience as an artisan had imbued him more with respect for workers than with zeal for a future workers' republic. As photo-historian Susan H. Edwards has written, Shahn "was not interested in a rhetorical valorization of the underprivileged or dignification of labour" that was popular in much Communist-inspired art. By the

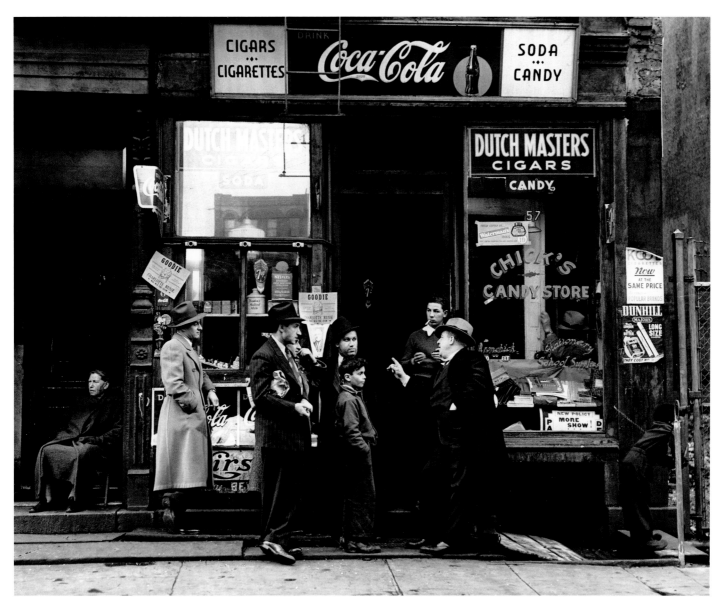

FIGURE 8
Walter Rosenblum,
Chick's Candy Store, Pitt Street,
New York, 1938, from
The Pitt Street Series
Approximately 18 × 24 cm
Collection of the artist

mid-1930s, around the time of the Popular Front, a Communist-led "coalition" of leftist organizations to combat fascism, Shahn had rejected the authoritarianism of the Communist Party and was frustrated by the infighting between Stalinists and Trotskyists. He cut his ties with *Art Front* and, like many radicals, evolved into a moderate liberal and an ardent New Dealer.[35]

This change was catalyzed by Shahn's trips for the RA/FSA, which gave him more opportunities to see working-class people as diverse individuals. He later wrote that his travels in the South had exposed him to "such talent thriving in the same shell with hopeless prejudices, bigotry, and ignorance," that his Marxist "theories had melted before such experience." Yet even earlier, in New York, Shahn had sought to avoid stereotypes in his work, making distinctions among individuals within the same class and among those from different classes. He expressed in his photographs what he said was important for his paintings: "[the] difference in the way a twelve-dollar coat wrinkles from the way a seventy-five-dollar coat wrinkles."[36] Such attention to prosaic detail gave force to Shahn's generalizing about the larger issues of labor and unemployment.

Shahn's pictures show vendors, peddlers, and merchants without customers, indicating how small businesses suffered during the Depression. In one image, a candy vendor gazes worriedly past his modest stock of goods and empty scale (cat. 20). In another, shoe shiners stand idly by their unoccupied stools, their figures dwarfed by the Corinthian columns of the New York General Post Office (cat. 88). Many such sidewalk businesses were being driven from street locations into the municipally controlled marketplace. In a photograph Shahn entitled *East Side Merchant,* a woman wearing a creased babushka, torn sweater, and stained apron frowns and purses her mouth as she stands before the dirty wooden crates that hold the produce on which her livelihood depends (cat. 43). She exemplifies the market women the writer Alfred Kazin remembered from his own childhood in a working-class Jewish section of Brownsville, Brooklyn: "Their shrewd open-weather eyes missed nothing. The street was their native element; they seemed to hold it together with their hands, mouths, fists, and knees; they stood up in it behind their stands all day long, and in every weather."[37]

When Shahn depicted the jobless, they were also often waiting—effective Depression-era iconography in a city that by 1932 had more than a million people, or one-third of its labor force, out of work. One photograph taken in Seward Park, on Canal Street between East Broadway and Essex Street on the Lower East Side (fig. 9), shows four men sitting close together on a bench, apparently oblivious to one another, their attention dispersed. The figures are pictured against two fences, one mesh and one spiked, which separate them from the commercial and financial worlds signified by the truck and the Citizens Savings Bank sign in the background. In the context of the bank panic and the general bank closing of 1933, which Shahn recalled as a desperate and grim time, "citizens'" savings seemed out of reach indeed.[38]

That the men sit in Seward Park adds another element of irony to the image, since the park was originally designed for immigrants. Created in 1899, when the Lower East Side was the center of Jewish immigrant life in Manhattan, the park replaced two blocks of densely packed tenements with three acres of breathing space—a classic Progressive Era effort to introduce light, air, and recreation into slum neighborhoods. Even in its early years, however, Seward Park had become a gathering site for immigrants seeking daily work, and it is the persisting hardship rather than reformist hope that Shahn, who was familiar with the place, conveyed. He was a regular visitor to the park and read the Yiddish *Jewish Daily Forward,* whose building was in the area; as a young man he had studied art at night at the nearby Educational Alliance settlement house. Seward Park may even have

FIGURE 9
Untitled (Seward Park, New York City), 1932–35
13.4 × 20.3 cm
Fogg Art Museum, gift of Bernarda Bryson Shahn, P1970.2958

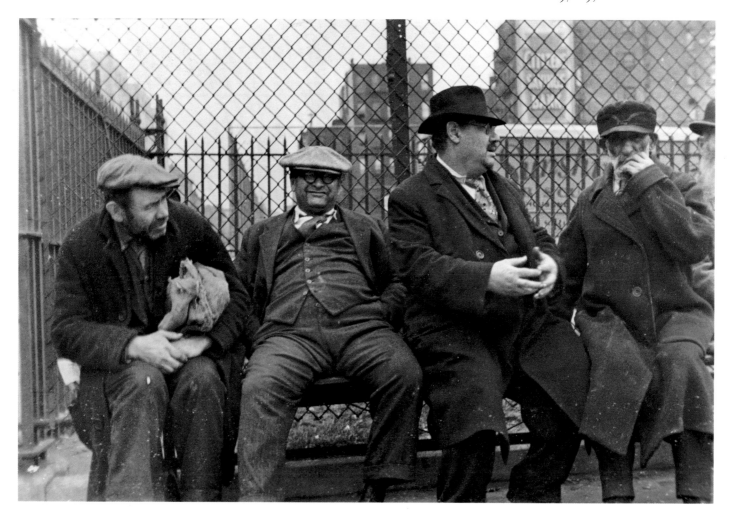

been one of the destinations of Shahn's boyhood hikes, for it was the first municipal park in America to be outfitted as a permanent playground, in 1903.[39]

Shahn delighted in the range of expressions and conditions typified by the men frequenting Seward Park, distinctions that he reinforced in the related lithograph *Seward Park* (1936) by exaggerating the facial features, enlarging the hands, and eliminating the gritty urban background (cat. 61). In both print and photograph, the bespectacled, half-smiling figure at center left, with a button popping on his wrinkled and soiled vest, is accessible. His open, frontal pose contrasts with that of the slightly better-dressed neighbor at center right who is separated from him by a vertical partition in the fence. Caught in mid-gesture, the neighbor is ignored by the bearded figure he addresses. The unshaven man at far left, with hands clasped around his ragged sack, is the most disheveled and poignant in his position at the end of the bench. With a troubled gaze that extends beyond the picture plane, he symbolizes the vagrants who in the 1930s occupied so many of the sidewalks, gutters, and gratings of New York.

POVERTY

The homeless sleep in various places. They sleep on benches and on the sidewalks, under the arches of markets . . . on the stairs of the metro and on the ramparts of fortifications. They sleep anywhere that their tired feet can get to. They also sleep while sitting, in a difficult, strained slumber. . . . Sometimes, having lost their strength, they collapse onto the sidewalk; pedestrians walk around them, as they would a puddle.

—Ilya Ehrenburg, *My Paris,* 1933

Shahn's photographs of the down-and-out are among the most explicit signs of hard times found in his New York work; yet he did not focus on the truly desperate. Representative of his approach are two photographs of men in worn suits sleeping on pavement against an iron fence. The severity of the images is tempered by the figures' near-elegant positions, the irregularity of the background trees, and the pleasing pattern of shadows (cats. 50, 119). When Shahn photographed such people on the notorious Bowery, the scene was milder than the place described in the *New York City Guide*—where "thousands of the nation's unemployed drift . . . and may be seen sleeping in all-night restaurants, in doorways, and on loading platforms, furtively begging, or waiting with hopeless faces for some bread line or free lodging house to open."[40] Shahn avoided the squatters' colonies near the Lower West Side docks and the Hoovervilles, those dismal settlements of makeshift shacks on the outskirts of the city. Instead, he presented men alone on the streets, seeking shelter against the unforgiving surfaces of modern urban life: metal gratings, concrete steps, brick walls. Although these figures are exposed to the stares of passersby, they are rarely infirm or helpless. Rather than showing the limbless beggars of Union Square, Shahn depicted a blind accordion player on Fourteenth Street eking out a living entertain-

ing the crowds (cats. 33, 34, 37). The artist's matter-of-fact images bring out the dignity of his subjects, suggesting a warmer engagement with the individual than Evans's dispassionate photographs of the homeless in Havana (1933) or Ehrenburg's records of the destitute in Paris (see fig. 53).

Yet Shahn's photographs of the poor are not simply respectful images. His pictures of sleeping vagrants, for example, involve a complicated, even disturbing relationship between the photographer and his subject, for the men's slumber makes them doubly vulnerable: they lack both the comfort of shelter and an awareness of the camera. The photographs necessarily raise questions about the nature of humanist documentary and the ethics of photographing strangers, questions that Shahn and his peers confronted in their work. The influential *New York Times* art critic Jacob Deschin reflected in 1950 that the moral issue of photographing people without their permission—and in an "unfavorable" light—had worried photographers since the candid camera was introduced in the early 1930s. In a book of advice to amateurs published in 1936, Deschin had warned that "candid photography should not be used as a tool for ridicule or from malicious motives." Ehrenburg was similarly aware of the moral dilemma this practice posed, referring to the Leica as "a camera of rare cunning" and to the camera in general as an instrument that "impudently intrudes into the affairs of others." This intrusion was even illegal in places like the New York subway, where Evans had to use a concealed camera; he did not publish the results until years later.[41]

The right-angle viewfinder, which Shahn often used, exacerbated the privacy issue. Photo-historian Colin L. Westerbeck claims that photographers who are "real purists" feel shame when employing it because it violates codes of professional ethics. Yet although Shahn was a purist about certain photographic matters, such as the flash, which he considered "immoral" because it destroyed the natural darkness and mystery of a scene, he expressed no qualms about the anglefinder and in fact delighted in its possibilities.[42] In some photographs he purposely allowed his profile to appear reflected in store windows as a way of letting viewers in on his deception. But unlike Helen Levitt, who sought when photographing to conceal her presence out of respect for her subjects, Shahn was more interested in catching the candid moment than in hiding himself. He rationalized the use of the anglefinder as contributing to the greater social good in the tradition of Honoré Daumier, Evans later recalled, and likely justified the use of the candid camera—as Deschin did, despite his admonitions—because it did not hurt his subjects and was the only way to capture unposed vignettes of life. Shahn went so far as to defend the right of painters and photographers to trespass into "every area of experience," as long as the responsible creator "sees in that area the making of a great symbol."[43]

Revisionist photography critics have been more critical of such practices and of the documentary mode in general. They describe the double subjugation in the social documentary act—the way subjects are at once victims of the society that has produced their

condition and of the camera that has produced their image for the consumption of that society. In this regard, all traditional documentary photography is inherently exploitative, as the photographer who holds the means of representation is necessarily part of a more privileged culture, recording the less powerful Other. Historians of the RA/FSA documentary project, in particular, argue that the federal agency supported the creation of dignified, palatable images of the "deserving" poor that did little to empower those disenfranchised subjects. They claim that such pictures were, on the contrary, a means of social control to maintain the status quo.[44]

Shahn's photographs of New York's underclass defy such reductive categorization; his subjects are neither victimized nor sanitized.[45] His pictures exhibit a combination of divergent qualities, such as humor and melancholy, and evoke a range of emotions from admiration to sympathy. For instance, in an image taken on the Bowery, a black man sleeps on a chair laid on the street grating, its thin metal legs balanced on horizontal struts (fig. 10). A branching fire hydrant protruding from the grating at an angle that mirrors the man's is as unexpected in this setting as the man is himself. Shahn seems to have marveled at the subject's remarkable balancing act, empathizing with his resourcefulness at transforming an inhospitable city street into a tolerable place for a nap. The British fashion photographer Cecil Beaton, who reproduced a variant of this image in his impressionistic account *Cecil Beaton's New York* (1938), responded to the wittiness of the scene by setting it among photographs of bridal shops in his chapter called "The Entertainment World and the Cultural Scene," taking the incongruity one step farther (fig. 46). But Shahn also accentuated the man's weaknesses; his juxtaposition with a stained yet sleek hydrant calls attention to the limpness of the body in its rumpled suit and battered shoes. By entitling the work *Bowery,* Shahn allowed this figure to both symbolize and qualify the street life of that squalid place.

Shahn's photographs of vagrants often gain deeper resonance when seen in the context in which they were taken. His images of the two sleeping homeless men, for example, are followed on the film roll by scenes of the Bible House at Astor Place, headquarters of the American Bible Society from 1853 to 1936 (fig. 11). The Bible Society, which translated Holy Scripture for worldwide distribution, rented space in its block-long building to organizations like the New York Association for Improving the Condition of the Poor. After photographing the men on the ground, Shahn aimed his camera upward to capture a worker cleaning the Bible House sign atop the curved pediment over the entrance. Through such ironic sequencing Shahn effectively contrasted the poverty on the street with the unimpressive record of even the best-intentioned institutions—and perhaps of the Bible itself—in improving the lot of the poor. Indeed, the *New York City Guide* noted that "no agency, at present, provides adequate food, shelter, and clothing for these wanderers. Missions furnish food and lodging for a few, and try by sermon and song to touch the souls of the down-and-outers and the sympathies of generous tourists."[46] Shahn could

offer no panacea either, but he did recognize how the dearth of resources affected the city's most oppressed peoples and how indigence was connected to issues like ethnicity and race.

THE "NEGRO QUESTION"

The question of what will ultimately happen to the Negro in New York is bound up with the question of what will happen to the Negro in America. It has been said that the Negro embodies the "romance of American life"; if that is true, the romance is one whose glamor is overlaid with shadows of tragic premonition.

—Federal Writers' Project, *New York Panorama,* 1938

Like many contemporary photographers in the RA/FSA and Photo League, Shahn rejected the prevalent racist stereotype of African Americans as slow, lazy, and unintelligent—the condescending "minstrel" images that persisted in the popular media. What is perhaps most noteworthy about Shahn's photographs of African Americans, however, is how similar they are to his images of other minorities. Although his treatment is in line with a tradition of photographing blacks as a neglected underclass, his photographs lack the hard-hitting indictment of society that one might expect from a leftist artist.[47] Still, the pictures contain subtle insights into those "shadows of tragic premonition" that the left-leaning writers of *New York Panorama* had observed.

FIGURE 10
Bowery (New York City), 1932–35
16 × 23 cm
Fogg Art Museum, gift of
Bernarda Bryson Shahn,
P1970.2862

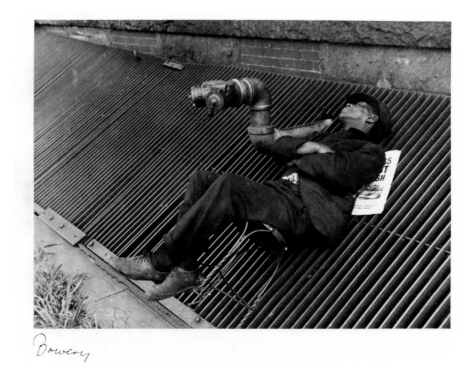

Shahn's interest in race must be seen in light of Jewish empathy for blacks and their struggle for equal rights. Historians have cited modern Jewish liberalism and Jews' acknowledgment of their own experience with oppression as reasons for this phenomenon. Hasia Diner explains it further by noting Jews' interest in "defin[ing] for themselves a meaningful role in American society . . . striving to prove their worth to their adoptive nation."[48] Shahn's empathy for the plight of African Americans was expressed in his photo source files, which included clippings on race-related issues and a folder on the famous "Scottsboro Boys" case, in which nine young black men from Alabama were accused and convicted of raping two white women. The artist assembled a scrapbook on Scottsboro, which became a cause célèbre for northern liberals, who denounced what they saw as southern bigotry. The case dragged on for years before the men were gradually released or acquitted. It is worth noting that in Shahn's source archive the categories "Negroes" and "Jews" constitute the only racial or ethnic groups singled out for separate folders.

Given his concerns about race, it is curious that Shahn rarely, if ever, photographed in Harlem, "the spiritual capital of black America."[49] Harlem was the largest black district in the city and, with increased black participation in the Labor, Socialist, and Communist Parties, was a center of cultural and political activity, which Aaron Siskind, a Photo League photographer, was documenting at length. Shahn instead photographed black people in downtown and midtown locations, where many worked but few lived. He took his camera around Greenwich Village, for instance, where the once sizable African American population of the Lower West Side had dwindled well before the 1930s; when Shahn resided in the Village, the area boasted Irish and Italian neighborhoods.[50] In one striking image entitled *Greenwich Village* (1932–34) (cat. 18), a young black couple sits on a dirty step flanked by a radio repair shop and a film poster, gazing skeptically at something beyond the picture frame, an action that hints at a larger narrative. The hard, tainted surfaces around them—the graffitoed brick, gouged wood, and stained cement—emphasize their

FIGURE 11
Untitled (possibly Fourth Avenue, New York City), 1932–34
Contact strip, 3.2 × 11.5 cm
Fogg Art Museum, gift of Bernarda Bryson Shahn,
P1970.4209.1–3

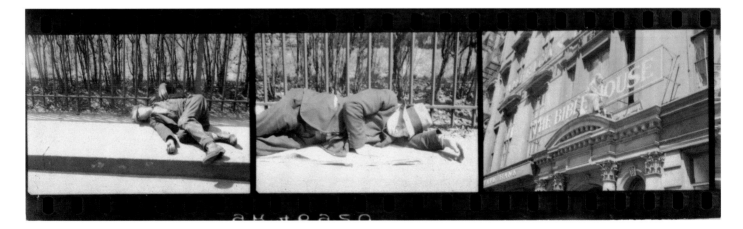

toughness, while the cropped word "murder" on the wrinkled poster sounds a note of foreboding.

This picture is typical of Shahn's stunning portraits of African Americans in New York; in a number of them, somber individuals stand in front of doors, windows, or "for rent" signs (see fig. 3, cat. 70). Shahn also made group portraits in which the figures seem unconnected—or, as photo-historian Nicholas Natanson has written of the artist's RA/FSA images, "curiously *alone* together" (see fig. 105). The divided attention of Shahn's subjects—seen also in the Seward Park image—could be attributed to his use of the anglefinder, which often made it difficult for the subject to tell who or what was being photographed, or could reflect what Natanson calls "depression-era disorder." But this effect also suggests the existence of worlds within worlds—diverse psychological states and a wide array of responses to the camera—and expands the implications of Shahn's images beyond the characterization of a particular race.[51]

And yet the African American experience during the Depression was quite distinct: according to historian Robert S. McElvaine, "black people suffered a disproportionate share of the burden." They were frequently the first to be fired from their jobs. Lynchings increased in the early years of the Depression, and an anti-lynching bill was defeated several times during Roosevelt's presidency. Concerned about retaining the support of powerfully placed southerners in Congress, FDR did little in the early years of his administration to ameliorate the plight of African Americans. The New Deal eventually brought about noticeable improvements for blacks, providing new jobs and higher wages through the WPA. But even this gain was limited by discrimination, which continued despite the executive order against it under the so-called Second New Deal, initiated in 1935. In New York City the unemployment rate for blacks was 50 percent, double the figure for whites. Blacks in Harlem had to contend with the deplorable state of public schools, housing, and medical care. This sparked demonstrations, even rioting, in the spring of 1935, a time when many white-owned businesses that refused to hire blacks were boycotted.[52]

Although Shahn provided little evidence of the repercussions of dire poverty, such as evictions, and few scenes of militancy, he was not ignoring the particularities of African American experience during the Depression. He was, as usual, emphasizing individuals over the group. As Natanson has observed, "Shahn was sensitive, and unusually so by 1930s standards, to a range of historical, cultural, and racial meanings embedded in the fabric of the everyday."[53]

When documenting African Americans without the presence of whites, Shahn asked the viewer to consider black experience independently. On other occasions, however, Shahn used the camera to observe race relations, particularly as they were affected by class and ethnicity. This is best exemplified in a provocative series of photographs, taken on the Lower East Side, of a Greek American businessman flanked by an older Greek grocer and a young African American man wearing a worker's cap and leaning casually against a cast-

iron pilaster (cat. 54). Shahn later identified the iconography as: "Two men with negro—'American, Greek, Greek American.'"[54] As with so many of his photographs, Shahn used architecture to frame his subjects; in this case, a column separates the three men, and the darkened doorways isolate the figures further. Thus, while presenting them in the same picture plane, Shahn suggested that blacks and whites reside in distinct worlds. He reinforced this message in the related painting *Three Men* (1939), in which he pushed the white men closer together, made the black man burly, and strengthened the presence of the pilaster (cat. 53).

Race is not the only dividing force in this scene; class, occupation, and age also play a role. The grocer's apron contrasts with the businessman's suit, which implies higher status; the newspaper suggests literacy, if not acculturation. The merchant's thin, slouching figure seems the result of hard physical labor, while the businessman's double chin and substantial paunch testify to the sedentary life of an office worker. These details suggest that the merchant may be a new immigrant, distinguished from the more assimilated man who has risen to the middle class. Or they may differentiate between the first wave of Greek immigrants, who tended to be semi-skilled blue-collar workers or owners of service enterprises, and their American-born offspring, who were more likely to have professional white-collar and skilled blue-collar occupations.[55] Shahn explored these differences in greater depth with successive printings of the scene (cats. 52, 55).

The sign that reads "NRA member" adds an intriguing element to the relationship among the three men, although it is a detail that Shahn chose to eliminate in the later painting. The appearance of this sign in the photographs was likely accidental, but Shahn no doubt relished the coincidence when he printed his negatives, for the National Recovery Act of 1933 was a target of criticism for radicals. The controversial act, which FDR called "the most important and far reaching [New Deal] legislation ever enacted by the American Congress," gave relief to big business from the antitrust laws in exchange for allowing labor reforms. Dominated from the outset by the interests of large corporations, the NRA was eventually struck down by the Supreme Court as unconstitutional. A businessman like the Greek American in Shahn's photographs probably benefited from the NRA more than the grocer did and certainly more than the black man—who happens to be farthest from the NRA sign and separated from it by the pilaster. The NRA in fact discriminated against the black workforce; its codes set regional wage differentials whereby southern workers, who were mostly black, were paid less than those in other parts of the country. Moreover, the NRA did not apply to many commonly held African American occupations, such as farm laborer or domestic service: black newspapers referred to the NRA as "Negro Run Around" and "Negroes Rarely Allowed."[56]

Shahn's awareness of an African American dilemma is evident in his treatment of the black figure. Shown more fully than the white men, he has a thoughtful gaze and an open, approachable stance, qualities that make him the most engaging of the three. Shahn also

presented the black man by himself, in portrait shots, experimenting with how light and framing affect the picture's meaning (cats. 56, 57). In these images, which position the subject between two columns in an indeterminate space illuminated by a strange light and a commercial sign, this serious man seems utterly alone.

Shahn's photographs of African Americans raise questions about race and racism, but they neither offer solutions nor place blame. The pictures simply acknowledge the sobering reality of the separate worlds inhabited by blacks and whites during the segregated 1930s. Shahn's understated treatment contrasts with the more overt ways that he and his colleagues condemned racial prejudice in such radical publications as *Art Front* and *New Masses*—in 1935, for example, the Artists' Union and the John Reed Club helped organize an exhibition protesting lynching. Still, Shahn's isolated, contemplative figures represent a nuanced understanding of the plight of blacks in a progressive city like New York, where African Americans had lived and worked for more than three hundred years and where, according to *New York Panorama,* "legally, there [was] no racial discrimination." This understanding in turn would inform Shahn's subsequent RA/FSA images of southern blacks as well as his graphics of civil rights activists, renderings that address the complex and enduring racial tensions in American life at midcentury.[57]

A CHILD'S WORLD

In many of their games and in much of their play [children] . . . create scenes and a world different from their own. Indeed, when we, as adults, mention the term, "a child's world," we pay a tribute, not only to that one half of it which provides him with constant play as his serious business, but to the other half which is clearly of the mind's eye, imaginary, pretended and believed.

—Ethel and Oliver Hale, "From Sidewalk, Gutter and Stoop:

Being a Chronicle of Children's Play Activity," 1955

Children in Shahn's work are often seen apart from adults, absorbed in their own worlds—a testament to the capacity for invention noted by New York Public Library researchers Ethel and Oliver Hale, who were studying children's street games and songs, from hopscotch variations to jump-rope rhymes, at the time Shahn was working.[58] Shahn's images convey both the impact of dire social and economic conditions and the possibility that young people can be sheltered from them. Indeed, although children suffered from the same poverty as their parents, they were not burdened by the shame and guilt that were considered the Depression's most damaging psychological problems for adults. The offspring of working-class immigrants in particular may have reminded Shahn of his own boyhood or of his children Judith and Ezra, who sometimes accompanied their father on his photo jaunts throughout New York's neighborhoods.[59]

Shahn's photographs confirm that for urban children, much of everyday life was, in Alfred Kazin's words, "fought out on the pavement and in the gutter, up against the walls

of the houses and the glass fronts of the drugstore and the grocery."[60] Shahn mainly documented boys as they played, no matter how cold, dirty, or cramped the locale. They amused themselves with stickball, horseshoes, marbles, and craps (cat. 12), taunted one another (cat. 6), and rummaged in trash barrels for discarded comics (cats. 4, 5). In one photograph, girls on roller skates ascend the steps of the New York General Post Office (cat. 89). Even in difficult times and on desolate or crowded city blocks, the images tell us, children managed to find pleasure.

Shahn's pictures often depict the psychological drama of children's games. In a photograph entitled *Greenwich Village* (1932–35) (cat. 3), a mournful boy is isolated from his peers, whose activities are hidden from view by a large column and the backs of several of the participants. A study of the related negatives, whose sequence is unknown, reveals that Shahn waited to capture exactly the right moment, creating an image that could convey the anxieties of peer pressure and feelings of alienation (figs. 12–14). The variants of the scene focus more on the covert group activity than on the tension between the huddled boys and the lone child. They also illuminate Shahn's aesthetic decisions and how he reserved the acts of mounting, titling, and signing for the most provocative image in a series.[61]

The process of crystallizing *Greenwich Village* was inspired by Cartier-Bresson's concept of the "decisive moment," making images "in flight," as Shahn described it—freezing action at the split second when all elements coalesce into meaningful or magical form. Shahn spoke of his admiration for Cartier-Bresson's "feeling for the subject and the ability to know just when to press the shutter." He was especially moved by such pictures as *Seville, Spain* (1933) (fig. 15), which arrests the rhythm of children playing amid the rubble of war. Boys static in grief or confusion contrast with two who seem caught in mid-dance. One is framed by the ruin in the foreground, his open arms and light step animating the deep and eerie space, as the other raises his arm in the distance. Although Shahn's photographs are often less balanced and controlled than Cartier-Bresson's, he, too, used the urban landscape to record the ordinary play of children in ways that made it seem surreal.[62]

Shahn's images of young boys and teenagers playing handball on East Houston Street possess a unique dynamism (cats. 11, 13, 14). According to historian Hulbert Footner, Houston Street, which had been widened to let some sun into the Lower East Side, offered "little unoccupied spaces for games of handball or bowls." Writing in 1937, Footner noted that it was "heartening" to see playgrounds not just for children but for young men (whose leisure time had increased because of high unemployment). Handball could be played against any hard surface, an important factor in a city where space was such a precious commodity. Shahn, who had enjoyed the game as a boy, said about his painting on the subject: "I wanted to give a feeling [of] the total absorption that one is in when he's in the handball game and when the ball bounces off and you're not quite sure what direction the ball is coming." Kazin, who played daily, also remembered the excited anticipation: "Each

FIGURES 12–14
*Untitled (Greenwich Village,
New York City),* 1932–35
Modern prints from
original negatives
Fogg Art Museum, gift of
Bernarda Bryson Shahn,
P1970.3827, P1970.3836,
P1970.3828

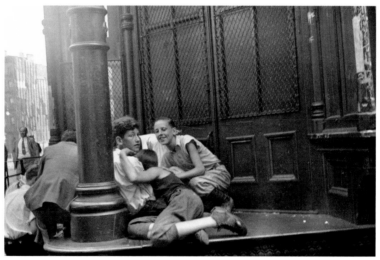

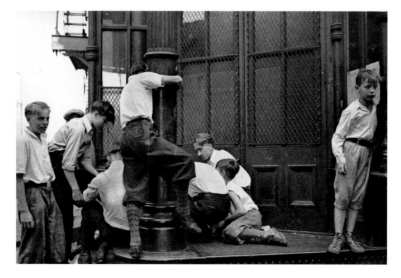

body slightly stooped in the agony of effort, we gravely and suspiciously danced around each other, darting into vacated positions with our hands still lifted, ready for anything."[63]

Shahn presented some of the East Houston handball scenes as an urban ballet, which photo-historian John Szarkowski described as "asymmetrical, ceremonial figures, floating elegantly in . . . shallow, shadowless space" before the looming backboard (see fig. 39).[64] In another handball picture, a tough-looking player stands in tense proximity to a black worker pushing a wheelbarrow, their bodies separated by the vertical wall divisions of the court (cats. 11, 13). The best-known photograph from the series is an iconic image Shahn made by pulling the frame in tightly so that only five players appear fully (cat. 14). Seen from behind and poised for action, the boys draw viewers into the distilled drama of the game. Their placement also causes our eyes to dart across the picture space in ways that mimic the movement of the ball in this high-energy game, suggesting the staccato rhythms of jazz, one of the many music forms Shahn loved. So successful was this photograph for Shahn that he used it as the main source for his famous painting *Handball* (1939) (see fig. 38), in which he shrank the size and scale of the figures in relation to the wall. *Handball* is actually a composite of several photographs, from which Shahn drew elements to help him situate the game on the Lower East Side amid tenements and billboards for movies—yet another type of diversion from the bleakness of the Depression.

Among Shahn's depictions of girls is an image of Eastern European Jewish children standing before a brick wall on the Lower East Side (cat. 44). An adolescent who engages the camera with gentle eyes and a tentative smile leans slightly forward. One of the youngest girls smiles innocently at the viewer, while a child in the center, wearing a fur collar and beret, looks with curiosity beyond the group. Despite the youngsters' closeness to

one another, a fence separates the bigger girl from the smaller ones, suggesting the difficulty of the passage from childhood to adolescence. Recognizing the universal elements in this scene, Shahn filed a mounted print of it in the "Children" folder of his source archive and later incorporated the girl in the coat and hat, and the bush at far left, into the postwar painting *Renascence* (1946) (cat. 45) as representations of hope and regeneration. Yet Shahn also saw the photograph as a historical document, inscribing one unmounted print on the verso "Jewish children between 1st and 2nd AVE NYC c. 1931–2." The inscription, along with Shahn's focus on the relationship between the oldest girl and the others, seems to allude to the responsibility the older children in poor families had for their younger siblings. Shahn, the oldest child in his own family, was forced to leave school at fourteen to earn an income for his immigrant household. His empathy for the adolescent girl with full, childlike cheeks and a slight overbite is palpable.[65]

Other sensitive images reflect the experience of Italian American children. In one photograph, possibly taken on Bleecker Street in Greenwich Village, a sullen adolescent girl is pictured apart from a group that comprises three generations of Italian women (cat. 19). The centrality of the grandmother suggests that despite her small size and furrowed brow, she is the upholder of tradition in a culture in which individual needs were subordinated to the good of the family. The tight circle of women is indicative of both close bonding and insularity. The girl's physical separation from the trio, emphasized by the wistful tilt of her head, the architecture, and her proximity to the bread shop which represents the outside world, hints at a gap between traditional values and modern American individualism. According to cultural historian Caroline Ware, author of a pioneering 1930s study of Greenwich Village, Italian girls were often seeking freedom from the strict parental surveillance that kept them at home, in part to preserve their virginity for marriage.[66] Yet the spatial division between the girl and the group is tempered by the strong connection between them, reinforced by such formal elements as the curve of a collar and the slope of an arm, as well as by the young girl's resemblance to the grandmother.

Shahn captured the pleasures and traumas of childhood at a time when psychologists and psychoanalysts were studying children as practically a separate species, with distinct stages of growth into adulthood. Social science researchers of the Welfare Council of New York City in 1935 made youth the subject of a study, examining the effects of the Depression in areas of education, work, and recreation. Historians and sociologists working in the 1970s and 1980s noted that youngsters of the 1930s in the most deprived families assumed greater responsibility at younger ages than the post–World War II generation and as a result tended to mature faster.[67] Yet Shahn's children are playing, not working, and he was well aware that Depression youth had higher standards of living than many of the working-class children of his own generation, who had endured appalling conditions in factories and sweatshops. Unlike Hine, who in his progressive campaign to reform child-labor laws had photographed small children operating big machines, Shahn documented the less ob-

vious burdens of Depression-era youth, subtly revealing their alienation and their absorption in a kind of play that was at once an attempt to maintain normalcy and escape from a world gone awry.

MEMORY AS IDENTITY

There are moments in street photography when images of children become images from the photographer's own childhood. What he sees in the viewfinder brings back half-lost memories, old phobias, bad dreams. A photograph [by Shahn] . . . carries such a sense of déjà vu. . . . It has the look of an archetypal dream, a moment when some inherited memory was tinged with anxieties of Shahn's own.

—Colin L. Westerbeck, Jr., "Ben Shahn: Artist as Photographer," 1982

Many of Shahn's photographs embody what Susan H. Edwards has called "the rhetoric of loss," for they provide "a representation of facts while simultaneously triggering memories of another time."[68] Although Westerbeck noted this quality in Shahn's RA/FSA work, he only briefly touched on its relation to Shahn's immigrant childhood. Shahn, who had come to America from Lithuania in 1906 at the age of eight, suffered from loneliness and a sense of displacement. He likened his experience to that of David Schearl in Henry Roth's novel *Call It Sleep* (1934), which he described as "a résumé of my own life and the impressions made on me here." Although Schearl's Lower East Side was darker and more hostile than Shahn's Brooklyn, both boys were bullied by rough Irish youth gangs and taunted for being Jewish. Understandably, Shahn craved the green grass of his home in Vilkomir and desperately missed the paternal grandfather he had left behind. He later said that he had not been happy in America until World War I, which, when it destroyed his roots, also ended his romantic longing for the past. Even Shahn's unhappy memories of his new environment, however, were mingled with wonder. The artist remembered the startling newness of gaslight, the subways, the immense scale of the city's buildings, and the rushing crowds.[69]

Shahn not only photographed scenes that reminded him of his own youth but also used these images to compose some of his most autobiographical works in other media. In *Myself Among the Musicians* (1943), for example, he drew on his photographs of children listening to unemployed German bandsmen on Fifteenth Street, an image of a vacant lot on the Lower East Side, and a family snapshot of himself at age thirteen to convey the isolation as well as the melancholic pleasures of his immigrant childhood. For the equally haunting allegorical painting *New York* (1947) (cat. 135), Shahn manipulated a number of his New York photographs. From his picture of two carefree youths sunbathing in the middle of the street (fig. 16), he extracted one of the figures but reversed and elongated his body, making him sickly and bony, his ribs visible. Shahn set him in a drab street with ghostly shells of buildings, reminiscent of the vacant lots and dreary tenements he knew so

FIGURE 16
*Untitled (Lower East Side,
New York City),* 1932–35
16.4 × 22.2 cm
Fogg Art Museum, gift of
Bernarda Bryson Shahn,
P1970.2935

well.[70] From a photograph of an East Side kosher fish market (cat. 134), Shahn appropriated a produce scale, a carp, and a bearded merchant that take on symbolic force when they surround the boy. Shahn endowed the merchant, who wears the broad-brimmed black hat of the Orthodox Jew, with a rectangular, rigid profile that gives him a more prominent, looming presence. The lack of connection between the boy and the man suggests Shahn's distancing of himself from observant Judaism in an attempt to assimilate into secular life in America. Indeed, despite his Hebrew education in Lithuania and bar mitzvah in New York, Shahn rejected aspects of his religion at an early age, questioning the justness of Judaic law and testing the power of an almighty god.[71]

The photographic source for the merchant standing between boxes of fish and the store window appears on a rare, intact roll of film Shahn shot on the Lower East Side in 1936 (cat. 123).[72] The image comes at the end of the roll, in a series of Jewish storefronts, including kosher markets, a bookshop, and a travel agency, replete with folksy, hand-painted signs. Shahn brought his camera in close to these windows, a few of which show workers at the periphery, or barely visible behind the dark glass, like faded artifacts of a personalized form of commerce. By the Depression, according to social historian Beth S. Wenger, the Lower East Side had become a nostalgic, mythic place for upwardly mobile Jews, a "living reminder of an idealized immigrant world as well as a mirror of the past that reflected the extent of Jewish progress." When Shahn took this roll, therefore, the neighborhood housed only a small proportion of New York's Jewish population and was the

poorest Jewish neighborhood in the city. Like the photographic studies sponsored by the Graduate School for Jewish Social Work, the Photo League, and the "Jews of New York" study of the Federal Writers' Project, Shahn's photographs reinvented the Lower East Side, concentrating less on exposing the area's destitution than on assessing the meaning and preserving the remnants of a disappearing Jewish culture.[73]

Signs advertising books, food, and theater in Yiddish, Shahn's first language, could transport the artist back to his origins. Shops offering candleholders and prayer shawls reminded him of the obligations of his Orthodox childhood—the rituals to which he was drawn as well as the spiritual values of earlier centuries that he felt had been forced upon him. Although by 1936 Shahn's connection to his heritage was more cultural than religious, Shahn, like many leftist Jews, was profoundly affected by the events of the Holocaust.[74] His childhood fascination with Jewish mysticism and folklore had never waned, and in the postwar period he reengaged with Judaism, incorporating Hebrew letters and biblical stories into his art. Thus, photographing these storefronts in adulthood, at a time of demographic change in the neighborhood and rising anti-Semitism in America and abroad, was akin to selecting which fading traditions were important enough to preserve.

The 1936 photographs of the Lower East Side became the ultimate image of New York for Shahn—intimate, down to earth, and human in scale. The roll was exposed in April, when Shahn returned to New York after less than a year in Washington, D.C., where he was working for the Resettlement Administration. He came back to research Eastern European immigration for his RA mural in the Jersey Homesteads community center and to see the children of his first marriage.[75] (The first thirteen pictures on this roll of thirty-eight are tender portraits of Judith and Ezra; see cats. 124, 125.) The roll, with its swift juxtapositions of poverty on the street and abundant displays in store windows, represents the artist's return to his favorite haunts, subjects, and working methods. Shahn's sequence of windows also reminds us that his New York is defined not only through the somber faces of its inhabitants but also through the city's humble and eclectic neighborhood architecture. The storefronts, though merely parts of buildings, nonetheless convey a potent sense of place, of worlds beyond their frames. The last storefront on the roll (cat. 136), a poultry shop owned by a Mr. R. Lapinkoff, with its nearly empty window and a pensive young woman leaning against the glass, is iconic in its evocation of human deprivation. It is a moving finale to a roll of film that turned out to be among Shahn's last known documents of New York from this period.[76]

Shahn's later images of New York, few in number, are remarkably close to his 1930s aesthetic. A group of photographs from the mid-1940s, for example, captures his Congress of Industrial Organizations (CIO) posters in situ on the gritty streets of New York, while images taken in 1949–50 of the San Gennaro festival in Little Italy single out individuals from the crowd and underscore the character and persistence of Italian immigrant religious traditions in Cold War America. Shahn's later photo-inspired paintings and prints

of New York also look to the past: *Bookshop, Hebrew Books, Holy Day Books* (1953) evokes the quaint storefronts of the old East Side, whereas *All That Is Beautiful* (1964), with its pairing of skyscrapers and cranes with older, irregularly shaped buildings embellished with handwrought detail and sculptural relief, conveys Shahn's "pain of seeing the city I grew up in being covered by the new wave of concrete and glass."[77]

The nostalgia in some of Shahn's New York photographs may at first seem at odds with the topicality and progressive outlook of the work as a whole. These seemingly opposing dimensions enrich one another more than they conflict, however. Certain images address the social conditions of the time—unemployment, homelessness, and racial inequities—from the point of view of the individual, transcending stereotypes of glorified workers or pitiful victims. Others, like the artists' demonstration pictures examined in chapter 2, project a future of greater social justice, or at least the empowerment of ordinary people through collective activity. Still others reflect unsentimentally on the near and the distant past—for Shahn, the experience of confronting a new land, new customs, and a new language. In the New York photographs, Shahn developed his own new language for conveying multifaceted impressions of the modern city. This uninhibited documentary approach—one that informed a widely influential aesthetic—places these pictures among the most penetrating and compassionate records of urban street life in America between the world wars.

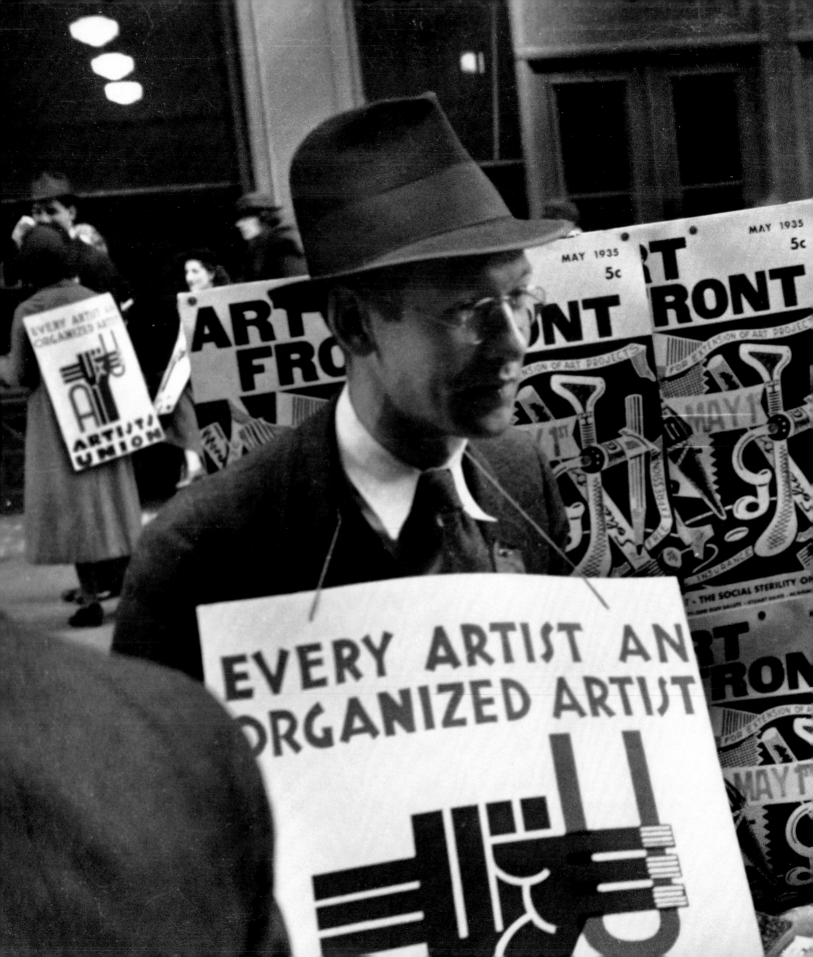

2. Ben Shahn and the Public Use of Art

Deborah Martin Kao

The depression of the past four years has hit a great many artists frightfully hard, although it had to get pretty bad before they noticed it at all. It was only natural that it should. In a capitalist society art is a luxury, and a luxury which potential patrons of the arts will forgo before they will give up their yachts, their automobiles, and their peregrinations from one rendezvous of pleasure-seekers to another.
—Suzanne La Follette, "The Artist and the Depression," *The Nation,* 1933

The achievement of a "public use of art" is . . . a social and economic question. It is not separate from the achievement of social equality. The very slogan "public use of art," raised in opposition to the limited and private use of art, attests to the present inequality.
—Meyer Schapiro, "The Public Use of Art," *Art Front,* 1936

As a teacher at the John Reed Club School of Art, a member of the militant Artists' Union and Artists' Committee of Action, and an editor of the radical journal *Art Front,* Ben Shahn helped shape a revolutionary movement in American art during the early years of the Depression. He belonged to a cadre of leftist artists in New York City that included Stuart Davis, Hugo Gellert, Boris Gorelick, William Gropper, Louis Lozowick, Lou Block, Moses Soyer, Bernarda Bryson, Stephen Dimitroff, Lucienne Bloch, and Max Spivak. Shahn and his peers, regarding themselves as members of the proletariat, sought to repudiate the conception of the artist as a bohemian who created hermetic imagery. Shahn later recounted with delight how this turn toward what he called the "social view" proved "irritating to the artistic elite who . . . [held] forth 'disengagement' as the first law of creation. As artists a decade or so earlier had delighted to épater le bourgeois," he continued, "so I found it pleasant . . . to épater l'avant-garde."[1] Stuart Davis, editor in chief of *Art Front* during Shahn's tenure at the magazine, spoke for all Artists' Union members when in August 1935 he asserted that "the work of art is a public act" and the "artist participates in the world crisis" and "recognizes his alignment . . . with the workers." In response to the overwhelming social ramifications of the economic collapse, Shahn became thoroughly engaged in radical activity, encouraging others to join leftist agencies. In 1934, attempting to persuade his friend Lincoln Kirstein to become a member of the Communist Party, Shahn described how his "weekly duties" for the organization, such as "getting money or leading a demonstration," had proved enlightening.[2]

Detail of figure 69

The art historian and cultural critic Meyer Schapiro, writing for *Art Front* in November 1936, advocated that artists create a socialist-based public art and make their images as accessible to the masses as "popular movies, comic strips, and magazine pictures." Indeed, Shahn and his comrades, in their efforts to engage the "life and labor and the struggle for a new society," had advanced mural painting, printmaking, photography, and film as forms of visual expression that would most effectively reach the populace with which they identified. Although leftist artists and critics generally refrained from prescribing a style for socially conscious art, many promulgated what they termed a "document" or "reportage" approach to picture making (others, like Davis, did not abandon abstraction). Shahn's paintings of the early 1930s were seen as an important model of the reportage aesthetic, which he developed through the use of newspaper and his own documentary photographs as source material. As Shahn later attested: "I felt the very directness of statement of these pictures was a great virtue in itself."[3] Shahn's commitment to achieving a public use for his art infused his political actions in the early thirties, as well as his choice of subject matter, source material, and media, and, perhaps most important, the development of his watershed "documentary" approach to painting, graphic art, and photography.

EVERY ARTIST AN ORGANIZED ARTIST

Into the streets May First!

Into the roaring Square!

Shake the midtown towers!

Shatter the downtown air!

Come with a storm of banners,

Come with an earthquake tread

. .

Out of the shops and factories,

Up with the sickle and hammer,

Comrades, these are our tools,

A song and a banner! . . .

. .

Comrades into the Square!

—"Into the Streets May First," a song based on a poem by Alfred Hayes,
 with music by Aaron Copland, *New Masses,* 1934

In 1929 Shahn returned to New York City from four years of intermittent travel abroad with his wife Tillie Goldstein and their infant daughter Judith. An experienced lithographer, who had apprenticed in the craft at age fourteen, he believed that he "could always get a job with the union." His sense of security collapsed, however, when, like millions of other skilled workers, he faced chronic unemployment, an experience he remem-

bered as "terrifying." Shahn's close friend Walker Evans recollected that the two were "being fed by the birds" and "not only didn't have jobs but . . . couldn't get jobs."[4]

During these first years of the Depression, however, Shahn resisted joining the ranks of demonstrators seeking economic aid. In 1931, en route to union offices to report for a temporary work assignment, he happened upon a demonstration at City Hall; he later recalled wanting to ask the crowd: "How can the government pay your rent?" But as the economy worsened Shahn too began demonstrating for relief programs and protesting against social and political injustice, racial and class discrimination, and the rise of fascism. It was during this time that he dedicated himself to employing art to promote social change. As he later avowed, " 'Propaganda' is a holy word when it's something I believe in."[5] By 1932 the theme of political dissent emerged as an important aspect of his increasingly polemical paintings and graphic art. Shortly thereafter, in early 1934, Shahn began photographing marches and demonstrations in and around lower Manhattan with a small-format Leica camera. These images, among Shahn's earliest photographs, show crowds rallying for the continuation of the Civil Works Administration, one of the first New Deal temporary emergency relief programs (see fig. 58). Shahn also documented May Day parades in New York City, which gave him and his peers an opportunity to march shoulder to shoulder with members of the international trade unions, from whom they sought official recognition. Shahn would use his May Day photographs as illustrations in *Art Front* in campaigns to rouse support for the Artists' Union and encourage members to participate in political action.[6]

In a later interview Shahn claimed that until September 1935 (when he joined the Special Skills Division of the Resettlement Administration as a graphic artist) his "knowledge of the United States came via New York and mostly through Union Square." As the Federal Writers' Project characterized it, Union Square "derive[d] its peculiar identity from its international reputation as the center of America's radical movement." Many leftist agencies, including the American Civil Liberties Union, the American Communist Party (CPUSA), the Socialist Party, the New Workers' School, and various workers' unions, were headquartered there. Throughout the Depression tens of thousands rallied in the square to protest worker exploitation, government indifference, police brutality, social injustice, and the spread of war and fascism at home and abroad. "Holy days" of the revolutionary movement were celebrated, such as May Day and the anniversary of the execution of Nicola Sacco and Bartolomeo Vanzetti.[7] For Shahn and his comrades these boisterous events offered a dramatic forum at which to voice their ambitions for the public use of art through banners, speeches, and the distribution of literature. Such occasions also provided fodder for the pervasive images of social protest that appeared in their paintings, graphics, and photographs.

Shahn passionately espoused the right "to assemble and to petition," actions protected by the First Amendment. Images of demonstrators featured prominently in his

work from this period, including *The Passion of Sacco-Vanzetti* (1931–32), a group of paintings based largely on documentary photographs Shahn had clipped from newspaper accounts of the controversy. Millions felt that Sacco and Vanzetti, two Italian American merchants and labor organizers, had been unjustly convicted of the robbery and murder of a paymaster and a guard in South Braintree, Massachusetts. As Bertram D. Wolfe, director of the New Workers' School, wrote, Sacco and Vanzetti had been "tried for robbery and murder and convicted of radical labor activities!" Central to Shahn's series were the panels *Demonstration, Union Square, New York* and *Demonstration, Paris,* which depict protests in support of the two convicted men. Shahn, who had witnessed similar demonstrations in New York and Paris, himself traveled to Boston (the site of the trial) to protest on behalf of the defendants.[8] But it was the artist's subsequent contemplation of the larger social meaning of the execution, which he likened to the Crucifixion, that propelled him to create the paintings. Shahn sought out "pamphlets and photographs on every possible angle of the Sacco-Vanzetti affair" as inspiration, a process that became an essential component in his formation of a socially motivated visual culture allied with working-class concerns.[9]

The representation of social protest remained so integral to Shahn's work on the Sacco and Vanzetti case that he repeated the scene from *Demonstration, Paris* in a three-part mural study he created at the invitation of Lincoln Kirstein for the 1932 exhibition *Murals by American Painters and Photographers* (fig. 17). Working with Julien Levy (who selected the "Photo-Murals" section of the installation), Kirstein conceived of the exhibition, which was to be held at the Museum of Modern Art, as a way of generating work for unemployed American artists and achieving a public use of art. In his essay for the catalogue, Kirstein contrasted the relevance of murals with what he viewed as the social and economic limitations of easel painting, which had become "ingrown, inorganic." Shortly after delivering his panel to the museum for installation, Shahn learned that despite Kirstein's support, his work, along with Hugo Gellert's and William Gropper's, was being eliminated from the display because it depicted an "offensive caricature or representation of a contemporary individual." Shahn's affronting image includes a portrait of the presiding trial judge, Webster Thayer, and the members of the Lowell Committee, who had upheld the death sentence, standing over the open coffins of Sacco and Vanzetti. Museum board members eventually allowed the controversial mural studies to be installed when Kirstein resisted their pressure and the artists threatened to organize a boycott of the exhibition. Kirstein even gained permission to reproduce Shahn's work in the exhibition catalogue. For Shahn and his comrades the incident proved that artists could successfully challenge authority through group action. Two years later, in attempts to rally Artists' Union members to attend demonstrations, the first issue of *Art Front* reprinted Gellert's sensational *New Masses* article about the affair. "'THE VICTORY WAS THE ARTISTS'.' THE STRENGTH OF NUMBERS: SHOWS WHAT CAN BE DONE IF WE STICK TOGETHER," read the new epilogue. "I

was in my glory," boasted Shahn. "The big money had wheeled out its heavy artillery and then wheeled it back without firing a shot. I had won my first battle."[10]

Following his Sacco and Vanzetti series, Shahn continued to amass a comprehensive collection of magazine and newspaper photographs of demonstrations and radical activity, imagery he would use heavily throughout the 1930s. An extensive source file in the artist's papers consists of articles and pamphlets denouncing the "frame-up" of the labor leader Tom Mooney, whose case inspired Shahn to begin a gouache and tempera series in 1933. A photograph that Shahn clipped from the 2 May 1932 issue of *New York Telegram* showing a raucous group of Union Square Communist demonstrators became the basis for a protest scene that appears in two of the sixteen panels (see cats. 93, 94; fig. 52).[11] In 1917 Tom Mooney had been convicted of first-degree murder for the deaths of ten people during a bombing at a Preparedness Day parade in San Francisco, despite convincing evidence to the contrary. By the time Shahn began work on the series, Mooney had been in prison for sixteen years and leftists had long been depicting his trial and incarceration

FIGURE 17
The Passion of Sacco-Vanzetti, 1932
In *Murals by American Painters and Photographers,* exhibition catalogue, Museum of Modern Art, New York, 3–31 May 1932

43

as part of the state's efforts to thwart labor unions. Diego Rivera called Mooney a "victim of a bourgeois frame-up and martyr in the social war," and throughout the 1930s, May Day agitators carried Mooney's effigy as a puissant emblem of the radical movement. Shahn's friend Louis Lozowick asserted in *New Masses* that "it is only working class vigilance and solidarity on an international scale that prevented [the execution of Tom Mooney] . . . by the ruling class." It was Shahn's Mooney series that Rivera held up as a tour de force of revolutionary art: "The case of Ben Shahn demonstrates that when contemporary art is revolutionary in content, it becomes stronger and imposes itself by the conjunction of its esthetic quality and its human expression."[12]

During the 1930s the Mooney case, which was often referred to as the "Dreyfus case of America," was linked to what the left saw as other infamous miscarriages of justice—such as the "Scottsboro Boys" trial. In 1931 nine African American youths were arrested on trumped-up charges that they had raped two white woman while stealing a ride on a freight train from Chattanooga, Tennessee, to Paint Rock, Alabama. The International Labor Defense, a legal bureau of the CPUSA, represented the accused; the Communists saw the case as an opportunity both to gain the support of black southern workers for the radical labor movement and to publicize what they interpreted as the continuation of slavery in the South. When eight of the defendants were convicted and sentenced to death, massive demonstrations erupted in northern urban centers. Concern that the youths would be lynched resulted in renewed efforts to pass anti-lynching legislation, which had been launched more than a decade earlier by the National Association for the Advancement of Colored People (NAACP).[13]

Revolutionary artists' organizations attempted to focus public attention on the cause through political action and exhibitions. "A Call for a United Anti-Lynch Exhibition" was published in *New Masses* and signed by Shahn and other members of the John Reed Club, the Artists' Union, and the Artists' Committee of Action. The proclamation endorsed the "militant struggle for a real Federal Anti-Lynch Bill," indicating that the NAACP's efforts to achieve similar goals had been severely compromised by what the radical left interpreted as the agency's bourgeois leadership. The left would also invoke the fate of Sacco and Vanzetti as a way of motivating workers to petition for the release of both the Scottsboro Boys and Tom Mooney. As the *Labor Defender* (the organ of the International Labor Defense) proclaimed: "The freedom of all class war prisoners and persecuted Negroes, the release of Tom Mooney and the Scottsboro boys will be a fitting monument . . . to prove that Sacco and Vanzetti shall not have died in vain."[14]

In his effort to compile research files on the major radical events of his day, Shahn assembled a substantial amount of material on the Scottsboro case, including an annotated notebook of newspaper clippings (fig. 18) and a special issue of *Labor Defender* (November 1932). Shahn was considering creating a painting series on the Scottsboro Boys to join those on Sacco and Vanzetti and on Mooney. Other artists directly linked the three causes

Morgan County Circuit Court – Decatur, Ala

The Crowd Outside of Court House – Guardsmen in Evidence

Defendants arriving in Decatur

SACCO AND VANZETTI THE SCOTTSBORO BOYS TOM MOONEY

Given Under These Our Seals . . .
A Drawing by Prentiss Taylor

left

FIGURE 18

Mounted newspaper clippings
related to the Scottsboro case,
c. 1933–34
27 × 20.5 cm
Source File, "Scottsboro,"
Shahn Papers

right

FIGURE 19

Prentiss Taylor, *Given Under
These Our Seals . . . ,* 1933
In *The Nation,* 23 August 1933,
203
27.5 × 20.5 cm

célèbres in their work. The lithographer Prentiss Taylor equated them in his illustration for *The Nation* (fig. 19). Similarly, Rivera included an homage to each case in the *New Freedom* panel of his *Portrait of America* (1933) mural at the New Workers' School, a project on which Shahn worked (fig. 20). The mural, a scathing critique of so-called economic freedoms in America, represented what Rivera saw as the government's efforts to impede unionization and maintain the "industrial serfdom" of the nation's sweatshop workers.[15]

As part of his increased involvement in the radical artists' movement, Shahn learned fresco painting from Rivera. After previewing the Sacco and Vanzetti series at the Downtown Gallery in 1932, Rivera invited Shahn to assist him on a mural commissioned by Nelson A. Rockefeller for the RCA Building in the newly constructed Rockefeller Center. The offer flattered Shahn, who was thankful to be on a payroll and was eager to learn fresco technique from the celebrated master.[16] Shahn's relationship with Rivera drew him further into the epicenter of leftist activity in 1930s New York. The agitprop spectacles surrounding the subsequent censure and destruction of the controversial mural schooled Shahn in

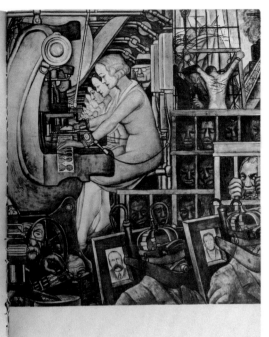

Within the figure, the following text appears:

and took them to police headquarters by the thousands. The Communist movement was driven underground and largely isolated from the labor movement into which it was just beginning to sink roots and to which it might have given militant leadership. Two of the victims of the "red hysteria" of 1919-20 were Niccolo Sacco and Bartolomeo Vanzetti.

THE OPEN SHOP DRIVE

The next step in the employing-class offensive was the open-shop drive. It was carefully prepared. It was thoroughly organized. The drive was initiated by the United States Chamber of Commerce.

"540 organizations in 247 cities of 44 states," wrote the National Founders' Association, "are engaged in promoting this American principle in employment relations. A total of 23 national industrial associations are included . . . 1,665 local chambers of commerce are also pledged to the principle of the open-shop."

In the series of defensive strikes which followed, the whole apparatus of national and state governments was mobilized by the employers. The courts issued injunctions, some of them so sweeping as to prohibit workers from calling the scabs "strikebreakers," and even to forbid workers to sit on their own porches when the strikebreakers were passing by on their way to or from work.

The Attorney General of the United States Harry M. Daugherty proclaimed: "So long and to the extent that I can speak for the government of the United States, I will use the power of the government within my control to prevent the labor unions of the country from destroying the open shop. . . ."

President Harding called out the troops, openly incited the railways and mines to employ strikebreakers and the governors to use the state militias, and assumed the role of commander-in-chief of America's business men in the big offensive for the breaking of labor's line of defense and the winning of the open shop, rebaptized "American Plan." Such was the industrial serfdom that jailed America's militants,

184

FIGURE 20

Diego Rivera, *New Freedoms* from the *Portrait of America* mural at the New Workers' School, New York City, 1933 Photographed by Peter A. Juley In Diego Rivera, *Portrait of America* (New York, 1934), 185 22.8 × 30.4 cm

the fractious politics of American radicalism, especially in the infighting between the CPUSA and the anti-Stalinist left.

In March 1933 Rivera and his helpers furiously began work, hoping to unveil the mural on May Day. Shahn labored alongside Rivera's other assistants, including Hideo Noda, Lucienne Bloch, Stephen Dimitroff, Ramon Alva, Art Niendorf, Clifford Wight, and Lou Block, a painter and photographer with whom he later collaborated in an ambitious mural proposal for the Rikers Island Penitentiary. As they worked, Shahn's friends would come to Rockefeller Center to watch the mural's progress. Walker Evans mentioned in a letter to his friend Hans Skolle that he frequently visited Shahn at Radio City, while Lincoln Kirstein posed for the figure of a "typical American Jew." Lucienne Bloch, who kept a diary during this period, recorded aspects of Shahn's involvement: on one occasion Rivera painted from a newspaper clipping of a demonstration that Shahn brought him; Shahn and Block did extensive research for various scenes, even soliciting people on the sidewalks and workers in the building as models. In later years Shahn vividly remembered sitting for hours on the scaffolding with Rivera, having "strong arguments" in French about politics and aesthetics. He found Rivera's treatment of the mural heavy-handed, with its "crowded" composition that read like "too many words," and he criticized the artist's programmatic approach, in which "the workman always had heavy wrists and that kind of

nonsense." Even so, Shahn reveled in his growing friendship with the famed man, bringing him to a seder at his parents' home in Brooklyn and inviting him and his companion Frida Kahlo to share his family's Greenwich Village flat for a short time following the forced cancellation of the project.[17]

Entitled *Man at the Crossroads with Hope and High Vision to the Choosing of a New and Better Future,* the Rockefeller Center mural was to represent a modern Sermon on the Mount, a grand summing-up of America's evolution and a contemplation of its new frontiers in science and society. As the mural progressed, however, Rivera developed a more revolutionary interpretation of this theme. He contrasted images of fascist warmongers and the decadent bourgeoisie—which for him characterized the "individualist, capitalist order"—with a utopian depiction of the "collectivist, socialist order" headed by Vladimir Ilich Lenin. Although Rivera's program undeniably took aim at his industrialist patrons, the blatantly anti-Stalinist message was primarily directed at his detractors in the CPUSA, who believed he had betrayed the Communist cause by speaking against Joseph Stalin. The Rockefellers, equally distressed, if for the opposite reason, negotiated with Rivera to replace Lenin with an anonymous worker or an American historical figure—Abraham Lincoln, John Brown, William Lloyd Garrison—but when talks broke down, the artist was summarily paid the remainder of his fee ($21,000) and ordered to leave the premises. Before departing, Bloch covertly photographed the painting with her tiny Leica camera, creating a unique visual record that was surreptitiously distributed to the press. The unfinished mural was covered with canvas and demolished a year later, on 11 February 1934. Rivera's dismissal and the subsequent effacement of his work enraged even the artist's critics and led to angry protests against what many considered a violation of freedom of expression. The artist and critic Walter Pach equated the mural's destruction with the Sacco and Vanzetti case, finding in both "the fear and attempted suppression of 'radicalism.'"[18]

Shahn played a central role in the events surrounding the Rockefeller Center controversy. He assisted Rivera in composing and translating the letter denying Rockefeller's request that Rivera alter the mural, later recording that he had "always honored [Rivera's] integrity." Bloch reported that "in fun" Shahn wrote "a 'protest note' to Rivera saying that we would all 'strike' if he changed the Lenin head." Shahn participated in the many protests surrounding the incident. He organized a "united-front" demonstration for 18 May 1933 that attracted more than three hundred activists from at least fifteen left-wing factions. Shahn's biographer Selden Rodman described the event as "perhaps unique in the history of left-wing demonstrations since it included delegations for the Stalin-Communists and Trotskyites as well as the Lovestoneites and other 'splinter' groups." The sense of unity proved short-lived, however. "Although they successfully defied the cops by marching from Columbus Circle to the mural by way of the Rockefeller town house on Fifty-fourth street—where the Rockefeller butler had unsuccessfully tried to push Shahn off the stoop and remove his standard—it broke up in front of the John Reed Club. Here the

Communist Joseph Freeman, who had glowingly defended Rivera at Columbus Circle a few hours before, made a speech attacking him as a 'Trotskyite faker.'"[19]

When Rivera decided to use the final installment of his fee from the Rockefeller project to finance his Marxist *Portrait of America* mural at the New Workers' School, Shahn worked with him, even though he found Rivera's handling of the subject matter brutal and moralizing. In spite of their philosophical differences Shahn remained loyal to Rivera. In the fall of 1935 after hard-line Communists within the Artists' Union published articles in *Art Front* disparaging Rivera, Shahn severed ties with the publication. As the artist subsequently explained: "I was fed up with factional bickerings from the start. . . . [But] when [the Communists] insisted on running an article entitled 'Rivera's Monopoly,' calling that artist 'a willing prostitute who makes his work pay,' I got out." Fifteen years later, in a lecture at Harvard University on his experiences during the Rockefeller Center mural project, Shahn underscored the incident's importance to his political development: "This was the first of the statements against vandalism and injustice that I've been making or signing ever since."[20]

Coincident with the Rivera mural destruction in February 1934 was *The First Municipal Art Exhibition,* a presentation of more than nine hundred works by New York–based contemporary artists. Sponsored by the recently inaugurated Mayor Fiorello H. La Guardia, the show was to be installed in a series of specially outfitted galleries in the same building where Rivera's destroyed mural had been. Holger Cahill (exhibitions director at MoMA during Alfred H. Barr, Jr.'s leave of absence) oversaw the exhibition, hoping that it would "establish a new understanding between artist and public" and spur the founding of a permanent municipal art gallery in Manhattan.[21] These admirable objectives notwithstanding, the ill-timed exhibition was scheduled to open less than three weeks after the destruction of Rivera's mural, and artists organized protests demanding that La Guardia either cancel the show or move it. Shahn and Hugo Gellert were among those who signed a petition charging artists to boycott the exhibition and others like it in protest of what the critic Stephen Alexander, writing for *New Masses,* termed the "Hitlerization of American Culture."[22]

The Artists' Committee of Action evolved out of the opposition by Shahn and his peers to the conditions surrounding *The First Municipal Art Exhibition*. This radical group, chaired by Gellert, called on La Guardia to establish a municipal gallery and art center run by artists. By early May leading figures offered their support, including John Dewey, Lewis Mumford, Alfred Stieglitz, and members of the city's major artists' organizations, among them the Society of Independent Artists, directed by John Sloan. In a statement on the need for a gallery and art center, Mumford maintained that it would "help make art part of the daily routine of the mass of people, and so bring painting and sculpture as close to them as the moving pictures and the comic strips now are." During an 8 May meeting at the New School for Social Research a mass gathering was arranged, and the following

evening more than three hundred artists arrived at City Hall with the "beating of tom-toms and the clashing of cymbals" to present La Guardia with their resolutions. Chanting "We want a place to show our work," the activists disbanded only after the mayor's representative, aldermanic president Bernard S. Deutsch, assured the group that he would assist them in securing their gallery and art center. But as the mayor assembled his Municipal Art Committee from more than a hundred prominent citizens, he ignored the members of the Artists' Committee of Action, who subsequently viewed his behavior as a pilfering of their ideas and an affront to their sovereignty. (A 1935 article in *Art Front* denouncing the mayor's Municipal Art "Committee of One Hundred" referred to the group as "Social-Registrites." The critique included a biting caricature by Shahn that presented the agency as a herd of feeble blue bloods [see fig. 56]).[23]

The artists, frustrated by what they characterized as the mayor's "run-around," planned additional protests. On 26 October 1934 the Artists' Committee of Action joined forces with the John Reed Club–affiliated Artists' Union to march again on City Hall—an event that Lucienne Bloch, Lou Block, and Shahn, who had been photographing life on the streets of New York, documented with their cameras. It was at this demonstration that the first issue of *Art Front* was distributed; it had been launched by the two groups from their shared headquarters at 11 West Eighteenth Street.[24] As Bernarda Bryson remembers, Shahn, along with Stuart Davis, was one of the key editors during the publication's inaugural year, and he helped establish the magazine's direction and design. Shahn's papers contain preliminary paste-ups for *Art Front* as well as editorial notes stressing that the magazine celebrate Artists' Union activities and be committed to radical politics. As Shahn wrote: "The aim of *Art Front* is to draw artists to the [Artists'] Union, to give them an economic orientation, to bring them close to the revolutionary movement. . . . *Art Front* must be so broad in its scope as to interest artists not yet acquainted with the revolutionary movement, and must be high enough in quality to command the respect . . . on the merits of its contents." Julien Levy, in a letter to film theorist Jay Leyda, described *Art Front* as "a highly intelligent sheet . . . mainly edited by Ben Shahn," whom Levy praised as one of the "first communist painters to invade the 57th st. art emporiums."[25]

For Shahn photography figured as a primary means of making *Art Front* a revolutionary publication. In 1934 and 1935 he assumed the role of amateur photojournalist, documenting the massive Communist-led May Day parades in New York City. Shahn photographed members of the Artists' Union among the hoards of activists, creating portraits of such placard-toting friends as Bernarda Bryson (see fig. 70), Stuart Davis, and Roselle Springer (cat. 96). Shahn documented spectators lining the parade route, which originated at Battery Place; with his camera he followed his compatriots north on Broadway, Houston, Seventh, Greenwich, and Eighth Avenues, then east on Thirty-eighth Street to Fourth Avenue, and finally south to Union Square, where they were reviewed.[26] Shahn was less interested in creating panoramas of the parades than in placing himself in the midst of

crowds and cavalcades of signs and pennants, thus creating compelling photographs that conveyed to viewers the sensation of participating in the event.

In his May Day imagery Shahn sought to emphasize the unity among members of various leftist organizations. In addition to photographing members of the John Reed Club and the Artists' Union, Shahn documented the activists marching for the Dance Union, the Theatre Union, the International Workers Order, the Marine Workers' Industrial Union, and the Greek Workers' Educational Club. An April 1934 issue of the Communist newspaper the *Daily Worker* encouraged "all participating organizations" to place orders for banners and floats with artists in the John Reed Club. Shahn's friends William Gropper and Hugo Gellert were mentioned as among those creating "a record number" of "signs and effigies" for the upcoming May Day march.[27] Shahn photographed many of these signs, such as the one for the Shirt Pressers Local 243 which lampooned the wealthy boss who offered his poor worker a one-cent raise for his weekly toil (see fig. 59).

Shahn's photographs of leftist activity address issues of race as well as economics, as exemplified by his commanding portrait of the painter Cecil Gaylord, an Artists' Union member (see fig. 68). By depicting African Americans as activists in the radical labor movement, Shahn undermined stereotypical representations of blacks as either servile or unrestrained. The Artists' Union took a strong stand against racism, supporting the Harlem Artists' Guild and in 1936 inviting the African American artist James Conroy Yeargans to join the editorial board of *Art Front*. Shahn also focused his camera on placards proclaiming the exploitation of the black working class in America's capitalist society. A particularly large sign visible in one of Shahn's negatives addressed the endemic problem of racial discrimination: "BLACK AND WHITE, UNITE AND FIGHT/LABOR WITH A WHITE SKIN CANNOT EMANCIPATE ITSELF WHERE LABOR WITH A BLACK SKIN IS BRANDED!"[28]

In contrast to Shahn's sympathetic depiction of ebullient marchers and supportive crowds are his photographs showing the heavy police presence at the May Day parade. On one occasion Shahn, with characteristic irreverence for authority, photographed a long line of police horses from the rear. Although the 1934 and 1935 May Day celebrations proceeded without incident, the possibility of clashes between police and marchers was ever present. The *New York Times* reported that nearly two thousand "patrolmen, mounted men, detectives, sergeants, captains and high ranking officers" in addition to "men in plain clothes from the criminal alien squad, the bomb squad, the pickpocket squad, and other details mingled with the crowd." The inaugural issue of *Art Front* warned its ranks of the potential danger of going "into the street." This edition also paid tribute to a member of the Artists' Union who was killed by police while picketing in Boston. A year later, the painter and critic Harold Rosenberg, in what was his first article for the journal, described the tension between activists and authorities: "Beneath the levity of the artists . . . the undercurrent of violence was at all times visible [as it was also] beneath the apparent friendliness . . . of the police." Agitators frequently perceived police actions as an assault on their

right to protest economic, social, and political policies they abhorred. In one instance Shahn trained his camera on a sign that read: "THE BILL OF RIGHTS GUARANTEES FREE SPEECH, FREE PRESS, FREEDOM OF ASSEMBLY! FIGHT WITH US FOR THESE RIGHTS." Although none of Shahn's extant protest photographs depict police violence, Shahn was attuned to this aspect of radical activity. His "Strikes and Police" source file contains many 1930s newspaper clippings documenting police brutality at pickets and demonstrations.[29]

Shahn used his evocative May Day photographs as illustrations for *Art Front*. For the July 1935 issue, he laid out his images as well as those made by Lou Block like a filmstrip (see fig. 57). Shahn specifically chose photographs that emphasized the activist program of the growing Artists' Union. Members are shown passing out copies of *Art Front,* which was designed as an eight-page tabloid for distribution at protest marches and street demonstrations. Visible in a number of these images is a graphic *Art Front* cover designed by Davis. In others artists appear carrying large banners that protest limits on municipal and federal support for the arts. Prominent among such posters was a billboard version of a witty cartoon by William Gropper satirizing Mayor La Guardia for failing to meet with the artists about the municipal art gallery and center. Shahn also featured activists marching in formation with placards displaying the distinctive logo of the Artists' Union, designed by Seymour Fogel, which depicted an arm raised with clenched fist—the universal gesture of revolutionary solidarity—holding paintbrushes. Shahn took care to photograph the Artists' Union signs that bore the organization's rallying cry, "EVERY ARTIST AN ORGANIZED ARTIST," which, as Davis wrote, reflected the broader program of the agency: "An artist does not join the Union merely to get a job; he joins it to fight for his right to economic stability on a decent level and to develop as an artist through development as a social human being."[30]

Shahn's treatment of his own imagery in the second issue of *Art Front* (January 1935) is particularly revealing (fig. 21). Emblazoned on the cover is the proclamation "JOBS FOR THE ARTISTS + MUNICIPAL ART CENTER = ART FOR THE PEOPLE," and inside are twenty photographs by Shahn, Bloch, and Block documenting an artists' march on City Hall. The photographs stretch across the top of six pages in a continuous band, evoking newsreels, which Shahn frequently watched. Above the images a block-letter headline reads: "ON OCTOBER 27 1934 DESPITE POLICE BAN ARTISTS MASSED AT UNION HEADQUARTERS AND MARCHED THROUGH THE STREETS OF NEW YORK TO CITY HALL TO PRESENT THEIR DEMANDS FOR JOBS RELIEF AND ART CENTER." The sequence creates a visual narrative while the composition, oscillating between long- and close-range views, suggests the dynamic cadence of the march. The first images depict policemen gathering to control the marchers, who were assembling even though the police had denied them a permit. Then come pictures of spirited artists carrying banners and placards, marching en masse amid large crowds of onlookers, shouting slogans, peddling advance copies of the first *Art Front* issue, and finally rallying at City Hall Plaza. Candid street portraits of union

leaders, including Davis, Max Spivak, Stephen Dimitroff, and Boris Gorelick are featured
along the parade route. A photograph taken by Lucienne Bloch shows Shahn at work with
his camera in the crowd (see fig. 55). One of the principal designers of *Art Front* at the
time, Shahn allowed—and probably even initiated—the publication of this image of him-
self. Here Shahn in effect became editor and publisher of his own news photographs,
manipulating them for political ends. In a later interview he affirmed his belief that "the
function of a photograph was to be seen by as many people as possible, and [publishing
them in] newspapers and magazines was one of the best ways [to achieve that end]."[31]

PHOTOGRAPHY IN MODERN TIMES

[Shahn] could not tolerate the idealized figures of "the workers" or the "downtrodden" that, in the
early 1930s, were becoming a distinct theme in the art world. "It's alright," he said, "to have a soft
heart, so long as you have a hard eye." It was the Leica that supplied him "the hard eye" that he
needed and wanted.

—Bernarda Bryson Shahn, "Ben Shahn, Photographer," in *Ben Shahn: The Thirties,* 1977

In the postwar era a generation of writers on American art would come to downplay
or disparage the dependence of Shahn's paintings and graphic art on a photographic aes-

Artists on Work Relief

Project Organization — Artists' Union

THERE is a great need for the services of unemployed artists...

ARTISTS' COMMITTEE OF ACTION

For the Municipal Art Galleries and Center

9 MACDOUGAL ALLEY NEW YORK GRAMERCY 7-9575

To His Honor
Mayor Fiorello H. LaGuardia,
City Hall,
New York.
Sir:

The idea of a permanent Municipal Art Gallery and Center...

Toward a Collective Exhibit

AN EXHIBITION of paintings and sculpture sponsored by the Artists' Committee of Action...

The Commercial Artist

The commercial artist through his creative abilities...

Notices

Page Four

Page Five

MEDIA

The Materials of the Artist, by Max Doerner, Translated by Eugen Neuhaus. Published by Harcourt-Brace & Company. ($3.75.)

THIS invaluable book for the artist relates to the chemistry of pigments and media...

REVOLUTIONARY ART AT THE JOHN REED CLUB

THE fifth annual exhibition season of the John Reed Club...

EIGHT MODES OF MODERN PAINTING

A Collage Art Association Exhibition
Julien Levy Gallery

THE exhibition is arranged with a good deal of taste and elegance...

PAINTINGS BY SALVADOR DALI

Julien Levy Gallery

THE paintings of Salvador Dali are completely successful...

LUIS QUINTANILLA

Pierre Matisse Galleries

CUTTING cleanly into the zinc and copper plates, Quintanilla builds up...

Page Six

Page Seven

thetic, virtually ignoring his work in photography. In the early 1930s, however, a number of critics writing from the left advanced what they identified as the "reportage" or "document" quality of Shahn's work. The political controversies over *The Passion of Sacco-Vanzetti* and *The Mooney Case* series brought Shahn public attention and made his imagery central to the radical artists' movement, but equally important for his working process was the transition these works marked in style, from an emulation of European modernism to a social realism based largely on news photographs. Shahn later characterized this development in his work as an attempt to "show the world how it looks through my eyes," although he could more accurately have said "through my camera eye."[32]

Shahn signaled his allegiance to news photographs and newsreels in *The Mooney Case,* whose panel *Walker Meets Mother of Mooney* (itself based on a newspaper clipping) features members of the press photographing and filming Mayor "Jimmy" Walker's visit to Mooney's mother. Malcolm Vaughan, who reviewed the *Mooney* exhibition for the *New York American,* aptly called this panel "one of Shahn's reportorial paintings," which depicts a scene being "recorded for the newspapers and the talkies." Critics cited Shahn's unique treatment of his imagery as a new path in art. The cultural critic Matthew Josephson, writing about the artist's Sacco and Vanzetti series for the *New Republic,* elevated Shahn's work as a type of new history painting for the revolutionary movement, in part because it broke through what he viewed as the "impasse of Pure Art." When the same series was exhibited in October 1932 at the Harvard Society for Contemporary Art, the curators similarly asserted that Shahn's work embodied "a new trend in art" since it discarded "the theory of 'art for art's sake.'"[33]

The painter and art critic Jean Charlot, writing in 1933 for Lincoln Kirstein's cultural magazine *Hound and Horn,* pointed out that Shahn's "source material consists mainly of newspaper reports, his models being the photographs of rotogravure sections and tabloid sheets." Charlot did not claim, however, that Shahn's paintings re-created their photographic sources literally. A particularly sagacious critic, he instead explained how Shahn extracted the details of gesture, dress, and architecture from news photographs and applied his translation of them over washes of paint, forming what the critic called a "third image" and a "new version of the world." Shahn himself referred to the way the precise details in photographs furnished his work with implicit social content: "There's a difference in the way a twelve-dollar coat wrinkles from the way a seventy-five-dollar coat wrinkles, and that has to be right." Charlot maintained that by presenting the abstract wash and the detailed image in tandem, Shahn redefined modern pictorial conventions, creating an "apparently mechanical vision" that was nonetheless "heavily loaded with moral values." For Charlot, Shahn thus became not only a "a painter of [contemporary] historical tableaux" but also "a witness to our epoch." He associated Shahn's photographically inspired paintings with those made by the newspaper reporter Constantine Guys in the second half of the nineteenth century—works that Charles Baudelaire, in his well-known

1863 essay "The Painter of Modern Life," had called the epitome of "modernity" because they expressed "the ephemeral, the fugitive, the contingent." Charlot similarly observed that Shahn "delight[ed] in what is peculiarly accidental, cynical, and ungentlemanly in camera work."[34]

Charlot's astute observations were seconded by the critic John Boling in his 1934 review for *New Masses* of Ilya Ehrenburg's *Moi Parizh* (*My Paris*, 1933). Of significant interest to Shahn, *My Paris* presents Ehrenburg's bleak view of the Parisian proletariat through gritty documentary photographs reproduced on cheap stock (see fig. 53). A master of reportage, Ehrenburg was considered one of the "greatest living reporters" writing for the revolutionary left, and his essays were regularly featured in *New Masses*. Boling, who also wrote for *Art Front* while Shahn was an editor, considered Ehrenburg's photographs an outstanding example of the type of radical "document pictures" that American artists should strive to create.[35]

According to Boling, the success of *My Paris* hinged on Ehrenburg's "unpretentious" record of the "intimate gestures and expressions" of the masses, a vision that neither romanticized nor dramatized but subtly conveyed the "sociological implications" of the subjects' plight. Boling called attention to what he saw as the "tragic case" of photographers in the United States, who had "surrendered" their talent to bourgeois advertising campaigns, sanguine "pictorial" scenes, and the "technical bravados of surréalist abstractions." "Document pictures," he lamented, "do not come from our photographers; they are accidental by-products of the newsmen." Boling singled out Walker Evans, however, as an American photographer who approached Ehrenburg's example. He also named Shahn, along with Reginald Marsh, as painters who used "photo material" to create document pictures, a practice that put them "many steps ahead of our photographers in recognition of the camera as a powerful medium of expression."[36] For Boling, as for Charlot and Josephson, the basis of Shahn's painting style in the seemingly accidental aesthetic of news photography signaled its revolutionary intention.

In his essay "'News'-Photography," published in the widely distributed anthology *America as Americans See It* (1932), Edward Steichen observed that news photographs had quietly infiltrated American culture, forever altering conventions of seeing. "Our famous man in the street," Steichen asserted, "has achieved a literal, a factual standard of vision, his eye has become photographic and the press camera man has been just as busy bringing this about as the movie." Kirstein made similar observations in his essay "Photography in the United States" for the 1934 publication *Art in America in Modern Times* and the accompanying radio series. Kirstein noted the "surprising vitality" of the "accidental quality" of news photographs and posited that "whether genuinely accidental or not, this type of picture often has real interest as a social document." Louis Aragon, in his 1937 *Art Front* article "Painting and Reality," also maintained that "the manufacture of cameras, such as those of the newspaper photographers . . . has developed a definitely new school of pho-

tography, [which has] abandoned the studio . . . [and] mixed into life." Aragon condemned what he had come to view as the "static" and "sterile" work of photographers like Man Ray, imagery that was "detached from life." Instead he favored the snapshot, seeing its apotheosis in the decisive street photography of Henri Cartier-Bresson, who had "abandoned the studio" to represent "men in movement." Aragon concluded that this modern "photographic eye" would lead to a "new realism" in paintings that were "a conscious expression of social realities."[37]

Discussion of the reportage aesthetic permeated radical literature, theater, and film. Joseph North, a *New Masses* editor, spoke on this subject at the 1935 American Writers' Congress, calling reportage a new form of literature that was "characteristic of the epoch." North invoked Emile Zola as the founder of modern reportage, although he hastened to add that America had its own masters, singling out John Reed, Agnes Smedley, and John Spivak. North spoke of reportage as "three-dimensional reporting" that "must help the reader experience the event" and "feel the fact." The writers of reportage, he continued, "do their editorializing through their imagery."[38] This practice of situating the audience in the scene as eyewitnesses to the headline stories and daily struggles of the masses occurred in leftist theater as well. *The International Theatre Art Exhibition* at MoMA in 1934, for example, included Mordecai Gorelik's set design (based on the "scenic technique" of the American Theatre of Action) for *They Shall Not Die,* a play by John Wexley about the Scottsboro Boys. An illustration of Gorelik's set in *New Theatre* (the magazine of the New York Film and Photo League, the Workers Dance League, and the Theatre Union) shows mural-sized news photographs of rallies and demonstrations projected above the Scottsboro courtroom. A caption below the illustration states that the projection "explodes outward" to illustrate the "need for public action against the Scottsboro frame-up." This socially motivated use of reportage reached its apogee with the "factual" dramatization of news items in the Federal Theatre's popular *Living Newspaper* productions, which began in 1935 under the leadership of Hallie Flanagan, a member of the editorial board of *New Theatre.*[39]

The first publication of Shahn's New York photographs occurred in this context. In November 1934 *New Theatre* published twelve of Shahn's photographs under the title "Scenes from the Living Theatre: Sidewalks of New York" (see fig. 4). A predecessor of the *Living Newspaper* concept, "Scenes from the Living Theatre" was an occasional feature used in *New Theatre* to present social concerns from the vantage point of the person on the street. In the September issue a sensational account had featured the San Francisco police raids against leftist organizations, the brutal breaking of workers' strikes, and an homage to Tom Mooney. As Laura Katzman noted in chapter 1, Shahn's photographs in the November issue present remarkably candid views of diverse working-class people in New York's distinct neighborhoods. Several years later the magazine, renamed *New Theatre and Film,* again published Shahn's camerawork under the title "The Living Theatre"—this

time reproducing a selection of the artist's RA photographs of sharecropper families taken during his trip through the South in 1935 (see fig. 93). The caption states: "These children play a continuous performance against a backdrop of privation and fear. Now the Share-croppers Union comes into the spotlight and says, 'We mean to live.'"[40] Readers of *New Theatre* would have recognized in the display of Shahn's photographs the reportage style and proletarian subject matter that articulated the aesthetic interests of the left.

Just as Shahn's documentary style originated from news photography in the early 1930s, so the photographers Shahn most admired at the time were similarly drawn to reportage. Evans recollected that in the early 1930s the photographs that "excited him were [in] newspapers." In the summer of 1931, while sharing a cottage on Cape Cod with Evans, Shahn first experimented with using news photographs as source material for a series of gouaches based on the Dreyfus trial. That fall the two artists informally installed Shahn's *The Dreyfus Affair* with a group of Evans's photographs in a neighbor's barn in Truro. Thereafter Shahn would look to photography for inspiration in his work, clipping images from magazines and newspapers, as well as "borrowing" material from the Picture Collection at the New York Public Library. Shahn also responded to Henri Cartier-Bresson's photographs, which received their first solo exhibition in America at Julien Levy's gallery in 1933. At the Cartier-Bresson show Levy installed a group of news photographs and film stills in an adjoining room to demonstrate the shared vocabulary of what he termed "anti-graphic photography."[41]

When making street photographs, Shahn, like Evans and Ehrenburg, frequently used a right-angle viewfinder attachment on his Leica to achieve the effect of being part of the scene, capturing candid moments unbeknownst to his subjects; it was the visual equivalent of North's "three-dimensional" reportage. Although Shahn, who considered himself a "worker," intended his photographs to be sympathetic rather than exploitative, the practice raised fundamental questions about the ethics of surveillance. Conscious of such criticism, Evans later justified the right-angle viewfinder by tracing reportage back to the technique and social meaning of the work of Honoré Daumier. Evans insisted that he and Shahn had "felt perfectly guiltless" about using the device, "because we, in the amplitude of our youth, believed we were working in the great tradition of Daumier and the *Third Class Carriage*." Daumier's example was in fact frequently invoked throughout the 1930s as an important model for the politically motivated artist. In an essay for a 1930 exhibition of Daumier's paintings at MoMA, Alfred H. Barr, Jr., characterized the artist as someone who held a "belief in social reform" and "violent hate of injustice." In his 1933 essay "The Revolutionary Spirit in Modern Art," Diego Rivera maintained that "Daumier was revolutionary both in expression and in ideological content. . . . [Even] when he was . . . merely drawing a woman carrying clothes or a man seated at a table eating, he was nevertheless creating art of a definitely revolutionary character."[42] In his radical interpretation of Daumier's scenes of daily working-class life, Rivera used

language that paralleled his description of Shahn's *The Mooney Case* written earlier the same year.

Documentary and news photographers also emulated Daumier's style, a phenomenon encouraged by Ralph Steiner's amusing feature "Candid Photographers Should Study Daumier" (fig. 22). Here Steiner juxtaposed drawings by Daumier with effective modern news photographs to make the point that "the good candid photographer should play the same part as a recorder of human thoughts and feelings as a painter such as Daumier." The emphasis placed on the "sociological purpose" of such eyewitness or documentary photographs became the defining issue for Beaumont Newhall, whose 1938 essay "Documentary Approach to Photography" acted as one of the earliest manifestos of the documentary photography movement. Here Newhall tied the meaning of "documentary" in still photography to that established by filmmakers John Grierson and Paul Rotha. Their definition of documentary, Newhall explained, "differs markedly from the dictionary meaning; it includes . . . a dramatic presentation of fact. It is thus more closely allied to the French *documentaire* as developed by Zola. Like the French writer's document-novels, these films are produced for definite sociological purposes. . . . The same is true of still photography." Newhall singled out Shahn's and Evans's photographs as models, noting: "Largely through [Evans's] example and through the extraordinary fine miniature camera shots of Ben Shahn, a direction was given to the [RA/FSA] project; a technical and an esthetic standard was raised which the other photographers in the project have maintained."[43] The documentary aesthetic, so celebrated by Newhall, that Shahn brought to the RA/FSA project was informed by his allegiance to the social meaning of reportage and his experiences as a documentary photographer in New York. In fact, Shahn's final project in New York City before moving to Washington to join the RA was his design for a mural at the Rikers Island Penitentiary (1934–35); it was based on what was at that point his most complex use of newspaper images. It marked as well a turning point in Shahn's use of his own documentary photographs as a research tool and source material for paintings.

MORALS IN MURALS

The murals designed for public buildings by artists of the Public Works Division seem to meet with official approval in inverse order to their social and artistic worth.

—"Morals in Murals," *Art Front,* 1935

Shahn and Lou Block first contemplated collaborating on a prison mural in the summer of 1933 while working on Rivera's *Portrait of America* together. In an August letter to the deputy commissioner of correction for New York City, Block proposed that he and Shahn create a large-scale mural "dealing with the progress of penology, from the earliest era research would disclose, through the present" and leading up to the "plans men like you and Warden [Lewis H.] Lawes [at Sing Sing Penitentiary] hold for the future."[44] The

artists offered to work for "day laborer's wages"; they also suggested that inmates assist them in preparing the walls and pigments. In devising their own mural plan and submitting it unsolicited to the heads of various institutions, Shahn and Block demonstrated their commitment to finding a public forum for their art.

Shahn and Block's initial concept for a sweeping historical program was most likely inspired in part by their work on *Portrait of America,* which told the history of revolutionary social struggle in America. Shahn's interest in examining the penal system was also fueled by what he saw as miscarriages of justice in prominent events of the day, which he had earlier memorialized in his painting series.[45] From Shahn's perspective the American prison population included martyrs and heroes of the revolutionary labor movement, as well as political agitators, the unemployed, and victims of racial and class discrimination.

Between the summer of 1933 and the spring of 1934 Block and Shahn periodically wrote to prison administrators, including Dr. Walter N. Thayer, Jr., the commissioner of correction for New York State. By April 1934 the artists were corresponding with New York City's recently appointed commissioner of the Department of Correction, Austin H. MacCormick, about painting a mural in the penitentiary then under construction on Rikers Island (see fig. 76). As part of their efforts, the artists also consulted with municipal engineers, the warden at Rikers Island, and architects from the office of Sloan and Robertson, the firm designing the new facilities (see fig. 75). In a letter to MacCormick, Block and Shahn indicated that after two visits to Rikers Island Penitentiary they had identified

FIGURE 22
Ralph Steiner,
"Candid Photographers
Should Study Daumier"
In *PM's Weekly,*
30 June 1940, 48–49
36.6 × 56 cm

a long corridor and its adjoining chapels as the ideal location for their proposed mural. They informed MacCormick that state money from the Temporary Emergency Relief Administration (TERA) would fund the total cost of the project. Shortly thereafter, in mid-May, the commissioner and Mayor La Guardia approved the artists' preliminary proposal. Commissioner MacCormick was particularly receptive to Shahn and Block's ideas. He continued to meet regularly with the artists as they developed their mural designs, and occasionally visited them at their Bethune Street studio to view their progress.[46]

That January the reform-minded MacCormick had made headlines by purging "grafters" from the penal system. His raid on Blackwell's Island Penitentiary (located on Roosevelt, then called Welfare, Island) exposed extreme overcrowding and other abhorrent conditions, drawing additional attention to his work. MacCormick told the *New York Times* that Blackwell's Island Penitentiary was "the worst penal institution in the United States." Rikers Island Penitentiary was MacCormick's solution, a model prison complete with medical and sanitary facilities and establishing an "unusual educational, vocational, and recreational program" for more than two thousand inmates. About four hundred acres in size, Rikers Island was a smoldering garbage dump with continually burning fires that caused "strange things" to grow, as Block remembered hearing when he was a child. At the time MacCormick took charge of Rikers, the construction, although it had been under way since 1931, was sinking into the soft ground because of massive engineering flaws. In July 1935, with the successful completion of the $9 million project, the first prisoners were transferred there. A *New York Times* account emphasized that the new complex was "designed not merely for security but for rehabilitation" with "an elaborate program of work and re-education."[47] The progressive reform program was based on a rigorous schedule of structured work and recreation (which included sports and movies) and had as one of its primary objectives the reduction of recidivism, goals that coincided with Shahn's vision.

At this time the issue of prison labor was being widely debated. As Diana L. Linden explains in her study of Shahn's Rikers Island mural designs, it had been brought to the fore by the Hawes-Cooper Act (1933), which effectively dismantled the interstate market for prison-made goods. Many unions supported the act because they did not want their products undersold. The penologist James V. Bennett, writing in 1935 for the progressive journal *The Survey,* blamed the Hawes-Cooper Act for exacerbating prisoner idleness, resulting in a "horde of despairing, discouraged, disgruntled men, milling aimlessly about an overcrowded prison yard." Bennett maintained that other laws or guidelines could be enforced to protect the free market. Like Bennett, MacCormick underscored the volatile situation that overcrowding and lack of activity had created on Blackwell's Island: "With 1,500 men milling around with nothing to do, anything can happen." At Rikers Island, meant to house inmates with sentences of three years or fewer, MacCormick designed a program that provided productive work for prisoners: "manufacturing clothing and other

goods for various city departments," "grading the island and breaking down and leveling off dump heaps close to the prison," farming, and tending the piggery.[48]

The mural project accorded with MacCormick's plans: it would employ prisoners in the creation of socially conscious art, and its content would reinforce the goals of the reform programs he was initiating. With MacCormick's backing, therefore, Block and Shahn embarked on intensive research. Shahn began in his usual manner, clipping relevant items from newspapers as divergent as the mainstream *Daily News* and the radical *Labor Defender*. His small sketchbook (17 × 13 cm) is filled with drawings and notes indicating the diverse range of sources he and Block consulted (see fig. 80). Shahn listed an array of treatises on the history of law and punishment: William Henry Siebert's *The Underground Railroad from Slavery to Freedom* (1898), Samuel Mendelsohn's *The Criminal Jurisprudence of the Ancient Hebrews* (1890), George Henry Mason's *The Punishments of China* (1801), Oscar Wilde's "Ballad of Reading Gaol" (1896), Lewis E. Lawes's *Twenty Thousand Years in Sing Sing* (1932), and John Spivak's *Georgia Nigger* (1932), as well as the *Pageant of America* series, which began publication in 1925. Shahn also listed the popular Hollywood prison movies *I Am a Fugitive from a Chain Gang* (1932), *Condemned* (1932), and *The Big House* (1930) among his sources, and the two artists ordered film stills from the First National Motion Picture Association. Shahn made brief mention of going to other prisons: Sing Sing, Blackwell's Island Penitentiary, and the New York City Reformatory in New Hampton. MacCormick had granted them the unusual privilege of photographing inside the last two, "provided the inmates are willing"; in addition, the artists visited the Central Court Building in New York City and MacCormick's office at the Centre Street police headquarters. Shahn remembered that he and Block also met with former Sing Sing warden George W. Kirchwey (a "famous sociologist and penologist at Columbia University"), officials in the Thomas Mott Osborne Association, and keepers of "other penitentiaries and reformatories all over the state."[49]

According to Block, it was Walker Evans who first suggested that they use photography as a means of sketching preparatory material. Although Block and Shahn photographed together on the streets of the Lower East Side for the project, in the end only Shahn took photographs of prisoners. His prison imagery is quite different in character from the pictures he made either at union demonstrations or on the sidewalks of New York, where he blended into the crowd and could work largely unobserved. When Shahn was photographing in correctional institutions, he was not only a conspicuous outsider but was required to secure the cooperation of his subjects in advance.[50] It was virtually impossible to attain the degree of spontaneity Shahn courted in his street photography.

In his prison imagery Shahn presented the two extremes of prison life: the primitive conditions at Blackwell's Island and the progressive environment of the reformatory. At Blackwell's Island, Shahn photographed listless inmates crammed into a small prison yard; yet even in these bleak views he emphasized the individual character of the prisoners, focusing, for example, on an inmate scratching his face (cat. 113). Shahn made a gouache

sketch of this figure that captures the immediacy of the man's expression (cat. 114). In contrast to Blackwell's, the reformatory (for first-time offenders aged sixteen to thirty with sentences of three years or fewer) sat on more than six hundred acres of farmland. Shahn primarily photographed the facility's work program, in which inmates learned skills as laborers and tradesmen. He made numerous studies of young men tilling fields, building stone walls, sewing, and working in the metal shop and the bakery (cat. 109, figs. 84, 87). Only the prisoners' garb indicates that these photographs were taken in a correctional institution. Indeed, many of the images seem to invite the viewer in to engage with the animated groups of inmates gathered around wooden benches on the reformatory grounds.

Shahn also created many thoughtful portraits of the men he encountered on his prison visits. He portrayed inmates at rest, in conversation, reading books and newspapers, and playing sports (cats. 108, 112, fig. 86). In a seemingly self-referential image, Shahn depicted an inmate in the process of painting a portrait from a tiny source photograph (cat. 110, fig. 88). Other images feature jocular young men who willingly posed for the artist's camera (cat. 111, figs. 82, 83). Through Shahn's lens these youths are not to be feared but regarded as rebellious adolescents. Sympathetically allied with his subjects, Shahn resisted the prevailing cliché of the hardened criminal. His photographs provide visual evidence of his belief that prisoners could be rehabilitated through education, work programs, and humane treatment. Kirstein, whom Shahn brought to Rikers Island in the winter of 1934 as he was beginning to prepare the walls of the main corridor, recollected Shahn "avow[ing] that at least a third of the inmates [in New York prisons] should be released forthwith, since they were no more guilty in the sight of blind Justice than the same number now packing Wall Street."[51] Shahn's prison photographs also include uncharacteristic studies of architecture and long views of prison grounds and the surrounding landscape (see fig. 89), scenes that the artist would use in structuring elements of his mural.

Coupled with the artists' extensive research into prison reform, Shahn's photographs exerted a formative influence on the project. In a memorandum updating Mayor La Guardia, Block and Shahn explained how their ideas had evolved. They had decided to abandon "the idea of dealing with the history of penology," believing that the mural would have "more force if they treated only . . . prisons of our own time"—those of "an unenlightened nature and those which have been administered by individuals who believe in the need for penal reform."[52] The two artists, who agreed with MacCormick that the mural should address a general audience, emphasized that although prisoners could view the murals on their way to and from and within the chapels, the work was primarily intended to edify visitors about the social benefits of progressive reform measures.

Shahn and Block planned two distinct programs for the project. For the prison chapels, which also served as an auditorium and a movie theater, Block imagined a series of fifteen panels presenting efforts to remedy social ills through the activities of "American evangelism." He planned to focus on "religious welfare and charitable organizations,

such as the Salvation Army, United Catholic Charities, [and] Y. M. C. A." (see fig. 49).[53] For the hundred-foot-long corridor leading to the chapels Shahn developed a didactic scheme on the topic of prison reform. One wall depicted the "unenlightened" penal system while the opposing wall envisioned a "reformed" American prison code (cat. 122).[54]

Motivated by the powerful social message of his plan, Shahn worked quickly, devising ways to create imagery that would have been clearly recognizable to an audience familiar with New York City and the headline events of the early 1930s. For the first time he drew extensively on his own documentary photographs (a practice he had tentatively begun the winter before while working on his ill-fated *Prohibition* mural [1933–34] study for the Central Park Casino [cats. 73–77]). He also continued to cull visual source material from newspapers and journals. On an extended visit to the artist's studio on 2 November, Kirstein admired the studies, feeling they were among the most sophisticated mural designs he had seen thus far. He also remarked on how personally involved Shahn seemed to be. Indeed, the artist later recollected that he "was really going all cylinders" and was "knocking out one foot after another of sketches." By early November, on a visit to Rikers Island, Kirstein had seen Shahn's "cartoons on the walls," and he recorded Shahn's concern that because of its strong content the work might be censored regardless of the support he had received.[55] Unfortunately, at this point Block, who devoted much of his time to the project's complicated administration, fell behind schedule and was able to complete only three panels. Thus when MacCormick submitted the project to the mayor for final approval in December, only Shahn's designs were included.

The sequence of Shahn's mural was to begin on the short north wall of the corridor. A depiction of a police lineup (figs. 23, 78) satirizes what the artist termed the "mechanical classification" of prisoners, a phenomenon he had himself witnessed at Centre Street police headquarters. The Federal Writers' Project described the lineup as an ordeal during which offenders stood on a brightly lit stage and were "questioned through a public address system, while detectives memorize[d] their appearance and mannerisms."[56] Shahn, aware of how the penal system programmatically categorized criminal behavior, sought to lampoon and condemn this established aspect of law enforcement. In the same panel, under the platform on which the "criminals" stand, two itinerant men sleep on newspapers with the pointed headlines "TWO GUN[S]" and "CRI[ME] WAVE" partially revealed. For his rendering of one vagrant figure Shahn used a particularly apt source photograph showing a man sleeping on the sidewalk (cat. 50). He had made the picture on the Lower East Side adjacent to the municipal district around Foley Square and Centre Street, a place he came to know through his participation in the many demonstrations there. He may have even taken the photograph while doing research for his Rikers project. In fact, the preceding exposure Shahn made on the roll of film shows another vagrant that the artist used as source material elsewhere in the mural (fig. 11).

Flanking the vagrants and police lineup on the left side of the panel is a depiction of

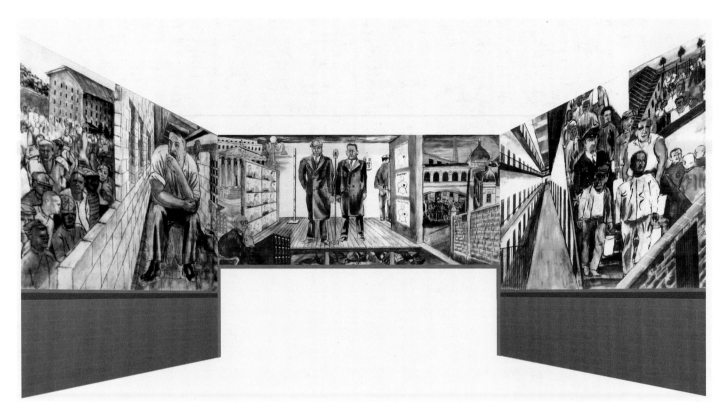

FIGURE 23

Computer-aided reconstruction
of unfinished Rikers Island
Penitentiary mural designs,
north end

the Centre Street courthouse. Shahn's design ironically juxtaposes the building and the
statement on its pediment—"THE TRUE ADMINISTRATION OF JUSTICE IS THE FIRMEST
PILLAR OF GOOD"—with imagery of homeless men and police lineups, thus identifying
the courthouse as a temple of ineffectual justice. The right side of this panel extends the
courthouse scene with a rendering of the so-called Bridge of Sighs, through which pris-
oners were transported from the courthouse to an antiquated jail commonly called the
Tombs.[57] Beneath the bridge, men seeking work contemplate a factory posting "NO HELP
WANTED" signs. By beginning the mural's narrative with a police lineup, vagrants, unem-
ployed men, and the court building, Shahn made direct connections between unemploy-
ment, poverty, and crime.

This narrative then threads into the first portion of the long east wall of the corridor,
where Shahn transformed the queue of jobless men into a procession of inmates de-
scending a cramped staircase with slop buckets in hand. Directly behind the convicts, seen
from above, is Blackwell's distinctive prison yard, an image based on the photographs
Shahn had made at the prison (cat. 105). These initial scenes locate the viewer right in the
middle of New York City's penal system. They also establish the central theme of the larger
mural, chronicling how "unenlightened" forms of penal justice in America ignored the
fact that crime had its basis in unemployment and indigence. An incident Shahn witnessed
at Sing Sing during the course of his research informed this biting portrayal. Watching a

parole hearing, Shahn observed that probation was denied to a youth who, rather than perpetrating the required fiction that he would "get a job" if he were released, admitted that he would have to "'steal! What else can I do?'" Shahn felt the youth was punished "because he was being honest."[58]

The east wall mural also displays what the philosopher Michel Foucault has called the "spectacle" of the "body condemned"—the state sanctioning of corporal punishment, which in its most extreme form ends in a public execution. As Shahn and Block noted, the grim situations painted on this wall represent the "bad features of archaic penal methods" that "leave very little to which the inmate can look forward." The artists made a detailed list of such reprehensible features of unreformed prison life: "idleness and milling of prisoners," "unsanitary" conditions, a "public whipping" in Delaware, "unproductive labor," chain gangs in "southern prison camps," lockdown "after 5 o'clock," "over-crowded" and "unsanitary dormitories," "restrictions" on receiving visitors, and finally the "release of the prisoner and an intimation of a return to crime."[59] In the central portion of the east wall is a graphic scene of shackled prisoners working in a southern prison camp, with a rural county courthouse visible in the background (cat. 115). Contemporary viewers would immediately have recognized the courthouse as the Morgan County Circuit Court House, the site of the ongoing Scottsboro Boys trials. Newspaper photographs of the courthouse like the one the artist clipped for his "Scottsboro" source file appeared throughout the media (see fig. 18). That Shahn includes a scene visually tied to the Scottsboro Boys in a mural meant to persuade viewers that society could benefit from a revision of the nation's penal code would have struck a distinctive chord with the American public, whom the leftist press had schooled in the controversial case.

The artists were also interested in images depicting the brutal treatment of African American prisoners in work camps and on chain gangs, especially in the South. In the early fall of 1934 the two artists wrote to Walter White, the executive secretary of the NAACP, to verify the authenticity of photographs published in John Spivak's controversial book *Georgia Nigger*. The ethics of chain-gang labor especially preoccupied early 1930s culture, and denouncements of the archaic system appeared in forums as diverse as Erskine Caldwell's "'Parties Unknown' in Georgia," published in *New Masses,* and the Hollywood feature *I Am a Fugitive from a Chain Gang.* Proponents of southern penal reform frequently connected crusades against lynching with protests against chain gangs. Yet relevant as these sources were for Shahn's understanding of the issue, his depiction of black and white chain-gang prisoners is actually based on news photographs, including a tabloid picture of hunger marchers and an image of a Georgia chain gang published in *Labor Defender* (December 1933). The latter was obtained from an article contrasting the supposed "regenerative" education of the Soviet Union with the repressive Georgia chain-gang system of convict labor. The article suggested that this example "reveal[ed] . . . the ways in which the world of capitalism and the world of socialism . . . solve

their social problems; the one by retreating to dark age methods, the other by leaping forward."[60]

That Shahn culled source material for his chain-gang imagery from this obtuse reference would not, of course, have been evident to his audience. But the artist clearly infused his mural with what he felt was the disparity between the capitalist and socialist models of prison administration—ideas expressed in the *Labor Defender* article from which he sketched. Corresponding to the earlier portions of the east wall, on the final section Shahn chose to illustrate the social ills wrought by America's archaic modes of prison administration. The narrative begins on the left, where inmates are forced to stand in metal-screened cubicles during visiting time. A door labeled "EXIT" beyond them leads to a forced-perspective view of cavernous city streets, where only unemployment lines, "NO HELP WANTED" and "FOR RENT" signs, and vagrancy are visible—portents of what Shahn saw as the men's inevitable return to prison. Shahn populated this panel with figures derived from his own photographs of the streets of lower Manhattan and New York City's correctional facilities. One of the men behind bars is the prisoner from Blackwell's Island whom Shahn had sketched in gouache (cats. 113, 114). Shahn also placed an African American laborer there whom he had photographed on the streets of the Lower East Side (cats. 52, 54–57). The artist depicts the black man visiting with a couple lifted from a source photograph in which they wait at a corner bus stop (cat. 118).

Shahn also reused figures from his earlier painting series in this section. The female visitor holding her hand to the bars is based on a press photograph Shahn had used in *The Passion of Sacco-Vanzetti*. In the previous use, entitled *Sacco and Vanzetti: In the Courtroom Cage,* Shahn placed the woman outside the defendants' holding cell. In another instance, a sleeping indigent, based on one of the artist's photographs (cat. 119, fig. 11) and used in tandem with a standing figure from a newspaper source (cat. 120), provided the basis for a figure group in Shahn's *Prohibition* mural study as well as in the Rikers Island project (cat. 117). Shahn thus used the same ensemble in two different mural studies; in both cases the image served to illustrate how the social policies he deplored aggravated the chronic problem of unemployment. For his prison mural, however, Shahn intensified the message. He visualized the wretched cycle of joblessness and crime through the suggestion of endless unemployment lines. These are based on a *Daily News* photograph depicting "jobless veterans on Riverside Drive" who line up "for chow" at a soup kitchen (fig. 24).[61]

In counterpoint to the narrative on the east wall, Shahn executed for the west wall his utopian vision of penal reform—what the *New York Times* art critic Edward Alden Jewell optimistically described as representing "the New Deal in prison life, as we find it practiced day to day at Rikers Island." The idealistic sequence begins with a memorial portrait of Thomas Mott Osborne, the former warden of Sing Sing Penitentiary, who was widely considered the father of progressive prison reform measures during the early twentieth century (cat. 116). Osborne had challenged the prevailing cultural view that criminals were

morally deficient and that their behavior stemmed from foreordained degradations of character. To inform his understanding of the effect incarceration had on the convict, Osborne had voluntarily endured a week of hard labor and confinement in a cramped cell at Auburn Prison. His subsequently published account of his experiences initiated a fundamental revolution in prison administration. Shahn depicts Osborne as if he were still a prisoner in his tiny cell, sitting on a wooden stool and contemplating the reformist vision of prison life he would help unfold. In the layout of the Rikers mural, the "symbolic figure of Thomas Mott Osborne," rendered over the chapel entrance, points "the way toward proper prison method." Shahn's monumental representation of Osborne isolates the figure of the reformer, placing him in a distinct architectural setting that recalls the presentation of Tom Mooney in the *Mooney Apotheosis* panel (see fig. 52). Shahn adapted this formal device from Giotto's early Renaissance frescoes, which he greatly admired as representing "humane and freshly observed images."[62]

Following his portrait of Osborne, Shahn presented scenes of prisoners studying under the direction of teachers wearing everyday attire. Other scenes show inmates learning skilled trades, like auto mechanics, carpentry, farming, masonry, and sewing. Men can also be seen playing baseball or sitting in the spacious prison yards, similar to those Shahn had documented during his visit to the reformatory in New Hampton. Indeed, the surrounding architecture, the landscape, and many of these figures are based directly on the images Shahn made there (cats. 106, 109 and fig. 86).

In Shahn's scheme the model prison also provides medical facilities for its population,

FIGURE 24
Newspaper clipping from
the *Daily News,* 1933–34
11.2 × 16.2 cm
Clippings File, Shahn Papers

(NEWS photo)

Lining up for chow at Camp Thomas Paine, home of jobless veterans on Riverside Drive at 72d St. Many were taken care of at the spic and span camp with a turkey dinner, complete from soup to nuts! Mild weather added to happiness of the homeless.

as can be seen in his depiction of inmates receiving care in a state-of-the-art infirmary. Although the program for Shahn's mural was incomplete when he was forced to abandon the project in spring 1935, a sketch for the west wall maps his initial conception for missing scenes that would follow the medical panel. Above a doorway to the chapels, Shahn envisioned prisoners weaving and playing musical instruments. This was to be followed by a final scene picturing former inmates finding productive labor as a result of the skills they acquired in prison. Shahn's plan for the short south wall of the corridor was the most tentative. His sketchbook indicates that he had alternately considered depicting the Statue of Liberty, a Janus head, or a prisoner breaking free of his chains. His final thought, however, was to move the monumental portrait of Osborne to the south wall, allowing it to act as an "apotheosis" for the entire mural scheme.[63]

In January 1935 the mural painter Stephan Hirsch wrote an eloquent description of how Shahn had organized the space and paced the scenes in his mural study. Hirsch found the work "a new departure in mural painting," and he described the artistic challenges of a long narrow space like the prison corridor at Rikers: "Shahn . . . created narrower and wider panels which lend the wall a certain rhythm and force the onlooker to step from panel to panel with renewed interest all the time. . . . He uses what I should call an 'open and shut' composition. I mean by that the use of a scene with deep perspective, such as an outdoor scene in one panel and in the next an indoor scene with a limited depth of perspective. This creates a dramatic change for the eye . . . and to my knowledge is a completely new device in modern art." Shahn further dramatized his mural by placing figures in the foreground of the picture plane, which he set against deep recessional spaces. This is an attribute of his work that the critic Clement Greenberg later ascribed to Shahn's use of "the monocular photograph, with its sudden telescoping of planes."[64] Shahn also absorbed this distinctive spatial quality from the film stills he had studied, such as one of a cellblock reproduced in Lewis E. Lawes's *Twenty Thousand Years in Sing Sing* (fig. 25).

In November 1934, discussing his Rikers panels with Kirstein, Shahn told his friend "how much he believed in a musical form for murals: overture with parts of a whole work: statement of terms: variations, etc." The dynamic visual tempo that Shahn established in the formal design of the mural approximated the oscillating space and abrupt shifts in scale common to the moving camera. In fact, Shahn's newsreel-inspired layout of protest photographs documenting the 27 October 1934 march on City Hall for *Art Front,* which coincided with his work on the Rikers Island project, exhibit similar formal qualities to his mural. Hirsch noted that with his mural painter's eye he could imagine Shahn's paintings on the prison walls. In the winter of 1935, however, after Shahn had affixed the cartoons for his mural to the walls of the prison corridor, the Rikers Island project was "disapproved" by the Municipal Art Commission on the grounds that the design was "psychologically unfit."[65] Today, with the aid of a computer rendering, we can approximate what Shahn's dramatic mural would have looked like in situ (cats. 121–22). The viewer would

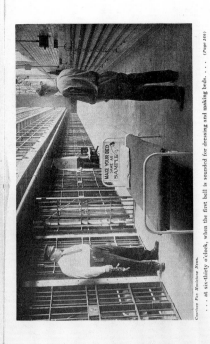

FIGURE 25
Fox Movietonews film still
In Lewis E. Lawes, *Twenty
Thousand Years in Sing Sing*
(New York, 1932), 108–9
21 × 26.4 cm

have stood as if he or she were inside Foucault's all-seeing "Panopticon"—an eyewitness to both the "archaic" and the "reform" models of how to exert social control over the prisoner.

Many critics considered Shahn's Rikers Island Penitentiary mural study a tour de force of public art. Holger Cahill published a panel as an outstanding example of contemporary American mural painting in the anthology *Art in America in Modern Times* (1934). Forbes Watson also included an illustration for an article highlighting the accomplishment of the nationwide government-sponsored art programs. Shahn's mural studies had been exhibited at the Brooklyn Museum of Art and the Downtown Gallery, and praised by Edward Alden Jewell. The unexpected rejection of the mural became an instant cause célèbre in the arts community. Articles protesting the decision were written by critics throughout the political spectrum, from Stuart Davis of *Art Front* (fig. 26) to Phillippa Whiting of the *American Magazine of Art*.[66] The authors raised the question of whether the commission could judge a work's "psychological" as opposed to aesthetic merit.

Blame for the decision was placed primarily on Municipal Art Commission member Jonas Lie, a traditional painter who was also president of the National Academy of Design. Lie was denounced in *Art Front* as "an enemy of art and artists" for his callous attitude toward the destruction of public art and his threat to whitewash murals he found offensive. Shortly after the rejection of the mural, Shahn achieved a small measure of revenge: he

published in the April 1935 issue of *Art Front* a caricature of Lie as "Jonas Patrick Henry Lie," waving an American flag in one hand and brandishing a whitewash-doused paintbrush in the other (see fig. 50). In an effort to appeal the decision in the spring of 1935, Commissioner MacCormick, under the guidance of the criminal psychologist Harry Manuel Shulman, helped the artists to canvass forty prisoners at Blackwell's Island Penitentiary. They were trying to ascertain whether the imagery would have a negative psychological effect. The poll's results were interpreted differently by the two sides, however, and failed to affect the commission's decision. In the aftermath of this and other similar experiences, Harold Rosenberg best summed up the opinion of Shahn's peers when he proclaimed: "The similarity between the police and the Art Commission is perhaps more than metaphorical; a definite cultural relation exists between the Academy and the Police Station, a relation which every artist can sense."[67]

In the spring and summer of 1935, while Block and Shahn were exploring the remaining options for executing their prison mural, they also became involved in preparations for the First American Artists' Congress. Inspired by the American Writers' Congress of 1935, the Artists' Congress was an event born of political necessity. Horrified by the spread of fascism abroad and the rise of reactionary trends at home, its participants rallied behind the Communist-led politics of the Popular Front. In June, Shahn, Davis, Gellert, Aaron Douglas, and William Siegel penned the call for the congress, which emphasized the need

FIGURE 26
Stuart Davis
"'We Reject'—
The Art Commission"
In *Art Front* 1 (July 1935): 4–5
41.4 × 55.6 cm
Taller Archive

for "collective action" against "war and fascism" both at home and abroad and cited the "economic plight" of the artist as well as the "constant attack against his freedom of expression." "Rockefeller Center, the Museum of Modern Art, . . . Riker's Island Penitentiary—in these and other important public and semi-public institutions," the writers noted, "censorship or actual destruction of art works has occurred." Davis wrote in an open letter to *New Masses* that "one of the major topics" of the congress would be "Repression of Art in America," noting that Block would speak about the events that led to the rejection of the Rikers mural as an example of "how these cases are the direct outcome of the general rise of reactionary and fascist tendencies." Although the mural painter Joe Jones ended up delivering the "Repression of Art in America" speech, he, like other artists and critics, eulogized Shahn and Block's rejected project, elevating it from cause to symbol.[68]

Block and Shahn later attempted to place the mural in a correctional institution outside Manhattan. As part of their efforts, which received full support from TERA and the College Art Association, the two artists met with officials at the prisons in Coxsackie, Elmira, Woodbourne, and Walkill, New York. Audrey McMahon (director of TERA) went so far as to write an official letter in June to State Commissioner of Correction Thayer. She pledged that the Shahn-Block mural would be paid for in full by TERA and offered to meet with him in Albany to discuss the project further. But Shahn by that time was discouraged and later recalled that "all the time in my heart of hearts I knew that it was pretty hopeless."[69] By late summer 1935, in spite of support from MacCormick, La Guardia, the College Art Association, and TERA, Shahn and Block had abandoned their prison mural. Block later tried unsuccessfully to secure funding to complete his religious panels.

Shahn did not complete a mural until 1936, when the RA commissioned him to paint one for the New Deal planned community at Jersey Homesteads on the history of the immigration and unionization of Jewish garment workers in New York City. In the summer and fall of 1935, however, Shahn did apply central aspects of his Rikers Island designs to the scenery and costume design for a proposed ballet adapted from Harriet Beecher Stowe's *Uncle Tom's Cabin,* to be performed by Kirstein's recently formed School of American Ballet. Kirstein, who had been contemplating the production of *Tom* since 1933, had invited the poet e. e. cummings, who had just spent the summer in Europe (including Moscow), to write the libretto, George Balanchine to choreograph the piece, and Nicolas Nabekoff to write the score. Edward M. M. Warburg, who helped fund the School of American Ballet and with whom Kirstein and their classmate John Walker III had founded the Harvard Society for Contemporary Art in 1929, agreed to cover the cost of commissioning Shahn to create the scenery and costume designs.[70]

Shahn's work had had a radicalizing influence on Kirstein, and in the winter of 1934 Kirstein wrote about the artist's effect on him: "Had [*Hound and Horn*] continued it would have been definitely left. My two painter friends, Philip Reisman and Ben Shahn, and Harry Potamkin [a film critic] . . . had shown me the great richness in revolutionary sub-

TOM

E·E CUMMINGS

FIGURE 27

Tom

Frontispiece for

E. E. Cummings, *Tom*

(New York, 1935)

21.7 × 31.4 cm

ject matter." Kirstein associated his desire to produce *Tom* with the radical lessons he had learned from Shahn, recollecting that the painter had brought him "closer to skirmishing in the class war" and that he "knew by this time that slavery was not simply a property of Allen Tate's non-revivable South and that dissident behavior had more formidable attributes than bootlegging." In a letter to Jay Leyda the following September, Kirstein had expressed his excitement about the prospect of mounting the radical ballet: "We are working on a new ballet on the subject of Uncle Tom's Cabin, which is going to have scenery and costumes by Ben Shahn. . . . This is going to be quite a remarkable production I think, about the first really revolutionary ballet that's been achieved in this country."[71]

In November 1935 Kirstein wrote to Shahn, who had moved to Washington; Kirstein called *Tom* a Ballet Manifesto, and responded to some of Shahn's ideas for the stage design. He expressed concern about Shahn's apparent desire to include in his set projected "photographs of men having their shoes shined," in the manner of the "Theatre Union production of Gorki's MOTHER." The New York Theatre Union had opened its production of *Mother,* based on Bertolt Brecht's adaptation of Maxim Gorky's novel, at the Civic Repertory Theatre on November 19. Mordecai Gorelik, who had also created the scenery for John Wexley's play about the Scottsboro case, *They Shall Not Die,* designed the set. For *Mother,* as in the Scottsboro production, Gorelik projected newspaper photographs and film stills onto an immense screen at the back of the stage.[72] Although Kirstein makes only a fleeting reference to Shahn's intention to attempt similar techniques, it is likely that the artist had in mind projecting news photographs or his own documentary images, which

may have included a selection of those he had taken on his trip through the American South for the RA earlier that fall.

Unfortunately, Balanchine found cummings's work impossible to choreograph, so *Tom* was never produced, and Kirstein later called it one of his "dreams" that had "come to nought." The only known surviving design by Shahn related to the project is the frontispiece for the publication of cummings's script for the ballet, the prose poem *Tom* (fig. 27). Yet even here the immediate connection to Shahn's design for the Rikers Island mural is evident. The towering figure of Tom stands before a plantation house pointedly based on the Morgan County Circuit Court House: once again, art is serving to remind the audience of contemporary political issues. Given Kirstein and Shahn's close collaboration on *Tom,* especially during the summer of 1935, I believe that Kirstein had Shahn's work in mind when he wrote what amounted to a manifesto for the radical painter in modern times for *Art Front.* His essay, "An Iowa Memling," was a critique of the work of the regionalist Grant Wood as backward-looking. Kirstein used the occasion, however, to encourage contemporary painters to absorb the documentary vocabulary of film stills, Leica snapshots, and movies, a process that he had observed firsthand in Shahn's work:

> Modern painting has not only its walls to cover, its medium to popularize, but its medium to actually use. A lyrical, intense eclecticism, a collective vision of what has been done and what can be done is the only thing that can save much of the painting of our most hopeful men from apologetic uselessness.... One path toward strong expression is ... the frank, tactful, enormously valuable aid of photographs, not as excuses for weak drawing or uninstructed sight, but for the power and truth of their unequaled documentation, an exactness ten times more unequivocal than any parody of the Van Eycks. Every age produces its own technique. The search for the mystery of an antique recipe for an emulsion of oil and water is not nearly so rewarding as a study of the quality of light in movie-stills, in Leica-snaps, in the different ranges of perspective in a moving camera.[73]

Kirstein expressed this view just two months after the American Writers' Congress, for which he had signed the call. At the meeting Joseph North and others had heralded reportage as "one of the most important literary forms of the revolutionary movement." North had concluded his speech by explaining how reportage could be used as the foundation for the modern novel: "Its relation to the novel is the relation of the cartoon to the mural." Here North offers a markedly apt paradigm for understanding Shahn's use of the reportage aesthetic in his painting, documentary photography, graphic art, and mural making during the early 1930s. At that moment reportage signified for Shahn a radical art form that provided the vocabulary from which he created revolutionary public art.[74]

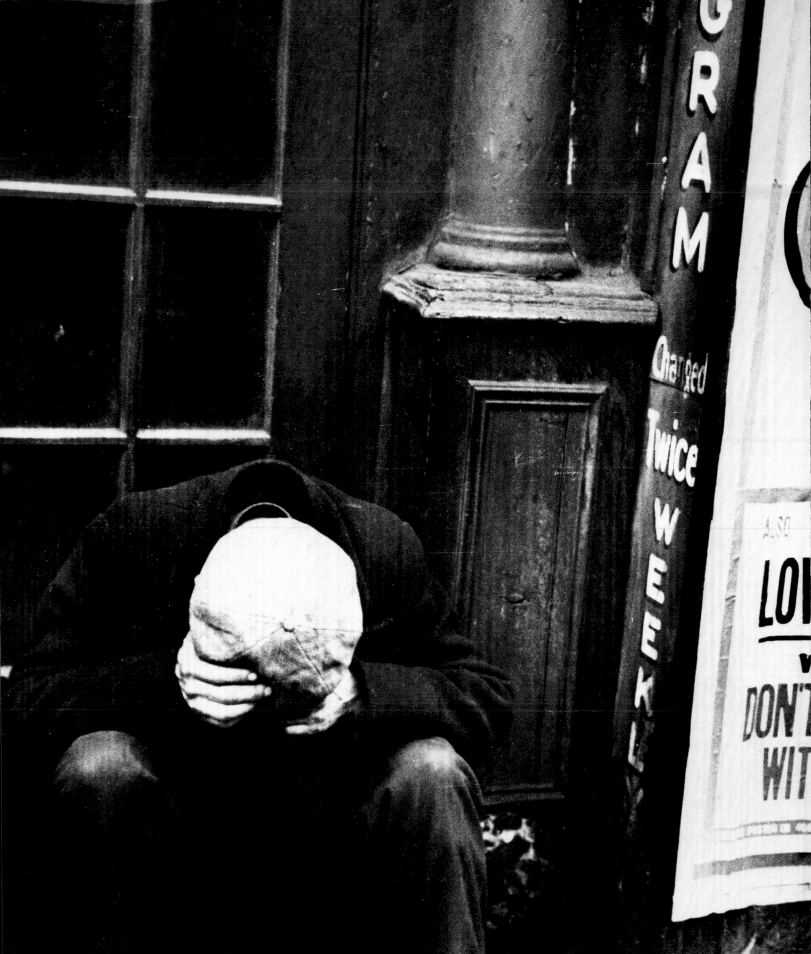

3. Ben Shahn and the Master Medium

Jenna Webster

n mid-October 1936 the photographer Walker Evans wrote to his friend Jay Leyda: "I want to stick around just now and turn in something that is wanted."[1] Evans was referring here to his and Ben Shahn's plans to shoot a half-hour thirty-five millimeter documentary film about New Deal suburban resettlement communities. The film was to feature Greenbelt, Maryland, a town designed by the Resettlement Administration (RA) to alleviate poor living conditions in Washington, D.C., and Baltimore, where overcrowding had forced rent to one-third above the national average. Shahn, who had established significant ties with film, eagerly began the project, hoping to convey to large audiences the New Deal ideology he passionately supported. Evans, who had also maintained an interest in film, anticipated gaining "practice" and "experience" from the assignment. But to the disappointment of both artists, the Greenbelt film was canceled. Today the project remains relatively unknown because little evidence of it exists and that which does is scattered. Among the few extant items, however, are three photographs by Shahn of Evans holding a movie camera. One, taken from a medium distance, shows Evans cradling the camera and chatting with project foremen (fig. 28); another, a close posterior view, shows Evans filming; the third, taken from a farther distance, pictures him making adjustments to the camera.[2]

Compared to the fairly well-documented accounts of Evans's interest in film, assessments of Shahn's regard for the medium have been limited to general characterizations of his approach to photography as "cinematic." Scholars analyzing instances in which Shahn made a sustained group of photographs on a single topic have imagined the images arranged in a continuous succession that, could the scenes be placed in motion, would form a dramatic whole, like a movie.[3] Indeed, it is tempting to interpret series like those Shahn made of a sideshow near Times Square (cats. 80–83) or musicians on Fourteenth Street (cats. 33, 34, 37) as adhering to a "cinematic" order. Yet little evidence exists that Shahn shot still photographs in a premeditated sequence, and only on rare occasions did he subsequently arrange his work in deliberate narratives.[4]

In the 1930s, when Shahn was most engaged with photography, critics were seeking to articulate the fine distinctions between the aesthetics of a motion picture and that of a series of photographs. Beaumont Newhall, writing in 1938, claimed that "there is a profound difference between still and motion-picture photography. The former is a spatial art; the

Detail of catalogue 128

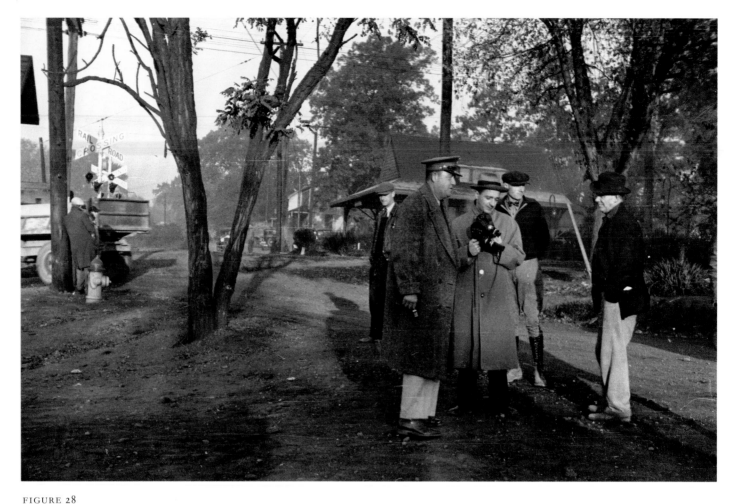

FIGURE 28
Untitled (Walker Evans,
Branchville, Maryland)
November 1936
Modern print from an
original negative
Fogg Art Museum, gift of
Bernarda Bryson Shahn,
P1970.4369.1

latter a temporal one." Newhall explained that unlike a still photograph, film always consists of a prescribed "sequence of images" that remain as a unit unless cut apart "by exhibitors for moral or economic reasons." Therefore, "while there is a unity of spirit between still and cinematic documentary, their approaches to the same problem must be through separate channels."[5] Shahn's friend Lincoln Kirstein, also writing in 1938, reached similar conclusions. In an essay for Evans's book *American Photographs* (1938), Kirstein stated that the photographs lacked the "obvious continuity of the moving picture, which by its physical nature compels the observer to perceive a series of images as parts of a whole. But these photographs, of necessity seen singly, are not conceived as isolated pictures made by a camera turned indiscriminately here or there. . . . They exist as a collection of statements."[6] Although Shahn's photographs "by necessity" must also be seen singly, they too function together as a "collection of statements" exploring and documenting the social issues of concern to the artist. In Kirstein's parlance, Shahn's still photographs, taken as parts of a whole meant to be viewed one at a time and in any order, do not have the continuity of the moving picture either.

A more rewarding line of inquiry than the preoccupation with whether Shahn wished to achieve a cinematic sequence or quality in his photography comes from a diverse and compelling body of evidence that attests to the artist's far-reaching interest in the medium of film itself, which he on numerous occasions called "the master medium."[7] In this essay I consider that evidence, including the unfinished Greenbelt project, to indicate how Shahn's relation to film and film culture in the 1930s broadly influenced his thinking and aesthetics.

FILM AND THE MAKING OF A MODERN ARTIST

Shahn's fascination with movies began early in his life. Like many young urban immigrants, Shahn found in cinema a means of acclimation and an escape from the harsh realities of growing up in New York City. At the beginning of the 1930s—artistically, politically, and personally an important decade for Shahn—his interest in film deepened, and he began using film as source material for his murals and painting series. Like newspaper photographs, which were essential to Shahn's artmaking at the time, motion pictures enabled him to engage a populist aesthetic, his way of irritating the "artistic elite who had already . . . begun to hold forth 'disengagement' as the first law of creation."[8] The movie *The Dreyfus Case* (1930), for example, inspired Shahn's gouaches on the controversial case (1930). In preparation for a series on Sacco and Vanzetti the following year, Shahn requested filmed material from the National Sacco and Vanzetti Committee. Similarly, *The Strange Case of Tom Mooney* (1933), a compilation of newsreel clips and shots of still photographs, was a likely source of inspiration for the artist's fifteen gouache paintings and tempera panel (1932–33) on the famous controversy. It was a method of working that Shahn used throughout his mid-career, commenting in 1947, "I take in all the newsreels . . . [and] they influence my work quite a bit."[9]

Popular prison movies particularly influenced Shahn's designs for his Rikers Island Penitentiary mural (1934–35), discussed in chapter 2. In a sketchbook Shahn made note of *The Big House* (1930), *Condemned* (1932), and *I Am a Fugitive from a Chain Gang* (1932). The latter, with its powerful screenplay and cinematography, proved especially inspiring. Based on a true story, *I Am a Fugitive* (as it was titled in rerelease; Shahn referred to both titles in his sketchbook) featured Paul Muni as an unemployed, impoverished World War I veteran forced to commit a crime. The hero, sentenced to ten years of brutal chain-gang labor, escapes and through incredible perseverance rises to respectability as an engineer in Chicago. Betrayed, however, he returns to the chain gang when officials lead him to believe he will be pardoned. This tale of an ordinary person crushed by unjust social practices and the horrors of the chain gang was, according to Jack L. Warner of Warner Brothers, "the first sermon I had ever put on film."[10] Its informed depiction of chain-gang atrocities interested Shahn, who had studied the history of penology at length and photographed inside area prisons and reformatories.

Shahn and his colleague on the Rikers Island mural project, Lou Block, viewed bound volumes of film stills as part of their research.[11] Stills from *I Am a Fugitive* showing Muni sitting on a cot with his fellow prisoners behind him in long perspective informed at least one of Shahn's preparatory drawings. Elements of Shahn's sketch (see fig. 80), which was appropriately labeled *I Am a Fugitive* and described as "prisoners sitting on cots in long perspective," appeared in the final mural proposal (cat. 122). Such a use of film and film stills was by no means unique, for Shahn belonged to a growing group of muralists and filmmakers who regularly made use of one another's work. Thomas Hart Benton, in his *America Today* mural (1930–31) done for the New School for Social Research, depicted film technology playing a central role in modern life, as did Diego Rivera in his Rockefeller Center project, on which Shahn worked in 1933. Dialogue between muralists and filmmakers was particularly prevalent between Russian directors and Mexican artists, like Rivera. David Alfaro Siqueiros, in his Chouinard School mural in Los Angeles (1932), employed innovative techniques he had learned after spending time with the Russian filmmaker Sergei Eisenstein. Similarly, Eisenstein and his cameraman Edouard Tisse drew upon José Clemente Orozco's compositions while filming the controversial *Que vivá México!* (1934).[12] Rivera himself may also have been influenced by Eisenstein, whom he met in New York in the early 1930s.

Shahn's appreciation of film coincided with the medium's growing role in Depression-era American culture. In spite of harsh economic times, the public thronged to gangster movies, romances, musicals, comedies, and newsreels; it was the beginning of Hollywood's so-called golden age. Developments in color and sound, while debated by the press, ultimately drew large crowds. Improvements in eight millimeter and sixteen millimeter movie cameras and projectors encouraged hundreds of amateur cinematographers, just as advancements in the thirty-five millimeter still camera had created a "miniature-camera craze."[13] Serious film criticism also emerged, as the intelligentsia became more interested in the medium. Gilbert Seldes, author of *The Movies Come from America* (1929), regularly published reviews in major newspapers and magazines. Leftist film critics were particularly active, given the radical political climate of the period. David Platt and Lewis Jacobs produced *Experimental Cinema* while their colleagues Harry Alan Potamkin, Tom Brandon, Robert Forsythe, and Leo Seltzer, among others, contributed to *Filmfront, New Theatre,* the *Daily Worker,* and *New Masses*. Cultural journals like *Creative Art* and *Hound and Horn* included film columns as well. By the late 1930s, seminal works on the cinema's history appeared, such as Lewis Jacobs's *The Rise of the American Film* (1939) and volume one of *The Film Index* (1941), published by the Works Progress Administration (WPA) and the MoMA Film Library. Cinema, although barely forty years old, had become one of the most popular art forms of the day. "A public art already exists," wrote the critic Meyer Schapiro; "the public enjoys . . . the movies with a directness and whole-heartedness which can hardly be called forth by the artistic painting and sculpture of our time."[14]

A diverse group of artists had been exploring this popular medium, including Salvador Dalí, Fernand Léger, Viking Eggeling, Man Ray, Vladimir Mayakovsky, Paul Strand, Charles Sheeler, Margaret Bourke-White, and Berenice Abbott. Movies, as the noted film critic David Platt wrote, suited modern artistic expression: "*Cinema . . .* is great enough in possibilities to not only *contain* but to give *direction* and *purpose* to poetry, music, painting, [and] sculpture. . . . It is the . . . only medium in control of the artist today that can possibly unite with him in attempting a modern humanistic synthesis of the world."[15] This flourishing film culture naturally influenced Shahn's relation to the medium. He began using his Leica camera to photograph Hollywood's attention-grabbing posters on display throughout New York City, as in his image of two boys mesmerized by a movie poster and stills for *Werewolf in London* (1935) and *Thunder in the East* (1934) (fig. 29). Shahn was familiar with photographs of movie posters by other photographers, including those by Walker Evans, whose famous *Torn Movie Poster* (1930–31) was taken in Truro, Massachusetts, where Shahn and Evans summered together in the early 1930s. Shahn shared Evans's interest in the aesthetics of graphic movie posters, but unlike Evans, he was more intrigued by the public's response to the allure of film culture. Documenting movie placards also provided Shahn with the opportunity to see how posters could function as a form of public art. Such experiences proved useful to him when he began to design posters for New Deal and World War II agencies.

New York City, where Shahn spent the majority of his early artistic career, greatly informed the artist's relation to film culture. It was here that Shahn began photographing movie theaters, portraying them as centers of social activity. The Hippodrome, established by the creators of Coney Island's Luna Park, provided a backdrop for the artist's images of busy midtown Manhattan. And in the Union Square and Fourteenth Street district and around Forty-second Street, Shahn documented the brightly lit marquees and klieg lights of burlesque theaters, as well as the homeless men who took advantage of the theater's cheap admission and late hours to find shelter. Near Greenwich Village, the artist's own neighborhood, the Sunshine Theatre at 141 East Houston Street formed the background for a series of photographs (cats. 11–14) around which Shahn later based his painting *Handball* (1939) (see fig. 38). No evidence suggests that Shahn (who rarely shot indoors and claimed to disparage the flash) photographed inside movie theaters, as did some miniature-camera users.[16]

New York City was also the heart of independent filmmaking in America, and various film-production groups were headquartered there. Most important was the Workers' Film and Photo League, established in December 1930 in the tradition of the Workers' International Relief, a proletarian organization founded in 1921 by the Communist International. Shahn, like members of the Film and Photo League, addressed topical issues and sought to make them part of public discussion. And as an active member of the Artists' Union, Shahn had numerous opportunities to meet the league's nearly fifty photographers

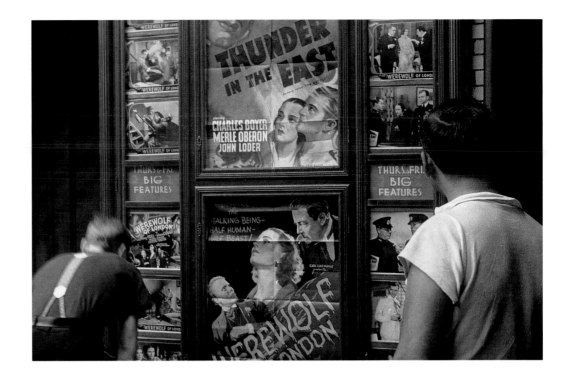

and approximately ten filmmakers at May Day parades and other demonstrations, which he and league members documented. One likely league acquaintance was Harry Alan Potamkin, America's first major leftist film critic, who was on the national committee for the league and was the executive secretary of the John Reed Club, with which Shahn was familiar. When Potamkin fell ill with leukemia in June 1933, twenty-six people from the league, the John Reed Club, and the *New Theatre* and *Daily Worker* staff volunteered blood, including Evans, who shared Potamkin's rare blood type.[17] Other of Shahn's acquaintances from the league included Leo Hurwitz and Ralph Steiner, both of whom left the league in September 1934 to form Nykino ("Ny": New York, and "kino": a Russian and German term for film). A full-time production unit, Nykino sought to create films based on works by Russian filmmakers, including Eisenstein and Dziga Vertov. The teachings of Lee Strasberg, an instructor at the Theatre Collective School, the Group Theatre, and the Workers' Laboratory Theatre, also greatly influenced Nykino productions. Herbert Kline, editor of *New Theatre* (which published twelve of Shahn's New York photographs in November 1934) (fig. 4), joined Nykino, as did Henri Cartier-Bresson, whose photographs Shahn greatly admired. Bresson participated in 1935, the same year his work was shown jointly with Evans's at the Julien Levy Gallery.[18]

The league and its splinter groups constituted only one facet of New York's independent film culture. Levy's gallery and the MoMA Film Library showed a wide variety of films, while movie houses like the progressive "Workers'" Acme Theatre on Fourteenth Street—a "treasure house of esoterica"; the "rendezvous of the intelligentsia"—and the

Cameo on Forty-second Street showed radical works daily from 9:30 A.M. to midnight.[19] Simon Gould, founder of the Acme and Cameo (as well as the New York and International Film Arts Guild), frequently advanced groups like the league twenty-five to fifty dollars for their productions, while the distributor Amkino helped cover high duty taxes involved in screening foreign films. Similarly, Tom Brandon's Garrison Film Distributors, which released *Pie in the Sky* (1934), Nykino's first production, made Mosfilm, Vostokfilm, and Soyuzkino productions available to clubs, schools, and unions interested in Russian films. Meanwhile, businesses like Fotoshop, Universal Camera Corporation, and Mogull's Home Movies and Photo supported the needs of New York's filmmakers; some of these stores even offered laboratories for developing motion picture film. Willoughby's Camera Store, where Shahn bought and developed film, sold sixteen millimeter movie cameras and, beginning in 1931, stocked a remarkably comprehensive movie rental library of one- and two-reel dramas, comedies, travelogues, and serials.

Shahn took advantage of this flourishing film culture in various ways. For instance, he viewed film stills at the New York Public Library Picture Collection, where during the Depression he, Evans, Berenice Abbott, Diego Rivera, Joseph Cornell, and other artists "used to hang out . . . all day," gathering material for their art from big wooden bins filled with clippings. There Shahn could access the nearly twenty thousand stills that had been deposited by movie studios. The curator Romana Javitz regularly assembled these images into pedagogic exhibits, such as *The Moving Picture as an Art Form,* an especially popular show arranged with the help of Jay Leyda.[20]

A MODERN ARTIST AND A MEDIUM FOR THE MASSES

Although Shahn's interest in film evolved in New York City, his trip in the fall of 1935 through the southern United States (Pennsylvania, West Virginia, Arkansas, Tennessee, Kentucky, Louisiana, and Mississippi) for the RA heightened his understanding of the medium and its role in American culture. Roy Stryker, head of the RA's Historical Section in the Division of Information, had instructed his photographers to include movie theaters in their photographic documentation of Depression-era America. Although Shahn at the time was officially employed as an Associate Art Expert for the Special Skills Division under Adrian Dornbush and was not obliged to follow Stryker's shooting scripts, he took this directive to a unique and personal level, for he had long been intrigued by film's influence on its viewers. His manner of photographing movie theaters would influence how other RA photographers approached the same subject.[21] Of particular interest to Shahn were the movies and movie posters that offered children enticing images of adventure and luxury during harsh economic times. While in New Orleans, for example, the artist documented children gathered outside the Casino Cinema, which featured matinees of *Stolen Harmony* (1935) and Laurel and Hardy productions. Photographing from the street, Shahn exaggerated the children's attraction to the house of entertainment, portray-

ing boys and girls clustered around the theater's large advertisements. In one image (fig. 30), he assumed a close, heightened perspective in order to dramatize the scene of a young boy waving his arm, mimicking the comedian's genial gesture in the poster. Shahn found similarly compelling scenes in the racially divided coalmining town of Omar (near Scotts Run), West Virginia. The artist documented young boys, whose fathers or older brothers were probably miners, studying film stills for *Hard Rock Harrigan* (1935), a film about a mining strike (fig. 31). Shahn, who photographed the scene at length, was clearly intrigued by the boys' curiosity about a movie that pertained immediately to their own experiences and at the same time tantalized them with images of adventure. Articulated photographs like these underscore the artist's interest in how film animated viewers and permeated their lives.

Shahn's interest in the relation between cinema and children coincided with a national debate about the medium's influence on adolescents. Discussion centered around the Payne Fund Studies, which published eleven volumes on the topic, including *Motion Pictures and the Social Attitudes of Children* (1933) and *The Emotional Responses of Children to the Motion Picture Situation* (1933). These publications supported the national censorship codes devised by the Legion of Decency, an affiliate of the Roman Catholic Church. Some members of the left applauded such studies as well, arguing that the findings proved Hollywood's inappropriate use of the medium. Most, however, recognized that Hollywood's depiction of sex and crime merely reflected interests and tendencies of contemporary American life. Shahn, a radical, regarded movie censorship as a restriction of the rights of the individual. He may have even equated film censorship with Prohibition—another form of state-sponsored social control debated during the 1920s and 1930s. A file of clippings in Shahn's papers in fact contains a newspaper photograph of four staid society women studying the "effects of motion pictures," an image that helped inspire the artist's mocking portrayal of the Women's Christian Temperance Union parade in his *Prohibition* mural studies (1933–34).[22]

In contrast to Shahn's photographs of children interacting with film culture, his images of the relation between adults and cinema are fraught with ambiguity. As part of his extended series documenting the activity around the Omar Theatre and its advertisements for *Hard Rock Harrigan,* Shahn photographed a lone black man studying the various stills. The photographs raise a number of complex issues. Is the man, likely a miner, perturbed by how Hollywood represents mining? "Was mining romance needed as a break from mining reality," inquires Nicholas Natanson, "or was romance being rejected in Omar?"[23] Is the theater admission beyond the man's means, leaving him to study the stills in lieu of seeing the film? Is this Omar resident, who as an African American living in the segregated South would have had to sit in the theater's poorest seats, offended or intrigued by the film's white actors? Shahn, always attentive to the plight of blacks in America, photographed the same man again, now standing with his back to the advertisements, with mine buildings visible in the distance (fig. 32). The powerful series urges viewers to consider the

FIGURE 30
*Untitled (New Orleans,
Louisiana),* October 1935
16.4 × 24.7 cm
Fogg Art Museum, gift of
Bernarda Bryson Shahn,
P1970.1480

FIGURE 31
Untitled (Omar, West Virginia)
October 1935
19.4 × 24.6 cm
Fogg Art Museum, gift of
Bernarda Bryson Shahn,
P1970.1667

contrast between Hollywood's representation of mining and the experiences of a black miner living in West Virginia's most developed and depressed coal region.

Believing that art should be politically relevant, Shahn frequently addressed the condition of the labor class. He sought, however, to avoid the stereotypes of the worker that resulted from vernacular culture, such as *Hard Rock Harrigan,* or the programs of radical organizations like the Artists' Union and the John Reed Club. As his widow, Bernarda Bryson Shahn, remembers, "He could not tolerate the idealized figure of the 'workers' or the 'downtrodden' that in the early 1930s were becoming a distinct theme in the art world. 'It's all right,' he said, 'to have a soft heart, so long as you have a hard eye.'"[24] The scene outside the Omar Theatre offered Shahn the perfect opportunity to use his hard eye to present how Hollywood's oversimplified portrayal of the Depression compared with his own more discerning vision. Such scenes also contributed to the artist's nuanced understanding of the problems, both significant and insignificant, facing working-class Americans. In later paintings like *Scotts Run, West Virginia* (1937), for instance, Shahn portrayed miners on strike as alienated rather than unified. His gouache *W.P.A. Sunday* (1939), with its bleak mining-company houses in the background, draws attention to the hardships working people suffer and the sense of malaise they experience even on days off. Shahn's observations outside the Omar Theatre also reiterated to the artist that unemployment af-

FIGURE 32

Untitled (Omar, West Virginia)

October 1935

17.8 × 24.6 cm

Fogg Art Museum, gift of

Bernarda Bryson Shahn,

P1970.1653

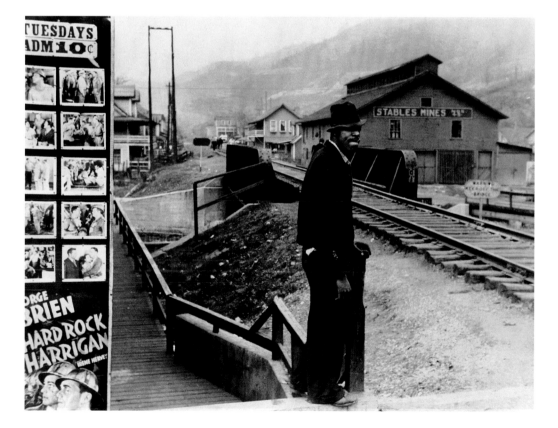

fected all Americans. Accordingly, in the tempera *Unemployed* (c. 1938) he depicted black and white men waiting together in an unemployment line, imagery he used again in his *The Meaning of Social Security* mural (1940–42).

Wherever Shahn traveled in the South he documented film culture. In Woodville, Mississippi, he photographed a rundown church serving as a makeshift movie house, bare lightbulbs dangling over the doorway and handwritten signs advertising feature films. The artist happened across other decrepit movie houses, like the Dixie Theatre in Morgantown, West Virginia, with its ragged posters promoting *Black Fury* (1935) (fig. 33). Shahn, as his captions for the scene suggest, was familiar with the film, a Warner Brothers' production starring Paul Muni as a Polish miner staging a one-man rebellion against self-serving mine owners. This well-known movie, endorsed by the labor leader John L. Lewis, contained the Hollywood trappings of a New Deal proletarian drama: working-class camaraderie, police brutality, dangerous mining conditions, and federal officials who intervene to enact justice—all subjects of concern to Shahn.[25] The scene at the Dixie Theatre so intrigued Shahn that he made close-ups of the ragged posters, which proclaimed, "STRIKE IN THE MINES! COAL POLICE! MEN, WOMEN AND CHILDREN DIE OF HUNGER!

FIGURE 33
Untitled (Morgantown,
West Virginia), October 1935
19.5 × 24.8 cm
Fogg Art Museum, gift of
Bernarda Bryson Shahn,
P1970.3182

SEE THE GREATEST SHOW EVER MADE ABOUT MINERS!" These carefully studied details suggest that Shahn found it both ironic and curious that the last screening at a theater going out of business in an impoverished mining town (which was enduring a strike at the time of the artist's visit) was a Hollywood film about a mining strike.

In April 1936 Shahn made a brief visit to New York City, where he photographed a scene that provides one of the most fascinating examples of his understanding of film and film culture. Three consecutive frames from an extant roll of film show a destitute man crouching in a doorway and resting his head in his hands (fig. 34).[26] Next to the man is a large poster advertising *Modern Times* (1936), which starred Charlie Chaplin's famed Tramp character. Shahn captured the scene first from a medium distance, juxtaposing the Bowery's decrepit architecture, the littered street, and the figure huddled in the doorway with the movie poster for one of the Depression's most famous films. In the second exposure Shahn, who as an RA photographer had refined his ability to frame subjects within their surroundings, moved closer to the scene, photographing the man from a lower perspective, thus cropping the top of the poster so as to accentuate the words "Chaplin" and "Modern Times." For the third exposure, the artist retreated slightly, assumed a somewhat skewed perspective, and settled on a framing that succinctly contrasted the actual vagrant on the street with the image of Chaplin dressed in baggy pants, oversize shoes, tight frock coat, and a disheveled bowler hat. Clearly, Shahn responded to the irony of the scene he had discovered.

Modern Times, produced and directed by Chaplin, received considerable prerelease publicity, and when it premiered in February at Broadway's Rivoli Theatre a riot squad had to quell the throngs of moviegoers. Chaplin was internationally famous for his Tramp character, which had earned him a fortune and proved a perennial source of debate among critics. Conservatives accused Chaplin of supporting Communist causes, while the mainstream press labeled the actor "a liberal . . . a champion of the common man and something of a rebel." Numerous left-leaning intellectuals lionized Chaplin, calling him a "Hollywood anarchist with an inherent sympathy for the underdog."[27] These same critics praised in *Modern Times* the representations of brutal police, merciless bosses, unemployed masses, and orphaned children living in Hooverville shanties. *New Theatre* even depicted the scissors of fascism (symbolized by a Nazi swastika) cutting—and thus censoring—strips of film showing the Tramp as a victim of police aggression (fig. 35).[28] Some reviewers, however, doubted Chaplin's sympathy for the common people. "For all its airs, Chaplin's independence [from Hollywood] is largely nominal," wrote Harry Alan Potamkin. According to Potamkin, Chaplin's Tramp served more as a simple comic type, "the happy hobo and blithe unregenerate," than as a protester of social evils. When reviewing *Modern Times,* Charmion Von Wiegnand, critic for *New Theatre, Art Front,* and *New Masses,* challenged Chaplin to discard his Tramp costume and espouse forthright the cause of the "vast majority of common folk from whom he has always drawn his strength."[29]

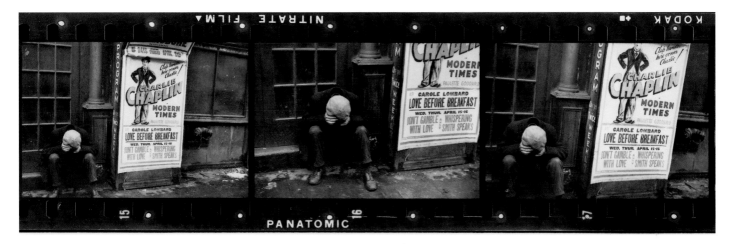

FIGURE 34
Untitled (New York City),
April 1936
Modern print from
original negatives
Harvard University Art
Museums, gift of
Bernarda Bryson Shahn,
P1998.135.16–18

Shahn's distinctive framing of the *Modern Times* poster suggests that he himself was less than convinced of Chaplin's sympathy for the disenfranchised. The artist had discovered his own "Tramp" on the streets of New York—a downtrodden man also of "modern times" but without a famous face to attract box-office crowds. Shahn's sensitivity to the itinerant figure on the street coincided with the rising public interest in the vagrant's way of life. John Worby's *The Other Half: The Autobiography of a Tramp* (1937) and *Sister of the Road: The Autobiography of a Box-Car Bertha* (1937), as told to Ben L. Reitman, were among the most notable autobiographical accounts being published at the time. Sociological studies of the vagrant as a cultural phenomenon included Thomas Minehan's *Boy and Girl Tramps of America* (1934) and W. A. Gape's *Half a Million Tramps* (1936).

In the darkroom Shahn manipulated his three negatives—the first and third exposures in particular—to enhance the contrast between Hollywood's representation of modern times and his own. The artist thus created a potent critique of Hollywood entertainment, an industry able to pay its stars thousand-dollar weekly salaries even at the height of the Depression. The prints Shahn made were of such importance to him that he mounted a number of them and titled a print from the third exposure *Bowery* (cat. 128). Later the artist sketched the destitute man, rather than Chaplin's Tramp, as an emblem of the Depression itself.[30]

Shahn sought to better the condition of the disenfranchised, and over the course of his career he used nearly every medium at his disposal to convey his beliefs about social welfare. While working for the RA, he skillfully presented New Deal ideology in various formats, and from personal experience he knew that film could convey the agency's programs to the largest audience. As one critic wrote, "light projected on a canvas screen" would reach more Americans "than any painted mural possibly could."[31] Cognizant of this, and hoping that a film made under his direction might arouse emotional support for President Franklin Roosevelt's relief programs, Shahn was eager to embark on a film project

that would have a major audience. And in October 1936 he and Walker Evans were hired to make such a film — the two-reel documentary for the RA about Greenbelt, Maryland.

A MEDIUM FOR A MODERN ARTIST

Shahn and Evans's film was intended to promote RA suburban resettlement communities, a topic of special interest to the RA's director, Rexford Guy Tugwell, who advocated the settlements as the solution to the nation's urban housing crisis. The film was to feature the newly created suburb of Greenbelt, Maryland (often called "Tugwelltown" by the press), touted at its groundbreaking on 12 October 1935 as "the beginning in the creation of new and better homes for America."[32] To build Greenbelt, one of the most massive New Deal projects undertaken, the federal government had assembled nearly 3,400 acres of overworked farmland at a cost of $165 an acre. Modeled on England's garden cities, the settlement was surrounded by a "belt" of forest and rolling farmland. The town provided modern homes for almost nine hundred lower-middle-class families who had previously occupied tenements in Washington and Baltimore. When Greenbelt opened officially on 1 June 1937, it boasted 574 International-style group houses, 5 prefabricated farmhouses,

FIGURE 35
Miguel Covarrubias, Cover for
New Theatre 3 (March 1936)
29 × 22.5 cm
The Harvard Theatre Collection,
The Houghton Library

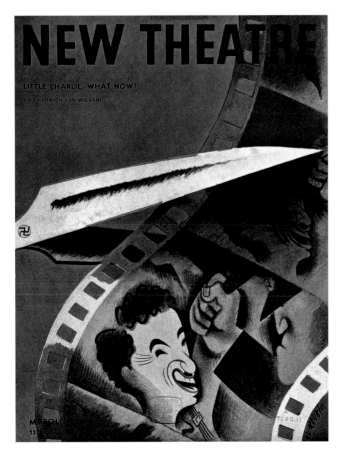

306 garden apartments, a library, a community auditorium and recreation hall, a 23-acre lake, 2 schools, and sculpture by the WPA artist Lenore Thomas Straus. "It [is] an experiment that ought to be copied by every community in the United States," proclaimed President Roosevelt.[33]

To elicit support for such relief efforts the RA had embarked on a massive publicity campaign organized by the agency's Division of Information. The campaign utilized radio bulletins, posters, pamphlets, and photographs to dramatize the necessity of settlements like Greenbelt. This elaborate and creative public relations effort included a film production unit as well, headed by the movie critic Pare Lorentz, who in the late summer of 1935 began making *The Plow That Broke the Plains* with cameramen Paul Strand, Ralph Steiner, and Leo Hurwitz. Released in May 1936, this twenty-five-minute film dramatized the causes of the Dust Bowl.[34] In late August of that year Lorentz began a second film, *The River* (1937), this time about the RA's efforts to control floods ravaging deforested and excessively farmed areas of the country.

Two months later, unbeknownst to Lorentz, Tugwell commissioned the Greenbelt film. Although aware that disagreements among agency administrators had often hindered and otherwise complicated Lorentz's filmmaking efforts, Shahn and Evans accepted the assignment. Evans believed, however, that he and Shahn would ultimately have free artistic rein, for in his opinion Tugwell did not know much about "pictures or photography or art." The commission remained largely confidential since division officials feared that Lorentz, as chief administrator of the Documentary Film Unit, would resent not being asked to participate in or supervise the endeavor.[35] Tugwell also sought to avoid bringing attention to the project since some RA officials wished to close the Documentary Film Unit and employ private production companies instead. Moreover, film presentations of Greenbelt communities had already caused problems for Tugwell. Republican politicians had censored the ending of *The Plow That Broke the Plains,* which originally concluded with shots of resettlement communities celebrating towns like Greenbelt as a solution to America's substandard living and working conditions.[36]

Tugwell's staff provided Evans and Shahn, who were both working on other government projects as well, with a detailed shooting script on 14 October, proposing that an opening montage contrast views of Washington landmarks with scenes of the city's squalid housing conditions. The script indicated that subsequent sections should emphasize the extensive research and planning that were to make Greenbelt such a pleasant, safe place to live. The film was to end with shots of crowded slums in New York City and Chicago, thus implying that Greenbelt provided a model housing solution for all the nation's cities. Evans, however, was dissatisfied with the script, feeling in particular that documenting the evolution of a suburban resettlement town would be tedious and uninspiring. He suggested integrating dramatized sections as a way of involving viewers.[37] Shahn did not express outright opposition to the script, but he shared Evans's views, although he occa-

sionally challenged his friend's ideas. In spite of their initial concerns, the two continued to work on the project, feeling that "the chance to make a film for [the] government is . . . worth scrapping over."[38] They prepared brief clips to show Tugwell and a dozen RA administrators, and at an evening meeting on 6 November they screened "a few sample shots," which received, according to Evans, "a properly negative reaction." Tugwell continued to support their efforts, however, and suggested that they draft a new prospectus and in the meantime make "detailed shots at Berwyn emphasizing especially the people arriving on the job and also trying to take a house through its various phases of construction as a series."[39]

Shahn and Evans immediately began revising the script, preparing numerous drafts, many of which indicate their familiarity with film techniques, such as fade-in and montage. According to Evans, he and Shahn imagined "a film about people, people and unemployment, people and slums, using an employment office interviewer and questionnaire blank as a device to jump off into various backgrounds, into unemployment, housing, child labor."[40] They often consulted with Jay Leyda, who was working at the MoMA Film Library and residing at Evans and Shahn's Greenwich Village apartment on 20–22 Bethune Street. Evans and Shahn's most significant modification to the script was the opening sequence, which showed in detail five unemployed men from various backgrounds—some with families to feed, others merely trying to find productive work—who were applying for Greenbelt construction jobs. In the middle sequence they intended to show actual construction scenes in "rapid dramatization."[41] Newsreel clips, shots of newspaper headlines broadcasting the need for better housing in America, Paramount Studio stock, and views of other resettlement projects were to embellish the artists' original footage. Some versions of the revised script included selections from *Bonus March* (1932), a New York Film and Photo League production about the famous Washington hunger strike. The film was to conclude with shots of the completed town bustling with contented and productive tenants. Shahn and Evans proposed various titles, eventually favoring *We Are the People,* a phrase common to Depression-era culture. Since recording sound on location was expensive, arrangements were made for voice-overs similar to those by Thomas Chalmers in *The Plow That Broke the Plains,* as well as musical accompaniment, which was to resemble Virgil Thomson's score from Lorentz's film.[42]

In mid-November, Shahn and Evans began filming. Bernarda Bryson Shahn told Evans's biographer Belinda Rathbone that the two were very "excited . . . rising early to shoot the site in the misty hours of the morning."[43] As was common at the time, one artist, in this case Evans, operated the movie camera while Shahn made still photographs that were to be compiled into a sort of sketchbook to assist in the film-editing process. It is not clear whether the two artists, who worked in close proximity, took turns using the motion picture camera.[44] Like Evans, Shahn possessed a certain degree of filming experience. When traveling through the South for the RA the year before, Shahn had shot at least nine

rolls of sixteen millimeter motion picture film, work that proved useful when he and Evans were commissioned to make the Greenbelt documentary.[45] Shahn applied this knowledge to *We Are the People,* sketching various shooting tactics on his copies of the film script.

Following Tugwell's advice, Shahn and Evans documented relief laborers arriving by special train at Branchville to be transported by truck the last two miles to Greenbelt. These workers were among the nearly four thousand employed by the RA for the Greenbelt project.[46] Earlier that year Shahn had documented similar laborers in Jersey Homesteads, New Jersey, as he began preparing for his mural there (1936–38). Once in Greenbelt, Shahn and Evans emphasized the clearing of land, the pouring of concrete, the laying of pipe, and the raising of buildings. They also documented piles of construction equipment and created distant views of partially completed two-story multifamily houses with brick veneer.

Housing initiatives and towns like Greenbelt had always been of great interest to Shahn. In 1930 he had begun collecting articles and photographs on housing, resulting in a substantial "Houses" source file to which he contributed until the mid-1940s.[47] When employed by the RA's Special Skills Division in 1935 Shahn made posters and pamphlets championing New Deal land and housing reforms. Similarly, he submitted designs in 1937 for a mural in Greendale, Wisconsin, a resettlement community founded at the same time as Greenbelt.[48] Throughout his tenure as an RA employee, Shahn also visited numerous RA-funded resettlement communities, including Cumberland Homesteads, Tennessee; Penderlea Farms, North Carolina; Red House, West Virginia; Skyline Farms, Alabama; Tygart Valley Homesteads, Elkins, West Virginia; and West Moreland Homesteads, Pennsylvania. He photographed the layout of a number of these settlements and portrayed inhabitants working in family and community gardens. Although Shahn indicated in 1964 that such towns did not interest him the way struggling communities like Omar, West Virginia, did, his images suggest a regard for the benefits these settlements offered.[49] Many of his photographs show well-dressed, playful children, quite unlike the bedraggled, somber adolescents the artist documented in poorer areas of the country. The contrast between these model communities and the destitute towns, which the RA referred to as "stranded," deeply affected Shahn's thinking. A number of his photographs of inferior housing conditions illustrated texts like Rupert B. Vance's *How the Other Half Is Housed: A Pictorial Record of Sub-Minimum Farm Housing* (1936).

As testament to his belief in New Deal housing, Shahn chose in 1939 to settle his own family in an RA agricultural-industrial cooperative known as Jersey Homesteads (renamed Roosevelt in 1945), near Princeton, New Jersey. The town, only a short distance from New York City, became the artist's permanent home. Shahn continued to pursue his interest in housing into the 1940s. While working on his *The Meaning of Social Security* mural in the fall of 1941 in Washington, the artist photographed a Shenandoah Valley rural resettlement

community. These photographs, a tribute to President Roosevelt and his public policies, culminated in a book maquette (fig. 36) that included text by the New Deal administrator Inslee Hopper, who had worked for the Treasury Relief Art Project (TRAP) and was a supervisor for Shahn's Social Security mural.[50] Given Shahn's efforts to promote the New Deal in posters, photographs, and film, he was the perfect artist to praise Roosevelt's commitment to social welfare.

To the great disappointment of Shahn and Evans, the Greenbelt film was canceled in the first week of December 1936, just as Tugwell's resignation became public. Shahn, who received news of the cancellation via telegram, blamed funding cuts. He was correct to a certain degree, for the RA's Documentary Film Unit was being accused of producing costly, unauthorized propaganda. Similarly, communities like Greenbelt were being criticized as unduly expensive when compared to other government-funded projects. Evans, meanwhile, blamed Washington bureaucracy. The RA was in fact suffering from internal conflict caused in part by resentful field officials who denounced the Division of Information for focusing primarily on activities of the Washington office; some even felt that the division had become Tugwell's personal press agency. It is understandable that RA officials resisted continuing the Greenbelt project since it would only have contributed to discontent within the agency and worsened the RA's already tainted public image. So with Tugwell's leaving, administrators quickly and quietly canceled *We Are the People.* The town of Greenbelt finally received its due in 1939 when it was featured in *The City,* produced by the American Institute of Planners, written by Pare Lorentz (then director of the U.S. Film Service), and shot by Willard Van Dyke and Ralph Steiner with assistance from the photographer Peter Sekaer, a friend of both Shahn and Evans's.[51]

After *We Are the People,* Shahn's interest in filmmaking waned—or as he later stated: "Look, [I couldn't] start in the movies at thirty-five. [My] aesthetic arteries [were] hardened. You've got to be in there at eighteen. . . . I just faced it and stepped away from it. It was that kind of a serious decision to make."[52] Shahn's friends, knowing his passion for motion pictures, attempted to resuscitate the artist's interest in staying involved with film. A year after the cancellation, Roy Stryker updated Shahn on the formation of the Washington Film Society. Stryker envisioned a similar organization in New York spearheaded by Shahn and their friends the photographers Edwin Locke, Russell Lee, and the photography aficionado Willard D. Morgan. In the following months Evans considered other movie projects, including one for Nykino with James Agee, Jay Leyda, and the filmmaker Fritz Lang. He also contemplated making a film under Harry Hopkins of the Temporary Emergency Relief Agency (TERA) or for the Department of Agriculture, which actively sponsored documentary filmmaking throughout the 1930s. Nonetheless, Shahn would always speak nostalgically of *We Are the People,* and he preserved both his and Evans's drafts of the shooting script. A year after the film's cancellation he even added a press photograph of Greenbelt's opening to his personal source files.[53]

FIGURE 36
*Untitled (near Shenandoah
Homesteads Resettlement Community,
Elkton, Virginia),* fall 1941
In a book mock-up with text
by Inslee Hopper
30 × 56 cm
Collection of Kathryn H. Mackey

Unfortunately, none of the film footage survives. More than a hundred of Shahn's preparatory still photographs for the Greenbelt film do exist, however. Unremarkable aesthetically, they show men preparing for a day's work, clearing land, and beginning construction. A few document the work of carpenters, who, as skilled workers, were not part of the RA relief labor force. Others show the racial segregation of the workers, a standard phenomenon on government relief projects during the 1930s.[54] The majority of the images are hand numbered in graphite on the verso, suggesting that Shahn arranged them in series, a procedure similar to assembling motion picture stills. A handful are folded or show signs of heavy use in the studio, and Shahn in fact did use a number of images as source material for later work.[55]

Although Shahn's interest in making films waned, he remained an advocate of what he would always call "the master medium." He continued integrating images from and references to film in his work according to patterns he had established during the early to mid-1930s. For example, while photographing the Ohio harvest for the Farm Security Administration in the summer of 1938, Shahn again focused his attention on small-town movie theaters. Moreover, because of his recent experiences with film, the artist regarded his documentation of the harvest in cinematic terms, explaining that he structured his photographs "almost like a movie script, except that they were stills."[56] This statement has typically been interpreted without regard to Shahn's filmmaking experiences, which naturally influenced his sense of narrative and image sequencing.

Following his documentation of the Ohio harvest, Shahn copiously painted movie posters into the background of some of his best-known temperas, including *Handball*

(1939) and *Portrait of Myself When Young* (1943). His war paintings *Italian Landscape* (1943–44), *Italian Landscape II: Europa* (1944), *The Red Stairway* (1944), and *Liberation* (1945) were informed by newsreels, which exposed Shahn to the bombed-out remains of Europe's major cities. In summer 1946, while traveling through the South photographing the efforts of the American Federation of Labor and Congress of Industrial Organizations to organize southern workers, the artist stopped to document a large, graphic poster advertising the movie *The Walls Came Tumbling Down* (1946) (fig. 37).[57]

Shahn also incorporated themes from the ill-fated *We Are the People* into his murals that most passionately celebrated the New Deal. In preparatory sketches for *Jersey Homesteads* and in the finished mural itself, construction workers, similar to those Shahn documented in Greenbelt, build homes for the garment workers moving from New York City tenements to Jersey Homesteads' pastoral setting. Shahn included views of the settlement's signature flat-roofed cinderblock dwellings and portrayed RA administrators and other officials planning the cooperative, a scene Tugwell and his staff had envisioned for *We Are the People*. A year later Shahn used his photographs of the Greenbelt carpenters as source ma-

FIGURE 37
Untitled (probably North Carolina)
summer 1946
Modern print from an
original negative
Fogg Art Museum, gift of
Bernarda Bryson Shahn,
P1970.4318.4

terial for figures in *The Meaning of Social Security*. Interestingly, one of the preparatory gouache studies for the mural was entitled *Greenbelt*. Intended for the portion of the mural displaying the benefits of Social Security legislation, the study attests to the enduring importance of the Greenbelt experience for Shahn.[58]

That Shahn applied film stills from popular movies as well as images and themes from the Greenbelt film to his murals is not particularly surprising given that contemporary literature often discussed murals and films as similar forms of public art executed on a large scale. The two media afforded artists a narrative structure, which Shahn, who advocated the storytelling aspects of art, employed in the service of New Deal ideology. Indeed, *We Are the People* and the murals *Jersey Homesteads* and *The Meaning of Social Security* remain equal pedagogic examples of socially conscious art. Shahn may have even considered cinema a type of animated mural. He particularly liked its public presence, a quality he also appreciated in murals, remarking that, "I like doing murals because more people see them than they do easel pictures."[59] Thus when *We Are the People* was canceled and Shahn returned to mural painting shortly thereafter, he found in murals a closely allied outlet for the concepts, images, and social engagement defined by his filmmaking efforts and knowledge of film culture.

When reminiscing at the end of his life about the 1930s, Shahn explained that he wished he had been "far more involved in movies," suggesting that his relation to the medium would have evolved in more profound ways had he persisted. Although records of the artist's interaction with film and film culture are limited, when they are considered in the context of his larger artistic output, it becomes clear that Shahn integrated the iconography and techniques of filmmaking into his artistic and intellectual processes. It should come as no surprise, then, that Shahn would always contemplate creative involvement with the medium: "If I could do it again, I would have gone into movies. It has everything—image and after-image, music and speech. . . . Its communication is . . . total."[60] This is not to say, however, that Shahn would have ignored painting, printmaking, or photography, for he was committed to each of these art forms in various ways. Of all media, however, film, in the artist's opinion, engaged viewers completely, communicating with them through speech, music, and images according to an infinite number of possibilities. And so five years before his death, Shahn, the accomplished painter and draftsman, expert printmaker, experienced muralist, and photographer, still referred to film as the "greatest medium there is today."[61]

4. The Politics of Media

Painting and Photography in the Art of Ben Shahn

Laura Katzman

n 1947 Ben Shahn was given his first major retrospective exhibition at the Museum of Modern Art (MoMA). This exhibition helped establish Shahn as one of the most popular figurative painters of his generation and affirmed MoMA's commitment to his work at a time when Abstract Expressionism was emerging on the New York art scene, and when the museum was taking an international approach to modern art. Curator James Thrall Soby wished to display a representative selection of Shahn's paintings, posters, drawings, book illustrations, mural studies, and photographs but worried about how to include the latter. In a letter to Shahn concerning the catalogue, which became one of the formative essays on the artist's work, Soby wrote: "I'll try to work out the photography business carefully and accurately. As a matter of fact, I've worried about the latter all along. There is a tendency to link your painting far too closely to photography, as in the *U.S. Camera* article and numerous reviews, and I tried to qualify whatever I said about your photography by pointing out how different the paintings are in final conception and spirit. But I'll go over it again with a fine tooth comb. It's important."[1]

In a *MoMA Bulletin* supplement devoted to the exhibition, Soby chose not to reproduce Shahn's photographs. He made a general reference to "photographs" but did not think they needed to be listed individually. Soby even took the liberty of halting an article the *New York Times* magazine planned on Shahn's painting and photography. Clearing his decision with Shahn after the fact, Soby wrote: "I vetoed the idea on the theory that this would turn into another *U.S. Camera* article, which you hadn't liked—nor I. Hope this was the right thing to do, even though it may mean they won't do the article at all. They've published a lot of bad articles in that section, including attacks on modern art, and I felt that we shouldn't take a chance, particularly in view of your reluctance to have any photos in the show at all."[2] Although nine Shahn photographs were in fact included in the exhibition, they were shown as a separate group and not integrated with the paintings to which they relate.

What was it that worried Soby and Shahn about the photographs? How can we understand their reluctance to exhibit them? Their concerns at first seem linked to the fact that photography was still not fully accepted as an art form, despite efforts made earlier in

the century by Alfred Stieglitz and others. By the 1930s a lively and expanding community of art photographers flourished in New York, and expressive photography was exhibited and even collected by galleries like Julien Levy and Delphic Studios. Yet these galleries could not survive on the sale of photographs alone, nor could photographers support themselves outside the commercial world. In the United States, a form of straight or documentary photography prevailed throughout the Depression and World War II. Some scholars have even claimed that the status of photography as art was a remote issue in this period, when the medium served the more urgent function of recording the harsh conditions of the day. Given this popular conception of photography, a painter's use of photographs would have been perceived as compromising creative imagination and integrity, taking shortcuts in a noble endeavor, and hence, a type of cheating. In 1934 Beaumont Newhall noted that contemporary artists saw the photograph as a "mechanical debasement" of their work; indeed, photography's indexical relation to the material world was long seen as being at odds with the transcendent status of art.[3]

Soby's concern, then, seems to have stemmed from the close connection between Shahn's paintings and photographs. Soby probably felt that public juxtaposition of work done in the two media would encourage simplistic and literal linkages by people who were unattuned to the nuances of Shahn's working process. Public knowledge of the photographic sources of paintings could thus diminish the paintings' aesthetic or market value. This would certainly have been the attitude of Shahn's dealer, Edith Halpert, who in the 1930s (and later) refused to exhibit Charles Sheeler's paintings and photographs together in her Downtown Gallery, deliberately stifling public exposure of his photography. As art historian Diane Tepfer has suggested, Halpert feared that Sheeler's photographs would eclipse his paintings and thereby reorient his reputation as a painter, which she had helped construct. The close relation between the two media would, in Halpert's opinion, allow critics and collectors to judge the paintings as "merely photographic," an added hindrance to sales during the Depression.[4]

Halpert was probably relieved that Shahn did not pursue photography to the same degree as his painting. Judging from her response in 1963 to Van Deren Coke's request to include Shahn in the pioneering exhibition and catalogue *The Painter and the Photograph* (1964), Halpert either possessed little knowledge of the extent of Shahn's use of photographs or downplayed what she did know. She asserted that Shahn always "personalized" and changed photographs when appropriating them for his paintings.[5] Bernarda Bryson Shahn, the artist's widow, worried even more than Halpert in these years about the connection between Shahn's paintings and photographs. In 1969, shortly after Shahn's death and on the occasion of his first photography retrospective at the Fogg Art Museum, Bryson Shahn wrote to curator Davis Pratt that Shahn did not take photographs with the intention of employing them in another medium because "Ben felt . . . too much respect for the integrity of any medium to use it as a prop for another."[6] Pairing the two media

would, she implied, lessen in the public eye Shahn's seriousness as both a photographer and a painter and would misrepresent his belief in photography and painting as independent art forms.

To protect the integrity, autonomy, and perceived originality of Shahn's paintings and photographs, some critics and biographers have made distinctions between the two media at different points in Shahn's career. These writers have acknowledged interrelations, noting that Shahn's paintings and photographs each grew out of similar humanist concerns; the same critics often qualified their statements, though, with assertions that each medium stands on its own.[7] Critics have also made qualitative judgments about Shahn's handling of the two media, claiming that he was a better painter than photographer or vice versa, as was apparent in reviews of the 1947 MoMA exhibition. The photo-historian Nancy Newhall, in a positive review, explained why Shahn was a better painter than photographer: "In his photographs [Shahn] does not work for the most expressive moment; he snaps an interesting but incomplete idea, usually an architectural setting with suggested placements of figures. His painting is to him what the climax of a series is to the miniaturist or the print visualized on the final ground glass image to those who use large cameras." Critic Clement Greenberg, in a more critical review, said just the opposite. He claimed that Shahn was "more naturally a photographer than painter, feels only black and white, and is surest of himself when he orients his picture in terms of dark and light." Photography, according to Greenberg, was responsible for Shahn's best work in painting: "It was the monocular photograph, with its sudden telescoping of planes, its abrupt leaps from solid foreground to flat distance, that in the early 1930's gave him the formula which remains responsible for most of the successful pictures he has painted since then."[8]

Other reviews of the MoMA exhibition commented on photography's negative effect on Shahn's art, noting that it hindered his work, creating a "hint of the mechanical," and "retarded his development as a painter": his paintings revealed "a subservience to small forms and rather clever detail." These views express biases particular to the time: on the one hand, the concern over upsetting traditional media boundaries, and on the other, modernism's insistence on the separation of painting and photography and on the independent status and "discrete, self-generating aesthetic" of each medium. Paul Strand, for example, believed that "the full potential power of every medium is dependent upon the purity of its use," and that a painting done from a photograph was "a kind of spiritual theft."[9]

The words of these critics tell us as much about their own agendas as they do about Shahn's process. Nancy Newhall, for instance, wrote for *Photo Notes,* the journal of the Photo League, a left-wing organization devoted to the practice and teaching of socially conscious camerawork. An advocate of photography, she may have called Shahn a better painter than photographer because his dismissals of technique and his self-taught experience rendered photography easy, an attitude that would have invalidated the pedagogical foundation of the Photo League School. Greenberg's comment that Shahn was a better

photographer was, in effect, as Frances K. Pohl has noted, a double-edged compliment. At the time, Shahn and Soby wanted "to distance Shahn's paintings from his photographs, giving primacy to the former." Greenberg's praise of the photographs at the expense of the paintings was also a way to criticize Shahn's social-realist practice as "not important . . . essentially beside the point as far as ambitious present-day painting is concerned"—which for Greenberg meant abstraction.[10]

The privileging of one medium over another occurred in discussions of one of Shahn's most famous paintings, *Handball* (1939) (fig. 38), and the photograph(s) to which it relates (fig. 39, cats. 11, 13, 14). In a letter to Shahn at the time of the MoMA exhibition, Soby noted how different the painting was from one of its source photographs (fig. 39): "I read one review which seemed to claim that *Handball* was directly based on your photograph of the scene, whereas the opposite seems to me true." Since Soby wanted to promote Shahn as an easel painter, he claimed in his catalogue that whereas "Shahn's painting often records a photographically arrested reality, its impact is quickened by the most exacting and imaginative painterly means"; Shahn "proceeds under the compulsion of a painter's inner vision," and drawing was "the backbone of his art."[11] Soby's attitude toward Shahn's photographs is especially curious, since he collected photographs, published on the medium, and was briefly apprenticed to Walker Evans in 1933. For a time he even served as chairman of the photography department at MoMA, which was a leader in the institutionalization of photography as a fine art.

In 1973 John Szarkowski, then director of that department, commented on the similarity between *Handball* and the photograph to which Soby referred: "It is not remarkable that [Shahn's] painting based upon [the photograph] resembles it so closely, for to what purpose would he change it?" Szarkowski was instrumental in promoting photography as a unique entity existing within its own distinct realm, adhering to its own pictorial syntax. Whereas linking paintings and photographs might at first seem to challenge his belief in the independent authority of photographs—their inherently "photographic" and modernist qualities—it actually reinforces photography's importance as a picture-making system, connected more to other pictures and traditions than to external reality. Szarkowski's attitudes must also be seen in light of MoMA's larger construction of a formalist history of photography that has generally neglected the social, political, and commercial uses and contexts of the photographs in its collections.[12]

The social and political meanings of Shahn's camerawork may explain in part why in 1947 MoMA did not exhibit his photographs in large numbers or even in relation to his paintings. The type of photography Shahn had practiced for the New Deal's RA/FSA had become politically suspect after World War II. Even during the organization's heyday, RA/FSA photographs were attacked as Communist propaganda by conservative congressmen who recognized that images of poor Americans could be used to criticize the capitalist system or highlight the ineffectiveness of democratic policies. Similarly, in the

FIGURE 38
Handball, 1939
Tempera on paper over
composition board,
57.8 × 79.4 cm
The Museum of Modern Art,
New York, Abby Aldrich
Rockefeller Fund

FIGURE 39
*Untitled (Houston Street
Playground, East Houston Street,
New York City),* 1932–35
15.3 × 21 cm
The Museum of Modern Art,
New York, gift of the artist

mid-1940s conservatives criticized Shahn's radical Congress of Industrial Organizations (CIO) posters (cat. 104) and his contribution to the controversial State Department exhibition of 1946, which was the subject of an anti-Communist assault; his government mural on the theme of Social Security (1940–42) (cat. 15, fig. 106) was also threatened with destruction. A few years later, his paintings and even his photographs were among those singled out in congressional records for their forceful messages, irreverent overtones, and allegedly "red" associations. Therefore, downplaying Shahn's New Deal photographs might have been Soby's way of averting further potential controversy in the increasingly oppressive political climate of postwar America. Additionally, Shahn's photographs of destitute Americans may not have fit the image of him that MoMA encouraged at the time: an American artist and Cold War liberal whose universalizing work appealed to members of the political left and right both.[13]

These aesthetic and political biases of Shahn's critics perpetuated misleading impressions of his art. They explain in part how a certain image of Shahn has been promoted and why we have such fragmentary knowledge of his photography beyond the RA/FSA work housed in public collections, portions of which have been reproduced and celebrated. But these circumstances also explain why we know relatively little about the role of photography in Shahn's art. Writers who have compared his paintings and photographs have done so narrowly, either proving that a particular photograph inspired a particular painting (with the discovery of the source photograph seen as an end in itself) or briefly describing his usage with minimal, if any, analysis of how the interaction between the two media affects the meaning of specific works. Shahn himself encouraged this state of affairs when he downplayed his photography.

Shahn used photography in more complex ways than either he or scholars have acknowledged, however, and its link to his painting raises far-reaching issues. The debates concerning the problematic relation between painting and photography were obviously not new to the 1930s. But what was the status of the debate at that time, and how did Shahn's work respond to these issues? Examining both Shahn's attitudes toward photography and his paintings that take photography as their subject, I explore how Shahn addressed problems of artistic representation, as well as the nature of the documentary expression that was so central to New Deal culture.

ARTIST AS PHOTOGRAPHER

Shahn took more photographs than is generally recognized. Anecdotal accounts indicate that he gained basic technical knowledge from Walker Evans, with whom he shared studio space in Greenwich Village in the early 1930s. Equipped with a used Leica (one of the most popular thirty-five millimeter miniature cameras of the day) Shahn enjoyed a stint as a street photographer, snapping pictures of merchants, unemployed workers, the children of immigrants, and homeless people in lower and midtown Manhattan neighbor-

hoods. He also recorded prisoners in New York State, and Artists' Union and labor demonstrations around Union Square; in fact, Shahn's embrace of photography came during his most active participation in radical politics.

Shahn used photography as a sketchpad for future paintings, seeing the camera as an aide-mémoire, more efficient than the pencil for capturing movement, gestures, and details. Photographs were raw materials to him, what he called "documents for myself."[14] But although Shahn himself saw the process this way, photography figured even more critically in his work than he realized. Shahn used photography, in part, as a vehicle for examining urban and rural working-class peoples, and relationships between individuals from the same minority group and between those from different groups. In his series of photographs of a Greek, a Greek American, and an African American from the Lower East Side (cats. 52, 54–57), for example, he skillfully employed the architecture within the picture frame to establish physical barriers between the men—barriers suggestive of larger social divisions.

From 1935 to 1938 Shahn photographed more professionally for the RA/FSA, documenting rural poverty and small-town life as part of a campaign to bring relief to the nation's farmers by raising public consciousness of their plight and thus bolstering support for New Deal policy. His warm, spontaneous photographs, characterized by asymmetry, compressed space, and dramatic cropping—along with Evans's more detached pictures and Dorothea Lange's elegantly compassionate images—have come to shape the way our culture views Depression-era America.

Shahn took his work for the government seriously. He spoke retrospectively of the total involvement he felt on the RA/FSA project and how his photographic trips around the country challenged his preconceptions about oppressed people, enabled him to put art at the service of social change, and helped him build a collection of visual materials for future use. But at the same time Shahn kept his distance from photography, as is evident in his writings, interviews, and art. He wrote relatively little about the medium, but when he did, he downplayed the importance of technique, emphasizing content over print quality. He claimed that he never made a photograph for its own sake but only for documentary or communicative purposes, and that he was uninterested in making an "art of photography." He rejected hierarchies of media, asserting that images were equal whether they were made with the brush or the camera. Whereas in later years he could be dismissive about his involvement with photography, asserting that it was neither his livelihood nor his career, he nonetheless maintained strong opinions about the relation between painting and photography.[15]

Shahn's attitudes are conveyed more graphically in a witty drawing from around 1939 in which he depicted himself with his Leica and right-angle viewfinder capturing his subjects off guard (frontispiece). In this spirited caricature, Shahn's eager, forward-leaning stance and his exaggerated body, tiny feet, and open mouth express his delight at taking

photographs in this way. Such playfulness points to the zeal with which thousands of dark-room "bugs" embraced these small instruments during the miniature-camera craze of the 1930s (fig. 40). According to social historian Frederick Lewis Allen,

> During the early years of the Depression one began to notice, here and there, young men with what appeared to be leather-cased opera glasses slung about their necks. They were the pioneers of the camera craze who had discovered that the Leicas and other tiny German cameras, which took postage-stamp-size pictures capable of enlargement, combined a speed, a depth of focus, and an ability to do their work in dim light which opened all sorts of new opportunities to the photographer. The number of "candid camera" addicts grew rapidly. . . . During the eight years from 1928 to 1936 the importation into America of cameras and parts thereof—chiefly from Germany—increased over five-fold despite the Depression.[16]

Shahn's self-portrait functions like Leica manuals and popular photo journals in its display of the camera's special features—its compactness, portability (emphasized by Shahn's large hand), and simple, streamlined design. The drawing plays on the catch phrase to "handle a Leica," a promotional tactic that implies human control over the camera machine. And just as the advertisements asserted the advantages of the right-angle viewfinder, Shahn cleverly boasted of the device's effectiveness in capturing people unaware. For by the time we, the subject-viewer, figure out what Shahn is doing, he has already snapped our picture.

Shahn's drawing also suggests that he embraced an amateur status. Initially, miniature cameras were reputed to be the toys of rich amateurs and were just beginning to be taken seriously in professional circles.[17] But what did it mean to be an amateur photographer in the 1930s? The advent of miniature cameras spawned a new breed of users generally known as "serious amateurs," gadgeteers, or minicamers, distinguished from earlier snap-shooters by their fanatic dedication to technical matters, equipment, and experimentation. Shahn disliked this obsession with how, rather than why, pictures were taken. His anti-technical stance was evident in his resistance to filters, exposure meters, and flashes (which he deemed "immoral"), and in the irreverent delight he took in nonart photographs, such as newspaper pictures. He poked fun at camera clubs and even sent misleading technical information to a popular photo journal publishing his photographs.[18]

Although Shahn rejected the technical focus of "serious amateurs," an amateur stance allowed him the freedom to experiment. If his photographs turned out poorly, he had an excuse; if they turned out well, he could attribute their success to his natural talent (steady hand) or luck rather than to technical know-how or sophisticated equipment. Colin L. Westerbeck, Jr., has argued that Shahn was not restricted by the compunctions of a professional. In Westerbeck's view, that Shahn's photography was secondary to his painting accounts for the "originality" of his photographs, while his uninvolved ego—his

FIGURE 40
From "The U.S.
Minicam Boom," *Fortune,*
October 1936, 126–27
35.5 × 56.5 cm

willingness to try anything and to fail—contributed to his great output and facility in photography.[19]

Behind Shahn's irreverence about technique, however, lurked the probability that he cared more than he let on. He developed, printed, burned, dodged, enlarged, and cropped his photographs, and he mounted, signed, and titled many of them, becoming a good technician in spite of himself. In the early years of the RA/FSA, Shahn insisted on printing his own material as models for the government printers. While in the field he received flash and synchronizers and more instruction than has previously been assumed from Roy Stryker, chief of the Historical Section, with whom he also exchanged technical information. But Shahn's commitment to photography should not be exaggerated; he was cavalier about technique, and he lost many potentially powerful pictures because he did not use equipment appropriate to poor light situations. He even refused to learn more than he needed to get by. What is at issue here is not the extent to which Shahn cared about technique, but how his attitude has deterred in-depth examination of his work and how it became for the artist a kind of self-conscious stance.[20]

The Leica drawing, for example, was inspired by staged photographs of Shahn from around 1939 (fig. 41). As one of the few known portraits of Shahn as a photographer, the image became closely identified with his photographic persona and was how his colleagues liked to remember him (see fig. 92).[21] More than twenty years later (at the time of Shahn's last major photographic activity), similar photographs were staged on a trip to the Far East and Southeast Asia. Pictured humorously in one Polaroid with camera cases and

binoculars slung around his neck and a souvenir poster in hand that reads "TELL ME ABOUT JAPAN," Shahn at once acknowledged and poked fun of the tourist's vision—a vision mediated by lenses, preconceived notions of other cultures, and the desire to take home "views." This lighthearted tourist identification is yet another example of how in later years Shahn tended to resist a serious, professional association with photography.[22]

SHAHN'S USE OF PHOTOGRAPHY: THE MEANING OF SOURCES

Shahn's deep involvement with photography is further affirmed by the photographic source files he maintained as part of his visual reference library, files to which he would refer when he needed a picture of, say, a miner, a child, a building, or a politician to make a work in another medium. That these files have only recently come to light in an accessible repository is due to concern on the part of Shahn's widow that public exposure of the artist's use of photography might jeopardize her husband's reputation as a painter. It also underscores the wider acceptance in recent years of photography as an aid in the artistic process.[23]

These files indicate the extent to which the artist used his own photographs as well as those of other photographers, both known and unknown. A substantial number of the photographs are newspaper and magazine clippings of the 1930s and 1940s, a time when photographic illustrations proliferated in publications like the big picture magazines. Pictures also come from government bureaus and news agencies, which sent photographs to Shahn in response to his requests for images when working on a particular project or commission. Many of the newspaper photographs—often with captions intact—feature political figures or events. Photography and politics are thus inextricably linked for Shahn, who wanted to retain the documentary specificity of his sources.

Shahn's files also reveal the artist's awareness that one photograph can have multiple uses and that its meanings depend upon its context. Two versions of a photograph of a 1937 Ford plant labor dispute appear twice in his files, for example, under the headings "Strikes and Police" and "Conventions," the latter suggesting the relevance of labor union issues to political campaigns. In other cases Shahn used seemingly innocuous photographs to make stronger social commentary, as in the painting *Carnival* (1946), which was inspired by his own 1938 photographs of a carnival game operator in London, Ohio; a Buckeye Lake Amusement Park ride; and a couple at a July Fourth celebration in Ashville, Ohio. Juxtaposed and transformed in the painting (the game operator becomes a sadder figure), these images helped Shahn convey the disparity between the haves and the have-nots— the play of some depends on the work of others. Conversely, Shahn also used politically charged photographs, watering down their historical implications to make more generalized, universal images, as in *Brothers* (1946), a painting that borrowed from a news photograph of about 1944 (in one of his "War" folders) showing a survivor of Estonia's Klooga death camp.

Art historian Ziva Amishai-Maisels has shown how Shahn used graphic, emotionally wrenching photographs of Holocaust victims as the basis of wartime and postwar paintings, hiding their original meanings behind more general antiwar messages and those regarding the plight of children as victims of society's ills. In his Office of War Information graphics, Shahn did not refer specifically to the oppression of Jewish people but rather emphasized the suffering of the Poles, Danes, Czechs, and French in general. He could only cope with Nazi atrocities indirectly, Amishai-Maisels argues, distancing himself from haunting photographic imagery, using "substitute tragedies" to extend the picture's meaning beyond the Holocaust. Linking the artist's choice of imagery and hidden use to his Jewish heritage, she claims that Shahn's "complex expression of his ethnic identity reveals a struggle between his need for self-identification as a Jew and his fears of being labeled parochial," which he felt "would impinge upon his identity as an American and as a 'rational humanist.'"[24] This might explain Shahn's simultaneous attraction to and distance from his Jewish culture at a time of rampant anti-Semitism.

Although it is tempting to read Shahn's so-called covert use of Holocaust photographs in an ethnic context, Amishai-Maisels's argument is problematic because Shahn typically employed photographs in this way for most of his painting and mural work at the time. In *Blind Accordion Player* (1945) (cat. 36) and its related New York photographs (cats. 33, 34, 37), for example, Shahn decontextualized the musician, eliminated extraneous details, and monumentalized the man's body and hands, transforming him from a specific Depression-

FIGURE 41
Unknown photographer,
Untitled (Ben Shahn, Jersey Homesteads), c. 1936–39
Approximately 6 × 8 cm
Fogg Art Museum, gift of Bernarda Bryson Shahn,
P1998.136

era performer on congested Fourteenth Street into an isolated figure in a surreal, barren landscape. The artist thereby made a powerful statement about the human condition that speaks beyond the specificity of the photograph's content.

This universalizing tendency was not unique to Shahn. Other politically engaged realists of his generation, such as William Gropper and Philip Evergood, moved in the mid-1940s from topical and reportorial imagery to an allegorical language that addressed broader, more humanistic and philosophical issues of good and evil. Pictorial change grew in part from disillusionment with radical ideals shattered by the harsh realities of World War II. Such changes were also a response to criticism of art as a means of propaganda: through symbolic forms, artists could affirm the status of their work as "high art" that transcended mere propaganda.[25]

Shahn never denied his reliance upon photography. Beginning in the 1930s he openly requested photographs from the RA/FSA and other agencies for his work in various media, saying late in his life that his government photographic experiences formed the basis of most of his art from the late 1930s into the mid-1940s. He also expressed annoyance at the longstanding debates on the relation between painting and photography and hoped they would come to an end. Shahn was open about showing his source files to interested individuals, thereby naturalizing his use of photographs as common studio paraphernalia and tools of the trade.[26]

What is curious, however, is that when Shahn traced the origin of photo-inspired canvases, he rarely mentioned the specific photographs he used, implying that his experiences and memories, as they were recorded by preparatory drawings, were the seeds of his ideas. Even when he did acknowledge the photographic source of a painting, he did not credit the photographer or newspaper from which it came. These omissions were the combined result of the artist's failed memory, his own awareness of the biases against using camera images, and the ubiquity of documentary photographs in our society. So thoroughly do photographs—especially newspaper images—saturate our culture that they are considered authorless public property, fair game to be used, manipulated, and reproduced.[27]

PHOTOGRAPHER'S WINDOW

Shahn employed photographs for reference, research, and documentation throughout his career. But at crucial moments he also used them to comment on the medium of photography itself, reflecting upon the nature of representation. This is exemplified by *Photographer's Window* (1939–40) (cat. 141), a tempera completed after Shahn's official resignation in 1938 from the RA/FSA—a time when photography was still on his mind. *Photographer's Window* has not received much attention in Shahn scholarship, although in 1977 a critic called the picture "a curious 1939 painting. . . . One is never certain whether Shahn is portraying a literal transcription of a real window or an invented situation."[28] Had this reviewer known about the photograph from which the painting derives—a photograph

that provides clues to the painting's larger meanings—her uncertainty might have been clarified.

The photograph depicts a studio photographer's window that Shahn saw in New York in 1936 (cat. 140). Adorning the window are four rows of pictures of wedding and anniversary couples, graduates, a bar mitzvah boy, and small children. Most of the images are matted, though some are framed, indicating a more expensive option available at the studio. In the foreground, lightbulbs and reflections from the window partially block the face of a child and a bride, and light obliterates two photographs entirely, a detail that will be shown to bear considerable significance.

The photographs present formally dressed people posed for momentous occasions. The couples stand in stock poses, either frontally or at angles with their heads cocked toward each other. They smile or look wistfully away from the camera into the distance. Some couples appear with flowers against arched backdrops that enclose and bathe them in a soft halo of light. The windows suggest worlds beyond the loving shelter of their union; staircases point to the eternal road of their joined lives. The photographs of the children, interspersed among those of the couples and also filled with flowers and studio props, suggest more literally the future products of marriage.

Shahn was clearly interested in the ordinariness of this image. He had already embraced the "common man" in his series on Sacco and Vanzetti (1931–32), Tom Mooney (1932–33) (fig. 52), and in his mural studies on Prohibition (1933–34) (cat. 73) and for the Rikers Island Penitentiary (1934–35) (cats. 115–17, 121–22). Such work was part of a larger artistic response to the Depression, exemplified by the federal art projects that recorded the basic values of "the people" as a way of fostering national pride. In a quest to document what was American about America and to find a "usable past," government-funded artists celebrated the country's agrarian roots in the rural midwest. For Shahn, this window would have represented a slice of American life—a window on the world.

Yet this is not just any world, and it is certainly not middle America. Shahn's window displays a specific urban and ethnic community, which becomes apparent when the photograph is considered in the context of the other images taken on the same roll of film (cat. 123).[29] On this roll Shahn focused closely on aspects of Lower East Side street life in April 1936—beginning with his children, continuing with portraits of down-and-outers, shoppers, and merchants, and ending with the storefronts of Jewish-owned businesses. Read in sequence, these images at once evoke the intimate, insular world of a Jewish neighborhood and inform us of Jewish rituals and religious responsibility. The photographer's window, with its wedding photographs, is situated between a photograph of a matzoh advertisement (suggesting Passover), pictures of Jewish men and a Hebrew bookstore (learning and the perpetuation of faith), and kosher markets (dietary laws).

Shahn took these photographs at a time when he was breaking from his own Jewish immigrant past, having recently left his first wife and two young children. In 1935 he

moved from Greenwich Village and his radical artistic circles to Washington, D.C., and began traveling around the United States as a graphic artist and photographer for the Resettlement Administration (RA). On at least one visit back to New York to research Eastern European immigration for his RA-funded Jersey Homesteads mural, he photographed what remained of this immigrant world, as if attempting to examine how it had changed since his childhood and how it coped during the Depression.[30]

But Shahn had more than personal or sociological reasons for being drawn to a photographer's window. For Shahn the artist, the window presented an opportunity to reflect upon the practice of photography itself: the mere act of photographing a photographer's window necessarily established a connection between the photographer and the pictures in the window—between studio photography and documentary street photography. In fact, the image tells us less about the people depicted in the window than it does about the conventions of depiction in portrait photography. Studio photography, as a commercial business, differed greatly from Shahn's kind of photography. It took place indoors, with large view cameras, controlled lighting, and props. In contrast, Shahn's portable Leica enabled him to work informally and to take candid photographs in available light, which often resulted in pictures with cropped edges and uneven illumination. Contemporary advertisements and promotional literature capitalized on this distinction, comparing stiff and formal studio practice with free and natural Leica photography and, in the process, creating the popular perception of the Leica's ability to capture "true" life situations.[31]

To have photographed a photographer's window involved a conceit on the part of Shahn, the candid photographer who snapped the image in an instant when it took at least twenty-four sittings for the studio photographer to fill his window with pictures. There is a long tradition in the history of painting and photography of using a picture within a picture for aesthetic and social commentary. Walker Evans, for example, in his well-known photographer's window of 1936, documented a cross-section of the middle-class population in a southern city (fig. 42). As in Shahn's photograph, Evans's window is also an image about image making, for it appropriates a ready-made image, replaces the act of making with the more self-effacing act of taking, and thus calls into question the notion of authorship. It is an image about mass production and the way technology can reduce individuals to small, uniform squares—to just images. It is equally about the way the camera can bring all these strangers into the same nonhierarchical, democratic space, creating a kind of "family of man." The commercial photographs look as if they were taken by an automatic machine, and even though Evans emulated such banal, deadpan realism, it bore little resemblance to the kind of photography he actually produced. Both Evans and Shahn thus used the photographer's window as a means of defining their own roles in photography.[32]

These statements are more explicit in Shahn's somber painting *Photographer's Window,* which he distinguished from its source photograph in significant ways. He reduced the

FIGURE 42
Walker Evans,
Photographer's Window Display,
Birmingham, Alabama
(or Savannah, Georgia), 1936
20.3 × 25.4 cm
Library of Congress, Prints
and Photographs Division,
Washington, D.C.

number of photographs to fifteen and rearranged and enlarged them. By omitting the bar mitzvah student—the most obvious sign of Jewishness—the image is less specifically ethnic. Shahn made the couples' faces fuller, the children plumper, one even a bit monstrous. Most significant, the artist added to the window three images based on his own RA/FSA photographs: an Ozark tenant farmer (cat. 143), a Hungarian miner and his wife, and the children of an Arkansas rehabilitation client (cat. 142). The contrast between these poor rural folk (who could not afford to have their pictures taken) with smiling middle-class urbanites posed for special occasions is stark.[33] Shahn presented his Resettlement subjects in sharper focus than their neighbors in the window, with greater detail and intensity of expression. They appear as flesh and blood, engaging us directly and evoking our sympathies in the way that RA/FSA photographs were intended to do.

Such glaring juxtapositions necessarily raise questions of class inequities. Was Shahn elevating the social and economic status of the farmers and miners, giving them a visibility and exposure typically denied them? By separating the images in the window was he emphasizing the separation of classes, calling our attention to ignorance about poverty in certain circles of society? By presenting a more representative selection of the American

population, one that included the oft-forgotten disenfranchised, Shahn sought to show us how the other half really lives.

Shahn's window also comments on the nature of the documentary project itself. The image functions as the artist's own advertisement for RA/FSA photography (which he undoubtedly favored over studio photography) and displays the types of photographs that made for effective propaganda. It is instructive to compare Shahn's use of RA/FSA photographs in the window with the way the government and media used the same images to promote rural rehabilitation (see fig. 98). Like newspaper or government editors, Shahn cropped the photographs he employed and removed them from their larger contexts (many were originally parts of series with captions). He thus transformed them into watered-down icons of poverty with dignity. Shahn may have chosen the image of the destitute children, for example, because two children could generate more sympathy and less judgment than a picture of a poor family with many children. (In his painting, the picture of the two boys was altered to show only one). This affirms historian James Curtis's findings that RA/FSA photographers manipulated their images by arranging subjects, eliminating elements, and selecting photographs for publication that conformed to the values of an urban middle-class audience.[34]

On one level, then, *Photographer's Window* illustrates a form of humanist documentary that has been criticized by revisionist historians. Scholars have argued that 1930s documentary (especially palatable pictures of the "deserving" poor) did not so much effect social change as reinforce mainstream notions about poverty and class relations. The government exploited documentary photographs, critics have contended, to appease those who wanted something to be done to ameliorate poverty and to suppress a potential working-class uprising. On another level, however, Shahn may have used his RA/FSA images more subversively, for not only do they intrude on a world of greater privilege and celebration, but he presented that world as imperfect. Some of the studio clients are visually unappealing, with pasty faces, distorted features, squinty, beady eyes, toothy smiles, and stiff, unnatural poses. By not idealizing his better-off subjects and by endowing the poorer people with more documentary specificity, Shahn's treatment differs from that of government pamphlets and newspapers, which used "before and after" comparisons to show the superior state of the destitute farmers and their communities after federal assistance. Cultural historian Maren Stange has argued that RA/FSA images were more radical in their implications than the ends to which the government and media used them in legitimizing reform ideology.[35] In *Photographer's Window,* however, Shahn went one step farther by using his RA/FSA photographs to make his painting even more provocative in its social commentary than its photographic sources.

The painting asks us to consider the effectiveness of documentary images and their power to produce social change. Shahn subjected both his RA/FSA photographs and the more innocuous studio photographs to the same conventions of presentation. The child

of a rehabilitation client appears within the same dramatic shadow as a married pair in the top row; the miners stand on a platform reminiscent of the stage settings of the nearby children. Their worried expressions are visual tropes for reflection and suffering. By displaying them in a window intended to attract business, was Shahn underscoring a commercial aspect of the RA/FSA enterprise? Just as the portraits of smiling couples were intended to sell a particular image, so too were the RA/FSA photographs, according to some historians, intended to sell a certain sanitized notion of poverty. In its contrivance, then, *Photographer's Window* acknowledges the problems encountered in attempting to represent marginalized peoples for purposes of social reform.[36]

The tension between promoting and questioning the documentary mode is also revealed in Shahn's Leica self-portrait (frontispiece). Shahn dedicated the drawing to Stryker: "To Roy who made it possible for us to work uninterruptedly for 5 years—a full lifetime." This gesture suggests the nature of Shahn's working relationship with Stryker and, on a larger level, the artist's ambivalent and complex feelings about government work. Shahn shared Stryker's belief in photography as a tool for dramatic communication and effective propaganda, and he had been valuable to his employer in helping him clarify the RA/FSA's goals. Shahn was grateful for Stryker's efforts to protect the photographers' jobs from government cutbacks and right-wing charges of boondoggling. At the same time, the artist disliked Stryker's ignorance about art, as well as the bureaucratic authority he represented.[37]

In his drawing, Shahn's mixed feelings come through in the clever commentary he inscribed on the lens of the camera: "misery, desolation, erosion, cropping, and oh god!" These were the subjects RA/FSA photographers were supposed to look for. To prepare for their travels, the photographers received reference books, articles, and regional reports from Stryker, as well as outlines (shooting scripts) written by him and others. Once in the field, photographers were required to send all their negatives back to Washington. Even though several developed their own film, and most routinely received photographs and contact prints to identify and caption on-site, they still relinquished much control over their pictures to the printers, writers, editors, and layout staff who processed, cropped, filed, and distributed their work to newspapers, magazines, and exhibitions.

The inscribed lens reflects Stryker's general desire to make his photographers into sociologists with cameras and alludes to a running joke concerning Shahn's request for "super-psychic film" and a "philosophical lens" to obtain certain desired pictures. The word "cropping" refers to both sharecropping and the cropping of photographs. The lens thus suggests what Stange has termed the "management of vision" (in characterizing Stryker's earlier projects) and to the fact that RA/FSA photographers were not the sole authors of their pictures.[38]

Alternatively, the lens could be read as an acknowledgment of the teamwork, unity, and shared vision that Shahn and fellow photographers felt on the RA/FSA project. Stryker

encouraged collaborative effort and promoted an exchange of ideas among his staff. But in this drawing Shahn ultimately asserted his own authorship by rendering the Leica an extension of his eye and linking his hand so closely to the camera that the lines of his hand actually merge with those of the lens. The artist—rather than the camera and the words of sociologists or Stryker—is clearly presented as being responsible for the camera's picture.[39]

Shahn explored the issue of artistic control further in his painting *Myself Among the Churchgoers* (1939) (Introduction, cat. 2) which features a variant of his self-portrait with Leica. This image, constructed from a group of Shahn's RA/FSA photographs of a church in Kentucky, two elderly women in Natchez, Mississippi, and an unidentified street scene, was the artist's response to an instance of public censure. The Reverend Ignatius Cox had attacked Shahn's sketch for his Bronx General Post Office mural (1938–39), which incorporated a quote from Walt Whitman that Roman Catholics found offensive. In retaliation, the artist caricatured the churchgoers, using one photograph to suggest their rigid, crotchety nature and another their provincial setting. He further emphasized their dourness, contrasting their drab black garb with his own brighter, more stylish urban attire. His ultimate revenge, however, was in "shooting" them without their knowledge, denying them the chance to present themselves as they would presumably wish to be seen. Here Shahn used his Leica and angle viewfinder to separate the photographer, who holds the power of the gaze, from the objects of that gaze, thereby demonstrating both the photographer's ability to function as acerbic social critic and the camera's ability to construct social difference. For Shahn, then, photography did not just provide subjects for his paintings, it also served as a vehicle to defend his painting against conservative forces.

Similarly self-reflective, *Photographer's Window* shows more directly how photography assisted Shahn's art and how he generalized and exaggerated aspects of his photographs when transferring them onto canvas. Shahn also added elements that were more traditionally associated with painting, such as texture and color. By juxtaposing color and black-and-white photographs in *Photographer's Window,* Shahn called attention to the phenomenon of color photography, a hotly debated subject in his day. The desire for color in photographs was as old as photography itself and represented a general desire for added realism and fidelity. With the advent of color film in the 1930s, the period between the wars was hailed as the era of color. However, color film did not immediately replace black-and-white film because of the expense and labor-intensive processing. (The color of 1930s photographs often appears highly saturated to late-twentieth-century eyes.) In fact, because the big picture magazines were among the few that could afford the process, color became associated with commercial values, visual deception, image promotion, and profit making. These are among the reasons why the use of color was so limited on the RA/FSA project and why, in part, black-and-white photography maintained its special association with truth and realism.[40]

It is thus significant that Shahn did not render his own RA/FSA images in the some-

what artificial color that embellishes the studio portraits. Equally noteworthy is his use of studio lights—ordinarily intended to illuminate—to block and thus distort the color images. Shahn inverted the popular hierarchy that elevated polychrome over monochrome, especially in cinema. He reinforced traditional "high" art values that viewed black and white (and the basic foundation arts—drawing and design) as higher and more essential than color, which according to photo-historian Sally Stein was seen as an "extra" aesthetic element with "decorative appeal."[41]

Photographer's Window also calls to mind another color process commonly used in photography studios that existed alongside color-print photography at the time: hand coloring. Although hand coloring was a deluxe option, advertisements in *Commercial Photographer* reveal that it was a lowbrow art—quick, simple, and inexpensive. Hand coloring would have appealed to Shahn because it could be self-taught and lacked the pretensions of "high" art. Shahn followed some of the rules of the trade, as seen in contemporary manuals, such as laying down the flesh tone first, then the cheek color. But ultimately his expressive surface violated the standards of good photo-coloring, which used transparent paints so as not to mask the photograph beneath. Shahn's hand coloring is more chalky, textural, and modulated, implying that his image is not a photograph but a painting (or rather, that his image is at once a display of handpainted photographs and a painting of handpainted photographs). Photo-coloring must also have appealed to Shahn because, like painting, it involved handwork and allowed him to put the time and labor back into an image caught quickly and effortlessly by the camera.[42]

In *Photographer's Window,* Shahn favored painting over photography for its ability to show color more effectively than photographs could, given the infant state of color photography. As a sophisticated metacommentary, the painting also allowed Shahn to demonstrate his many talents as photographer, photo-colorist, and painter. The assertion of painting's representational powers as superior to those of photography asks us to consider the relationship between painters and photographers in Shahn's day. Critic Elizabeth McCausland noted that there were painters who feared the new technology would lead to unemployment and thus resisted photography. Conflict came mostly from painters and printmakers who saw their pictures displaced by photographs on the market and in the big picture magazines, because photography served advertising and commercial uses as sufficiently as "the hand methods of the old style commercial artist."[43] Shahn was undoubtedly sensitive to the threat photography posed.

After 1940 Shahn rarely reflected with such seriousness upon the nature of photography in his painting. Occasionally he commented on the current state of photography or expressed nostalgia for an older form of photography, as in *My Friend, the Photographer* (1945), which depicts an itinerant photographer with what appears to be an old-fashioned view camera. The painting was inspired by Shahn's 1938 RA/FSA photograph of a street photographer from Columbus, Ohio. Shahn underscored the honesty and diligence of the

photographer by enlarging his eyes, emphasizing his sincere expression, inflating his hand, and relocating him from the commercialism of a town environment (as in the source photograph) to a simpler, less congested rural setting. He then reinforced his perception of the man's piety by cleaning up his white smock (which is soiled in the photograph) and setting him against an Apostolic Gospel church derived from yet another of his RA/FSA Ohio photographs.

The last significant image in which Shahn addressed photography is *Candid Photographer* (c. 1954–55), a humorous line drawing of a press photographer poised for action with an imposing speed-graphic camera. The drawing was a comment on the state of photojournalism, which by the 1950s dominated the photography world and mass-circulation picture magazines like *Life* and *Look*. The photojournalist with his archetypal speed-graphic camera had been a ubiquitous presence in the public eye since the 1930s and was commonly regarded as an intrusive, crude, rough, and rowdy comic figure, exemplified by the New York photographer Weegee. Shahn's caricature affirms this stereotype, portraying the photographer's aggressive intensity with a tautly pulled barbed-wire line. Such images could still be found in popular photo journals. But because the drawing was executed at a time when photojournalists were adopting smaller-format cameras, it is unclear whether Shahn's rendering marks the apex of the older speed-graphic or the end of its day.

As a documentary photographer Shahn was certainly aware of the emergence of commercial photojournalism and its concurrent development with the RA/FSA project. Stryker stayed abreast of the picture press and its activities, but he made distinctions between what he considered "hurried and superficial" photojournalism, with its uninformed, manipulative approach, and the RA/FSA's more profound sociological investigation. Stryker and his photographers, while enthusiastic about mass media's use of RA/FSA images, were also critical of "the growing use of photography as a form of sensationalist entertainment." Shahn himself criticized certain forms of journalistic photography, such as Margaret Bourke-White and Erskine Caldwell's *You Have Seen Their Faces* (1937), which he called a "commercial job," derivative and lacking the dedication of RA/FSA work. Government photographers, however, did learn from photojournalists, especially in their adoption of shooting scripts and picture stories, and Stange has even argued that Stryker was actually promoting a kind of professional photojournalism, likening his work to corporate public relations.[44] This view, along with Shahn's extensive involvement in commercial art, precludes any simple interpretation of his photojournalist drawing.

Candid Photographer may also be a response to the most significant public celebration of humanistic photojournalism in 1955—Edward Steichen's *The Family of Man* exhibition at MoMA, in which Shahn's work was prominently featured. The exhibition displayed photographs from all over the world under the populist rubric of "family," which downplayed the differences between cultures represented in the show. Shahn respected Steichen and supported the event. He even wrote a letter to the *New York Times* in which he took ex-

ception to a review of the exhibition by Aline B. Saarinen, who referred to photography as a folk art, more obligated than painting to depict the external world. Yet after defending photography as "a highly developed art and keenly sophisticated," Shahn affirmed painting's higher status. Given his rejection by that time of the introspective tendencies of contemporary painting, exemplified by Abstract Expressionism, Shahn was probably referring to the kind of painting that contained both recognizable content and the social responsibility Saarinen ascribed to photography.[45]

Shahn embraced that social responsibility in *Candid Photographer*. The drawing pokes fun at both photojournalism and the press camera as an invasive piece of technology that was worlds apart from his unobtrusive Leica. Contemporaneous images he made of scientists overwhelmed by their atomic theories offer similar commentary. Considered in this context, Shahn's photojournalist resembles a robotic mad scientist. The picture also hints at the oppressive climate of the McCarthy years and the FBI's interrogation and surveillance of liberals, to which Shahn was frequently subjected.

The changed political atmosphere of the 1950s necessarily affected Shahn's use of photography. *Man Picking Wheat* (1950), for example, disguises its RA/FSA source (Dorothea Lange's *Member of the Farming Group at the Jersey Homesteads,* c. 1936) beneath a minimal, lyrical drawing style. Such veiled usage of 1930s photographs provided a way for Shahn and other leftist artists to maintain their connection to New Deal ideology while avoiding possible Cold War censorship and red-baiting. In fact, during this period Shahn promoted an image of himself that eschewed potentially dangerous aesthetic and political categories and contrasted sharply with his 1939 self-portrait as an active, socially engaged photographer. This new image is represented in his self-portrait of 1955, used as the poster motif for his Fogg Art Museum exhibition during his Charles Eliot Norton lectureship at Harvard University (1956–57). Shahn depicted himself as an aging, scholarly artist in a formal painter's smock, with spectacles and furrowed brow. This depiction helped to establish him as a man of letters, and it stands as the visual counterpart to the book that grew out of his Norton lectures, *The Shape of Content* (1957), his philosophical treatise on art. Together, the text and portrait present Shahn as a humanist—a safe reputation that brought him popular appeal, for it conveyed the social concern of his New Deal days without the critical edge of his New Deal photography.

Notes

Introduction

1. Ben Shahn, quoted in "Photos for Art," *U.S. Camera* 9 (May 1946): 57.

2. Studies from the 1990s by Susan H. Edwards and Laura Katzman constitute the first in-depth treatments of Shahn's photographs (see Selected Bibliography).

3. Morris Dorsky, interview with Walker Evans, 18 July 1951, Taller Archive; Walker Evans, slide lecture at the Fogg Art Museum, in conjunction with the exhibition *Ben Shahn As Photographer,* Cambridge, Mass., 13 November 1969; Bernarda Bryson Shahn, "Ben Shahn, Photographer," in *Ben Shahn: The Thirties,* exh. cat. (Williams College Museum of Art, Williamstown, Mass., 1977), n.p.

4. Bryson Shahn remembers watching Shahn dodge his photographs in the darkroom; she also recollects counting the number of seconds for the amount of time he exposed the photographic paper to light. See Deborah Martin Kao and Jenna Webster, interview with Bernarda Bryson Shahn, Roosevelt, N.J., 20 January 1997.

5. Shahn, quoted in Richard Doud, interview with Ben Shahn, Roosevelt, N.J., 14 April 1964, Archives of American Art, Smithsonian Institution; see *U.S. Camera Annual,* 1935 (fig. 95) and *U.S. Camera Annual,* 1936 (fig. 108) and Shahn's statements in John D. Morse, "Henri Cartier-Bresson," *Magazine of Art* 40 (May 1947): 189. Throughout this catalogue the Artists' Union and the Artists' Committee of Action are spelled with an apostrophe, though the organizations sometimes did not do so. Except in quotations and reprinted material, the Rikers Island Penitentiary does not have an apostrophe, the spelling preferred by the New York City Department of Correction.

6. Archibald MacLeish, "Foreword," in *The Photographic Eye of Ben Shahn,* ed. Davis Pratt (Cambridge, Mass., 1975), v–vi.

7. Lincoln Kirstein, "Photography in the United States," in *Art in American in Modern Times,* ed. Holger Cahill and Alfred H. Barr, Jr. (New York, 1934), 87.

Chapter 1: Ben Shahn's New York

This essay expands on material from my Ph.D. dissertation, "The Politics of Media: Ben Shahn and Photography," completed for Yale University in 1997. My greatest intellectual debt is to Deborah Martin Kao and Jenna Webster for their invaluable insights and exhaustive research during the course of our collaboration. I am also grateful to Susan H. Edwards, Diana L. Linden, and Frances K. Pohl for the contributions their scholarship has made. Bernarda Bryson Shahn and the late Stephen Lee Taller deserve special thanks; their dedication to Shahn's art and support of this project have been continual sources of inspiration.

1. "Scenes from the Living Theatre" was an occasional special feature in *New Theatre.* Shahn's RA/FSA photographs appeared in this section under the title "The Living Theatre" in April 1937, when the magazine had changed its name to *New Theatre and Film.* Jenna Webster provided information about "The Living Theatre" and the term "the sidewalks of New York."

2. "The Sidewalks of New York" was a famous song from the 1890s about Irish immigrant life in the Lower East Side's Paradise Alley district. It was also the title of a 1930s stage ballet performed at the Roxy Theatre against the backdrop of Robert Flaherty's 1926 film about New York City, *Twenty-Four Dollar Island.* In July 1935 *Art Front* used the phrase as the title of a column describing the "pathetic" situation of artists trying to sell their work on the sidewalks. For Shahn's interest in cinema see chapter 3, Jenna Webster, "Ben Shahn and the Master Medium."

3. *New Theatre,* which Shahn used as a model for revamping *Art Front,* was the organ of the league until January 1935. See *Filmfront* 1 (15 March 1935): editor's foreword, and *Filmfront* 1 (15 February 1935): 20. Anthony Slide edited a reprint edition of *Filmfront* (Metuchen, N.J., 1986). See also James E. Murphy, *The Proletarian Moment: The Controversy over Leftism in Literature* (Urbana, Ill., 1991), 115–19. Further information is from my telephone interview with Herbert Kline (editor of *New Theatre* from April 1934 through 1936) of 3 April 1991.

Bernarda Bryson Shahn has consistently claimed that Shahn was not a Communist Party member, as she was, but new evidence uncovered by Deborah Martin Kao indicates otherwise; see chapter 2: "Ben Shahn and the Public Use of Art." In the early to mid-1930s Shahn was affiliated with many Communist-linked organizations, including *New Theatre*. He was an editor of *Art Front,* a member of the Artists' Union, marched in May Day parades, taught at the John Reed Club School, and assisted Diego Rivera on the ill-fated Rockefeller Center mural (which was destroyed because of its leftist content) and on a related project at the New Workers' School. At age sixteen Shahn belonged to the Young People's Socialist League; as late as 1949, his drawings appeared in *Masses and Mainstream,* an organ of the Communist Party.

4. There are approximately six hundred known New York photographs (including prints, negatives, and contacts) by Shahn in the collection of the Fogg Art Museum, Harvard University Art Museums. Smaller holdings of New York images are at the University of Louisville, the Shahn Papers, and in private collections, including the Estate of Ben Shahn.

5. Edith Halpert's Downtown Gallery exhibited Shahn's *New Theatre* spread in *Practical Manifestations in American Art* (13–31 December 1934). His New York photographs were also exhibited at *U.S. Camera* Salons at Rockefeller Center (c. 1935–36). They were alluded to in *New Masses* (18 September 1934) and reproduced in *Art Front* (January and June 1935), *U.S. Camera Annual* (1935, 1936), *U.S. Camera* (May 1946), and *Cecil Beaton's New York* (1938; reprinted 1948). In 1940 the newspaper *PM* wanted to include Shahn's work in a feature on painters who use photographs. Shahn sent the magazine a group of his New York photographs, in addition to his RA/FSA work. Shahn to Ann Henry, 17 June 1940, Shahn Papers, 5007F236. Deborah Martin Kao and Jenna Webster searched for this feature to no avail.

6. Shahn's archive at the Fogg includes his New York, RA/FSA, and later photographs. Cataloging and conservation efforts begun in 1994 by Deborah Martin Kao and departmental assistants now enable complete public access to the museum's collection of Shahn photographs. In 1969 Davis Pratt organized the exhibition *Ben Shahn as Photographer* at the Fogg Art Museum. Also see Pratt, ed., *The Photographic Eye of Ben Shahn* (Cambridge, Mass., 1975).

7. Walker Evans, slide lecture at the Fogg Art Museum in conjunction with the exhibition *Ben Shahn as Photographer,* Cambridge, Mass., 13 November 1969.

8. Jane Livingston overlooked Shahn in her study of New York photographers who created unromantic images of the city in a "tough-minded" and "consciously unartistic modality" (Jane Livingston, *The New York School Photographs, 1936–1963* [New York, 1992], 259).

9. Documentary photographs are "highly mediated" and "densely coded" representations whose meanings are informed by the point of view of their maker, the agendas of those who commission or use them, and the contexts in which they are viewed. See Abigail Solomon-Godeau, *Photography at the Dock: Essays on Photographic History, Institutions, and Practices* (Minneapolis, 1991), xxviii.

10. Richard Doud, interview with Ben Shahn, Roosevelt, N.J., 14 April 1964, Archives of American Art, Smithsonian Institution. For recollections of Evans's and Shahn's photographic activity and their makeshift bathroom darkroom, see author's interview with Judith Shahn, Truro, Mass., 1 January 1992, and author's and Deborah Martin Kao's interview with Judith Shahn, Truro, Mass., 24 November 1996.

11. For more on the sparring and mutually beneficial relationship between Evans and Shahn, see Belinda Rathbone, *Walker Evans: A Biography* (Boston, 1995), James R. Mellow, *Walker Evans* (New York, 1999), and author's interview with Isabelle [Evans] Storey, Boston, Mass., 9 December 1991. I am grateful to Jeff L. Rosenheim and Doug Eklund for sharing information from the Walker Evans Archive at the Metropolitan Museum of Art. See Maria Morris Hambourg, Jeff L. Rosenheim, et al., *Walker Evans,* exh. cat. (Metropolitan Museum of Art, New York, 2000).

12. Evans's photographs and negatives from the 1930s appear in Shahn's archive and vice-versa (a mounted variant of Evans's *Girl in Fulton Street, New York* is in the Shahn Papers). The work of each has even been mistaken for that of the other. For instance, photographs by Shahn are misattributed to Evans in Jerry L. Thompson, *Walker Evans at Work* (New York, 1982), 96; also see 148–49.

13. Alan Trachtenberg, *Reading American Photographs: Images as History, Mathew Brady to Walker Evans* (New York, 1989), 246.

14. On the miniature-camera craze of the 1930s, see chapter 4, Laura Katzman, "The Politics of Media: Painting and Photography in the Art of Ben Shahn." For Strand, see

Doud, interview with Shahn; Judith Mara Gutman, *Lewis Hine and the American Conscience* (New York, 1967), has an epigraph by Shahn. Dale Kaplan and Bonnie Yochelson gave me information on Hine. As early as 1936 Shahn used Hine's photographs as sources for his RA/FSA posters and murals.

15. On Atget, see Selden Rodman, *Portrait of the Artist as an American: Ben Shahn, a Biography with Pictures* (New York, 1951), 92, and Ingrid Schaffner and Lisa Jacobs, eds., *Julien Levy: Portrait of an Art Gallery* (Cambridge, Mass., 1998), 173. The review is Walker Evans, "The Reappearance of Photography," *Hound and Horn* 5 (October–December 1931): 125–28. *Hound and Horn* was founded by the influential writer and patron of the arts Lincoln Kirstein, a friend of both Evans and Shahn, who loaned them money and was instrumental in having Shahn's Sacco and Vanzetti work exhibited at the Museum of Modern Art in New York (a related panel) and at Harvard's Society for Contemporary Art in 1932 (the whole series).

In his book review Evans dismissed the pretensions of nineteenth-century art photography and the superficiality of fashion and commercial photography represented by Edward Steichen. Elsewhere Evans expressed disdain for the high-art aesthetic of Alfred Stieglitz, about whom Shahn also had strong opinions: Judith Mara Gutman to Shahn, 5 October 1966, Shahn Papers, 5013F1339.

16. Shahn, quoted in John D. Morse, "Henri Cartier-Bresson," *Magazine of Art* 40 (May 1947): 189. According to Evans, many Greenwich Village artists were acquainted with Cartier-Bresson: Evans, slide lecture, Fogg. Julien Levy, *Memoir of an Art Gallery* (New York, 1977), 49. The adjectives quoted are Levy's. Also see Schaffner and Jacobs, *Julien Levy,* 175, 177. Shahn owned a typescript of a review by Parker Tyler of an April 1935 exhibition of photographs by Cartier-Bresson, Evans, and Manuel Alvarez Bravo at Levy's gallery: Shahn Papers, 5021F582–5021F585. In May 1932 Levy hosted *Photographs of New York by New York Photographers,* an exhibition that included photographs by Berenice Abbott, Margaret Bourke-White, Evans, and Ralph Steiner, among others.

17. John Boling, "The Face of a City," *New Masses* 12 (18 September 1934): 26, 27. Deborah Martin Kao and Jenna Webster called my attention to this remarkable review. Evans, slide lecture, Fogg.

18. Shahn to Ann Henry, 17 June 1940, Shahn Papers, 5007F236; Doud, interview with Shahn. In the résumé for his job as a graphic artist with the RA's Special Skills Division, Shahn did not mention his New York photography: Shahn to Fred Parker, 6 September 1935, Shahn Papers, D147F492–D147F493. Yet Shahn later said that he was "so interested in photography" when he began working for the RA/FSA (Doud, interview with Shahn).

19. Shahn believed in the documentary value of photographs and that certain images were complete in themselves and should not be employed for making paintings: Shahn, "Photos for Art," *U.S. Camera* 9 (May 1946): 30. My understanding of Shahn's treatment of his photographs results from collaborative research with Deborah Martin Kao and Jenna Webster.

20. Shahn to Edith Halpert, 5 November 1932, Downtown Gallery Papers, Archives of American Art, unmicrofilmed. For Shahn's Paris remarks, see Shahn to Philip Van Doren Stern, 1929, collection of Jonathan Shahn, Roosevelt, N.J. On Shahn's childhood, see Saul Benison and Sandra Otter, interview with Shahn, Oral History Research Office, Columbia University, 29 October 1956 and 5 January 1957, and William Snow, "Ben Shahn: His Background," unpublished manuscript (July 1969), Stephen Lee Taller Ben Shahn Archive, the Fine Arts Library, Harvard College Library. Snow was a close childhood friend of Shahn's.

21. Irving Howe, *A Margin of Hope: An Intellectual Autobiography* (San Diego, 1982), 26.

22. Doud, interview with Shahn; Shahn, quoted in "Art: Angry Eye," *Time,* 13 October 1947, 63.

23. See Frederick Lewis Allen, *Since Yesterday: The Nineteen-Thirties in America, September 3 1929–September 3, 1939* (New York, 1940), 181–82.

24. Shahn's approach was a departure from guidebooks like W. Parker Chase's *New York: The Wonder City* (New York, 1932). Chase's book, which serves as architectural guide, encyclopedia, business directory, and social register, asserted New York's unrivaled supremacy in building, commerce, finance, and industry, thus promoting civic pride at a low point in the Depression.

25. Shahn occasionally cut out newspaper photographs of cityscapes for his clipping files: see "East Side, West Side, as Seen From Aloft," *New York Times Magazine,* 13 December 1936, 14–15, Shahn Papers, 5025F7–5025F8.

26. Gilbert Seldes, ed., *This Is New York: The First Modern Photographic Book of New York* (New York, 1934), iii, 5; Frederick Lewis Allen and Agnes Rogers, *Metropolis: An American City in Photographs* (New York, 1934), preface.

27. See Michael Sundell, "Berenice Abbott's Work in the 1930s," *Prospects* 5 (1980): 289. Also see Bonnie Yochelson, *Berenice Abbott: Changing New York* (New York, 1997).

28. Anne Tucker notes Shahn's Photo League membership in "Photographic Crossroads: The Photo League," *A Special Supplement to Afterimage* (6 April 1978): p. 5, n. 14. Shahn left New York for Washington, D.C., before the Photo League evolved out of divisions within the Film and Photo League in 1936. Although the league requested permission to exhibit Shahn's RA/FSA work in 1940, and Shahn defended the league against its Cold War blacklisting in 1947, the artist sometimes joked about what he saw as the predictable nature of the league's documentary work (author's interviews with Sol Libsohn, Roosevelt, N.J., 25 May 1990, 8 January 1991, and 1995). Also see Shahn to Roy Stryker, 20 September 1940, Shahn Papers, unmicrofilmed and "From Ben Shahn, FSA Photographer," *Photo Notes* (June–July 1940): 2.

29. The Photo League sponsored collaborative projects that documented Chelsea, Harlem, the Bowery, Pitt Street, and Park Avenue, among other neighborhoods.

30. "A Note About the Author," in Ilya Ehrenburg, *Chekhov, Stendhal, and Other Essays* (New York, 1963), n.p. Evans learned of the book from Jay Leyda, who had obtained it while studying film in Moscow (Walker Evans to Jay Leyda, 21 February 1934, Leyda Papers). Jenna Webster discovered this source. For the influence of *My Paris* on Shahn, see Bernarda Bryson Shahn, "Ben Shahn: Fotografías y pinturas," in *Ben Shahn: Dibujos y fotografías de los años treinta y cuarenta,* intro. Manuel Fernandez Miranda, exh. cat. (Salas Pablo Ruiz Picasso Museum, Madrid, 1984), 10. I am grateful to Timothy C. Harte for his meticulous translation of *My Paris.*

31. Boling, "Face of a City," 26.

32. Controversial even in his day, Ehrenburg has since been written off by many for participating in Soviet propaganda, accepting official privileges, and keeping silent about Stalin's crimes. A new biography restores Ehrenburg's reputation, revealing his courageous acts of resistance against anti-Semitism and state repression of creative freedom. See Joshua Rubenstein, *Tangled Loyalties: The Life and Times of Ilya Ehrenburg* (New York, 1996). Rubenstein reads *My Paris* as a book that "brought a vivid, loving portrait of Paris to Moscow just as the Soviet Union was becoming more isolated" (104). Shahn apparently followed Ehrenburg's career; he owned at least one installment of Ehrenburg's memoirs, and his 1957 Harvard lecture, "On Non-Conformity," may have been inspired by Ehrenburg's attacks on Cold War American culture and Nikita Khrushchev's restrictions of art in the Soviet Union.

33. What Shahn knew during the 1930s about Stalinist Russia is unclear, but the disillusionment of the American intellectual left began in the 1930s with such events as the Moscow show trials (1936–38), the Nazi-Soviet Pact (1939), the partition of Poland, and the Soviet invasion of Finland (1939). See Andrew Hemingway, "Meyer Schapiro and Marxism in the 1930s," *Oxford Art Journal* 17 (1994): 13. Leftists could have learned about Stalin's atrocities from Trotskyists even earlier.

34. Boling, "Face of a City," 26–27.

35. See Susan H. Edwards, "Ben Shahn: The Road South," *History of Photography* 19 (Spring 1995): 16. Edwards notes that Shahn studied the work of Saint-Simon and Karl Marx. Many American radicals were also studying Marx's *Das Kapital, The Communist Manifesto,* and his historical pamphlets on working-class revolutions in nineteenth-century France. On Shahn's politics, see Frances K. Pohl, *Ben Shahn: New Deal Artist in a Cold War Climate, 1947–1954* (Austin, 1989), 56. Although Shahn had distanced himself from *Art Front* by late 1935, he continued to be politically active and in 1935 participated in the call for the 1936 American Artists' Congress.

36. Shahn, "The Biography of a Painting," in Shahn, *The Shape of Content* (Cambridge, Mass., 1957), 40–41; John D. Morse, "Ben Shahn: An Interview," *Magazine of Art* 37 (April 1944): 138.

37. Alfred Kazin, *A Walker in the City* (1946; New York, 1951), 31.

38. For unemployment statistics, see Allen and Rogers, *Metropolis,* plate 149. Shahn spoke of the "terrible winter of '32–'33," when he and Evans "went all over the city" to collect money to pay their overdue gas bills. See Harlan Phillips, interview with Ben Shahn, Roosevelt, N.J., 3 October 1965, Archives of American Art.

39. Richard Saul Wurman, *New York City Access* (New York, 1994), 42; Ethan Carr, *Three Hundred Years of Parks: A Timeline of New York City Park History* (New York, 1988), 26–28. Charles B. Stover, cofounder of the Outdoor Recreation League, was known as the Father of Seward Park. The park was named after the New York governor William Henry Seward (1801–72). According to historian Robert Snyder, Seward Park symbolized a mixture of Progressivist

uplift, paternalism, social control, and beneficence. Author's correspondence with Snyder, April 1999.

40. Federal Writers' Project, *New York City Guide* (1939; reprinted with an introduction by William H. Whyte, New York, 1992), 120. Also see Allen, *Since Yesterday,* 46–47.

41. Jacob Deschin, "The Candid Picture," *New York Times,* 25 June 1950, sec. 2, p. 11; Deschin, *New Ways in Photography: Ideas for the Amateur* (New York, 1936), 22; Ehrenburg, *My Paris,* 8. For Evans, see Sarah Greenough, *Walker Evans: Subways and Streets,* exh. cat. (National Gallery of Art, Washington, D.C., 1991), 25, 45. Evans, who used a thirty-five millimeter Contax, later claimed that he withheld publishing the subway photographs (1938–41) because they invaded people's privacy. There is speculation that Evans had trouble finding a publisher until the 1950s. Mia Fineman provided information on this subject.

42. Colin L. Westerbeck, Jr., and Joel Meyerowitz, *Bystander: A History of Street Photography* (Boston, 1994), 259–60; Doud, interview with Shahn.

43. On how Shahn sought "candor, not anonymity," see Edwards, "Ben Shahn: The Road South," 15; Evans, slide lecture, Fogg; Deschin, *New Ways in Photography,* 22; Shahn, "In the Mail: Art vs. Camera," *New York Times,* 13 February 1955, sec. 2, p. 15. In his paintings about photography Shahn appears to have been more critical of the documentary mode. See my reading of *Photographer's Window* (1939–40) in chapter 4, "Politics of Media."

44. See Solomon-Godeau, *Photography at the Dock,* 176, xxix–xxx; and the writings of Maurice Berger, James Curtis, Martha Rosler, Allan Sekula, Terence Smith, Solomon-Godeau, Maren Stange, Sally Stein, and John Tagg. Curtis and Stein are more open to traditional humanist readings than the others listed here.

45. See Susan H. Edwards, "Ben Shahn: A New Deal Photographer in the Old South" (Ph.D. diss., City University of New York, 1996), 63. See also Maurice Berger, *FSA: The Illiterate Eye: Photographs from the Farm Security Administration,* exh. cat. (Hunter College Art Gallery, New York, 1985).

46. Federal Writers' Project, *New York City Guide,* 120. On the Bible Society see Janice E. Pearson, "Bible Houses and Depositories, 1852–1966," ABS History Essay no. 21, part IV (Summer 1969), provided by Maria Deptula, Assistant Archivist/Historical Researcher, American Bible Society, New York City.

47. For black stereotypes in the 1920s and 1930s see

Bruce Robertson, *Representing America: The Ken Trevey Collection of American Realist Prints,* exh. cat. (University Art Museum, University of California, Santa Barbara, 1995), 51–52, and Robert S. McElvaine, *The Great Depression: America, 1929–1941* (New York, 1984), 190. On photographs of blacks as an underclass see Paul A. Rogers, "Hard-Core Poverty," in *Picturing Us, African-American Identity in Photography,* ed. Deborah Willis (New York, 1994), 159–68. I have borrowed the phrase "the Negro Question" from James S. Allen, *The Negro Question in the United States* (New York, 1936).

48. Hasia Diner, *In the Almost Promised Land: American Jews and Blacks, 1915–1935* (Westport, Conn., 1977), xiii. Also see Seth Forman, "The Unbearable Whiteness of Being Jewish: Desegregation in the South and the Crisis of Jewish Liberalism," *American Jewish History* 85 (June 1997): 122–28.

49. Federal Writers' Project, *New York City Guide,* 257.

50. On Harlem, see Federal Writers' Project, *New York Panorama* (1938; reprinted with a new introduction by Alfred Kazin, New York, 1984), 141–42. Although Siskind's "Harlem Document" project was not completed until 1940, he began photographing the community as early as 1932. His work was probably accessible to Shahn through the Film and Photo League, in which Siskind was active from 1932 to 1935. See Deborah Martin Kao and Charles Meyer, eds., *Aaron Siskind: Toward a Personal Vision, 1935–1955,* exh. cat. (Boston College Museum of Art, 1994). On black demographics in New York, see Federal Writers' Project, *New York City Guide,* 60, 126, 128, 257–65; Federal Writers' Project, *New York Panorama,* 132, 138–40.

51. Nicholas Natanson, *The Black Image in the New Deal: The Politics of FSA Photography* (Knoxville, Tenn., 1992), 92, 94, 93–94, 100.

52. McElvaine, *Great Depression,* 187–95 (quote on 187); unemployment figures in Kenneth T. Jackson, *The Encyclopedia of New York City* (New Haven, 1995), 114; protests discussed in Federal Writers' Project, *New York Panorama,* 139–42, 147–48.

53. Natanson, *Black Image in the New Deal,* 112.

54. Shahn to Julien Levy, c. 1940, Shahn Papers, D145F1619–D145F1620. Shahn was describing the painting *Three Men* (1939) based on the photographs, which the Julien Levy Gallery included in Shahn's solo exhibition of May 1940.

55. See George Kourvetaris, *Studies on Greek Americans* (New York, 1997), 38–39. Kourvetaris, who gathered these

statistics for populations in Chicago, notes: "The first generation resisted acculturation and tended to be more ethnocentric for some time" (42).

56. See "But the Patient Will Die," an editorial on the NRA decision, *New Masses* 15 (11 June 1935), 6–7, and McElvaine, *Great Depression,* 158–62, 189; Roosevelt, quoted in McElvaine, *Great Depression,* 156.

57. Federal Writers' Project, *New York Panorama,* 132, 149. In the mid-1960s Shahn produced prints of, among others, Martin Luther King, Jr., and the three young civil rights workers who were murdered in Mississippi in 1964. See Susan H. Edwards, "Ben Shahn and the American Racial Divide," *Tamarind Papers* 17 (January 1998): 77–85.

58. The Hale manuscript is in the New York Public Library, Manuscript Division, Box 1, 97. Sandra S. Phillips discovered this rich source and determined that much of the Hales' research was gathered in the 1930s: Sandra S. Phillips and Maria Morris Hambourg, *Helen Levitt,* exh. cat. (San Francisco Museum of Modern Art, 1991), 31, 42.

59. On psychological problems, see McElvaine, *Great Depression,* 185. Shahn left his wife Tillie and their children in New York in the mid-1930s to start a family with Bernarda Bryson. Judith and Ezra toured the city with their father before the split and during his somewhat irregular visits afterward. From the late 1930s to mid-1940s they saw him rarely and received only erratic financial support (author's interview with Judith Shahn). Also see correspondence between Shahn, Tillie, Judith, and Ezra Shahn in Shahn Papers, 5006 and 5007, and Howard Greenfeld, *Ben Shahn: An Artist's Life* (New York, 1998), 117–19, 165–67.

60. Kazin, *Walker in the City,* 84.

61. It appears that Shahn mounted but did not title or sign at least one other image in this series.

62. Doud, interview with Shahn; Shahn, quoted in Morse, "Henri Cartier-Bresson," 189. Cartier-Bresson also influenced Helen Levitt, whose street photographs of urban children are remarkably reminiscent of Shahn's. Younger, shyer than Shahn, and according to Sandra S. Phillips more "self-effacing" in her approach, Levitt claimed to have met him only briefly, although she knew of his work, and Evans was a mutual friend. See Phillips and Hambourg, *Helen Levitt,* 35, 39.

63. Hulbert Footner, *New York: City of Cities* (Philadelphia, 1937), 85. Footner wrote that credit for these urban improvement efforts went to either Mayor Fiorello H. La Guardia or Robert Moses. Still, the Federal Writers' Project

noted that while "New York's park area was more than doubled between 1933 and 1938 . . . in congested neighborhoods the parks are usually too far away and the playgrounds are too few" (*New York Panorama,* 462). WCBS-TV, interview with Ben Shahn, 1965 (the quote is from the television interview, not the altered transcription). Shahn noted the speed and violence of the game in the transcribed version of the interview (see Shahn Papers, 5023F1301–5023F1302). Kazin, *Walker in the City,* 109.

64. John Szarkowski, *Looking at Photographs: One Hundred Pictures From the Collection of the Museum of Modern Art* (New York, 1973), 118.

65. Shahn blamed this situation on his strong-willed mother, Gittel, with whom he had a bitter relationship and from whom he was ultimately estranged. See Greenfeld, *Ben Shahn,* 22–23. On the expectation that Jewish children of both sexes contribute to family income, see Beth S. Wenger, *New York Jews and the Great Depression: Uncertain Promise* (New Haven, 1996), 42–44, 59–63.

66. See Caroline Ware, *Greenwich Village, 1920–1930: A Comment on American Civilization in the Post-War Years,* (Boston, 1935; reprinted with a foreword by Deborah Dash Moore, Berkeley, Calif., 1994), 172–77, and 179–202. Ware claimed that the unity of the Italian family was undermined when American individualism and women's involvement outside the home threatened patriarchal authority. Deborah Dash Moore noted, however, that recent historians, in contrast to Ware, "stress the resiliency of Italian women and continuities in family ethnic culture" (xx, xxii). Also see Federal Writers' Project, *The Italians of New York* (New York, 1938).

Shahn knew many Italian immigrants; he later recalled the "lovely" Italian families in the Village who shared homecooked dinners with him and his fellow struggling friends during the early years of the Depression. See Harlan Phillips, interview with Shahn.

67. See Phillips and Hambourg, *Helen Levitt,* 30–31. Phillips cites the work of Bruno Bettelheim, Anna Freud, Karen Horney, Melanie Klein, and Harry Stack Sullivan. The study was published as Nettie Pauline McGill and Ellen Nathalie Matthews, *The Youth of New York City* (New York, 1940). For the comparison of generations, see McElvaine, *Great Depression,* 185. Also see Glen E. Elder, Jr., *Children of the Great Depression* (Chicago, 1974), a sociological study that informed McElvaine's work.

68. Edwards, "Ben Shahn: A New Deal Photographer in

the Old South," 170. Edwards uses these terms to describe 1930s photographs of the South. On photography's "semantic status as fetish objects and as documents," Edwards cites Allan Sekula, "On the Invention of Photographic Meaning," in *Thinking Photography,* ed. Victor Burgin (London, 1982), 94. I have borrowed my subhead from Beth S. Wenger, "Memory as Identity: The Invention of the Lower East Side," *American Jewish History* 85 (1997): 3–27.

69. Shahn, "Autobiography," unpublished (1965), Introduction, 16–18 (quote on 18), Taller Archive. See also Benison and Otter, interview with Shahn; Greenfeld, *Ben Shahn,* 3–18. For more on Shahn's immigrant background, see DeAnna E. Beachley, "Ben Shahn and Art as Weapons for Decency" (Ph.D. diss., Northern Arizona University, 1997), 12–45.

70. As a child, Shahn lived in railroad flats in Brooklyn. He later recalled the first new apartment house his family moved into, on the outskirts of Williamsburg, surrounded by empty lots and near a slum and crowded markets. See Benison and Otter, interview with Shahn.

71. The image of the old man could derive from Shahn's grandfather or his wood-carver father, Hessel, whom he admired for his gentle manner, craftsmanship, and socialist views. Despite Hessel's politics, he was still a devout Jew and thus a representative of Old World culture. For another reading of *New York* see Susan Chevlowe, "A Bull in a China Shop," in Chevlowe et al., *Common Man, Mythic Vision: The Paintings of Ben Shahn,* exh. cat. (The Jewish Museum, New York, 1998), 6–7.

72. I discovered this remarkable roll of film during the course of doctoral research in the private collection of Bernarda Bryson Shahn, who in 1998 donated it to the Fogg Art Museum. Because most of Shahn's New York negatives were cut into individual frames some time after his death, his shooting process has been difficult to assess—hence the importance of this roll.

73. For Berenice Abbott's comparable photographs of New York City storefronts, see John Raeburn, "Cultural Morphology and Cultural History in Berenice Abbott's *Changing New York,*" *Prospects* 9 (1984): 266–67. Even before the Depression, small Jewish businesses were threatened by the invasion of chain stores: see Wenger, *New York Jews and the Great Depression,* 20. On the Lower East Side see Wenger, *New York Jews and the Great Depression,* 81–84 (quote on 84); Wenger, "Memory as Identity," 4, 14–15. Also see Jenna Weissman Joselit, "Telling Tales: Or, How a

Slum Became a Shrine, "*Jewish Social Studies* 2 (Winter 1996): 54–63. Shahn's project thus differs from Michael Gold's book *Jews Without Money* (1930), a scathing Communist diatribe against the appalling conditions of the Lower East Side that Shahn nonetheless used as part of his research for his Jersey Homesteads mural (1936–38). Arnold Eagle and David Robbins's WPA project "One Third of a Nation" (1936–37) exposed the slum conditions of the district.

74. Shahn, "Autobiography," Introduction, 3. For Shahn's attitudes toward Judaism, see Diana L. Linden, "Ben Shahn's New Deal Murals: Jewish Identity in the American Scene," in Chevlowe et al., *Common Man, Mythic Vision,* 37–65, and Ziva Amishai-Maisels, "Ben Shahn and the Problem of Jewish Identity," *Journal of Jewish Art* 12–13 (1986–87): 304–19.

75. Shahn's research involved gathering photographic material from the New York Public Library, newspaper offices, and the Associated Press, and meeting with an editor of the *Jewish Daily Forward.* See Frances K. Pohl, "Constructing History: A Mural by Ben Shahn," *Arts Magazine* 62 (September 1987), 36. An April 1936 issue of the *Jewish Daily Forward* addressing Passover in New York City and Polish pogroms is filed under "Jews" in Shahn's source archive. See Shahn Papers, 5022F571–5022F574.

76. There are scattered examples of Shahn's New York photographs of Brooklyn from 1936 to 1937 in the Fogg Art Museum. There is some evidence that Shahn photographed casual street scenes on the Upper East Side in 1938 when he was living in Yorkville and working on a mural for the Bronx General Post Office with Bernarda Bryson. However, those photographs, a set of which is in the Library of Congress, are more often attributed to Walker Evans. See Thompson, *Walker Evans at Work,* 148–49, and Carl Fleischhauer and Beverly W. Brannan, eds., *Documenting America, 1935–1943* (Berkeley, Calif., 1988), 128–45.

77. Shahn, quoted in Kneeland McNulty, *The Collected Prints of Ben Shahn* (Philadelphia, 1967), 20.

Chapter 2: Shahn and the Public Use of Art

I should like to acknowledge my colleagues Laura Katzman and Jenna Webster for their work and inspiration during the process of preparing this exhibition and publication. I dedicate this essay to Bernarda Bryson Shahn, the late Dr. Stephen Lee Taller, and the late Davis Pratt. Their tireless efforts to preserve Shahn's legacy made my work possible.

1. Ben Shahn, "The Biography of a Painting," *The Shape*

of Content (Cambridge, Mass., 1957), 37; Stuart Davis, "The Artist Today: The Standpoint of the Artists' Union," *American Magazine of Art* 28 (August 1935): 478, 476, 477. For an introduction to this trend in American art, see David Shapiro, ed., *Social Realism: Art as Weapon* (New York, 1973), and Patricia Hills, *Social Concern and Urban Realism: American Painting of the 1930s,* exh. cat. (Boston University Art Gallery, 1983). Hugo Gellert was editor in chief for the first issue of *Art Front;* beginning with the second issue, Stuart Davis took the helm for a year, the time at which Shahn was involved with the magazine.

2. Lincoln Kirstein, diary entry, 8 November 1934, Lincoln Kirstein Papers, Dance Collection, New York Public Library for the Performing Arts (hereafter Kirstein Papers). I am grateful to Nicholas Jenkins and Claudia Roth Pierpont for allowing me to view and cite this material. I also thank Jenna Webster, who on behalf of our collaborative project read Kirstein's fascinating diaries and took copious notes.

Various writers have interpreted the importance of Shahn's involvement with radical political organizations quite differently. At the height of Cold War Red-baiting Selden Rodman asserted that "whether Shahn was or was not a card-carrying Communist for a brief time is beside the point" because the artist had been so enmeshed in Communist-dominated organizations in the early 1930s (Rodman, *Portrait of the Artist as an American: Ben Shahn, A Biography with Pictures* [New York, 1951], 99). For a recent summary of Shahn's leftist activities see DeAnna E. Beachley, "The Artist as Radical, 1933–35," in "Ben Shahn and Art as Weapons for Decency" (Ph.D. diss., Northern Arizona University, 1997), 78–132.

3. Meyer Schapiro, "Public Use of Art," *Art Front* 2 (November 1936): 5; Shahn, "Biography of a Painting," 37 (Shahn was referring specifically to his watercolor series *The Dreyfus Affair* from 1930). Schapiro's article was in part a critique of government-funded art projects. Between 1932 and 1936 Schapiro published a number of important essays in *Art Front, New Masses,* and *Partisan Review* detailing his vision for a public use of socialist-based art and architecture. For a cogent analysis of Schapiro's early Marxist-influenced essays and his "independent" position relative to the American Communist Party (CPUSA), see Andrew Hemingway, "Meyer Schapiro and Marxism in the 1930s," and Patricia Hills, "1936: Meyer Schapiro, *Art Front,* and the Popular Front," *Oxford Art Journal* 17 (Spring 1994): 13–29 and

30–41, respectively. Also see my chapter "Meyer Schapiro and the Social(ist) Bases of Modern Art," in "Radioactive Icons: The Critical Reception and Cultural Meaning of Modern Religious Art in Cold War America" (Ph.D. diss., Boston University, 1999), 127–82.

In 1936 Shahn considered asking Schapiro to act as a consultant for his Jersey Homesteads mural (1936–38); see Diana L. Linden, "The New Deal Murals of Ben Shahn: The Intersection of Jewish Identity, Social Reform, and Government" (Ph.D. diss., City University of New York, 1997), 132–37. In the spring of 1951 Shahn, Schapiro, the painter Robert Motherwell, and the noted historian of American art Oliver W. Larkin helped organize the exhibition *Thirty Contemporary Paintings* at the Fogg Art Museum and gave lectures for a series entitled "Modern Paintings—Open Forum." A manuscript of Shahn's lecture is in the Harvard University Art Museums Archives.

4. Harlan Phillips, interview with Shahn, Roosevelt, N.J., 3 October 1965, Archives of American Art, Smithsonian Institution; Walker Evans, slide lecture at the Fogg Art Museum, in conjunction with the exhibition *Ben Shahn as Photographer,* Cambridge, Mass., 13 November 1969.

5. Phillips, interview with Shahn. Also see Audrey McMahon, "A General View of the WPA Federal Art Project in New York City and State," in Francis V. O'Connor, ed., *The New Deal Art Projects: An Anthology of Memoirs* (Washington, D.C., 1972), 51–52. McMahon wrote that the reluctance to accept state-sponsored relief in the early years of the Depression stemmed in part from the humiliating rules of the "dole," which required poverty oaths and degrading home searches. Shahn described his changed opinion to Richard Doud in an interview, Roosevelt, N.J., 14 April 1964, Archives of American Art, Smithsonian Institution.

6. Although it is impossible to know how many protest photographs Shahn made between 1933 and 1935, more than 150 of his negatives of demonstrations are in the Fogg Art Museum. To my knowledge, fewer than twenty of the artist's gelatin silver prints of these images survive in public and private collections. The paucity of extant prints may in part reflect the time-specific nature of this material. I am indebted to Jenna Webster for her assistance in researching and cataloguing Shahn's protest photographs and to Laura Katzman for introducing me to the reproductions of these images in *Art Front.*

For the efforts by the Artists' Union to achieve membership in labor unions, see Gerald M. Monroe, "The

Artists Union of New York," (Ed.D. diss., New York University, 1971), 187–220, and Monroe, "Artists as Militant Trade Union Workers During the Great Depression," *Archives of American Art Journal* 14 (1974), 7–10. In 1935 the Artists' Union applied for, but did not receive, official recognition from the relatively conservative American Federation of Labor (AFL). In 1938 the more progressive Congress of Industrial Organizations (CIO) granted the Artists' Union membership; it was renamed the United American Artists, Local 60 of United Office and Professional Workers of America.

7. Doud, interview with Shahn; Federal Writers' Project, *New York City Guide* (New York, 1939; reprinted as *The WPA Guide to New York City,* 1992), 198–99. Orrick Johns, a *New Masses* associate editor, commented that "the communist calendar [was] as full of dates as the 'festas' in Italy": quoted in Daniel Aaron, *Writers on the Left: Episodes in American Communism* (1961; New York, 1992), 159.

8. Bertram D. Wolfe, "Portrait of America," in Diego Rivera, *Portrait of America* (New York, 1934), 190. Wolfe directed the New Workers' School in Union Square and later became Rivera's biographer. Here he was explaining Sacco and Vanzetti references in a panel from Rivera's *Portrait of America* mural (1933), painted for the New Workers' School. See also Frances K. Pohl, *Ben Shahn: With Ben Shahn's Writings* (San Francisco, 1993), 11–12.

Shahn used imagery of social protest in work throughout his career. In his mural designs for post offices in St. Louis, Missouri (1939), and Jamaica, Queens, New York (1939–41), he used groups of protesters with clenched fists held aloft to represent the citizen's right to assembly. In the 1940s Shahn continued to use protest imagery in his graphic work for the CIO and the Office of War Information (OWI).

9. Shahn's request for photographs and literature is paraphrased in Gardner Jackson to Shahn, 13 October 1931, Shahn Papers, 5006F718. Shahn spoke about the paintings with John D. Morse in "Ben Shahn: An Interview," *Magazine of Art* 37 (April 1944): 137. Morris Dorsky's "The Formative Years of Ben Shahn: The Origin and Development of His Style," (M.A. thesis, New York University, 1966) is the first substantial study of Shahn's use of news photographs in *The Passion of Sacco-Vanzetti*. For reproductions of a number of these photographs see Martin H. Bush, *Ben Shahn: The Passion of Sacco and Vanzetti* (Syracuse, N.Y., 1968), 11, 14, 18. Laura Katzman will contribute an essay about Shahn's use of news photographs for his Sacco-Vanzetti series to Alejandro Anreus et al., *Ben Shahn: The Passion of Sacco and Vanzetti,* exh. cat., Jersey City Museum, New Jersey, forthcoming.

10. Lincoln Kirstein, "Mural Painting," in *Murals by American Painters and Photographers,* exh. cat. (MoMA, 1932), 10; Hugo Gellert, "We Capture the Walls! The Museum of Modern Art Episode," *New Masses* 7 (June 1932): 29, reprinted with modifications in *Art Front* 1 (November 1934): n.p.; Shahn, quoted in Rodman, *Portrait of the Artist,* 109. The artists were instructed to address the theme of "The Post-War World" in their mural studies: Gellert's panel, *Us Fellas Gotta Stick Together—Al Capone,* associated the actions of the industrialists Henry Ford, Herbert Hoover, J. P. Morgan, and John D. Rockefeller, Sr., with the criminal activities of the famous gangster. Gropper's *The Writing on the Wall* also lampooned capitalism.

Shahn's panel depicted Harvard University president A. Lawrence Lowell, who led the committee that investigated the trial's bias charges, and committee members President Samuel W. Stratton of the Massachusetts Institute of Technology and Governor Alvan T. Fuller. See in addition Rodman, *Portrait of the Artist*, 108–9, in which he states that a "Hang Shahn Committee" was formed after a museum patron attempted to acquire Shahn's panel in order to keep it from being installed. Martin H. Bush contends that Horace Kalen suggested the "Hang Shahn Committee": Bush, *Ben Shahn,* 16–22. Kirstein was distraught by the negative response to his exhibition in the mainstream press, and he wrote an extended explanation for his magazine *Hound and Horn:* Lincoln Kirstein, "Art Chronicle: Contemporary Mural Painting in the United States," *Hound and Horn* 5 (July–September 1932): 656–63. It is not surprising that the various parties involved recollect the details of this episode somewhat differently. For an alternative view to those recorded by Gellert and Kirstein, see Russell Lynes, *Good Old Modern: An Intimate Portrait of the Museum of Modern Art* (New York, 1973), 98–101, and Alice Goldfarb Marquis, *Alfred H. Barr, Jr.: Missionary for the Modern* (Chicago, 1989), 94–95. For a broader understanding of Kirstein's role at MoMA during this period, see Lincoln Kirstein, *Mosaic: Memoirs* (New York, 1994), and Douglas R. Nickel, "*American Photographs* Revisited," *American Art* 6 (Spring 1992): 79–97.

11. For Shahn's practice of clipping protest photographs from newspapers, see Source Files, "May Day," and "Strikes

and Police," Shahn Papers, 5022F707–5022F717 and 5023F414–5023F515, respectively. For protest imagery that appears in other source files and in a number of the artist's general clipping files, see Shahn Papers, 5024. For the Mooney case, see Source File, "Mooney," Shahn Papers, 5022F941–5022F1137. See also *Ben Shahn: The Mooney Case*, exh. cat. (Downtown Gallery, New York, 1933), n.p. This file also contains the August 1931 issue of *Labor Defender*. The *New York Telegram* clipping is in Source File, "May Day," Shahn Papers 5022F708. Shahn later used the same newspaper image of Communist demonstrators as the source for an ink drawing illustrating Gino Bardi's "The Politics of the Workers in Italy," *New Republic* 120 (24 January 1949): 15.

12. Rivera, "Introduction," in *Portrait of America,* 15; Louis Lozowick, "Mooney in Pictures," *New Masses* 8 (August 1933): 31; Diego Rivera, "Foreword," in *Ben Shahn: The Mooney Case,* 1933, brochure to accompany the exhibition of the series at the Downtown Gallery. Lozowick was reviewing Anton Refregier's booklet of drawings based on the Mooney case: *Tom Mooney: A Story in Pictures* (International Labor Defense, 1933). Lozowick first met Shahn in 1925 and for the February 1927 issue of *Menorah Journal* wrote an exhibition review of Shahn's work: Dorsky, "The Formative Years," 8, 113. In 1932 *New Masses* published a May Day greeting from Mooney: "On this day workers in the United States . . . will be pouring out into the streets to demonstrate . . . against unemployment, wage cuts, starvation, and for the defense of their comrades who have fallen in the struggle": "Tom Mooney Greets *New Masses* on May Day," *New Masses* 7 (May 1932), inside front cover. Mooney was pardoned and released in 1939.

13. See "What Was Justice?" *Sunday News,* 29 November 1931, 10. This article can be found in Source File, "Mooney," Shahn Papers, 5022F1106–5022F1107. The case is recounted in James Goodman, *Stories of Scottsboro* (New York, 1994). For an account of CPUSA and the NAACP disagreements over the political meaning of the Scottsboro case, see Robert L. Zangrando, *The NAACP Crusade Against Lynching, 1909–1950* (Philadelphia, 1980), 98–101, and Marlene Park, "Lynching and Antilynching: Art and Politics in the 1930s," *Prospects* 18 (1993): 311–65.

14. See "A Call for a United Anti-Lynch Exhibition," *New Masses* 14 (26 February 1935): 21, and James S. Allen, "New Attack on the Scottsboro Defense," *New Masses* 13 (6 November 1934): 18; "Lest We Forget," *Labor Defender* 9 (August 1933): 1. The politics of this exhibition, which was sponsored by the signing organizations in addition to the League of Struggle for Negro Rights, the International Labor Defense, and Vanguard, are explicated in Marlene Park, "Lynching and Antilynching," 338–47. Park shows how the resulting exhibition, "The Struggle for Negro Rights," held at the American Contemporary Artists (ACA) Gallery, was organized in pointed opposition to a similar show assembled by Walter White for the NAACP. See also Helen Langa, "Two Antilynching Exhibitions: Politicized Viewpoints, Radical Perspectives, Gendered Constraints," *American Art* 13 (Spring 1999): 10–39.

15. For Shahn's Scottsboro material, see Source File, "Scottsboro," Shahn Papers, 5023F102–5023F141. In a 22 October 1951 interview Shahn recounted that he contemplated painting a series on the Scottsboro Boys trial to follow *The Mooney Case:* Morris Dorsky, interview with Shahn, handwritten notes, "Shahn—2nd Interview," Taller Archive, folder 2. I appreciate the work that Jenna Webster did unearthing and cataloguing the Dorsky interviews.

The same issue of *The Nation* that used Taylor's illustration also included the feature story "Sacco-Vanzetti—Six Years After" (200). Taylor collaborated with Langston Hughes on *Scottsboro Limited* (1932). See Bruce Keller, "Working Friendship: A Harlem Renaissance Footnote," in Ingrid Rose and Roderick S. Quiroz, *The Lithographs of Prentiss Taylor: A Catalogue Raisonné* (New York, 1996), 11–18. On Rivera, see Wolfe, "The New Freedom," in *Portrait of America,* 183–91.

16. At the time of the Rockefeller Center commission Rivera was at the height of his success in the United States. He had painted a number of significant murals, including *Allegory of California* for the Pacific Stock Exchange (1930–31), *The Making of a Fresco* for the San Francisco Art Institute (1931), and *Detroit Industry* for the Detroit Institute of Art (1932–33), which he was working on when he invited Shahn to help with the Rockefeller project. In 1931 he had also been honored with one of the first major single-artist exhibitions at MoMA.

17. An excerpt of Evans's letter is published in Jerry L. Thompson, *Walker Evans at Work* (New York, 1982), 95. On Kirstein see Nicholas Jenkins, "The Great Impresario," *New Yorker,* 13 April 1998, 59. I am grateful to Jenna Webster for bringing this article to my attention. Excerpts from Bloch's diary are published in Bloch, "On Location with Diego Rivera," *Art in America* 74 (February 1986): 114–15.

Shahn's comments on Rivera are recorded in his interview with Harlan Phillips, and his reminiscences in an interview with Saul Benison and Sandra Otter, 5 January 1957, Oral History Research Office, Columbia University.

18. Rivera, introduction to *Portrait of America,"* 21–31; Pach, quoted in "1,000 Voice Protest at Ruined Mural," *New York Times,* 19 February 1934: 13. See also Irene Herner de Larrea, *Diego Rivera's Mural at the Rockefeller Center* (Mexico City, 1990), and her "Diego Rivera: Paradise Lost in Rockefeller Center Revisited," in *Diego Rivera: Art and Revolution,* exh. cat. (Cleveland Museum of Art, 1999), 235–59. In his account of the affair, Rivera exulted: "Fortunately, Miss Lucienne Bloch, one of my assistants, was adroit enough to take a series of ten details and one complete view, with a tiny Leica camera under the very noses of the enemy spies, who were so efficient that they failed to notice!" (introduction to *Portrait of America,* 26). Also see Bloch, "On Location with Diego Rivera," 116–18.

Rivera had been expelled from the Communist Party three years earlier because of his opposition to Stalin's "bureaucratic communist party": Diego Rivera, "The Position of the Artist in Russia Today," *Arts Weekly* 1 (11 March 1932): 7. For a critique by the American Communist press of Rivera's politics on the eve of the Rockefeller Center commission, see Robert Evans, "Painting and Politics: The Case of Diego Rivera," *New Masses* 7 (February 1932): 22–24. For an analysis of Rivera's relationship with the Trotskyists, who were also anti-Stalinist, see Alberto Híjar, "Painting After Trotsky," in *Diego Rivera: Art and Revolution,* 261–69.

19. A draft of Rivera's letter written in Shahn's hand is in the Shahn Papers, D147F1468–D147F1479. The quote comes from notes Shahn compiled for a lecture on the Rockefeller mural controversy given at Harvard University on 16 November 1949 (Shahn Papers, 5019F486; also see D144F1609). Bloch's diary quote of 6 May 1933 is excerpted in Bloch, "On Location with Diego Rivera," 116. Shahn also cited this incident in his notes for the 16 November 1949 lecture at Harvard (Shahn Papers, 5019F485). Rodman's description is in *Portrait of the Artist,* 102. Shahn's central role in the event is confirmed in the article "Comrade Rivera Causes Red Row," *New York Times,* 15 May 1933, Art 32. The protest march was reported in "The Art Row Pressed by Rivera Friends," *New York Times,* 18 May 1933, Art 39.

20. Shahn, quoted in Rodman, *Portrait of the Artist,* 100–101 (referring to Mary Randolph, "Rivera's Monopoly," *Art Front* 1 [November 1935]: 5; Randolph's critique of Rivera is continued in *Art Front* 1 [December 1935]: 12–13); Shahn's notes for 16 November 1949 lecture (Shahn Papers, 5019F486). For Shahn's opinion of Rivera's mural, see Howard Greenfeld, *Ben Shahn: An Artist's Life* (New York, 1998), 97.

21. Holger Cahill, foreword to *The First Municipal Art Exhibition,"* exh. cat. (the Forum, RCA Building, Rockefeller Center, 1934), n.p. In addition to Cahill, the selection committee included representatives from the majority of the city's most prominent art institutions and organizations: Juliana R. Force, director of the Whitney Museum of American Art; Alfred H. Barr, Jr., director of MoMA; William H. Fox, director of the Brooklyn Museum; Herbert E. Winlock, director of the Metropolitan Museum of Art; Leon Kroll, chairman of the American Society of Painters, Sculptors and Engravers; and Harry W. Watrous, president of the National Academy of Design.

22. Stephen Alexander, "Broad-Minded Medici," *New Masses* 10 (20 March 1934): 13. A. S. Baylinson, Maurice Becker, George Biddle, Hugo Gellert, Hendrick Glintenkamp, William Gropper, Edward Laning, Louis Lozowick, Walter Pach, Helene Sardeau, Ben Shahn, and John Sloan signed the protest statement, which was partially quoted in "Artists Quit Show in Rivera Protest," *New York Times,* 14 February 1934, Art 73.

23. Mumford, quoted in "Letters from Our Friends," *Art Front* 1 (November 1934), n.p.; "300 Artists Demand Municipal Center; Deutsch Pledges Aid to Group at City Hall," *New York Times,* 10 May 1934, 24 (Shahn saved a clipping of the article: Clipping File, Shahn Papers, 5024F218); Alfred Sinks, "Potted Palms and Public Art," *Art Front* 1 (February 1935): 3. See also Michael E. Landgren, "A Memoir of the New York City Municipal Art Gallery, 1936–1939," in O'Connor, *New Deal Art Projects,* 269–70; Monroe, "Artists Union," 56–59; and Francine Tyler, "Artists Respond to the Great Depression and the Threat of Fascism: The New York Artists' Union and Its Magazine 'Art Front' (1934–1937)" (Ph.D. diss., New York University, 1991), 137–38, 148–49.

The Artists' Union sometimes inflated the impact of its demonstrations, but such actions did help achieve concessions from both the municipal and the federal government. Even public art project administrators like Audrey McMahon, who was heckled on occasion during protests, admit-

ted that the agitation often achieved results "beneficial to the artists and to the projects." See "For a Federal Permanent Art Project," *Art Front* 1 (November 1934): 3–4, and McMahon, "General View of the WPA Federal Art Project," 67. Efforts to establish an independent municipal art center ultimately failed. The Temporary Gallery of the Municipal Art Committee, which was finally established at 62 West Fifty-third Street in 1936, did not include an art center, nor were artists invited to join its board. See Tyler, "Artists Respond to the Great Depression," 157–58.

24. See "History of the Artists Union," *Art Front* 1 (November 1934): n.p. According to Gerald M. Monroe, the idea for *Art Front* came from Herman Baron, the proprietor of the ACA Gallery, who offered Hugo Gellert his gallery's bulletin as a mouthpiece for the Artists' Union. The idea was so well received by the union's executive committee that Baron became managing editor of the first issue. Herb Kruckman suggested the title *Art Front* (Monroe, "Artists Union," 156–58).

25. Deborah Martin Kao and Jenna Webster, interview with Bernarda Bryson Shahn, Roosevelt, N.J., 20 January 1997, and Shahn Papers 5025F157–5025F187; Shahn, editorial notes for *Art Front,* summer 1935, Shahn Papers, 5006F726 (in mock-ups for a 1935 issue of *Art Front* Shahn used one of his New York photographs of men waiting at the South Street docks as a placeholder for a later illustration: Shahn Papers, 5025F172); Julien Levy to Jay Leyda, 4 May 1935, Leyda Papers. Julien Levy's gallery was located at 602 Madison Avenue. Jenna Webster discovered this correspondence while researching Shahn's relation to film and film culture: see chapter 3: "Ben Shahn and the Master Medium."

26. The *New York Times* reported that more than 100,000 people participated in the May Day festivities of 1934. The "rival" Socialists and Communists organized separate May Day parades in 1934 and 1935. See "100,000 Rally Here, with No Disorder," *New York Times,* 2 May 1934, 1; "1,500 Police Put on Parade Guard," *New York Times,* 1 May 1934, 2, and "May Day Peaceful Here as Thousands March in Gay Mood," *New York Times,* 2 May 1935, 1, 3. For the route that the activists marched, see the *Daily Worker,* 1 May 1934, 2. Shahn's photographs of the 1935 May Day parade are bolder and more technically mature than those he made in 1934, evidence that as he gained experience photographing demonstrations and marches, he refined his skills and aesthetic decisions.

27. See Shahn negatives, accession numbers, P1970.3889, P1970.4080, P1970.4084, P1970.4097, Fogg Art Museum; "Colorful Floats and Effigies to Enliven Giant New York May Day Parade," *Daily Worker,* 17 April 1934, 3. Bernarda Bryson Shahn recollected that members of the Artists' Union frequently made banners and signs for other worker groups (Kao and Webster, interview with Bryson Shahn).

28. The Harlem Artists' Guild was founded in 1935. See Ellen Harkins Wheat, *Jacob Lawrence: American Painter,* exh. cat. (Seattle Art Museum, 1986), 29, and Romare Bearden and Harry Henderson, "Emergence of African-American Artists During the Depression," in *A History of African-American Artists: From 1792 to the Present* (New York, 1993), 234–39. For a thorough discussion of Artists' Union efforts to confront racial prejudice, see Tyler, "Artists Respond to the Great Depression," 198–238. The characterizations of African Americans are described in Nicholas Natanson, *The Black Image in the New Deal: The Politics of FSA Photography* (Knoxville, 1992), 17. Natanson, who analyzed the photographs Shahn made of African Americans during his trip throughout the American South for the RA in 1935, observed that the artist rejected stereotypes and "common assumptions about a predictable black mindset" (85–112, esp. 100). This opinion is also held by Susan H. Edwards in "Ben Shahn: A New Deal Photographer in the Old South" (Ph.D. diss., City University of New York, 1996), 99–132, as well as in her essay "Ben Shahn and the American Racial Divide," *Tamarind Papers* 17 (January 1998): 77–85. The sign appears in Shahn negative, P1970.4029, Fogg Art Museum.

29. Police horses appear in Shahn negative, P1970.4093, Fogg Art Museum; "100,000 Rally Here, with No Disorder," 1; *Art Front* 1 (November 1934): n.p. (the tribute saw the member's death as a call to action: "Her activity in the Artists' Union was particularly notable for its sincerity and militancy. We grieve her loss and honor her memory as an inspiration and incentive."); Harold Rosenberg, "Artists Increase Their Understanding of Public Buildings," *Art Front* 1 (November 1935): 6; the sign appears in Shahn's negative, P1970.4004, Fogg Art Museum; Source File, "Strikes and Police," Shahn Papers, 5023F414–5023F515.

30. Gropper's cartoon was first published in *Art Front* 1 (February 1935): 7; Davis, "The Artist Today," 506. For the logo, see Marlene Park and Gerald E. Markowitz, *New Deal for Art: The Government Art Projects of the 1930s with Examples from New York City and State,* exh. cat. (The Gallery Associ-

ation of New York State, 1977), 95. Hugo Gellert designed the logo for the Artists' Committee of Action.

31. Doud, interview with Shahn. Francine Tyler described this six-page illustration as resembling "scenes in a moving picture" and a "cinematic 'picture essay'" ("Artists Respond to the Great Depression," 78–79). Shahn mentioned his affinity for newsreels in "Art: Angry Eye," *Time,* 13 October 1947, 63. The denial of a marching permit is mentioned in "Artists to Demand a City Art Center," *New York Times,* 27 October 1934, 17. Shahn appears in the center of the first photograph on page four. Laura Katzman first identified the photograph.

32. Shahn, quoted in Morse, "Ben Shahn," 137. For an analysis of later critical responses to Shahn's photographic aesthetic, see Laura Katzman's "The Politics of Media: Painting and Photography in the Art of Ben Shahn," *American Art* 7 (Winter 1993): 61–87, reprinted here with revisions as chapter 4.

33. Source File, "Mooney," Shahn Papers, 5022F1116 (a reproduction of the panel appeared as an illustration in Jean Charlot, "Ben Shahn: An Appreciation," *Hound and Horn* 6 [July–September 1933]: 638); Malcolm Vaughan, "The Painter as Reporter," *New York American,* 23 April 1933, clipping in the Shahn Papers, 5204F183 (an examination of the 23 April 1933 issue of *New York American* indicates that the inscribed date on the clipping in Shahn's papers is incorrect. The correct date is not known.); Matthew Josephson, "The Passion of Sacco-Vanzetti," *New Republic,* 20 April 1932, 273. (At the time that Josephson reviewed *The Passion of Sacco-Vanzetti,* Shahn told the critic that Josephson's 1928 book *Zola and His Time* had helped inspire *The Dreyfus Affair* of 1930, the gouache series that first signaled a shift in Shahn's approach to both the form and content of his art: Mathew Josephson, *Infidel in the Temple: A Memoir of the Nineteen-Thirties* [New York, 1967], 123); "Paintings By Ben Shahn: October 17–October 29," *Fourth Annual Report, The Harvard Society for Contemporary Art* (1932–33), n.p.

34. Charlot, "Ben Shahn," 633, 634; Morse, "Ben Shahn," 138; Charlot, "Ben Shahn," 634, 633, 632; Charles Baudelaire, "The Painter of Modern Life," in *The Painter of Modern Life and Other Essays,* trans. and ed. Jonathan Mayne (London, 1995), 13; Charlot, "Ben Shahn," 634.

35. John Boling, "The Face of a City," *New Masses* 12 (18 September 1934): 26–27; William Stott, *Documentary Expression in Thirties America* (New York, 1973), 54; see Boling, "A Perfectly Honorable Business," *Art Front* 1 (April 1935):

6. Jay Leyda sent a copy of *My Paris* to Walker Evans (Evans to Leyda, 21 February 1934, Leyda Papers). Jenna Webster brought this letter to my attention. Shahn may have also learned about Ehrenburg from Rivera, who had met the writer in Paris around 1911. See Joshua Rubenstein, *Tangled Loyalties: The Life and Times of Ilya Ehrenburg* (New York 1996): 32. In his "What Is Art For?" *Modern Monthly,* June 1933, 275, Rivera mentions his admiration for Ehrenburg.

36. Boling, "The Face of a City," 26, 27, 26.

37. Edward Steichen, "'News'-Photography," in Fred J. Ringel, ed., *America as Americans See It* (New York, 1932), 294 (Shahn probably knew of this book since photographs by his friends Walker Evans and Paul Grotz appear in the frontispiece; I thank Rodger Kingston for bringing it to my attention); Lincoln Kirstein, "Photography in the United States," in Holger Cahill and Alfred H. Barr, Jr., eds., *Art in America in Modern Times* (New York, 1934), 88; Louis Aragon, "Painting and Reality," *Art Front* 3 (January 1937): 9, 8, 9–10.

38. Joseph North, "Reportage," in Henry Hart, ed., *American Writers' Congress* (New York, 1935), 120, 121. For more on the reportage debate, see Stott, *Documentary Expression,* (New York, 1973), 53–54, and Warren I. Susman, "The Culture of the Thirties," in his *Culture as History: The Transformation of American Society in the Twentieth Century* (New York, 1984, 1973), 150–83.

39. Lee Simonson, *International Exhibition of Theatre Art,* exh. cat. (MoMA, 1934), 61; "They Shall Not Die," *New Theatre* 3 (February 1934): 6. Gorelik was a contributing editor of *New Theatre.* For more on *Living Newspaper* productions see Hallie Flanagan, *Arena* (New York, 1940), esp. 51–80, and Mordecai Gorelik, *New Theatres for Old* (New York, 1940), 397–430.

40. Shahn used the example of *New Theatre* as a model for the design of *Art Front,* and his friends Jay Leyda and Louis Lozowick were among its contributing editors. See Ben Shahn's editorial notes for *Art Front,* Shahn Papers, 5006F726. See Philip Sterling, "Scenes from the Living Theatre . . . San Francisco 1934," *New Theatre* 1 (September 1934): 16–17. This article included reproductions of reactionary newspaper headlines, protest marches, and a portrait of Tom Mooney behind bars. Shahn's sharecropper images appeared in "The Living Theatre," *New Theatre and Film* 4 (April 1937): 24–25.

41. Morris Dorsky, interview with Walker Evans, handwritten notes, "Evans interview," 18 July 1951, Taller Ar-

chive; Julien Levy, *Photographs by Henri Cartier-Bresson and an Exhibition of Anti-Graphic Photography,* exh. cat. (New York, 1933). See also Ingrid Schaffner and Lisa Jacobs, eds., *Julien Levy: Portrait of an Art Gallery* (Cambridge, Mass., 1998), 128–29, 175–76. Shahn spoke of his admiration for Cartier-Bresson's work in John D. Morse, "Henri Cartier-Bresson," *Magazine of Art* 40 (May 1947): 189. For Shahn's early use of news photographs see Dorsky, "Formative Years," 39–62. In his important study of Shahn's early paintings, based largely on interviews he conducted with the artist and his colleagues in the 1950s, Dorsky argued that it was Shahn's close relationship with Evans that most significantly modulated his thinking about documentary photography. Evans's photographs depicted the home of Shahn's Cape Verdean Portuguese neighbors, the De Luze family, in whose barn the two artists installed their work. Dorsky and Greenfeld suggest that the exhibition was mounted in protest of the exclusive white summer community's treatment of the De Luze family. Shahn recollected that he and his unemployed friends would "hang out" at the Picture Collection of the library all day (Phillips, interview with Shahn). Many clippings scattered throughout Shahn's papers are stamped "N.Y. Public Library Picture Collection." A letter from Romana Javitz, curator of the Picture Collection, scolded Shahn for not returning "May Day" pictures (Romana Javitz to Shahn, 24 April 1946, Shahn Papers, D145F1207).

42. Evans, slide lecture, Fogg Art Museum; Alfred H. Barr, Jr., "Introduction," *Corot/Daumier,* exh. cat. (MoMA, 1930), 16–17 (see also Francine Tyler, "The Impact of Daumier's Graphics on American Artists: c. 1863–c. 1923," in *Honoré Daumier: A Centenary Tribute,* ed. Andrew Stasik (New York, 1980), 109–26; Diego Rivera, "The Revolutionary Spirit in Modern Art," *Modern Quarterly* 6 (Autumn 1932): 51.

43. Beaumont Newhall, "Documentary Approach to Photography," *Parnassus* 10 (March 1938): 3, 4.

44. Lou Block to [Joseph Fulling] Fishman, 20 August 1933, Block Papers, Box 11. Warden Lewis E. Lawes was a prominent prison official.

45. In her study of Ben Shahn's New Deal murals, Diana L. Linden ties Shahn's crusade against injustice and interest in the law to his Jewish heritage, noting that "in the Riker's studies he negotiated deftly between ancient Talmudic teachings and the contemporary American penal system" ("New Deal Murals" 44).

46. See Dr. Walter N. Thayer, Jr. to Block, 20 October 1933; Block and Shahn to MacCormick, 23 April 1934; MacCormick to Fiorello H. La Guardia, 11 May 1934; and La Guardia to MacCormick, 12 May 1934, all Block Papers, Box 11. For MacCormick's visits, see Phillips, interview with Shahn. Shahn and Block originally considered executing a mural at Sing Sing Penitentiary in Ossining, New York.

47. "MacCormick Plans Prison Shake-Ups," *New York Times* (11 January 1934): 4; Block, "A Little Old New Yorker," undated typescript, 22–23, Block Papers, Box 27; "The New Penitentiary," *New York Times,* 4 July 1935, 14; "New Prison Ready on Riker's Island," *New York Times,* 30 June 1935, 21. See also "Payment Held Up on Sinking Prison," *New York Times,* 17 January 1933, 2, and Linden, "New Deal Murals," 36–37.

48. Linden, "New Deal Murals," 39; James V. Bennett, "American Prisons—Houses of Idleness," *The Survey* 71 (April 1935): 99; "M'Cormick Plans New Jail Reforms," *New York Times,* 13 February 1934, 9; "New Prison Ready on Riker's Island," 21.

49. Paul Boochever [secretary, Department of Correction, City of New York] to Alan Stuyvesant [secretary to the New York City Police Commissioner], 28 May 1934, Block Papers, Box 11; and Boochever to Heads of All [New York City Correctional] Institutions, 28 May 1934, Block Papers, Box 11. Block later told Donald R. Anderson of the Photographic Archives at the University of Louisville that Shahn agreed not to exhibit the prison photographs and not to identify the prisoners or locations of the prisons in his lifetime (Donald R. Anderson to Davis Pratt, 17 September 1969 and 29 September 1969, Department of Photographs, Fogg Art Museum). The restrictions placed on these photographs accounts in large part for why they are so little known.

Shahn mentioned the meeting with Kirchwey to Phillips in their interview; meetings with others appear in Block and Shahn, "Memorandum for the Mayor on the Projected Murals for the Rikers Island Penitentiary," 10 December 1934 [6 December 1934], Block Papers, Box 11. I am indebted to Ezra Shahn for allowing me access to his father's sketchbook. Block was informed that the film stills from First National Motion Pictures were ready to be picked up by Paul Boochever: Boochever to Block, 11 June 1934, Block Papers, Box 11.

50. Evans's role is discussed in Harlan Phillips, interview with Lou Block, Louisville, Ky., 31 May 1965, Archives of

American Art, Smithsonian Institution. There are almost a hundred negatives in the Fogg Art Museum from Shahn's visits to Blackwell's Island and the New York City Reformatory. To my knowledge approximately fifty gelatin silver prints from these negatives survive in public and private collections. The majority of Shahn's extant prison photographs are in the Lou Block Collection, Photographic Archives, University of Louisville. I conjecture that around the fall of 1935, Block asked his colleague for a set of reference photographs of the images Shahn made during their prison visits. These prints may even have been created by Block or Evans in the studio they shared with Shahn.

51. Kirstein, *Mosaic,* 183.

52. Block and Shahn, "Memorandum for the Mayor"; and Block, "Plan of Work," draft of an application for a John Simon Guggenheim Memorial Foundation grant, [November] 1935, Block Papers, Box 17.

53. Block to MacCormick, 5 October 1934, Block Papers, Box 11.

54. By means of a variety of surviving sources, I was able to reconstruct Shahn's Rikers Island Penitentiary mural study. This is the first time the mural study has been seen in its entirety since the artist abandoned the project in spring 1935. The reconstruction indicates what Shahn's mural would have looked like if it had been executed according to his finished gouache studies. I would like to acknowledge Michelle Tarsney of Kao Design Group who created the stunning computer-generated images of the reconstructed mural illustrated in this book (cats. 121 and 122, fig. 23). The reconstruction is made to scale without alteration to Shahn's projected design. From photographs documenting Shahn's mural panels (provided by diverse archives and collections) Kevin Dacey produced the digital scans that were used in the reconstruction. Jenna Webster was an essential research partner and insightful sounding board.

Sadly, like many works created under the auspice of government-sponsored art project in the 1930s, the panels that comprised Shahn's Rikers Island mural study were sold in the early 1940s as used art supplies. At least some of Shahn's panels of the mural study were acquired by Robert's Book Store (a junk shop on Canal Street) and then resold. See Harlan Phillips, interview with Ben Shahn; "End," *Art Digest* 18 (15 February 1944) 7, and Dorothy Miller to James Thrall Soby, 21 May 1947, James Thrall Soby Papers, MoMA. To my knowledge, only three of Shahn's original gouache panels for his prison mural study survive: the southern chain-gang panel is held in a private collection (cat. 115); the Thomas Mott Osborne panel is in the collection of the Wichita Art Museum (cat. 116); and the medical panel is in the Gallery Sei collection (formerly Art Point) in Toyko. But photographs documenting a number of the missing panels were published in newspapers as well as in the art press at the time Shahn was involved in the project. Moreover, negative photostats made in 1934–35 of four of Shahn's panels (and a detail of one of them) are in the collection of the Municipal Art Commission, New York: they are the first and last panels for the east wall and the first two panels for the west wall. The Art Commission's file on Shahn's mural also contains a 1934 blueprint of a scale section (¼ inch = 1 foot) of the designated prison corridor. It specifies the exact dimensions of the space, as well as the height of the tile dado and the location of ceiling crossbeams and door openings. A photograph by Lou Block now in the Photographic Archives, University of Louisville, shows the corridor when construction was nearly complete, including the finished tile work and the style of the metal gates at the doorways.

Early in my research I benefited from Laura Katzman's knowledge of the Rikers Island–related material in the Shahn and Block Papers. I was also fortunate to have the assistance of the late Dr. Stephen Lee Taller. Through the extensive database he had compiled on Shahn's work, I was able to locate material related to the Rikers Island mural project held by private and public collections. Perhaps most noteworthy, in Shahn's former studio I found a box of photographs made in 1934–35 documenting the panels that comprised his completed mural study for the north, east, and part of the west wall of the prison corridor. Bernarda Bryson Shahn graciously allowed me unlimited access to study this remarkable material. The photographs are contact-printed from 8 × 10 negatives and were probably made by Walker Evans. (In the 1934 book *Art in America in Modern Times,* Evans is given the photo credit for an illustration of one panel from Shahn's Rikers Island mural.) Some of the photographs of Shahn's mural study are mounted to mat board and have original typed captions affixed to the mount below the image (see fig. 78). I also identified a sketch by Shahn for the west wall of his prison mural in the Gallery Sei collection. It confirms that although the artist never completed his design, he had projected the content of the missing panels. My access to the Gallery Sei collection was

facilitated by Charles Danziger. Finally, Shahn's Rikers Island sketchbook (previously unbound), in the collection of the artist's family (as well as a page in the Block Papers), provides clues to his preliminary concepts for the missing scene on the south wall. I thank Ezra Shahn for allowing me to bring the sketchbook to the Fogg Art Museum for close study of its contents.

55. Kirstein, diary entry, 2 November 1934, Kirstein Papers; Phillips, interview with Shahn; Kirstein, diary entry, 8 November 1934, Kirstein Papers.

56. Block and Shahn, "Memorandum for the Mayor"; Federal Writers' Project, *New York City Guide,* 118.

57. Built around 1835 and designed to resemble a mausoleum, the Tombs jail was also called the Hall of Justice.

58. Phillips, interview with Shahn.

59. Michel Foucault, *Discipline and Punish: The Birth of the Prison,* trans. Alan Sheridan (New York, 1975, 1995); Block and Shahn, "Memorandum for the Mayor."

60. Walter White to Will W. Alexander [Commission on Interracial Cooperation, Atlanta, Ga.], 19 September 1934; White to Block, 21 September 1934; White to George F. Milton [*Chattanooga News,* Tenn.], 21 September 1934; Arthur Raper [Commission on Interracial Cooperation] to White, 21 September 1934; White to Block, 24 September 1934; and G. D. Homer [United Press Associations], 25 September 1934; Alexander to White, 27 September 1934; White to Block, 2 October 1934, all Block Papers, Box 11; Erskine Caldwell, "'Parties Unknown' in Georgia," *New Masses* 10 (23 January 1934): 16; for the news photograph of hunger marches see Clippings File, Shahn Papers, 5024F1241. For the chain-gang photograph see Anthony Trent, "Two Worlds—Two Roads," *Labor Defender* 9 (December 1933): 83–84. Two ink sketches in the Gallery Sei collection in Tokyo (formerly Art Point) depict prisoners on a chain gang. One of these is a transcription of the news photograph in Trent's article. Shahn's Rikers Island sketchbook, in the collection of the artist's family, also includes a gouache rendering based on another news photograph of a prisoner reproduced in the same essay. Shahn also made written reference to "Copy of USSR prison workers on canal" in his sketchbook.

61. The source photograph and gouache panel are illustrated in Bush, *The Passion of Sacco and Vanzetti,* 18–19; the *Daily News* photo is in Clippings File, Shahn Papers, 5024F1240.

62. Edward Alden Jewell, "Sketches Stress New Prison Policy," *New York Times,* 10 May 1935, 10; Block and Shahn, "Memorandum for the Mayor"; Shahn, "The Biography of a Painting," 78. See Frank Tannenbaum, *Osborne of Sing Sing* (Chapel Hill, N.C., 1933), 3–12, and Thomas Mott Osborne, *Within Prison Walls: Being a Narrative of Personal Experience During a Week of Voluntary Confinement in the State Prison at Auburn, New York* (New York, 1914).

63. Block and Shahn, "Memorandum for Dr. Walter Thayer, Jr., On Murals Proposed for a Prison," 28 June 1935, Block Papers, Box 11. The sketch of the west wall is located in the Gallery Sei collection. A gouache study by Shahn entitled *Prisoners Milking Cows* (1934–35) has been attributed to the Rikers Island mural project. It is possible that this work represents Shahn's plans for part of the missing section of the west wall, but Shahn's notes for the scene in the Gallery Sei sketch are vague. They indicate only that the artist intended to show the release of prisoners into a viable work environment.

64. Stephan Hirsch to Audrey MacMahon, 25 January 1935, Shahn Papers, D147F1631–D147F1633; Clement Greenberg, "Art," *The Nation,* 1 November 1947, 481.

65. Kirstein, diary entry, 2 November 1934, Kirstein Papers; "Rikers Island Penitentiary, Mural Decoration," Submission 4611 Series 1554, 7 January 1935, Municipal Art Commission, New York City. Disapproved on 14 February 1935; Block and Shahn, "Outline of Material in Murals," typescript, Shahn Papers, D147F1634–D147F1637.

66. Forbes Watson, "Art and Government in 1934," *Parnassus* 6 (January 1933): 16; for a summary of where the mural study was shown and written about see Lou Block and Ben Shahn to Audrey MacMahon, 16 April 1935, Block Papers, Box 11; for Edward Alden Jewell's ongoing support of the mural project see his "In the Realm of Art," *New York Times,* 19 May 1935, X-9; Stuart Davis, "We Reject—The Art Commission," *Art Front* 1 (July 1935): 4–5; Phillipa Whiting, "Speaking About Art," *American Magazine of Art,* August 1935, 492–96.

67. "Vandalism and Jonas Lie," *Art Front* 1 (November 1934): n.p.; and "Treason Is Treason," *Art Front* 1 (April 1935): n.p.; Harold Rosenberg, "Artists Increase Their Understanding of Public Buildings," 6. See also "Mural for Prison Rejected by City," *New York Times,* 8 May 1935, 21; "Prisoners' Poll Kills Mural for Rikers Island," *Herald Tribune,* 9 May 1935, 21; and Stephen Alexander, "Jonas Lie, Red-Baiter," *New Masses* 15 (11 June 1935): 28–29.

68. Garnett McCoy, "The Rise and Fall of the American

Artists' Congress," *Prospects* 13 (1988): 325–40; "Call for an American Artists' Congress," *Art Front* 1 (November 1935): 6 (see also Matthew Baigell and Julia Williams, eds., *Artists Against War and Fascism: Papers of the First American Artists' Congress* [New Brunswick, N.J., 1986], 9, 47–52); Stuart Davis, "Repression of Art in America," *New Masses* 18 (14 January 1936): 22; Joe Jones, "Repression of Art in America," reprinted in Baigell and Williams, *Artists Against War and Fascism,* 75–77. Sessions were held in New York City at the Town Hall (14 February) and at the New School for Social Research (15–16 February).

69. Phillips, interview with Shahn. On efforts to place the mural elsewhere see Block and Shahn to Dr. Walter N. Thayer Jr., 8 July 1935, and Audrey McMahon to Dr. Walter N. Thayer, Jr., 4 June 1935, both Block Papers, Box 11.

70. Kirstein, *Mosaic,* 183, 229–30; and Mitzi Berger Hamovitch, ed., *The Hound and Horn Letters* (Athens, Ga., 1982), 101–2.

71. Kirstein, from *Harvard Advocate* 121 (Christmas 1934), quoted in *Hound and Horn Letters,* 19–20; Kirstein, *Mosaic,* 183; Kirstein to Jay Leyda, 21 September 1935, Leyda Papers. I thank Jenna Webster for bringing this letter to my attention.

72. Lincoln Kirstein to Ben Shahn, 22 November 1935, Shahn Papers, D145F1399; Samuel L. Leiter, *The Encyclopedia of the New York Stage,* 1930–1940 (New York, 1989), 521–22. Kirstein's reluctance to use projected photographs in *Tom* was motivated by what he saw as the failure of this technique in *Mother,* an opinion shared by other critics of the play.

73. Kirstein, *Mosaic,* 183; Kirstein, "An Iowa Memling," *Art Front* 1 (July 1935): 8. In spite of Kirstein's harsh critique, Stephen Alexander, a critic for *New Masses,* felt that he had been nonetheless too generous to Grant Wood, underestimating the "danger" of Woods's "reactionary tendencies" (Stephen Alexander, "New Issue of *Art Front,*" *New Masses* 16 [2 July 1935]: 41).

74. North, "Reportage," 120, 123.

Chapter 3: Ben Shahn and the Master Medium

I am grateful to Susan H. Edwards, Deborah Martin Kao, and Frances K. Pohl for reading drafts of this essay.

1. Walker Evans to Jay Leyda, undated [8 November 1936], Leyda Papers. I have been able to date this letter based upon corresponding subject matter between documents in the Leyda Papers and the Shahn Papers. See Grace E. Falke to Shahn, 19 October 1936, Shahn Papers, 5016F953.

2. Instead of using the acronym RA/FSA, this essay uses "RA" because the material discussed herein pertains to the Resettlement Administration before it was absorbed by the Department of Agriculture on 31 December 1936. (The name of the agency was officially changed to Farm Security Administration on 1 September 1937.) For a history of the organization, see Sidney Baldwin, *Poverty and Politics: The Rise and Decline of the Farm Security Administration* (Chapel Hill, N.C. 1968). For Evans's expectations of the Greenbelt film, see Evans to Leyda, [8 November 1936], Leyda Papers; brief mention of the Greenbelt film appears in the following publications: James R. Mellow, *Walker Evans* (New York, 1999), 336–41; Howard Greenfeld, *Ben Shahn: An Artist's Life* (New York, 1998), 134; Belinda Rathbone, *Walker Evans: A Life* (New York, 1995), 143; Susan Noyes Platt, "The Jersey Homesteads Mural: Ben Shahn, Bernarda Bryson, and History Painting in the 1930s," in *Redefining American History Painting,* ed. Patricia M. Burnham and Lucretia Hoover Giese (New York, 1995), 299–300; and Beverly W. Brannan and Judith Keller, "Walker Evans: Two Albums in the Library of Congress," *History of Photography* 19 (Spring 1995): 64–65. A reproduction of a detail from fig. 28, an image I first identified, appears in James R. Mellow's posthumously published biography of Evans. John T. Hill and Edward Grazda confirmed my identification of the three pictures.

3. Published references to Evans's interest in film include Mellow, *Walker Evans,* 168, 336–40; Rathbone, *Walker Evans,* 88–89, 90, 142–44, 147, 192–93; and Douglas R. Nickel, "*American Photographs* Revisited," *American Art* 6 (Spring 1992): 94. Also see the statement by Evans reprinted in Jerry L. Thompson, *Walker Evans at Work* (New York, 1982), 44. For references to Shahn's photography as "cinematic" see, for example, Davis Pratt, Preface, *The Photographic Eye of Ben Shahn* (Cambridge, Mass., 1975), x, and Carl Fleischhauer and Beverly W. Brannan, eds., *Documenting America, 1935–1943* (Berkeley, 1988), 78. Nancy Newhall went so far as to use the term "cinematic" to describe some of Shahn's paintings, writing that his "most amazing use of detail is more cinematic than photographic ("Ben Shahn," *Photo Notes* [November 1947]: 3). Susan Noyes Platt compares Shahn's murals to the spatial and temporal collage of early Soviet cinema ("Jersey Homesteads Mural," 298, 304). Others have claimed that Shahn's "originality in seizing a

gesture of facial expression is reminiscent of the mime of silent film acting" (Roberta Hellman and Marvin Hoshino, "The Photographs of Helen Levitt," *Massachusetts Review* 19 [Winter 1978]: 729). Laura Katzman brought the article by Hellman and Hoshino to my attention. A more fruitful approach to Shahn and film is used by Susan H. Edwards, who considers how Shahn's portrayal of class struggle, among other elements, in his 1935 RA photographs anticipated themes explored by Italian neorealist cinema: Edwards, "Ben Shahn and the American Racial Divide," *Tamarind Papers* 17 (5 January 1988): 82. Shahn greatly admired Roberto Rossellini's *Open City* (1945), as Edwards points out. See Shahn, quoted in Richard Kostelanetz, "Ben Shahn: Master 'Journalist' of American Art" (1969), in *On Innovative Art(ist)s: Recollections of An Expanding Field* (Jefferson, N.C., 1992), 170. As I do, Susan H. Edwards cautions against using the term "cinematic": see Edwards, "Ben Shahn: A New Deal Photographer in the Old South" (Ph.D. diss., City University of New York, 1996), 49–50.

4. In chapter 2 Deborah Martin Kao argues that Shahn designed a layout of photographs for *Art Front* (January 1935) approximating the newsreel format (see fig. 21). Shahn's extant negatives from this period (those he made in New York, 1932–35, and for the RA/FSA, 1935–38) have been accessible in only a limited way, thus making it all but impossible for scholars to fully understand the order in which the artist made his images. Laura Katzman has begun to explore this area, however. See Katzman, "The Politics of Media: Ben Shahn and Photography" (Ph.D. diss., Yale University, 1997), 117–118, 120. For more on Shahn's New York negatives see our Note to the Reader. Caption sheets and other documents in the FSA/OWI Collection in the Prints and Photographs Division at the Library of Congress can in some cases help determine the sequence of a select number of Shahn's RA/FSA negatives. See Fleischhauer and Brannan, "Appendix: The FSA-OWI Collection," in *Documenting America,* 330–42. A small number of RA/FSA contact strips are in the Shahn Papers, 5027F582–5027F590.

5. Beaumont Newhall, "Documentary Approach to Photography," *Parnassus* 10 (March 1938): 6. Newhall makes similar statements in his *Photography 1839–1937,* exh. cat. (Museum of Modern Art, New York, 1937), 89. For later discussions of the relation between a series of photographs and the motion picture film see Norton Batkin, *Photography and Philosophy* (Boston, 1981, 1990), 38–39, 117–29, 139–53.

6. Lincoln Kirstein, "Photographs of America: Walker Evans," in *American Photographs* (New York, 1938), 192–93.

7. Shahn, quoted in "Art: Angry Eye," *Time,* 13 October 1947, 63. Shahn made this statement in a brief interview conducted as part of a review of his retrospective exhibition at the Museum of Modern Art. In later interviews Shahn made similar comments, explaining that to create his art he employed any available visual medium.

8. Shahn, "Biography of a Painting," *The Shape of Content* (Cambridge, Mass., 1957), 37. William Snow, the artist's childhood friend, remembers attending films with Shahn: Snow, "Ben Shahn: His Background," unpublished manuscript (July 1969), Taller Archive. Shahn also enjoyed comic strips, which Erwin Panofsky called "a most important root of cinematic art": Panofsky, "On Movies," *Princeton University, Department of Art and Archaeology Bulletin* (1936): 5–15.

9. Shahn, quoted in "Art: Angry Eye," 63. Shahn told Morris Dorsky how *The Dreyfus Case* piqued his interest in the incident: Dorsky, "The Formative Years of Ben Shahn: The Origin and Development of His Style" (M.A. thesis, New York University, 1966), 53. Selden Rodman claims that Shahn wanted his Dreyfus watercolors to be exhibited at the theater showing the film but that the theater's manager feared the works would be stolen or mutilated and so returned them to Shahn: Rodman, *Portrait of the Artist as an American: Ben Shahn, A Biography with Pictures* (New York, 1951), 124. For evidence of Shahn's request for filmed material on Sacco and Vanzetti, see Gardner Jackson to Shahn, 13 October 1931, Shahn Papers, 5006F718.

10. Jack L. Warner, with Dean Jennings, *My First Hundred Years in Hollywood* (New York, 1964), 218. *I Am a Fugitive* was based on an autobiographical novel by Robert Burns published in 1932. The film received two Oscar nominations and a National Board of Review award for best movie of the year. Because of its success the story was subsequently adopted into other formats, including comic books. In response, the Georgia legislature accused Warner Brothers and the author of defamation. Warner Brothers, however, continued releasing other so-called films of social conscience, including *Public Enemy* (1932) and *Wild Boys of the Road* (1933), earning them the title "New Deal Studio." See Colin Schindler, *Hollywood in Crisis: Cinema and American Society 1929–1939* (London, 1996), 166. Incidentally, these productions were often scripted by playwrights and stage directors of Jewish descent who, like Shahn, grew up in Brooklyn (or on the Lower East Side) and moved to Holly-

wood during the Depression. In fact, one of Shahn's assistants on the Rikers Island mural project, Michael Simmons, pursued a Hollywood screenwriting career in the 1930s. See Harlan Phillips, interview with Shahn, Roosevelt, N.J., 3 October 1965, Archives of American Art, Smithsonian Institution; also see Michael Simmons to Shahn, 20 February 1934, Shahn Papers, D147F1290.

11. S. Paul Boochever to Lou Block, 11 June 1934, Block Papers. Shahn could also have seen stills for *I Am a Fugitive* in movie posters and advertisements, which he often photographed.

12. Karal Ann Marling claims that cinematic montage particularly influenced Benton's *America Today*. See Marling, *Wall to Wall America: A Cultural History of Post Office Murals in the Great Depression* (Minneapolis, 1982), 40. In 1949 Shahn referred to what Rivera termed a "Cinematograph" that appeared in the left and right portions of the central panel of the Rockefeller Center mural (notes for a lecture Shahn gave to literature and art history students at Harvard University on 16 November 1949, Shahn Papers, 5019F481 and D144F1609). I am grateful to Deborah Martin Kao for bringing this to my attention. Rivera also used what Bertram D. Wolfe coined a "'moving picture' technique": Wolfe, "Industrial America: Portrait of Detroit," in Diego Rivera, *Portrait of America* (New York, 1934), 53. In addition to admiring the Hollywood stars Mae West and Charlie Chaplin, Rivera, like many artists during the 1930s, found Disney cartoons particularly compelling. See Diego Rivera, "Mickey Mouse and American Art," *Contact Magazine* 1 (February 1932), reprinted in Irene Herner de Larrea et al., *Diego Rivera's Mural at the Rockefeller Center* (Mexico City, 1990), 184, 186. For Siqueiros, see Desmond Rochfort, *Mexican Muralists: Orozco, Rivera, Siqueiros* (San Francisco, 1993), 145–46. For Eisenstein, see Walter Gutman, "News and Gossip," *Creative Art* 8 (1934): supplement 94.

13. Beaumont Newhall claimed that the "present popularity of the miniature camera is due to the moving pictures" (Newhall, "Documentary Approach to Photography," 6). Photographers like Shahn were particularly conscious of ties with cinema since roll film for their thirty-five millimeter cameras actually evolved from the film developed by the movie industry. In fact, Shahn's colleague Helen Levitt used the tail ends of unexposed movie film (known as shortends) in her Leica (James Oles provided me with this information, 12 May 1999). For Shahn's connection to the "miniature-camera craze" see Laura Katzman, "The Poli-

tics of Media: Painting and Photography in the Art of Ben Shahn," *American Art* 7 (Winter 1993): 60–87. Katzman's article is reprinted in revised form as chapter 4.

14. Meyer Schapiro, "Public Use of Art," *Art Front* 2 (November 1936): 4. Deborah Martin Kao drew my attention to this article. While studying film in Moscow with Sergei Eisenstein and Dziga Vertov in the mid 1930s, Shahn's friend Jay Leyda sent film stills and articles on Russian filmmaking activities to many leftist magazines. On early film criticism, see Myron Osborn Lounsbury, *The Origins of American Film Criticism 1909–39* (New York, 1973). For more on 1930s film culture see Andrew Bergman, *We're in the Money: Depression America and Its Films* (New York, 1971). Although not as rigorous as later publications, *We're In the Money* is an important early study.

15. David Platt, "Focus and Mechanism," *Experimental Cinema* 1 (1 June 1930): 3.

16. The Hippodrome showed a combination of movies and stage shows in its 5,200-seat theater. See Milton Epstein, "The New York Hippodrome: Spectacle on Sixth Avenue From 'A Yankee Circus on Mars' to 'Better Times,' A Complete Chronology of Performances, 1905–39" (Ph.D. diss., New York University, 1993). For the use of thirty-five millimeter cameras inside movie theaters see "'Shooting' the Screen: Taking Your Minicam to the Movies," *Minicam* 1 (March 1938): 43, 67.

17. Film and Photo League members Joris Ivens, David Platt, and Leo Seltzer ascertained that Shahn was never involved in the league's film division. See "Film and Photo League Responses," *Jump Cut* 1 (1989): 22. The artist's widow also stated: "Ben was not a very good friend of the Film and Photo League because he felt that they had just become a cliché" (Davis Pratt, interview with Bernarda Bryson Shahn, Fogg Art Museum, Cambridge, Mass., 30 October 1972). According to Anne Tucker, Shahn took an interest in joining the Photo League, a splinter group of the Film and Photo League active from 1936 to the early 1950s: Tucker, "Photographic Crossroads: The Photo League," *A Special Supplement to Afterimage* (6 April 1978): p. 5, n. 14. For more on Shahn's interest in joining the Photo League, see William S. Johnson, "*Photo Notes* 1938–1950: Annotated Author and Photographer Index," *History of Photography* 18 (Summer 1994): 193. On Potamkin and Evans, see William Alexander, *Film on the Left: American Documentary Film from 1931 to 1942* (Princeton, 1981), 22, and Mellow, *Walker Evans,* 208. It is likely Shahn knew Potamkin through Kirstein as

well. See Lincoln Kirstein, "The Hound and Horn, 1927–1934," *Harvard Advocate* 121 (Christmas 1934): 9–10. Other league members, like Jay Leyda, were also friends with Shahn.

18. For Nykino see Ralph Steiner and Leo Hurwitz, "A New Approach to Filmmaking," *New Theatre* 2 (September 1935): 22–23. In 1937 Nykino became Frontier Films, which is best known for *Native Land* (1940) and the newsreel *The World Today* (1936–1940s). For Bresson, see *Documentary and Anti-Graphic Photographs by Henri Cartier-Bresson, Walker Evans, and Manuel Alvarez Bravo* (23 April–7 May 1935). *Photographs by Henri Cartier-Bresson and an Exhibition of Anti-Graphic Photography,* Cartier-Bresson's first monographic American exhibition (25 September–16 October 1933) at Levy's gallery was a revelation to Shahn. For more on radical American film culture during the 1930s, see Russell Campbell, *Cinema Strikes Back: Radical Filmmaking in the United States* (Ann Arbor, 1982); Alexander, *Film on the Left;* and Anthony Slide, ed., *Filmfront:* a reprint edition (Metuchen, N.J., 1986).

19. For a listing of the city's theaters see Federal Writers' Project, *New York Panorama* (New York, 1938): 284–93, and Federal Writers' Project, *New York City Guide* (New York, 1939), 30–31.

20. Interview with Shahn (it is not known who conducted the interview), 1965, Shahn Papers, 5023F1249; also see Phillips, interview with Shahn. In late 1930 or early 1931 Shahn first visited the Picture Collection; for more see Laura Katzman, "Politics of Media" (Ph.D. diss.), 195–99. For a history of the Picture Collection see Anthony T. Troncale, "Worth Beyond Words: Romana Javitz and the New York Public Library's Picture Collection," *Biblion: The Bulletin of the New York Public Library* 4 (Fall 1995): 115–38. Romana Javitz wrote Leyda that twenty thousand people visited *The Moving Picture as an Art Form* (Javitz to Leyda, 14 September 1933, Leyda Papers). In 1933 Julien Levy installed film stills as part of the Cartier-Bresson and anti-graphic photography exhibition. MoMA also exhibited film stills beginning in 1935 with the opening of its Film Library.

21. For Stryker's shooting script see "Suggestions for a Documentary Photographic Study of the Small Town in America," Shahn Papers, 5007F107. For a discussion of Shahn's influence on Stryker's shooting scripts and other RA photograpers see Edwards, "Ben Shahn," 55–57.

22. Clippings File, Shahn Papers, 5024F1266. For leftist views supporting conservative studies on film's effect on children, see Nathan Adler, "The New Wonderland," review of *Our Movie Made Children,* by Henry James Forman, *New Masses* 9 (September 1933): 30. For an opposing leftist view see William Troy, "Films: The Bogy of Hollywood," *The Nation,* 5 July 1933, 26–27.

23. Nicholas Natanson, *The Black Image in the New Deal: The Politics of FSA Photography* (Knoxville, 1992), 107. Also see Edwards, "Ben Shahn," 80–83.

24. Bernarda Bryson Shahn, *Ben Shahn: The Thirties,* exh. cat. (Williams College Museum of Art, Williamstown, Mass., 1982), n.p. Similarly, Shahn once commented: "Our entertainment, in great part, [is] reduced to common denominators and clichés" (in Bernarda Bryson Shahn, "Ben Shahn, His Graphic Work," *Graphis* 11 [1955]: 469).

25. See undated typed captions for Shahn's RA photographs, [November 1935], Shahn Papers, D147F1548. For John L. Lewis and *Black Fury* see Bergman, *We're in the Money,* 105. Leftist critics writing for journals with which Shahn was familiar faulted *Black Fury* for an inconsistent portrayal of labor struggles. A reviewer for *The Nation* claimed that Film and Photo League productions possessed a more authentic "class analysis": William Troy, "Half a Loaf," *The Nation,* 24 April 1935: 491–92. Also see Albert Maltz, "Coal Diggers of 1935," *New Theatre* 2 (May 1935): 8–9.

26. It is not likely that the destitute figure covers his face so as to evade Shahn's camera. The only possible examples of such avoidance appear in photographs of prisoners that the artist made in preparation for his Rikers Island Penitentiary mural. For discussion of the extant roll of film see chapter 1, Laura Katzman, "Ben Shahn's New York," and chapter 4, Katzman, "Politics of Media."

27. Unidentified author, "Charlie Chaplin's 'Modern Times,'" *New York Times,* 17 November 1935, sec. 9, p. 5; "Peter Ellis," "Let's Build a Ditch!" *New Masses* 13 (16 October 1934): 30. For charges of communism, see *Motion Picture Herald* (7 December 1934). Chaplin's expensive, often decadent lifestyle was well known. See Charlie Chaplin, *Charlie Chaplin's Own Story* (Bloomington, Ind., 1985).

28. The artist of this cover, Miguel Covarrubias, was once introduced to Chaplin: Al Hirschfeld, "Recalling Miguel Covarrubias," in Beverly J. Cox and Denna Jones Anderson, eds., *Miguel Covarrubias: Caricatures* (Washington, D.C., 1985), 21. From 12–26 April 1930, MoMA installed Covarrubias's and Shahn's work in *An Exhibition of Work of 46 Painters and Sculptors under 35 Years of Age.* Covarrubias was

also an acquaintance of Diego Rivera's. He was often present during the painting of the Rockefeller Center mural and was angered when it was destroyed. Shahn first met Covarrubias in the late 1920s: see Morris Dorsky, interview with Philip Shan, 18 June 1955, Taller Archive.

29. Harry Alan Potamkin, untitled review of "Celluloid the Film Today," *Creative Art* 10 (1932): 150; Potamkin, quoted in Edward Newhouse, "Charlie's Critics," *Partisan Review and Anvil* 3 (April 1936): 25; Charmion Von Wiegnand, "Little Charlie, What Now?" *New Theatre* 3 (March 1936): 6–8, 35. Also see John R. Chaplin, "Charlie Chaplin in 'Modern Times,'" *New Theatre* 2 (November 1935): 12–13, 31. Members of Shahn's own circle had equally mixed reactions. See James Agee to Evans, [probably December 1936–January 1937], James Agee Papers, Harry Ransom Humanities Research Center, the University of Texas at Austin (hereafter Agee Papers).

30. MoMA Artists Scrapbooks, Microfiche 2. Kevin Dacey brought this drawing to my attention.

31. Frederick J. Kiesler, "The Architect in Search of Design Correlation: A Column on Exhibits, the Theater, and the Cinema," *Architectural Record* 81 (February 1937): 14.

32. Untitled RA document, Shahn Papers, 5016F873.

33. Franklin Delano Roosevelt, quoted in *New York Times,* 14 November 1936, 3. For other contemporary reactions, see "Green-Belt Towns for the Machine Age," *New York Times Magazine,* 2 February 1936, 8–9, 18–19. For Greenbelt cost figures see Joseph Arnold, *The New Deal in the Suburbs: A History of the Greenbelt Town Program, 1935–54* (Columbus, Ohio, 1971), 55. For more on garden cities see Henry Wright, *Rehousing Urban America* (New York, 1935), and Paul Conklin, *Tomorrow a New World: The New Deal Community Program* (Ithaca, N.Y., 1959).

34. The title for *The Plow That Broke the Plains* derives from a Sioux saying. For a history of government-sponsored films see Robert L. Snyder, *Pare Lorentz and the Documentary Film* (Norman, Okla., 1968), and Richard Dyer MacCann, *The People's Films: A Political History of U.S. Government Motion Pictures* (New York, 1973).

35. Evans to Leyda, [October 1936], Leyda Papers. Both Shahn and Evans knew Lorentz, though more evidence exists for Evans's opinion of the filmmaker than Shahn's. Evans told Leyda that he admired Lorentz's RA productions ([October 1936], Leyda Papers). Near the end of his life, however, Evans referred to the work as "tedious" and "embarrassing" (slide lecture at the Fogg Art Museum in

conjunction with the exhibition *Ben Shahn as Photographer,* Cambridge, Mass., 13 November 1969). For Lorentz's criticisms of Evans's *American Photographs* (1938), see *Saturday Review,* 17 December 1938, 6. Evans and Shahn knew about the Greenbelt film no later than 7 October. See Evans to Stryker, 7 October 1936, Roy Stryker Papers, Photographic Archives, University of Louisville (hereafter Stryker Papers), Library of Congress microfilm, 1F208.

36. For the ending change of Lorentz's film, see Tom Gunning, "Cinematic Documentaries for the People," in Barbara Haskell, *The American Century: Art and Culture, 1900–1950,* exh. cat. (Whitney Museum of American Art, New York, 1999), 244.

37. Evans to Leyda, [October 1936], Leyda Papers.

38. Evans to Leyda, [October 1936], Leyda Papers. Shahn and Evans apparently had a minor quarrel over "petty matters" regarding the project (Evans to Leyda, 3 December 1936, Leyda Papers).

39. Grace E. Falke (Tugwell's secretary and his second wife) to Shahn, 19 October 1936, Shahn Papers, 5016F953; Evans to Leyda, [8 November 1936], Leyda Papers; M. E. Gilfond (director of the RA's Information Division) to Shahn, 6 November 1936, Shahn Papers, 5016F966.

40. Evans to Leyda, [8 November 1936], Leyda Papers. See scripts for *We Are the People,* Shahn Papers, 5016F859–5016F970. Both artists made annotations on their separate drafts. Shahn's file on the Greenbelt film also included plans for an RA animated cartoon script about the struggles of small farmers. It is unclear whether Shahn worked on this production.

41. See draft for *We Are the People,* Shahn Papers, 5016F911.

42. Analysis of Shahn and Evans's shooting script indicates that they were most likely interested in Paramount newsreel footage of Roosevelt's tour of Greenbelt with Tugwell and his assistant Will Alexander on 13 November 1936. Paramount would probably not have released such footage, however, since Will Hays, president of the Motion Picture Producers and Distributors of America and creator of a production and advertising censorship code, had ordered Hollywood studios to deny any RA requests for stock footage as a way of keeping the government out of movie making. Shahn clipped newspaper photographs on the Bonus March for his research files (Clippings File, Shahn Papers, 5024F1241. Also see Source File, "May Day," Shahn Papers, 5022F707–5022F717). An example of "we are the

people" was Louise V. Armstrong's *We Too Are the People* (Boston, 1938). Other proposed titles for Shahn and Evans's film included *What of These?* and *Where Shall They Turn?* Chalmers also narrated *The March of Time* newsreel series (1935–51).

43. Bernarda Bryson Shahn, in Rathbone, *Walker Evans*, 143. Bryson Shahn also inscribed a similar recollection on the verso of one of Shahn's photographs taken in Branchville. See Shahn, *Untitled (Branchville, Maryland),* November 1936, Fogg Art Museum, Harvard University Art Museums, gift of Bernarda Bryson Shahn, P1970.1831. Bryson Shahn most likely made this inscription while at the Fogg in late October 1972 during a series of interviews and discussions with Davis Pratt.

44. For brief discussions of Evans's filmmaking efforts before 1936 see Rathbone, *Walker Evans,* 88–89, 90 and Mellow, *Walker Evans,* 153. The sequencing of Shahn's negatives suggests that the two artists did not visit Greenbelt and Branchville on the same day, and they may not have even visited Greenbelt together. Alternatively, Evans may have filmed only in Branchville and not in Greenbelt itself. No evidence has been located to suggest that Shahn and Evans filmed other sections from their script.

45. Stryker to Evans, 9 November 1935, Stryker Papers, 4F48. The films were most likely silent. Stryker, interested in film's potential as a means of visual communication, believed that motion pictures could acquaint RA staff with areas receiving relief funds. He was also investigating a means of distributing educational sixteen millimeter film shorts to schools and civic organizations as part of his comprehensive efforts to familiarize the public with New Deal programming. See reports and correspondence, Stryker Papers, 4F431–4F468. It is highly likely then that Shahn, eager to try his hand at filmmaking, offered to experiment with the agency's movie cameras on his travels and report his findings to lab technicians in Washington. Evidence in the Shahn Papers indicates that the artist may have acted similarly when using the agency's still camera equipment (Arthur Rothstein to Shahn, 22 June 1938, Shahn Papers, 5007F134; Stryker to Shahn, 22 June 1938, Shahn Papers, 5007D132.) Unfortunately none of the footage seems to have survived, although this is not surprising given that the Documentary Film Unit, rather than Stryker's Historical Section or Adrian Dornbush's Special Skills Division, both of which Shahn was affiliated with, was responsible for RA film production.

46. The RA, which received WPA funding, adhered to WPA regulations aimed at creating jobs. Such regulations added an extra five million dollars to Greenbelt construction costs.

47. See Source File, "Houses," Shahn Papers, 5022F515–5022F549.

48. For a discussion of Shahn's proposed mural for Greendale, see Diana L. Linden, "The New Deal Murals of Ben Shahn: The Intersection of Jewish Identity, Social Reform, and Government Patronage" (Ph.D diss., City University of New York, 1997): 72–101.

49. On Shahn's greater interest in communities like Omar, see Richard Doud, interview with Shahn, Roosevelt, N.J., 14 April 1964, Archives of American Art, Smithsonian Institution.

50. For more on Jersey Homesteads, see Edwin Rosskam, *Roosevelt, New Jersey: Big Dreams in a Small Town and What Time Did to Them* (New York, 1972). Arthur Rothstein and other RA photographers documented the same Shenendoah Valley community in the 1930s. Shahn's photographs of this settlement constitute a heretofore unknown work in the artist's career. Robert Brown, formerly of the Boston regional office of the Archives of American Art, helped me locate this book maquette. Inslee Hopper first met Shahn on 7 December 1938 in the Bronx General Post Office, where the artist and Bernarda Bryson were painting a mural. After inspecting the artists' cartoons, Hopper indicated to Edward Bruce that a quotation from a Walt Whitman poem selected by Shahn and Bryson might be offensive to church interests, as proved to be the case.

51. For Tugwell's departure see Paul W. Ward, "The End of Tugwell," *The Nation,* 28 November 1936, 623. Tugwell submitted his resignation to President Roosevelt on 18 November 1936 and left on 31 December. Shahn attended a farewell party for Tugwell, who was also on the Advisory Board of TRAP. Shahn's and Evans's explanations for the cancellation are in Doud, interview with Shahn, and Evans to Leyda, 3 December 1936, Leyda Papers. For more on the RA's difficulties, see Baldwin, *Poverty and Politics,* 119. It is arguable that Shahn and Evans's plans for *We Are the People,* which they shared with several friends as well as various Washington RA staff members, influenced planning for *The City.* For a list of RA staff aware of the project, see RA "Transmittal Slip," 14 October 1936, Shahn Papers, 5016F860. Stryker stayed informed of the artists' progress, and M. E. Gilfond, Arch A. Mercey (who later became Pare

Lorentz's assistant), and J. Dreier may have assisted in minor capacities. Susan H. Edwards postulates that Shahn and Evans may have worked on *The City* ("Ben Shahn," 50).

52. Doud, interview with Shahn. Shahn was actually thirty-eight years old at the time.

53. For Stryker's letters to Shahn on the Washington Film Society, see Stryker to Shahn, 18 November 1937, Shahn Papers, 5007F116; 1 October 1937, Shahn Papers, 5007F103. A nonprofit organization presenting motion pictures "of unusual character," the Washington Film Society began showing films regularly on 7 May 1937 and collaborated frequently with the MoMA Film Library. Founders included Stryker, Lorentz (who rarely went to meetings but sent his assistant Mercey), and Charles L. Turner, who ran a film society at Yale University under the guidance of the Film Library. For Evans's film plans, see Evans to Leyda, [8 November 1936], Leyda Papers. Agee suggested doing a film on the lives of tenant families during the winter: Agee to Evans, [c. January 1937], Agee Papers. For pictures of Greenbelt's opening, see Source File, "Houses," Shahn Papers, 5022F535.

54. Arnold, *New Deal in the Suburbs,* 111. Arnold also explains that blacks could not apply for residency in Greenbelt (142–45). Legend has it that Evans gave the existing film footage to the Archives of American Art, and it was lost when he borrowed it later. (Other film footage by Evans, including his sixteen millimeter clips of Saratoga Springs [1931] and thirty-five millimeter shots of Tahiti [1931–32], resides in the MoMA Film Study Center.) A search of the following collections proved unsuccessful: Special Media Archives Division, National Archives and Record Administration; Motion Picture Division, Library of Congress; Shahn Papers; Taller Archive; and various film repositories. Jeff L. Rosenheim informed me that there is no material about the film in the Walker Evans Archive at the Metropolitan Museum of Art. Research on the Greenbelt project is further complicated because Evans's diary from 3 January 1936 through January 1937 is missing from the Evans Archive. Susan H. Edwards has also searched for the missing film footage to no avail ("Ben Shahn," 50). Shahn either printed the Greenbelt photographs himself or had them done privately since none bear RA cataloguing numbers or stamps. Numerous photographs of Greenbelt by other RA photographers do exist since many took advantage of the town's proximity to Washington to document the town's progress. It has been suggested but not

proven that some of Shahn's extant Greenbelt photographs are actually stills from the lost film footage. Brannan and Keller, "Walker Evans," 65. Penelope Dixon contends that the thirty-one-page pamphlet *Greenbelt Towns* (September 1936) reproduces photographs of Greenbelt by Shahn and Evans: Dixon, *Photographers of the Farm Security Administration: An Annotated Bibliography, 1930–1980* (New York, 1983), 213. I looked at the pamphlet, and to my knowledge none of the photographs were by Shahn. Moreover, it was published more than a month before Shahn and Evans officially began their Greenbelt project. I have not discovered any other publications from the period reproducing their photographs.

55. There are duplicate numbers on the versos of the prints, perhaps suggesting that Shahn created several sequential arrangements. Unlike the inscriptions on the Greenbelt photographs, the numbers marked on the verso of the majority of Shahn's RA/FSA images in his personal collection likely pertain to his filing system.

Images used as source material for later works include drawings from Shahn's *Coral Vets* series done for *Fortune,* September 1947, 72, 203. Other drawings from this commission that were not published in *Fortune* may also be based upon photographs related to the Greenbelt project. See the Taller Archive database for reproductions.

56. Shahn, quoted in John D. Morse, "Ben Shahn: An Interview," *Magazine of Art* 37 (April 1944): 136–37.

57. On various occasions Shahn mentioned the influence of newsreels on his art. See "Shahn Feels Deeply and Sees Clearly," *Art News,* 15–30 November 1944, 18; Shahn quoted in "Art: Angry Eye," 63; and Nadya Aisenberg, interview with Shahn, Boston, Mass., 1957. In his interview with Harlan Phillips, Shahn stated that newsreels of Roosevelt's funeral procession in part inspired *Blind Accordion Player* (1945) (cat. 36), a painting based on cats. 33, 34. For a discussion of the work relating to fig. 37 see Frances K. Pohl, "Ben Shahn and *Fortune* Magazine: Representations of Labor in 1946," *Labor's Heritage* 1 (January 1989): 46–55. Shahn also did drawings for the documentary *Ambassador Satchmo [The Saga of Satchmo]* (1956), a film about Louis Armstrong, and advertisements for a film version of *Porgy and Bess* (c. 1958), which apparently was never produced. See correspondence between Shahn and William H. Schneider, 26 September–31 December 1958, Shahn Papers, D143F798–D143F803.

58. Shahn in fact included a representation of Tugwell in

the Jersey Homesteads mural: he stands in the foreground wearing a red armband and surveying the construction. For identification of the other figures, see Frances K. Pohl, "Constructing History: A Mural by Ben Shahn," *Arts Magazine* 62 (September 1987): 39. The Taller Archive database indicates that at one time the *Greenbelt* study, still part of Shahn's estate, may have hung on a wall in the artist's garage.

59. Shahn, quoted in Morse, "Ben Shahn," 140. For discussions of murals and films see Charmion Von Wiegnand, "David Alfaro Siqueiros," *New Masses* 11 (1 May 1934): 18–21, and Oliver Larkin, *Art and Life in America* (New York, 1949), 441. Shahn's friend Diego Rivera even compared panels in his Rockefeller Center mural to movie screens. See Irene Herner, "Diego Rivera: Paradise Lost in Rockefeller Center Revisited," in *Diego Rivera: Art and Revolution,* exh. cat. (Cleveland Museum of Art, 1999), 252.

60. WCBS-TV, interview with Shahn, 1965, Shahn Papers, 5023F1321. For similar statements by Shahn on numerous occasions see Kostelanetz, *On Innovative Art(ist)s,* 170; and Phillips, interview with Shahn.

61. Doud, interview with Shahn.

Chapter 4: The Politics of Media

This essay was originally published in *American Art* 7 (Winter 1993): 61–87, during my tenure as a fellow at the Smithsonian Institution's Research and Scholars Center. I am grateful to the editors of *American Art* for permission to reprint it here in revised form. Thanks are also extended to Jules Prown, Jonathan Weinberg, Frances K. Pohl, and Mary Panzer for reading drafts of the earlier version, and Bernarda Bryson Shahn, Virginia Mecklenburg, Cindy Ott, Alan Tansman, Yoshiko Wada, Alan Wallach, and the late Stephen Lee Taller for their generous support of my work at that time. I am especially indebted to Beverly W. Brannan, who initially recommended this essay for publication.

1. James Thrall Soby to Shahn, 16 December 1946, Shahn Papers, D147F1433. Although MoMA had been collecting and exhibiting American art since its opening in 1929, the museum was generally perceived as Eurocentric.

2. Soby to Shahn, 18 September 1947, Shahn Papers, D147F1450.

3. See Merry Foresta, "Art and Document: Photography of the Works Progress Administration's Federal Art Project," in Pete Daniel et al., *Official Images: New Deal Photography* (Washington, D.C., 1987), 154; Beaumont Newhall, "Photography and the Artist," *Parnassus* 6 (October 1934): 24.

4. Diane Tepfer, "Edith Gregor Halpert and the Downtown Gallery Downtown: 1926–1940: A Study in American Art Patronage" (Ph.D. diss., University of Michigan, 1989), 98–101; Charles Sheeler referring to Halpert's opinion, quoted in Theodore E. Stebbins, Jr., and Norman Keyes, Jr., *Charles Sheeler: The Photographs,* exh. cat. (Museum of Fine Arts, Boston, 1987), 40; also see 44, 47–48, 51–52.

5. *The Painter and the Silver Icon* was Coke's original title. Halpert cooperated with Coke but was initially "puzzled" by his theme and hoped for "a fuller explanation" (Halpert to Coke, 10 May 1963, Shahn Papers, 5010F82). She encouraged Shahn to choose the pairings of paintings and photographs for the book (Halpert to Shahn, 14 September 1963, Shahn Papers, 5010F12; Halpert to Shahn, 11 October 1963, Shahn Papers, 5010F611). Early on, however, Halpert did exhibit Shahn's photographs as they appeared in a page spread of *New Theatre,* November 1934 (*Practical Manifestations in American Art,* Downtown Gallery, 13–31 December 1934).

6. Bernarda Bryson Shahn to Davis Pratt, 17 August 1969, Department of Photographs, Fogg Art Museum. Bryson Shahn was supportive of the Fogg's efforts to note Shahn's achievements as a photographer, but she did not want her husband promoted simply as a painter who used photography. She has always acknowledged the importance of photography to Shahn's art and vision but asserts that he did not use photography as a sketchpad for notes, as an adjunct to painting, or as a substitute for drawing. Based upon statements by Shahn, she believes that he put down his Leica in the early 1940s because it began to trap him into a certain point of view: Bernarda Bryson Shahn, *Ben Shahn* (New York, 1972), 133–35; author's interviews with Bernarda Bryson Shahn, Roosevelt, N.J., and Skowhegan, Me., 1989–93.

7. See James Thrall Soby, *Ben Shahn,* exh. cat (Museum of Modern Art, 1947), 13; and Selden Rodman, *Portrait of the Artist as an American: Ben Shahn, a Biography with Pictures* (New York, 1951), 96.

8. Nancy Newhall, "Ben Shahn," *Photo Notes* (November 1947): 3; Clement Greenberg, "Art," *The Nation,* 1 November 1947, 481.

9. The reviews are Robert Coates, "The Art Galleries: Contemporary Americans," *New Yorker,* 11 October 1947, 62, and Joseph Solman, "The Art of Ben Shahn," *New Masses* 65 (4 November 1947): 22; on modernist views see Andy Grundberg and Kathleen McCarthy Gauss, *Photogra-*

phy and Art: Interactions Since 1946, exh. cat. (Los Angeles County Museum of Art, 1987), 15; Paul Strand, "Photography," *Seven Arts* 2 (August 1917): 524–26, reprinted in *Photographers on Photography,* ed. Nathan Lyons (Englewood Cliffs, N.J., 1966), 136–37; and Strand, "Correspondence on Aragon," *Art Front* 3 (February 1937): 18.

10. Frances K. Pohl, *Ben Shahn: New Deal Artist in a Cold War Climate, 1947–1954* (Austin, 1989), 57; Greenberg, "Art," 481. Greenberg saw photography as a lower art form than painting, aesthetically conservative, and too dependent on external reality to be truly modern.

11. Soby to Shahn, 16 December 1946, Shahn Papers, D146F1433; Soby, *Ben Shahn,* 12–14.

12. John Szarkowski, *Looking at Photographs: One Hundred Pictures from the Collection of the Museum of Modern Art* (New York, 1973), 118; on MoMA, see Christopher Phillips, "The Judgment Seat of Photography," in *The Contest of Meaning: Critical Histories of Photography,* ed. Richard Bolton (Cambridge, Mass., 1989), 14–47.

13. The situation was complex because Shahn and MoMA were attacked in the late 1940s for both "aesthetic conservativeness" and "political radicalism" (Pohl, *New Deal Artist,* 76). Soby did not want "to soft pedal Shahn's political stand and activity" in the *MoMA Bulletin.* Along with Alfred H. Barr, Jr., and others, Soby defended Shahn against the conservative backlash and included his political posters in the MoMA exhibition, despite the disapproval of an elderly museum trustee. Soby even wanted to write later about the painter's use of photographs (Soby to Rene d'Harnoncourt and Monroe Wheeler, 3 July 1947, James Thrall Soby Papers, Museum of Modern Art, I.35–36.12). Ironically, Nancy Newhall praised Soby for "helping establish a more profound evaluation of the relation between painting and photography" ("Ben Shahn," 3). Shahn's photographs were in MoMA's collection as early as 1938 and periodically included in group exhibitions from the 1930s onward. The artist also participated in photography symposia and maintained good relations with Edward Steichen, chairman of the Photography Department at MoMA from 1947 to 1961. On 19 April 1944 Willard D. Morgan included Shahn in a panel "Photography and the Other Arts" held at MoMA. Shahn was also asked by MoMA to write an article on Henri Cartier-Bresson for the May 1947 issue of *Magazine of Art;* his comments appeared in John D. Morse's review in that same issue of MoMA's Cartier-Bresson exhibition (189).

14. Richard Doud, interview with Shahn, Roosevelt, N.J., 14 April 1964, Archives of American Art, Smithsonian Institution.

15. Shahn's most significant statements on photography include Shahn to Ann Henry, 17 June 1940, Shahn Papers, 5007F236; John D. Morse, "Ben Shahn: An Interview," *Magazine of Art* 37 (April 1944): 136–41; Shahn, "Photos for Art," *U.S. Camera* 9 (May 1946): 30–32, 57; Shahn, quoted in John D. Morse, "Henri Cartier-Bresson," *Magazine of Art* 40 (May 1947): 189; Shahn, quoted in Walter Rosenblum, "What Is Modern Photography?" *American Photography* 45 (March 1951): 147; Shahn, "In the Mail: Art vs. Camera," *New York Times,* 13 February 1955, sec. 2, p. 15; Shahn, "The Biography of a Painting," in Shahn, *The Shape of Content* (Cambridge, Mass., 1957), 40–41; Doud, interview with Shahn; Shahn, "Autobiography," part 2, 1965, Taller Archive; Arthur Goldsmith, "Ben Shahn: An Unfinished Interview," *Technical Photography* 1 (July 1969): 29, 33.

16. Frederick Lewis Allen, *Since Yesterday: The Nineteen-Thirties in America, September 3, 1929–September 3, 1939* (New York, 1940), 211. Also see "The U.S. Minicam Boom," *Fortune,* October 1936, 124–29, 160–70. On the Leica's exaggerated role in the development of a new kind of picture story and on the role publicity played in promoting the success of the Leica, see Colin Osman and Sandra S. Phillips, "European Visions: Magazine Photography in Europe Between the Wars," in *Eyes of Time: Photojournalism in America,* ed. Marianne Fulton (Boston, 1988), 84.

17. For aesthetic and practical reasons, editors and engravers at the time resisted thirty-five millimeter photography. Working with small negatives could be difficult, and enlarging them often produced grainy results. See Sally Stein, "FSA Color: The Forgotten Document," *Modern Photography* 43 (January 1979): 163; and F. Jack Hurley, *Portrait of a Decade: Roy Stryker and the Development of Documentary Photography in the Thirties* (Baton Rouge, 1972), 42. Major events in miniature-camera history occurred in 1935–36, when Leica promoters Willard D. Morgan and Henry M. Lester published *The Leica Manual* (1935), Kodachrome film became commercially available in the thirty-five millimeter format, and *Life* magazine appeared on newsstands.

18. On "serious amateurs," see Douglas Collins, *The Story of Kodak* (New York, 1990), 226–27. For Shahn's views on these matters see Doud, interview with Shahn; Shahn, quoted in Morse, "Henri Cartier-Bresson"; and Shahn, "Photos for Art." Artist-photographers like Berenice Abbott and Ansel Adams also disliked the technical obsession

of the miniature-camera craze; Adams felt that "the appalling number of gadgets" made thirty-five millimeter work "a nightmare for the serious student" (Adams, "The Expanding Photographic Universe," in *Miniature Camera Work,* ed. Willard D. Morgan and Henry M. Lester [New York, 1938], 74). Dismissing technique and fancy equipment could also be a way to preserve the mystique of the artistic process. In the early 1930s Steichen, Edward Weston, and Cecil Beaton, for example, boasted of their inexpensive cameras and lenses. See Frank Crowninshield, "Foreword," in *U.S. Camera Annual* (1939), 10–A. In 1936 Ralph Steiner refused to provide *U.S. Camera* with technical information on his photographs, claiming that the request was as silly as asking a painter what type of canvas he used or a writer what kind of typewriter he employed. See *U.S. Camera Annual* (1936), Index.

19. Colin L. Westerbeck, Jr., "Ben Shahn: Artist as Photographer," *Connoisseur* 211 (October 1982): 100–101. Shahn, who worked for Adrian Dornbush of the RA's Special Skills Division, enjoyed a certain freedom since he was not officially under Stryker's supervision for much of his involvement with the RA/FSA.

20. On Shahn printing his own pictures, see Doud, interview with Shahn. For Stryker's advice, see, for example, Roy Stryker to Shahn, 26 July 1938, Shahn Papers, 5007F145. Shahn handwrote on a letter from Stryker: "All my Leica life yearning for fast film and when I got it couldn't believe my meter" (Stryker to Shahn, 2 August 1938, Shahn Papers, 5007F147). The RA/FSA file editor Edwin Rosskam felt that Shahn exaggerated his illiteracy in photography: Rosskam, "Los años de la depresión," in *Ben Shahn: Dibujos y fotografías de los años treinta y cuarenta,* intro. Manual Fernandez Miranda, exh. cat. (Salas Pablo Ruiz Picasso Museum, Madrid, 1984), 23.

21. Shahn's self-portrait was also informed by Ilya Ehrenburg's politicized self-portraits, which show the renowned Russian Jewish novelist and foreign correspondent armed with his Leica and viewfinder on the opening pages of *Moi Parizh (My Paris)* (Moscow, 1933).

22. Shahn ironically referred to himself at the time of his travels as a tourist photographer (Bernarda Bryson Shahn, "Ben Shahn: Fotografías y pinturas," in *Ben Shahn: Dibujos y fotografías,* 11). Many of Shahn's Asian photographs—details of sculpture and monuments—are far from conventional postcard views, however. According to one Japanese source he captured sides of Kyoto that were unknown to even most Japanese. See *Geijutsu-Shincho* 9 (1991): 138–39. Although Shahn did not want an exhibition of his photographs at the Kennedy Galleries in the 1960s, he was supportive of group exhibitions and publications on the RA/FSA project in the last two decades of his life.

23. Shahn's clipping and source files were donated by Bryson Shahn to the Archives of American Art in the early 1990s. Shahn's files were inspired by the New York Public Library Picture Collection and the RA/FSA archive. Alan Trachtenberg interpreted the way the RA/FSA photographs are classified and used as an embodiment of New Deal cultural values: Trachtenberg, "From Image to Story: Reading the File," in *Documenting America, 1935–1943,* ed. Carl Fleischhauer and Beverly W. Brannan (Berkeley, 1988), 43–73. Although Shahn's files are not as systematized or theoretically conceived as these examples, they are not completely arbitrary either.

24. Ziva Amishai-Maisels, *Depiction and Interpretation: The Influence of the Holocaust on the Visual Arts* (Oxford, 1993), 76–80; Amishai-Maisels, "Ben Shahn and the Problem of Jewish Identity," *Jewish Art* 12 (1986–87): 318, 306.

25. On this subject see Cecile Whiting, "Politics of Propaganda During the Second World War," in *Antifascism in American Art* (New Haven, 1989), 133–69.

26. On Shahn's requests for photographs, see Shahn to Stryker, 20 September 1940, Shahn Papers, unmicrofilmed. On the impact of the RA/FSA trips on his art, see Doud, interview with Shahn. For the painting-photography debates, see Goldsmith, "Ben Shahn: An Unfinished Interview," 29. On photographs as working tools, see author's interview with Van Deren Coke, Santa Fe, N.M., 9 July 1990; and Morse, "Ben Shahn," 138.

27. See, for example, writings and interviews by Shahn published in John D. Morse, ed., *Ben Shahn* (London, 1972), 41–58; and Shahn, "Biography of a Painting," 25–52.

28. Ann Sargent Wooster, "Ben Shahn," *Art News* 76 (February 1977): 124.

29. As one of the rare extant uncut strips of film in Shahn's oeuvre, this roll is invaluable for gaining insight into his working process. On its discovery, see above, chapter 1, note 72.

30. Shahn was documenting the Lower East Side at a turning point in the history of immigration in the United States. Because of stricter immigration laws that were especially harsh on Southern and Eastern Europeans, "during the years between 1931 and 1936, the number of aliens em-

igrating from the United States had been larger each year than the number immigrating . . . and the sound of foreign languages would be heard less and less in the streets of American cities" (Allen, *Since Yesterday,* 169–70).

31. See, for example, James Lager, ed., *Leica Literature: 1930–1960* (Dobbs Ferry, N.Y., 1980), 241–47.

32. *Photographer's Window* and its alternate title, *Contemporary American Photography,* may have been a response to Evans's book *American Photographs* (1938), which includes his 1936 photographer's window. On *American Photographs,* see Alan Trachtenberg, *Reading American Photographs: Images as History, Mathew Brady to Walker Evans* (New York, 1989), 231–85. Shahn may also have conceived of *Photographer's Window* as a companion piece to his now unlocated painting *Contemporary American Sculpture* (1939), a critical commentary on the state of American sculpture. *Photographer's Window* was entitled *Contemporary American Photography* in Alfred H. Barr, Jr., and Dorothy Miller, eds., *Americans, 1943: American Realists and Magic Realists,* exh. cat. (Museum of Modern Art, New York, 1943), 66, and in *Shahn Paintings,* a Downtown Gallery exhibition that ran from 14 November to 2 December 1944.

33. Although the urban clients in Shahn's window are probably upwardly mobile working-class ethnic immigrants of Shahn's milieu, in juxtaposition with the rural poor, they are transformed into a more privileged group of people, hence my use of the term "middle-class."

34. James Curtis, *Mind's Eye, Mind's Truth: FSA Photography Reconsidered* (Philadelphia, 1989), viii–ix, 32, 45–67.

35. Maren Stange, *Symbols of Ideal Life: Social Documentary Photography in America, 1890–1950* (New York, 1989), xv. Stange saw the RA/FSA photographs as radical because they questioned capitalism and technological progress in the way they recorded the exodus of agricultural workers from their farms. For critical discussions of the documentary tradition see the writings of Martha Rosler, Allan Sekula, Terence Smith, Abigail Solomon-Godeau, Sally Stein, and John Tagg, among others.

36. As a committed New Dealer, Shahn believed in the goals of the RA/FSA. But he and his colleagues were also aware of the ideological implications of their pictures and their potential for being used, even abused, by different individuals and institutions for their own political ends. See Doud, interview with Shahn.

37. Shahn was one of the important figures in the early years of the RA/FSA project, and Stryker continued to consult him even after Shahn resigned in 1938. Although they maintained warm and friendly relations over the years, Shahn expressed contradictory views about both Stryker and the government. See Doud, interview with Shahn.

38. Stryker to Shahn, 10 July 1938, Shahn Papers, 5007F142; Maren Stange, "The Management of Vision: Rexford Tugwell and Roy Stryker in the 1920s," *Afterimage,* March 1988, 6–10. For a well-balanced account of Stryker's direction of and concession of control to photographers on the RA/FSA and Standard Oil projects, see Ulrich Keller, *Highway as Habitat: A Roy Stryker Documentation, 1943–1955,* exh. cat. (University Art Museum, Santa Barbara, Calif., 1985), 33–38. For a more critical assessment of Stryker's position, see Stange, *Symbols of Ideal Life,* 89–131.

39. Shahn explained, "I felt I had more control over my own medium than I did over photography. Extraneous material entered into it that I couldn't control in photography except in very few instances where I felt there was a total picture" (Doud, interview with Shahn).

40. See Stein, "FSA Color"; and Stein, "The Rhetoric of the Colorful and the Colorless: American Photography and Material Culture Between the Wars" (Ph.D. diss., Yale University, 1991).

41. Stein, "FSA Color," 92. I am grateful to Sally Stein for sharing her insights with me on this subject. Author's phone conversation with Stein, January 1993.

42. New Deal culture spawned a worker imagery in which hands featured prominently, as seen in Shahn's own posters. Many 1930s artists aligned themselves with manual workers as a fellow propertyless class; socially minded photographers were even referred to as "workers" in journals of the period. Shahn later admitted his biases against those who did not produce with their hands, which he attributed to craftsmanship in his Lithuanian family background. See Doud, interview with Shahn.

43. Elizabeth McCausland, "First International Show of Photography," *Springfield Union and Republican,* 24 April 1938, Roy Stryker Papers, Archives of American Art, NDA9F428. McCausland, "American Photography in Representative Show," *Springfield Sunday Union and Republican,* 24 October 1937, 6E, Stryker Papers, NDA9F426. Nonetheless, many interactions occurred between painters and photographers, as is evident in Barbara Morgan's efforts to organize a photography exhibition for the American Artists' Congress in 1937. Photographers like Bourke-White, Abbott, and Strand belonged to the congress, although they

had to fight to secure a special section for creative photography, working with a committee led by painters.

44. Stryker, quoted in Keller, *Highway as Habitat,* 33; Stein, "FSA Color," 94; Doud, interview with Shahn; Stange, *Symbols of Ideal Life,* 108.

45. Shahn wrote: "I feel that the status of painting as an art is a higher one than that of photography not because the one is responsible, the other irresponsible, but simply because painting is able to call much more out of the artist himself and is able to contain a fuller expression of the artist's own capacities than in photography": Shahn, "In the Mail: Art vs. Camera," sec. 2, p. 15.

Note to the Reader

DATING

Shahn rarely dated his New York photographs. In later years the artist and his family and friends would tell various anecdotes about his first efforts in photography, based on which scholars have attempted to construct a chronology. Yet this is difficult because many of the stories are inconsistent. We try here to place these diverse bits of testimony in a context that will provide a general guide to dating Shahn's earliest photographs. A number of sources establish that Shahn made his first pictures in 1931. For instance, the inscription in the artist's hand on catalogue number 44 dates the image "c. 1931–2." Shahn's oldest daughter Judith believes that her father began photographing at this time and that he probably owned several cameras before he acquired a Leica.[1] Conflicting stories exist as to when he obtained his secondhand Model A Leica with which he took the majority of his New York photographs. (The model, with its signature "hockey stick" screwplate and noninterchangeable fifty millimeter Leitz lens, came out in 1925.) But even if the artist did not own a camera, he could have borrowed one from various friends, such as the photographers Walker Evans and Paul Grotz.[2] In interviews conducted in the mid-1960s, Shahn remembered receiving advice from Evans about f-stops and exposure times on the day Evans left New York for a trip to Tahiti; an entry in Lincoln Kirstein's diary records that he, Grotz, and Shahn saw Evans off to the South Seas on or around 30 December 1931.[3]

More conclusive evidence indicates that Shahn began photographing seriously in 1933 or 1934. The artist recounted that his younger brother Philip purchased a used Leica for him on the condition that the artist would be able to publish images from his first roll of film in a national magazine; if they were not published, Philip would keep the camera.[4] The earliest known publication of Shahn's photographs is a spread in the November 1934 issue of *New Theatre* (see fig. 4), then the organ of the League of Workers Theatres, Workers Dance League, and New York Film and Photo League (with which Shahn was affiliated). A number of scholars have therefore dated Shahn's first activities as a documentary photographer to the fall of 1934. Philip, however, denied that there was a bet, claiming to have given his brother a camera as an outright gift sometime in 1933.[5]

By the time Shahn was working on his Prohibition mural study in the winter and spring of 1933–34, he was handling the camera with a certain degree of sophistication. Contact strips of negatives related to one panel of the mural study reveal that Shahn moved with apparent ease through the crowded sidewalks of Manhattan making compelling portraits as well as group studies. Analysis of the prints Shahn made from these

negatives, however, suggests that he either felt less comfortable in the darkroom or was interested primarily in making photographs for study purposes. The majority of Shahn's photographs from this group (cats. 74–76) are small "work" prints (generally 11.5 × 16.5 cm) that typically lack tonal range. In contrast, those of Shahn's photographs that can be dated with certainty to 1934 and 1935 are printed larger (generally 16.5 × 24.5 cm) and show evidence of the artist's growing technical proficiency with burning, dodging, and cropping images to achieve particular effects. Moreover, like many of his colleagues, Shahn frequently mounted and titled—and occasionally signed—his "finished" prints from this period (see, for example, cat. 3).

The artist Lou Block provided yet another account of Shahn's first efforts at photography. Block claimed that he and Shahn learned to photograph in the late spring of 1934 for their collaborative mural project at the Rikers Island Penitentiary.[6] As part of their research they documented prison life and the experiences of the poor on the Lower East Side. According to Block, it was Evans who suggested that they photograph rather than sketch their subjects. Yet the elegance of Shahn's portraits of prisoners made in preparation for his Rikers Island mural indicates that he was already accomplished with the camera. On the other hand, Shahn's photographs of the 1934 May Day parade, a particularly complex scene to capture with large crowds of demonstrators moving through the streets, are more tentative and technically immature than those he made a year later at the same event. As Shahn proceeded to photograph more intensely in New York in 1934 and 1935, his skills with the camera and in the darkroom developed quickly.

So although it is not possible to establish a definitive timeline for the New York photographs based on this fragmented and often contradictory evidence, we nonetheless believe that Shahn occasionally photographed in the city between 1931 and 1933 but that by late winter or early spring 1934 his interest in making his own photographs had intensified significantly. He continued to document life on the streets of New York until September 1935, when he moved to Washington, D.C., to work for the Resettlement Administration. Among the limited number of photographs that Shahn is known to have made in New York after fall 1935 is an important roll of film from April 1936 (cat. 123). The specific dates provided in this catalogue are the result of research that included a comparative study of related extant negatives and contact strips.

ILLUSTRATIONS

Illustration captions include title, date, dimensions, and credit lines. Unless otherwise indicated, the artist is Shahn. All photographs are gelatin silver prints. Image measurements are cited for each art object, and sheet measurements are used for ephemera like newspaper clippings and magazines. In every instance, height precedes width. Entries for objects held in the collections of the Fogg Art Museum, Harvard University Art Museums, include accession numbers.

MOUNTS AND TITLES

Like many of his colleagues, Shahn frequently mounted his "finished" prints. Typically he trimmed the sheet of photographic paper to the edge of the image and then affixed the photograph with glue to heavy paper stock or board. In some cases he subsequently trimmed the mount to the edge of the image. Photographs that Shahn treated in this manner are clearly distinguished both aesthetically and technically when compared to his "work" prints. In choosing images for *Ben Shahn's New York* we were guided by his practice of differentiating "finished" photographs from work prints.

Shahn periodically inscribed titles on the recto of his mounted photographs, typically on the left side of the mount beneath the image. These are the only instances in which we indicate titles for the photographs. On the verso of his prints and mounts the artist also frequently noted the location in the city where he had photographed the scene depicted. This practice occurs in both Shahn's finished photographs and his work prints. We put this information, as well as identification of where his images were created that we have gained by other research, in parentheses on the title line of the caption.

THE NEGATIVES

For his New York photographs Shahn used the following film brands common to the period: Dupont, Perutz, Agfa, and Kodak. Family members recollect that Shahn "stored" his strips of negatives between pages of books. Intact rolls of negatives were kept in standard metal film canisters in his studio in Roosevelt, New Jersey. More than five hundred of the artist's original thirty-five millimeter negatives made in New York in the early 1930s survive and are held in the collection of the Fogg Art Museum.

Except for the occasional cases where intact negative and contact strips remain, the exact sequencing of Shahn's New York negatives cannot be definitively determined. The majority of the artist's rolls of negatives and negative strips were cut apart after his death into individual frames and inserted into slide mounts, presumably for archival and storage purposes. Evidence as to when this occurred is unclear. Efforts to reconstruct sequences of the New York negatives are further complicated by Shahn's use of bulk-loaded film, which often did not have individual frame numbers. Shahn's extant contact strips reveal a limited amount of information about the order of negatives. Not one of these strips consists of more than three frames, however.[7]

Several of the photographs in this catalogue have been produced by Chicago Albumen Works from modern prints of the original negatives. In one instance an original contact strip containing three sequential frames is reproduced (fig. 11). In three places, modern prints were made from rare intact examples of Shahn's original negative strips (fig. 34, cats. 85, 123).

Digital scans of Shahn's original thirty-five millimeter negatives, which are available through the *Ben Shahn at Harvard* website (see below), provide reasonable facsimiles for research purposes.

SHAHN'S SOURCE AND CLIPPINGS FILES

For the majority of his career, Shahn maintained research files as part of his working process. These typically contain newspaper and magazine clippings, prints of his documentary photographs and those of his RA/FSA and OWI colleagues, as well as various other types of ephemera. When working on a project, Shahn often requested photographs from government, news, and photography agencies. Throughout the catalogue, reference is made to the titles that the artist himself gave to his source files. Shahn also assembled general files of newspaper clippings.

MAJOR RESEARCH RESOURCES FOR SHAHN'S PHOTOGRAPHS

Ben Shahn Papers, Archives of American Art, Smithsonian Institution, Washington, D.C. The Archives of American Art houses Shahn's personal papers, including the clipping and alphabetized source files he assembled over the course of his career. Also in the artist's papers are approximately sixty New York photographs, close to fifty RA/FSA photographs (including more than a dozen contact strips), and a smaller body of photographs that were made later in Shahn's life. The papers are available on microfilm.

Fogg Art Museum, Harvard University Art Museums More than five thousand photographs (prints, contact strips, and negatives) by Shahn are housed at the Fogg Art Museum. They include most of his earliest New York photographs, prints of many of his RA/FSA photographs, and works that represent his occasional return to the medium in the postwar era. Of the latter, a large group of photographs that were made on a trip to Asia in 1960 are particularly fascinating. The majority of these images represent the artist's personal collection of his own photographs, which were donated in 1970 by Bernarda Bryson Shahn. The Fogg's complete holdings of Shahn's work can be viewed on the *Ben Shahn at Harvard* World Wide Web site, accessible through the URL: http://www.artmuseums.harvard.edu

Farm Security Administration/Office of War Information (FSA/OWI) File, Prints and Photographs Division, Library of Congress The thousands of known photographs Shahn made for the Resettlement Administration and Farm Security Administration from 1935 to 1938 are filed with the eighty-eight thousand captioned prints that make up the FSA/OWI file. For more on this resource see Carl Fleischhauer and Beverly W. Brannan, eds., *Documenting America, 1935–1943* (Berkeley, 1988), 330–42. Various libraries, including the Fine Arts Library at Harvard, contain the FSA/OWI file on microfiche. *America, 1935–1946: Index to the Microfiche* (Cambridge, England, 1981) provides a useful guide to this material.

Stephen Lee Taller Ben Shahn Archive, Fine Arts Library, The Harvard College Library and Fogg Art Museum Donated by Dolores Taller in 1999, the research archive at the Fine Arts Library contains more than eight thousand items by or about Shahn, including a wide range of books, manuscripts, ephemera, and audio and visual tapes, as well as an important database of resources. The component of the Taller Archive housed at the Fogg Art Museum contains a substantial collection of Shahn's graphic art.

University of Louisville About forty extant photographs that Shahn made at the Blackwell's Island Penitentiary and the New York City Reformatory are in the collection of the university's Photographic Archives, also home to the Roy Stryker Collection, which contains a modest selection of Shahn's New York and RA/FSA photographs. Correspondence and ephemera related to Shahn and Lou Block's Rikers Island Penitentiary mural project can be viewed in the Lou Block Papers at the Margaret M. Bridwell Art Library.

NOTES

1. See Susan H. Edwards, interview with Judith Shahn, 6 January 1995. Quoted in Susan H. Edwards, "Ben Shahn: A New Deal Photographer in the Old South" (Ph.D. diss., City University of New York, 1996), 35.

2. Paul Grotz lent his Leica to Walker Evans in 1929. See Jerry L. Thompson, *Walker Evans at Work* (New York, 1982), 44. Shahn could have also borrowed cameras from his friends Philip Van Doren Stern and Dr. Iago Galdston, both amateur photographers.

3. See Richard Doud, interview with Shahn, Roosevelt, N.J., 14 April 1964, and Harlan Phillips, interview with Shahn, Roosevelt, N.J., 3 October 1965, Archives of American Art, Smithsonian Institution. Excerpts from both these interviews are reprinted in the appendix. For Kirstein entry, see James R. Mellow, *Walker Evans* (New York, 1999), 146. Paul Grotz remembered witnessing Evans's casual lesson (Belinda Rathbone, interview with Paul Grotz, New York City, 1 March 1990).

4. See Doud, interview with Shahn, and Phillips, interview with Shahn. The artist made this statement so often that it has become lore in Shahn scholarship.

5. See Morris Dorsky, "The Formative Years of Ben Shahn: The Origin and Development of His Style" (M.A. thesis, New York University, 1966), p. 115, n. 33. Dorsky conducted an interview with Philip, who recollected that Shahn complained about not having a camera, saying that he could do more with one, "that it was like making sketches." Philip also told Dorsky that he had been given a twenty-five-dollar gold coin as a Christmas present, to which he added another ten dollars to purchase a used Leica for his brother. In the interview with Harlan Phillips, Shahn stated that his used Leica cost twenty-five dollars.

6. See Harlan Phillips, interview with Lou Block, Louisville, Ky., 31 May 1965, Archives of American Art, Smithsonian Institution.

7. Kevin Dacey, assistant in the Department of Photographs at the Fogg Art Museum, researched this material. His findings appear as part of the *Ben Shahn at Harvard* online database. Also see Laura Katzman, "The Politics of Media: Ben Shahn and Photography" (Ph.D. diss, Yale University, 1997), 117–18, 120.

Exhibition Catalogue

Greenwich Village and Environs

In 1932 Ben Shahn, his first wife, Tillie Goldstein, and their young daughter, Judith, moved from Brooklyn Heights into a Greenwich Village apartment on 23 Bethune Street, two blocks east of the Hudson River. The photographer Walker Evans, the painter and photographer Lou Block, and the film critic Jay Leyda intermittently occupied the first-floor workshop, while the painter Moses Soyer lived in the third-floor flat. Although Shahn had moved his family to 333 West Eleventh Street by November 1934, he continued to maintain a studio with Evans and Block at 20–22 Bethune Street. Shahn had been drawn to the Village by its reputation for social tolerance and progressive politics; there he had easy access to the city's radical arts organizations, as well as to Edith Halpert's Downtown Gallery, where his work was frequently exhibited.

Shahn's photographs palpably evoke the feeling of walking through the neighborhood streets, where the artist courted unexpected perspectives and used the area's eclectic architecture to frame his subjects. Shahn focused on residents gazing out their windows or sitting on stoops, children playing or reading comics on the sidewalks, and merchants and shoppers on Bleeker Street (the heart of Little Italy). These working-class residents interested the artist far more than the historic sites or bohemian activities of the Village. On visits to Washington Square Park with his family Shahn chose to document locals resting on benches or visiting with their neighbors (cat. 16) rather than Stanford White's monumental arch. He later celebrated the characters who enlivened this human theater in his comical painting *Nearly Everybody Reads the Bulletin* (1946) (cat. 17).

Shahn was particularly intrigued by how youngsters coped during the Depression, and many of his Village photographs feature children playing handball, stickball, and sidewalk games. Some of these images reveal the artist's concern for the painful isolation that children experienced when excluded from group games. The melancholy *Greenwich Village* (1932–35) (cat. 3), for example, shows a wistful boy standing alone, physically and emotionally separated from his peers, who huddle together with their backs to the viewer. For Shahn this portrait may well have resonated with the sense of alienation he endured as an immigrant child growing up in Brooklyn's poor neighborhoods.

Shahn continued to draw on his observations of Depression-era children in later work. The somber painting *Girl Skipping Rope* (1943) (cat. 7), based in part on the artist's photographs of Village children, portrays a boy and girl in front of a dilapidated building. Although depicted at play, the two do not look at each other; each is absorbed in a private

world. Shahn painted this tempera during World War II, when he was employed as a graphic artist for the Office of War Information and was encountering disturbing photographs and newsreels of destroyed European cities. Yet even in this bleak portrayal, Shahn suggests the bittersweet resilience of these adolescents, as he did in his New York photographs of children during the 1930s.

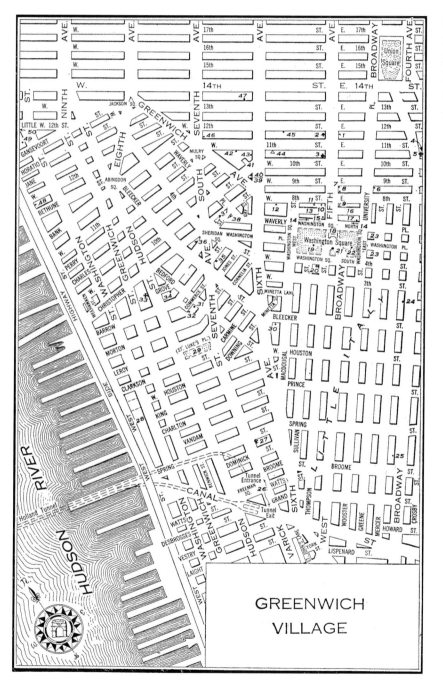

FIGURE 43
Federal Writers' Project,
Map of Greenwich Village
In *New York City Guide*
(New York, 1939), 127
19 × 12 cm

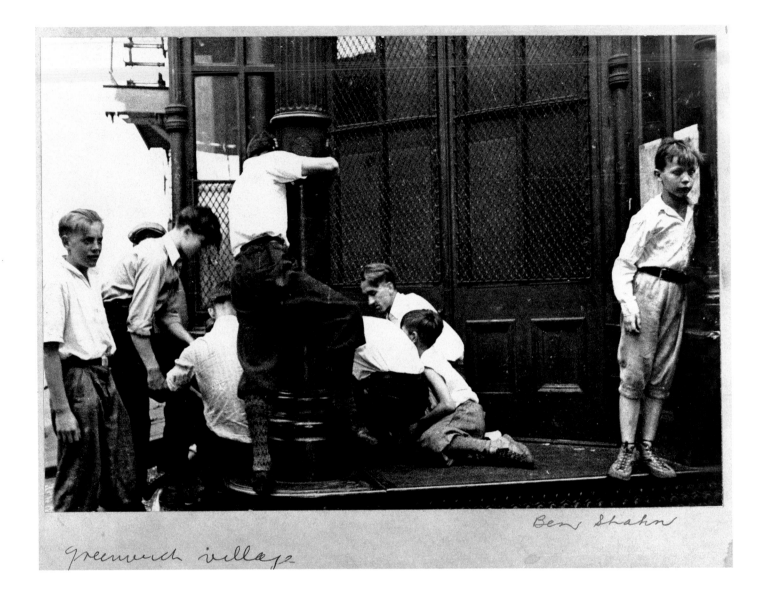

Greenwich village

Ben Shahn

3. *Greenwich Village (New York City)*, 1932–35, 16 × 24.2 cm
Fogg Art Museum, gift of Bernarda Bryson Shahn, P1970.2476

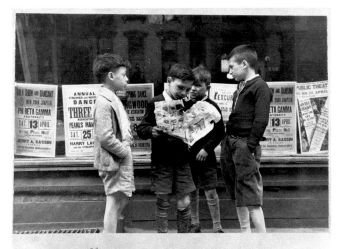

4. *Greenwich Village
(New York City)*, 1935
15.9 × 24.1 cm
Fogg Art Museum, gift of
Bernarda Bryson Shahn,
P1970.2771

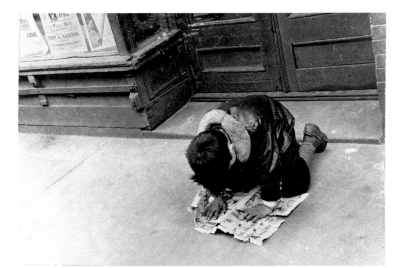

5. *Untitled
(Greenwich Village, New York City)*
1935, 15.3 × 23.1 cm
Fogg Art Museum, gift of
Bernarda Bryson Shahn,
P1970.2934

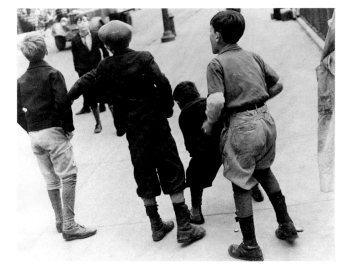

6. *Untitled
(New York City)*, 1932–35
17.5 × 23 cm
Fogg Art Museum, gift of
Bernarda Bryson Shahn,
P1970.2939

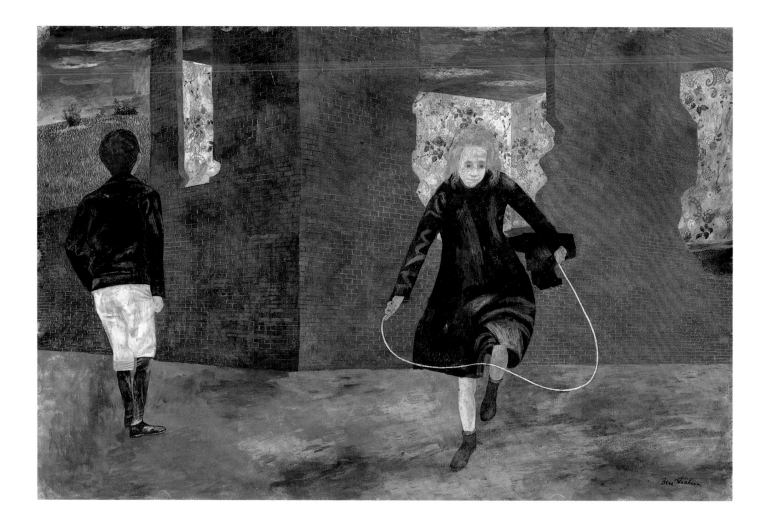

7. *Girl Skipping Rope,* 1943, Tempera on paper mounted to masonite, 40.3 × 60.6 cm
Museum of Fine Arts, Boston, gift of the Stephen and Sybil Stone Foundation

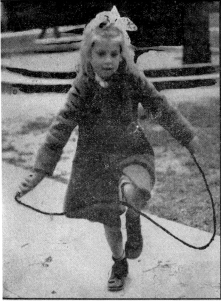

8. Newspaper clipping, c. 1937

14.2 × 10.2 cm

Source File, "Children," Shahn Papers

9. *Untitled (Calumet, Pennsylvania),* 1935, 19.4 × 24.6 cm

Fogg Art Museum, gift of Bernarda Bryson Shahn,

P1970.1675

10. *Untitled,* c. 1940, Graphite on tracing paper, 11.1 × 23.7 cm

Terry Dintenfass Gallery Inc., in association with Salander O'Reilly Galleries, New York City

Houston St Playground

11. *Houston St. Playground (New York City),* 1932–35, 15.9 × 24.3 cm

Fogg Art Museum, gift of Bernarda Bryson Shahn, P1970.2205

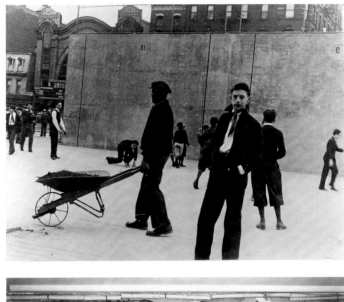

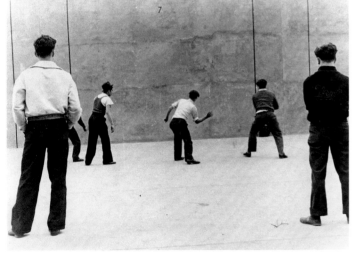

top left
12. *Untitled (Houston Street Playground, East Houston Street, New York City),* 1932–35, 15.7 × 24.2 cm
Shahn Papers

top right
13. *Untitled (Houston Street Playground, East Houston Street, New York City),* 1932–35, 17.5 × 24.5 cm
Fogg Art Museum, gift of Bernarda Bryson Shahn, P1970.2463
Shahn reversed the negative for this printing.

bottom left
14. *Untitled (Houston Street Playground, East Houston Street, New York City),* 1932–35, 15.1 × 22.8 cm
Fogg Art Museum, gift of Bernarda Bryson Shahn, P1970.2478

bottom right
15. *The Meaning of Social Security,* mural in progress, east wall, Social Security Building (now Wilbur J. Cohen Federal Building), 1940–42
National Archives and Records Administration, Record Group 121

16. *Untitled*
(Washington Square North,
New York City), 1932–35
14.2 × 20.2 cm
Terry Dintenfass Gallery Inc.,
in association with Salander
O'Reilly Galleries, New York City

17. *Nearly Everybody Reads the*
Bulletin, 1946, Gouache and ink
55.9 × 76.2 cm
Philadelphia Museum of Art,
The Louis E. Stern Collection

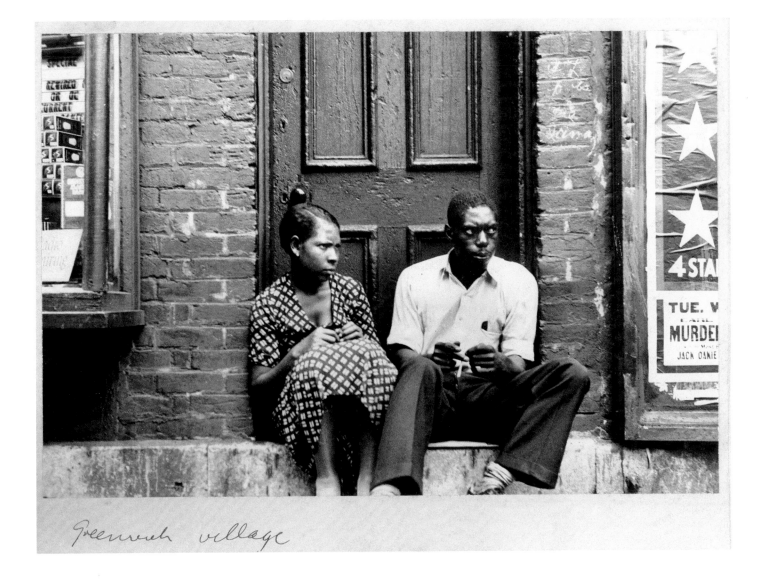

Greenwich village

18. *Greenwich Village (New York City)*, 1932–34, 16.2 × 24.3 cm
Shahn Papers

19. *Untitled (Greenwich Village, New York City)*, 1932–35, 15.2 × 24.2 cm
Fogg Art Museum, gift of Bernarda Bryson Shahn, P1970.3133

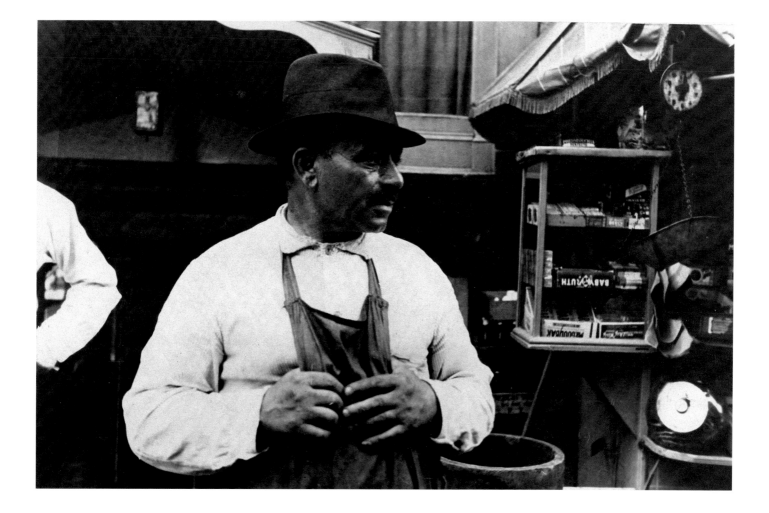

20. *Untitled (Greenwich Village, New York City),* 1932–35, 14.5 × 22.9 cm
Fogg Art Museum, gift of Bernarda Bryson Shahn, P1970.2851

21. *Untitled (West Street, New York City),* 1933–35, 15 × 22.8 cm
Terry Dintenfass Gallery Inc., in association with Salander O'Reilly Galleries, New York City

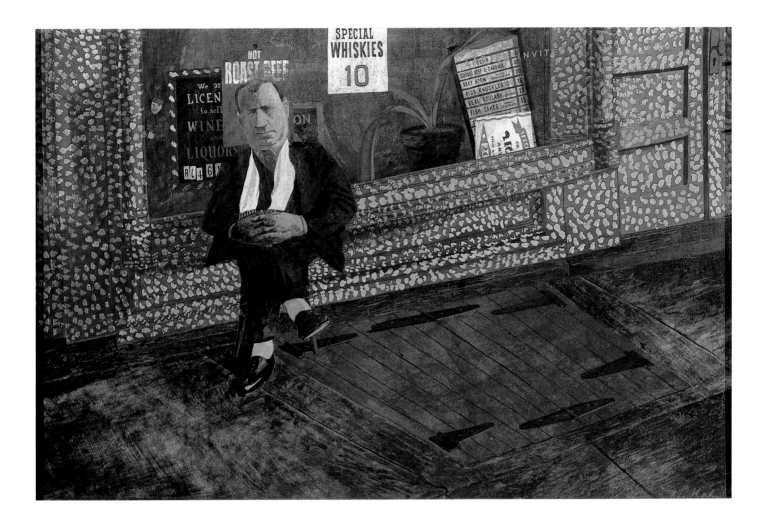

22. *Seurat's Lunch,* 1939, Tempera on masonite, 50.5 × 75.9 cm
Collection Museum of Contemporary Art, Chicago, gift of the Mary and Earle Ludgin Collection

23. *Untitled (Fifteenth Street or Bethune Street, New York City),* 1932–34, 14.2 × 20.5 cm
Fogg Art Museum, gift of Bernarda Bryson Shahn, P1970.2871

24. *Untitled (Fifteenth Street or Bethune Street, New York City),* 1932–34, 15.2 × 22.6 cm
Fogg Art Museum, gift of Bernarda Bryson Shahn, P1970.2857

25. *Untitled (Morton Street, New York City),* 1932–35, 15.9 × 24 cm

Fogg Art Museum, gift of Bernarda Bryson Shahn, P1970.2853

Union Square and Fourteenth Street

Shahn frequently visited the Union Square and Fourteenth Street district, commonly known as the poor man's Fifth Avenue. Said by the Federal Writers' Project to belong to the working people of New York, this mecca of retail trade, cheap amusements, and leftist politics posed particular challenges for a photographer. Jostling crowds of shoppers from such large department stores as S. Klein overflowed onto the streets and gathered around vendors and sidewalk entertainers. The headquarters for the Socialist and Communist parties, as well as the radical New Workers' School and the American Civil Liberties Union, were located in the area and contributed to its chaotic and robust character.

It was in this bustling neighborhood that Shahn claimed to have first realized the value of photography in recording fleeting details and freezing movement. Attempting to sketch the activity of a group of area musicians, he realized that the adaptable Leica would enable him to move easily through the crowd and capture the performers from a variety of angles and perspectives. From these photographs Shahn composed the tempera *Blind Accordion Player* (1945) (cat. 36). In this later context, a musician, plucked from the specificity of the New York streets and placed into a foreboding landscape, becomes Shahn's allegorical troubadour, sounding a ballad of international despair at the death of the New Deal president, Franklin Delano Roosevelt, and the carnage of World War II.

Many New York artists of the 1930s, most notably Reginald Marsh, Kenneth Hayes Miller, and Raphael Soyer, accentuated the congestion of the Union Square and Fourteenth Street area. Shahn, however, imbued the district with an uncharacteristic visual elegance. He singled out shoppers, vendors, businessmen, office workers, demonstrators, and entertainers, discovering amid the clamor and density unforgettable individual expressions. Shahn took particular interest in the shoppers gazing into tantalizing storefront displays, and he often photographed men and women against window reflections in order to create a more expansive sense of space. Interiors and exteriors seem to merge in these photographs, resulting in spatial inversions that inspired Shahn to experiment with printing his negatives in reverse (cats. 29, 30). The Fourteenth Street and Union Square district called upon Shahn's ability to isolate such found-montages within the modern urban milieu. It was photography that allowed him to produce kaleidoscopic images that contrasted the pageant of abundance with the actuality of poverty.

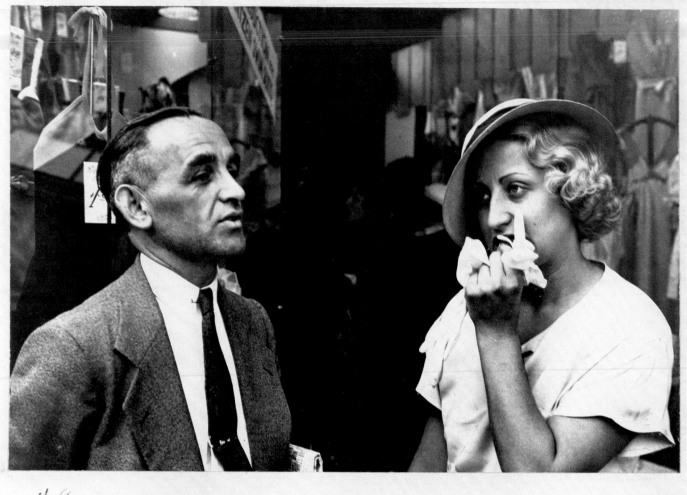

14th St.

26. *14th St. (New York City),* 1932–34, 16 × 24.3 cm

Fogg Art Museum, gift of Bernarda Bryson Shahn, P1970.3122

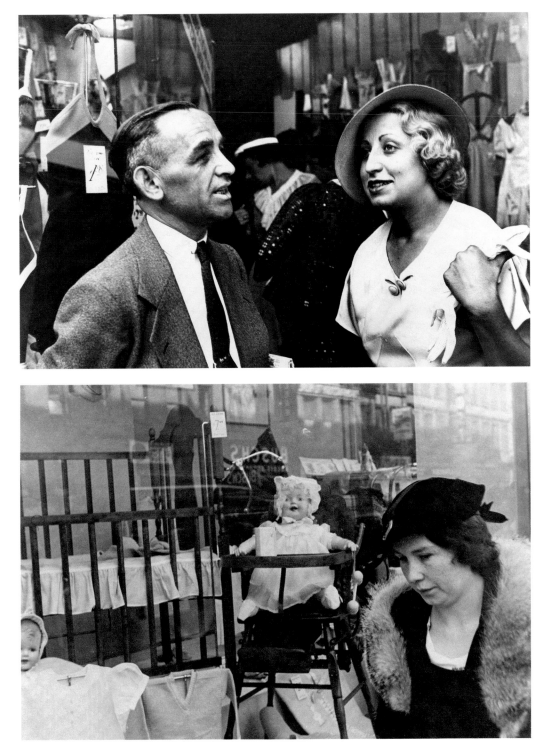

27. *Untitled*
(Fourteenth Street, New York City)
1932–34, 16 × 24.3 cm
Fogg Art Museum, gift of
Bernarda Bryson Shahn,
P1970.3142

28. *Untitled*
(Union Square and Fourteenth Street
District, New York City), 1932–35
16 × 23.5 cm
Fogg Art Museum, gift of
Bernarda Bryson Shahn,
P1970.2830

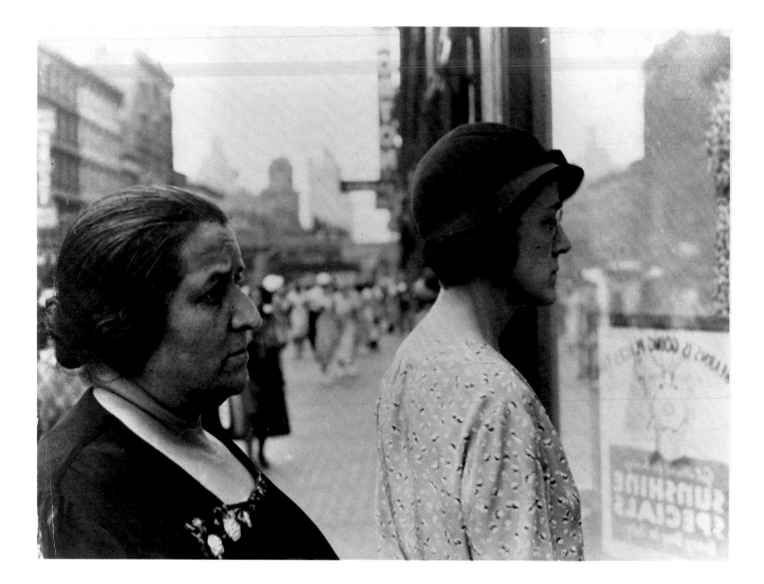

29. *Untitled (Union Square and Fourteenth Street District, New York City)*, 1932–35, 17.7 × 24.1 cm
Fogg Art Museum, gift of Bernarda Bryson Shahn, P1970.2079
Shahn reversed the negative for this printing.

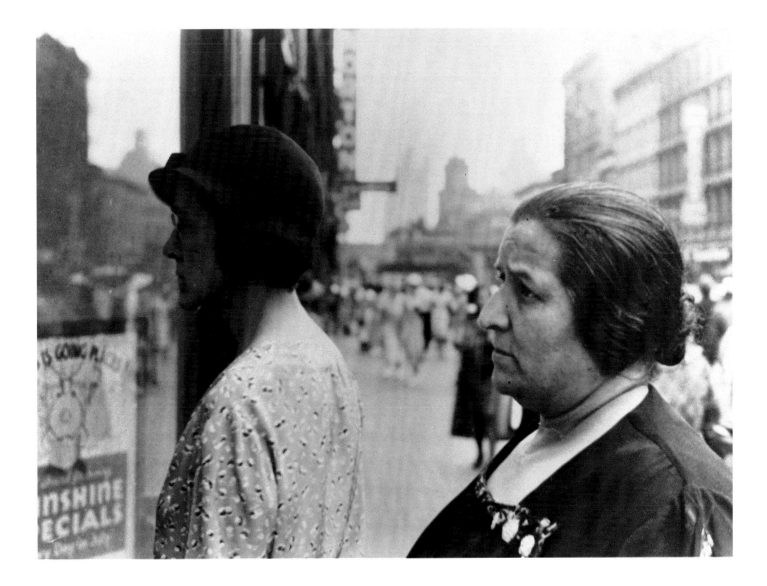

30. *Untitled (Union Square and Fourteenth Street District, New York City),* 1932–35, 17.8 × 24.3 cm

Fogg Art Museum, gift of Bernarda Bryson Shahn, P1970.3152

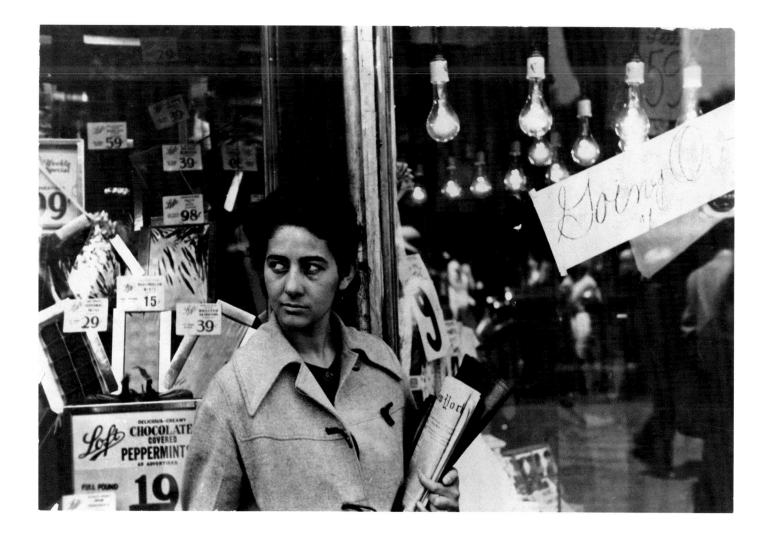

31. *Untitled (Fourteenth Street, New York City),* 1932–35, 15 × 22.8 cm
Howard Greenberg Gallery, New York City

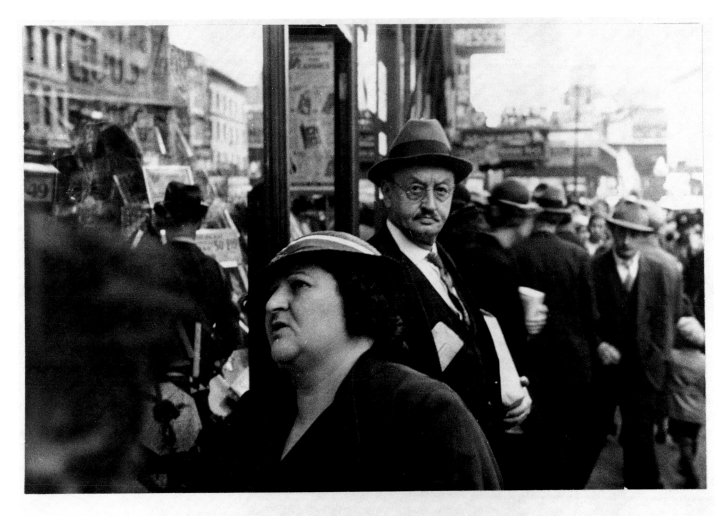

14th St.

32. *14th St. (New York City),* 1932–34, 15.7 × 24.3 cm
Fogg Art Museum, gift of Bernarda Bryson Shahn, P1970.2837

33. *Untitled (Fourteenth Street, New York City)*
1932–34, 20.3 × 15.5 cm
Fogg Art Museum, gift of
Bernarda Bryson Shahn,
P1970.2091

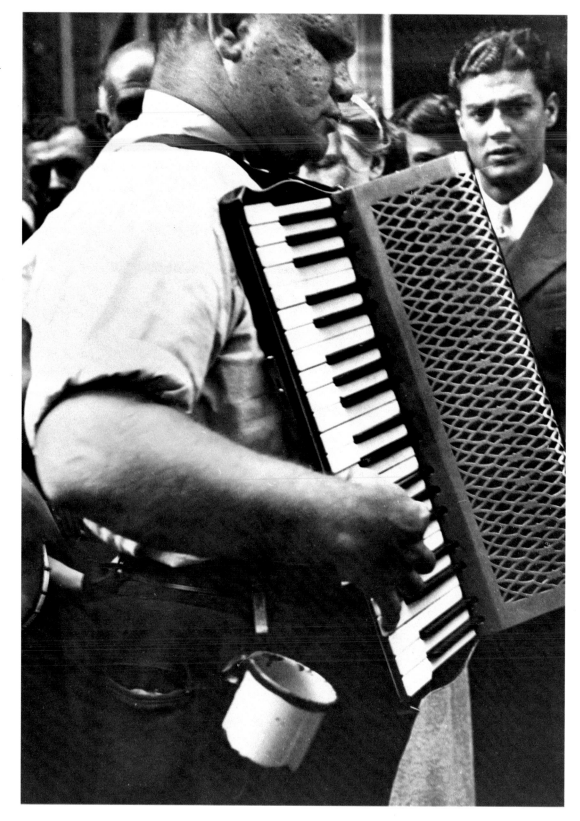

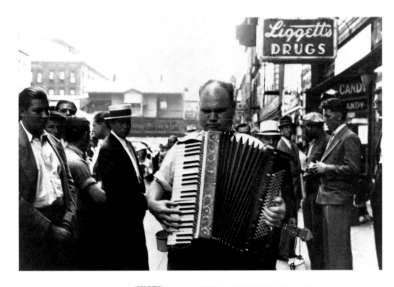

34. *Untitled*
(Fourteenth Street, New York City)
1932–34, 16.1 × 24.1 cm
Fogg Art Museum, gift of
Bernarda Bryson Shahn,
P1970.3146

35. *Accordion Player,* c. 1944
Pencil on paper, 17.8 × 21.6 cm
Collection Neuberger Museum
of Art, Purchase College,
State University of New York,
gift of Roy R. Neuberger

36. *Blind Accordion Player*
1945, Tempera on board
64.8 × 97.8 cm
Collection Neuberger Museum
of Art, Purchase College,
State University of New York,
gift of Roy R. Neuberger

14th St.

Ben Shahn

37. *14th St. (New York City)*, 1932–34, 15.8 × 24.2 cm
Shahn Papers

The Lower East Side

No sector of Manhattan captivated Shahn more than the Lower East Side, which he explored as an adolescent while apprenticing at a lithography shop at 101 Beekman Street. Immigrants of diverse nationalities inhabited this impoverished area, providing the city with a continual supply of cheap labor, as described by the Federal Writers' Project: "Here have dwelt the people whose hands built the city's elevateds, subways, tubes, bridges, and skyscrapers. Its two square miles of tenements and crowded streets magnify all the problems typical of New York. . . . From its dark tenements, generations of American workers of many different national origins . . . have emerged" (108).

During the early to mid-1930s the Lower East Side dominated Shahn's photographic repertoire. There he pictured residents of Little Italy, Orchard Street merchants, Bowery "down-and-outers," and men gathered in Seward Park and the South Street piers. Shahn's compelling photographs of the indigence that plagued the region contrasted with the dramatic vistas of the city's downtown skyscrapers that were being popularized in the work of Berenice Abbott (fig. 7). Indeed, Shahn's representations of the Lower East Side's living theater number among the most discerning of the era.

Continually drawn to the human dimension of this blighted district, Shahn created intimate portraits of area residents, as exemplified by the resolute middle-aged women in an untitled photograph (cat. 42) and the pensive girls in a work the artist inscribed "Jewish children, between 1st and 2nd AVE NYC c. 1931–2" (cat. 44). In Seward Park, located in the heart of the old Jewish section, Shahn observed the expressive gestures and dress that distinguished a group of men sitting on a park bench. These figures so engaged the artist that he further memorialized them in the lithograph *Seward Park* (1936) (cat. 61). Occasionally Shahn's own children accompanied him on his photographic sojourns on the Lower East Side. His daughter Judith fondly recalls Sig. Klein's Fat Men's Shop at 52 Third Avenue, where she posed in front of a window display comprised of oversized garments and comical signage (cat. 38).

In a remarkable group of photographs portraying a Greek merchant, a Greek American businessman, and an African American laborer (cats. 52, 54–57), Shahn contemplated the diverse races, nationalities, and classes that occupied the Lower East Side. In spite of their apparent proximity to one another, these men remain absorbed in their own thoughts, isolated visually by the distinctive architectural elements that separate them. Shahn translated precisely such qualities into the tempera *Three Men* (1939) (cat. 53), one of the most sophisticated examples of his use of his photographs as source material. In

Three Men, the artist situates the viewer directly in front of the figures, on a sidewalk in the Lower East Side. To further enhance the sense of a moment glimpsed by a passerby, Shahn painted a reflected view of the street as part of the plate-glass window behind the black man, a visual effect reminiscent of the photographs he made of store windows and their reflections on Fourteenth Street. Thus not only did the subject matter of Shahn's photographs inform his paintings, but the quality of the quickly captured image influenced his approach to composition itself.

FIGURE 44
Federal Writers' Project,
Map of the Lower East Side
In *New York City Guide*
(New York, 1939), 111
19 × 12 cm

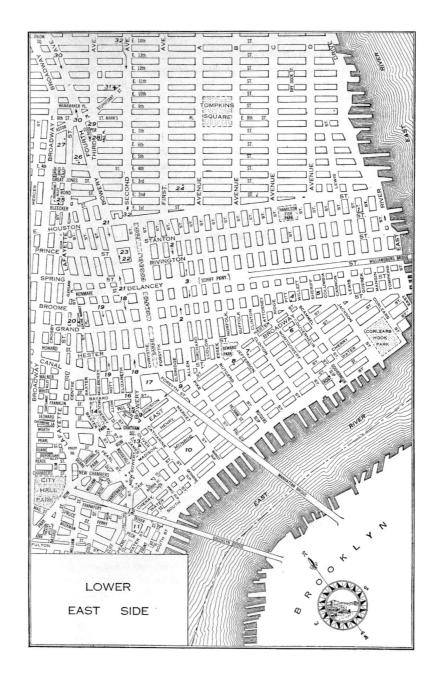

182

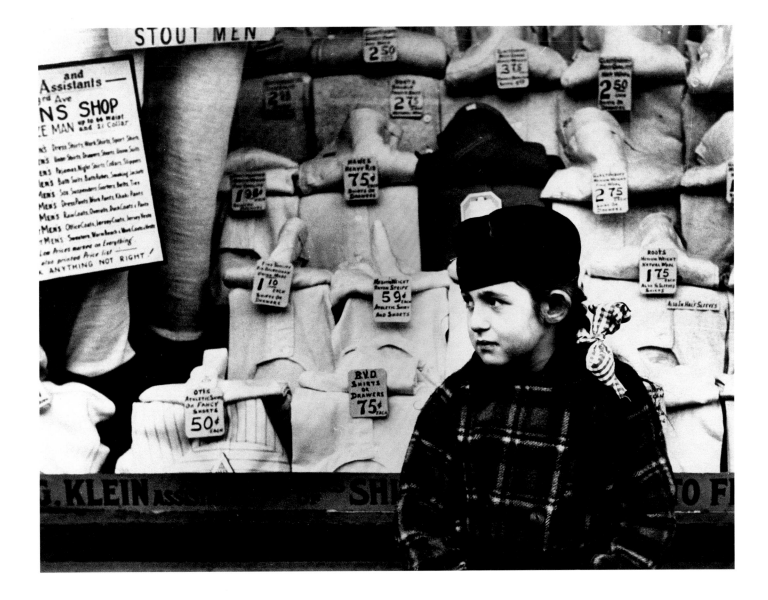

38. *Untitled (Judith Shahn, Sig. Klein Fat Men's Shop, 52 Third Avenue, New York City),* 1935–36, 18.9 × 24.4 cm
Fogg Art Museum, gift of Bernarda Bryson Shahn, P1970.195

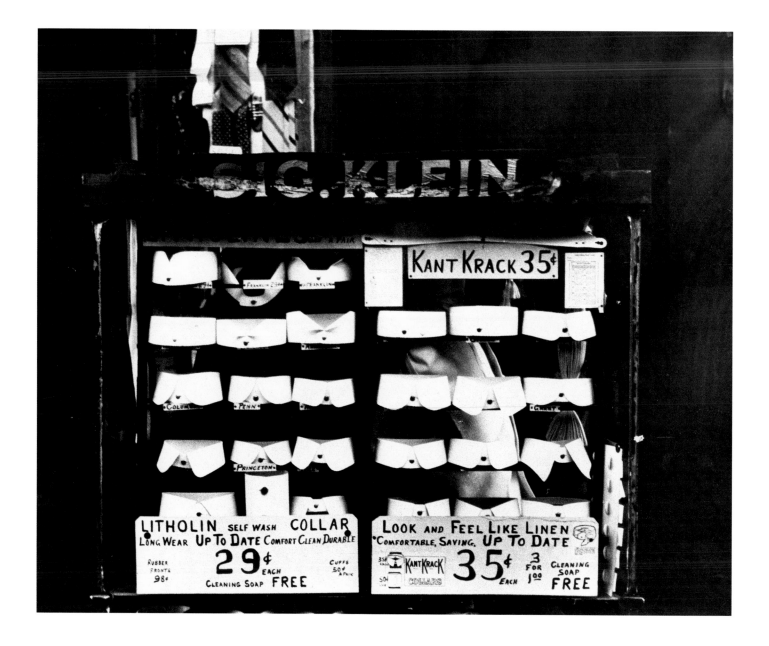

39. *Untitled (Sig. Klein Fat Men's Shop, 52 Third Avenue, New York City),* 1935–36, 18.2 × 22.7 cm
Fogg Art Museum, gift of Bernarda Bryson Shahn, P1970.2208

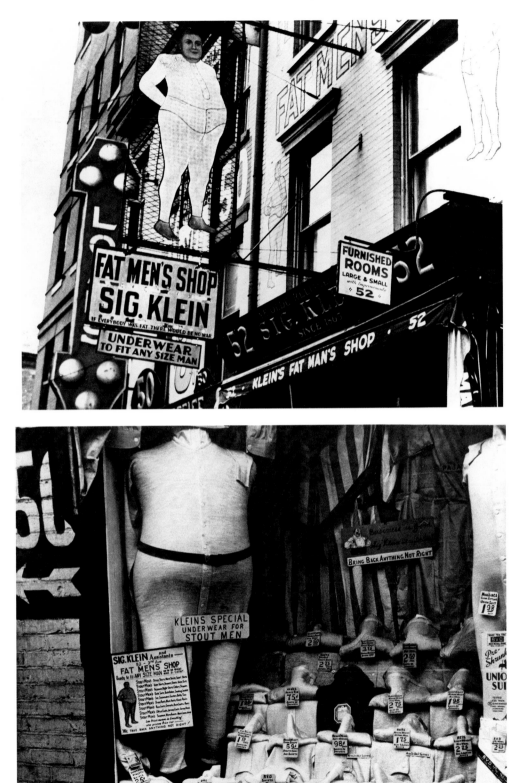

40. *Untitled*
(Sig. Klein Fat Men's Shop,
52 Third Avenue, New York City)
1935–36, 19 × 24.5 cm
Fogg Art Museum, gift of
Bernarda Bryson Shahn,
P1970.2926

41. *Untitled*
(Sig. Klein Fat Men's Shop,
52 Third Avenue, New York City)
1935–36, 18.4 × 24.3 cm
Shahn Papers

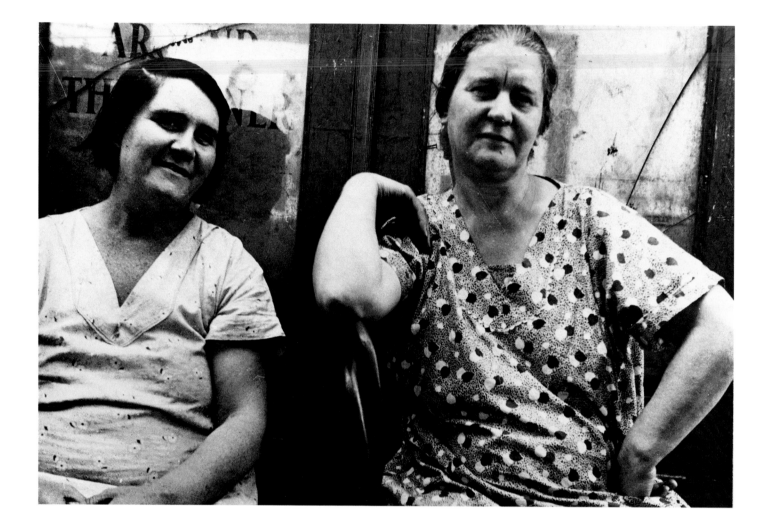

42. *Untitled (Elizabeth Street, New York City),* 1932–35, 16.4 × 24.4 cm
Fogg Art Museum, gift of Bernarda Bryson Shahn, P1970.2829

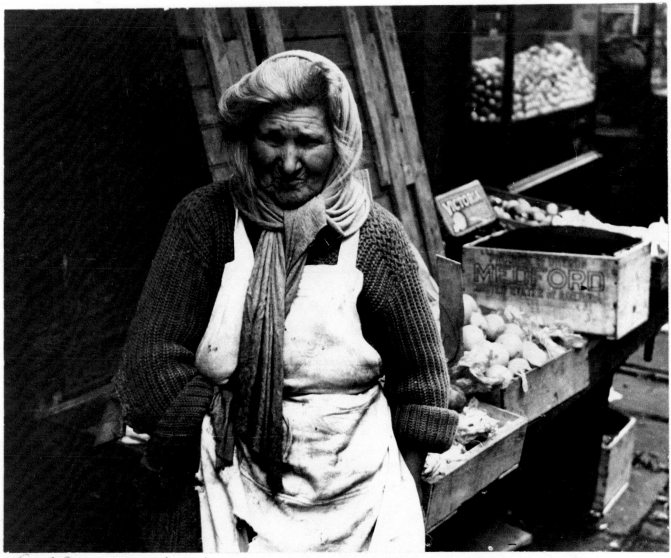

East Side merchant

43. *East Side Merchant (New York City),* 1932–35, 18.9 × 24 cm

Fogg Art Museum, gift of Bernarda Bryson Shahn, P1970.2854

44. *Untitled (Jewish children, between First and Second Avenues, Lower East Side, New York City)*
c. 1931–32, 17.5 × 24 cm
Shahn Papers

45. *Renascence,* 1946
Gouache on Whatman
hotpressed board, 55.6 × 76.2 cm
Collection Fred Jones Jr.
Museum of Art, University of
Oklahoma, State Department
Collection

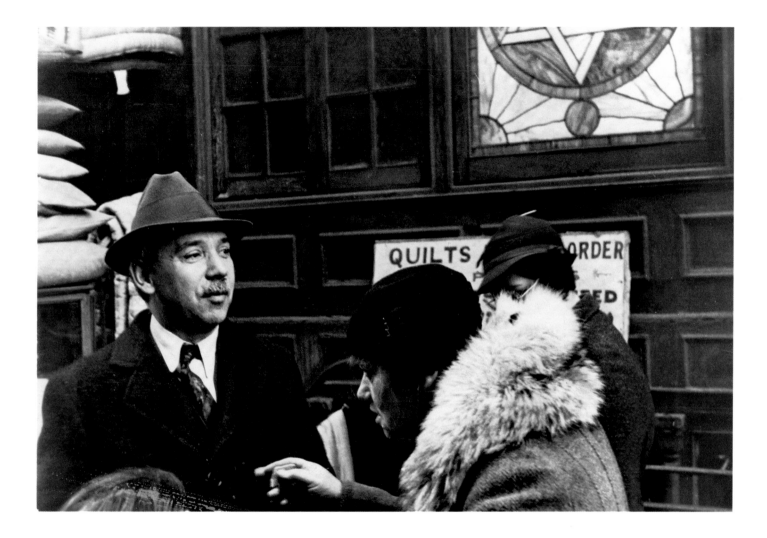

46. *Untitled (Orchard Street, New York City),* 1932–35, 15 × 22.6 cm
Fogg Art Museum, gift of Bernarda Bryson Shahn, P1970.2908

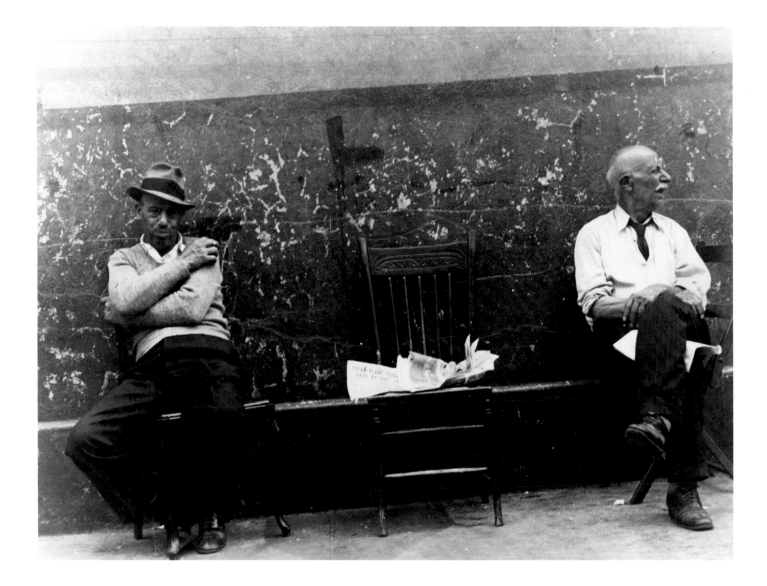

47. *Untitled (New York City),* 1932–35, 16.4 × 22.6 cm

Fogg Art Museum, gift of Bernarda Bryson Shahn, P1970.2873

48. *Democracies Fear New Peace Offensive (Spring, 1940),* 1940, Tempera on paper, 36.2 × 54.3 cm

Collection Museum of Contemporary Art, Chicago, promised gift of the Mary and Earle Ludgin Collection

49. *Untitled (Bowery, New York City),* 1932–34, 16.4 × 24.7 cm

Fogg Art Museum, gift of Bernarda Bryson Shahn, P 1970.2460

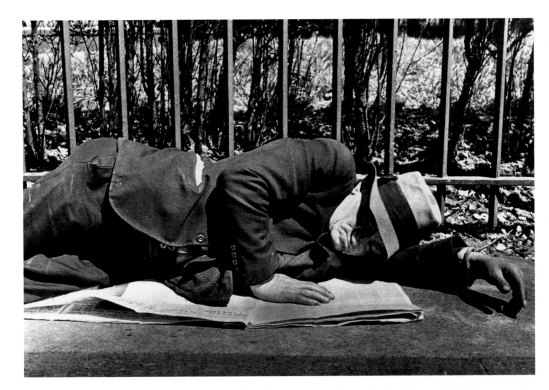

50. *Untitled*
(probably Fourth Avenue,
Lower East Side, New York City)
1932–34, 15.8 × 23.8 cm
Fogg Art Museum,
gift of Bernarda Bryson Shahn,
P1970.2864

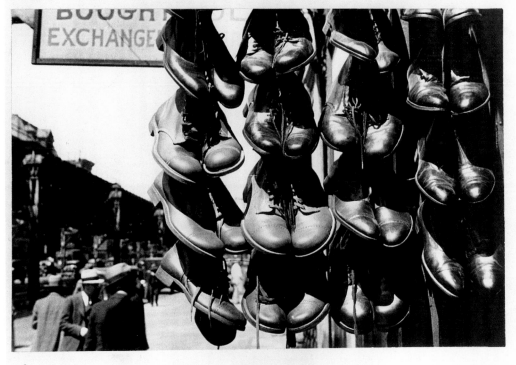

51. *Bowery*
(New York City)
1932–35, 16 × 24 cm
Shahn Papers

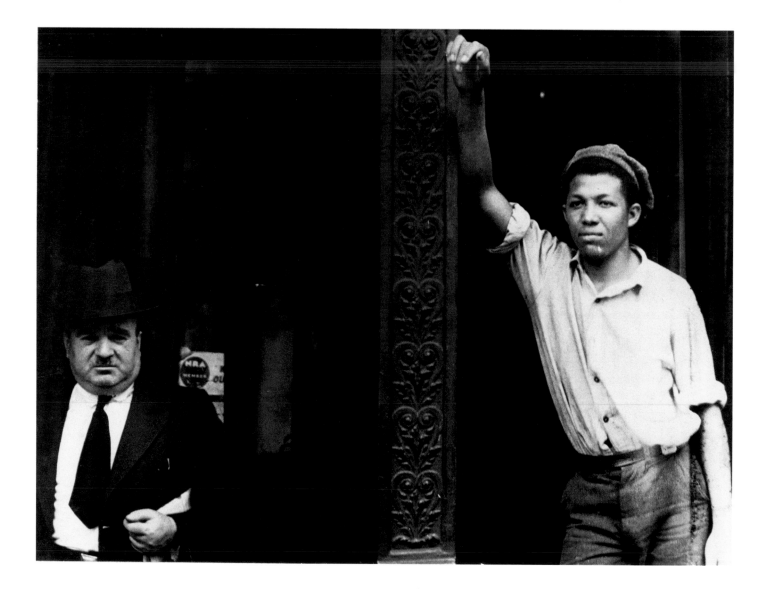

52. *Untitled (Lower East Side, New York City),* 1933–34, 17.2 × 23 cm
Fogg Art Museum, gift of Bernarda Bryson Shahn, P1970.2464

53. *Three Men,* 1939, Tempera on paper mounted to masonite, 45 × 76.8 cm
Fogg Art Museum, Louis Agassiz Shaw Bequest and the Richard Norton Memorial Fund, 1997.20

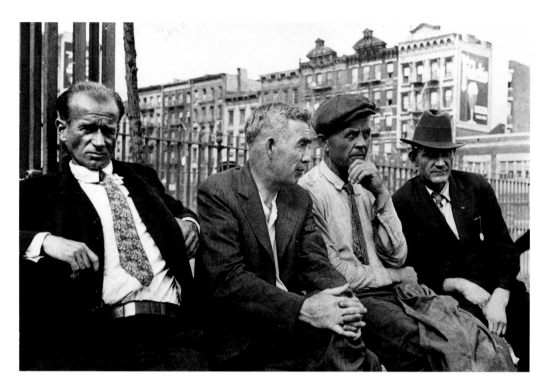

58. *Untitled
(Seward Park, New York City)*
1932–35, 15.8 × 24 cm
Fogg Art Museum, gift of
Bernarda Bryson Shahn,
P1970.2780

59. *Untitled
(May Day Parade, New York City)*
1 May 1934, 14.5 × 21.8 cm
Howard Greenberg Gallery,
New York City

60. *Seward Park*
(New York City), 1932–35,
15.9 × 23.9 cm
Fogg Art Museum, gift of
Bernarda Bryson Shahn,
P1970.3159

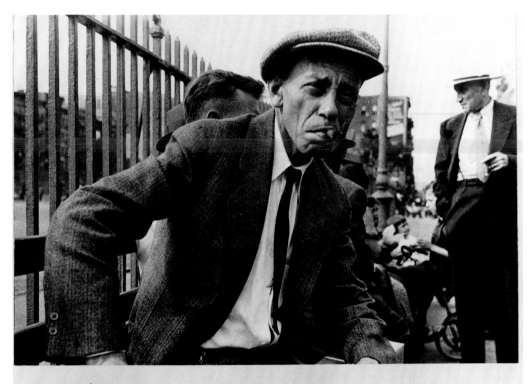

61. *Seward Park,* 1936
Lithograph in color, 30 × 45.1 cm
Fogg Art Museum, gift of
Bernarda Bryson Shahn, 1976,
M15532

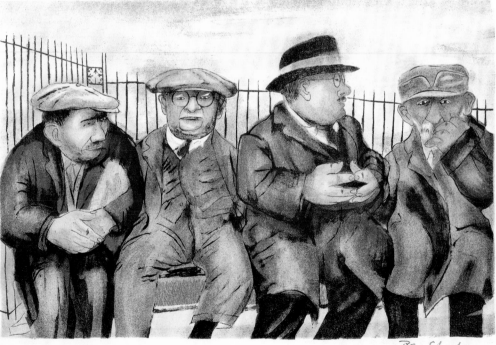

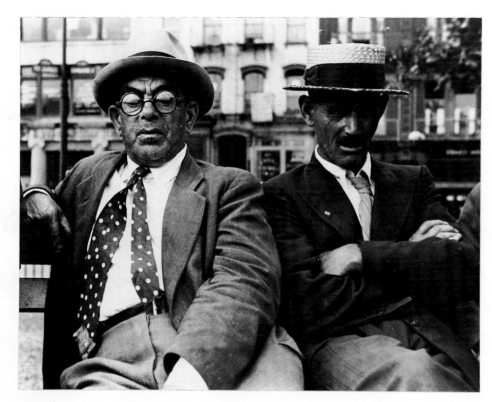

62. *Seward Park*
(or Hester Park, New York City),
1932–35, 17.3 × 22.5 cm
Fogg Art Museum, gift of
Bernarda Bryson Shahn,
P1970.2781

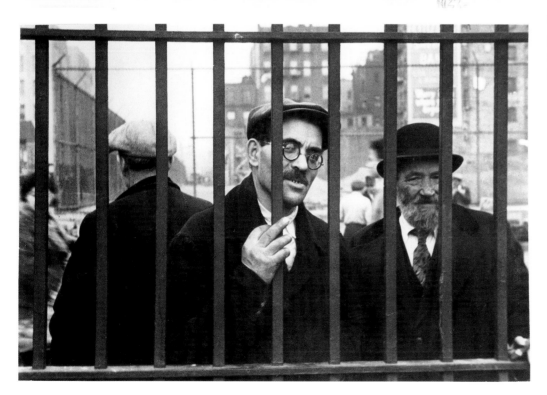

63. *Untitled*
(Seward Park, New York City),
1932–35, 14.9 × 21.7 cm
Shahn Papers

199

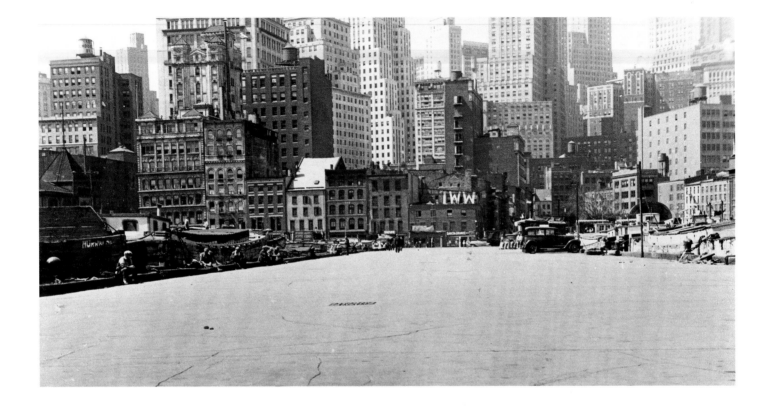

64. *Untitled (South Street pier, New York City),* 1932–35, 12 × 24 cm

Fogg Art Museum, gift of Bernarda Bryson Shahn, P1970.3042

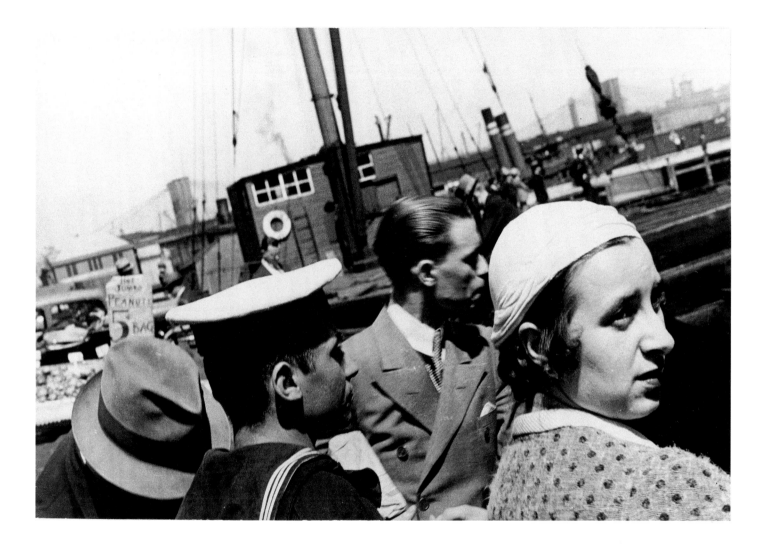

65. *Untitled (South Street pier, New York City),* 1932–35, 15.8 × 23.7 cm

Fogg Art Museum, gift of Bernarda Bryson Shahn, P1970.2073

66. *Untitled
(South Street pier,
New York City)*, 1932–35
16.8 × 24.2 cm
Fogg Art Museum, gift of
Bernarda Bryson Shahn,
P1970.2923

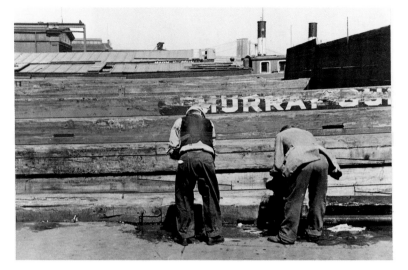

67. *Untitled
(South Street pier,
New York City)*, 1932–35
15.9 × 24 cm
Fogg Art Museum, gift of
Bernarda Bryson Shahn,
P1970.3158

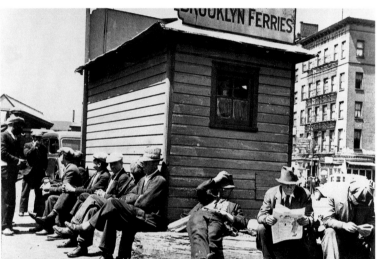

68. *Untitled
(South Street pier,
New York City)*, 1932–34
15.8 × 24 cm
Fogg Art Museum, gift of
Bernarda Bryson Shahn,
P1970.2861

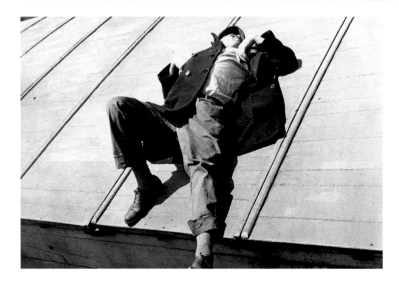

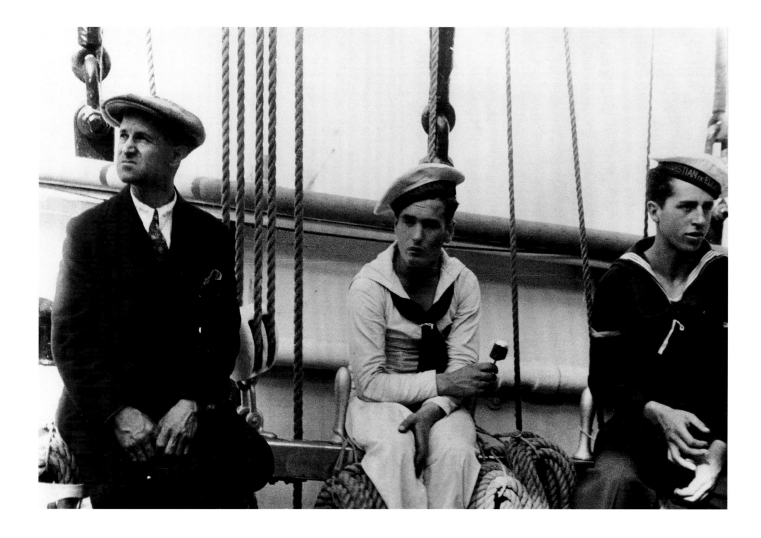

69. *Untitled (South Street pier, New York City),* 1932–35, 15.8 × 23.8 cm

Fogg Art Museum, gift of Bernarda Bryson Shahn, P 1970.2207

Middle West Side/Middle East Side

While assisting Diego Rivera with his ill-fated *Man at the Crossroads* (1933) mural at Rockefeller Center, Shahn became familiar with midtown Manhattan, an area known for its large shopping, garment, and theater districts. The Depression notwithstanding, the Midtown region was undergoing intense building activity, including some of Manhattan's greatest skyscrapers: Radio City Music Hall, the Chrysler Building, and the Empire State Building. When Shahn photographed in the vicinity, however, he relegated these monuments to the background. He focused instead on the crowds underneath the Sixth Avenue elevated or individuals standing before empty storefronts. A number of his photographs of the area's ubiquitous employment agency lines served as source material for *Village Speakeasy, Closed for Violation* (1933–34) (cat. 73), a gouache panel from his PWAP-funded mural study on the subject of Prohibition. In this witty and satiric commentary on the failure of the Eighteenth Amendment to enforce temperance, Shahn assembled his Greenwich Village speakeasy crowd from the jobless masses who gathered at Midtown—a particularly apt choice since Prohibition had exacerbated unemployment problems throughout the city.

Even as theaters in the Times Square district were folding, sideshows of every description were flourishing in vacant lots and alleyways. Shahn chronicled one of these performances taking place before a sober crowd in an Eighth Avenue and Forty-second Street alley (cats. 80–83). A classic type of period street theater, the skit dramatized the story of "Sailor White, the American Sensation," who exhibited feats of strength. A graphic banner behind the performers boasted that the strongman had performed in front of the U.S. Capitol during the 1931–32 Hunger March on Washington. Shahn later used the folk-art rendition of Sailor White's bus from the sideshow backdrop, together with RA/FSA photographs he made in 1937 in Warren, Ohio (cat. 87), and family snapshots taken in Brooklyn (cats. 85, 86), as inspiration for the tempera *Ohio Magic* (1945) (cat. 84). In this autobiographical painting, Shahn depicted a dreamscape that was informed by both his childhood memories of growing up in Brooklyn and remembrances of Depression-era culture as they were informed by his photographs.

In congested Midtown, as in Union Square, Shahn used his camera to isolate individuals amid the density and chaos of the modern metropolis. Across from Pennsylvania Station he showed solitary shoeshine men outlined against the massive General Post Office

building (cat. 88). In a related photograph, two young girls tottering on roller-skates ascend the building's many steps (cat. 89). More than a decade later, Shahn used this surreal scene in combination with an exaggerated view of Lower East Side warehouses (cat. 90) in the painting *East Twelfth Street* (1946) (cat. 91) to convey the uneasy climate of the postwar period.

FIGURE 45
Federal Writers' Project,
Map of the Middle West Side
and Middle East Side
In *New York City Guide*
(New York, 1939), 149 and 193
From digital scans of two maps
19 × 24 cm

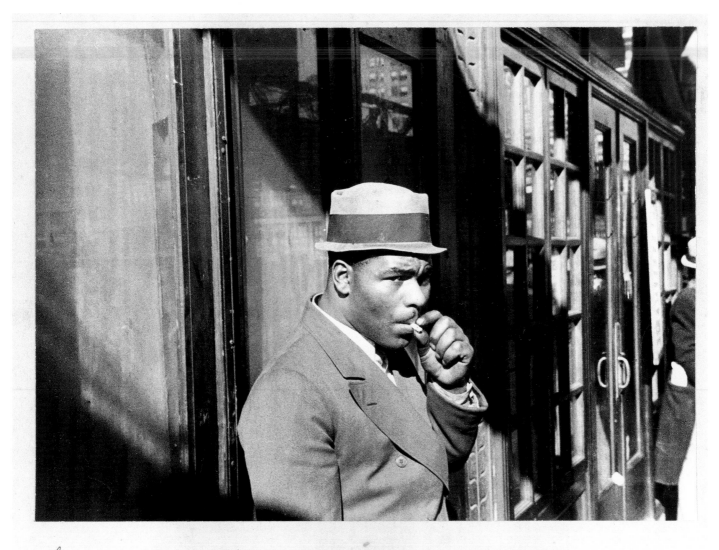

6th ave

70. *6th Ave. (New York City),* 1932–35, 16.3 × 22.5 cm
Shahn Papers

71. *Untitled*
(Sixth Avenue, New York City)
1932–35, 15.8 × 23 cm
Fogg Art Museum, gift of
Bernarda Bryson Shahn,
P1970.2902

72. *Untitled*
(Sixth Avenue, between West
Fiftieth and West Fifty-first Streets,
New York City), 1932–35
15 × 22.7 cm
Fogg Art Museum, gift of
Bernarda Bryson Shahn,
P1970.2957

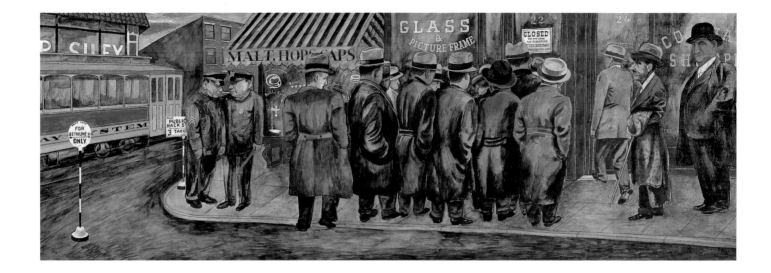

73. *Village Speakeasy, Closed for Violation,* from the *Prohibition* mural study for the Central Park Casino, 1933–34
Gouache on masonite, 40.6 × 120.7 cm, Museum of the City of New York

top left
74. *Untitled (Sixth Avenue, New York City),* 1932–34, 10.8 × 16.3 cm
Fogg Art Museum, gift of Bernarda Bryson Shahn, P1970.2845

top right
75. *Untitled (New York City),* 1932–34, 11 × 16.5 cm
Fogg Art Museum, gift of Bernarda Bryson Shahn, P1970.2998

bottom left
76. *Untitled (Sixth Avenue, New York City),* 1932–34, 11.2 × 17 cm
Fogg Art Museum, gift of Bernarda Bryson Shahn, P1970.2980

bottom right
77. Newspaper clipping, April–May 1933, 14.9 × 9.7 cm
Clippings File, Shahn Papers

78. *Untitled (Sixth Avenue, New York City)*, 1932–35, 14.8 × 22.6 cm
Fogg Art Museum, gift of Bernarda Bryson Shahn, P1970.2833

79. *Untitled (New York City),* 1935, 16.2 × 22.5 cm
Shahn Papers

Ben Shahn

80. *Untitled (Eighth Avenue and Forty-second Street, New York City),* 1932–35, 15 × 24 cm
Fogg Art Museum, gift of Bernarda Bryson Shahn, P1970.2969

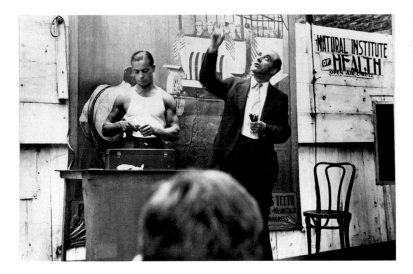

81. *Untitled (Eighth Avenue and Forty-second Street, New York City)*, 1932–35, 15.7 × 24.2 cm
Fogg Art Museum, gift of Bernarda Bryson Shahn, P1970.2965

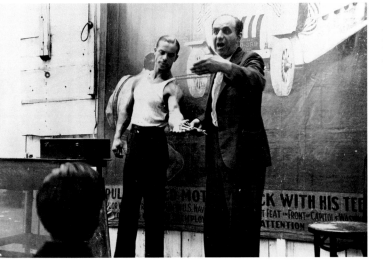

82. *Untitled (Eighth Avenue and Forty-second Street, New York City)*, 1932–35, 15.7 × 24.3 cm
Fogg Art Museum, gift of Bernarda Bryson Shahn, P1970.2967

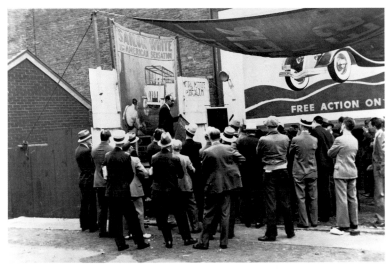

83. *Untitled (Eighth Avenue and Forty-second Street, New York City)*, 1932–35, 14.9 × 22.9 cm
Fogg Art Museum, gift of Bernarda Bryson Shahn, P1970.3038

84. *Ohio Magic,* 1945, Tempera on composition board, 66 × 99.1 cm
Fine Arts Museums of San Francisco, Mildred Anna Williams Collection, 1948.14

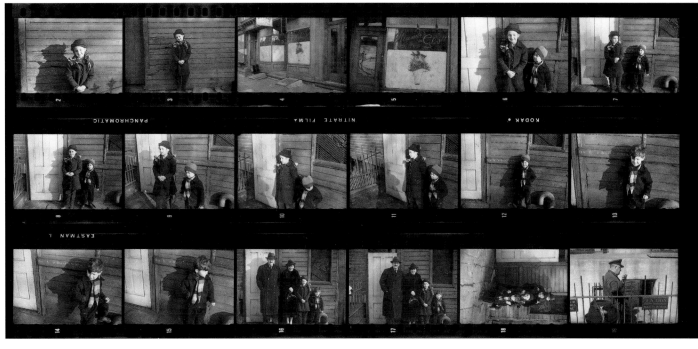

85. *Untitled (Philip, Hattie, Judith, and Ezra Shahn, Walton Street, Brooklyn, New York City)*, Fall 1936–Spring 1937

Modern print from original negatives

Fogg Art Museum, gift of Bernarda Bryson Shahn, P1970.4376.1–6, P1970.4377.1–6, P1970.4378.1–6

86. *Untitled (Walton Street, Brooklyn, New York City)*
Fall 1936–Spring 1937, 17 × 24.3 cm
Shahn Papers

87. *Untitled (Warren, Ohio)*, 1937
18.8 × 24.2 cm
Shahn Papers

88. *Untitled (New York General Post Office, Eighth Avenue and Thirty-third Street, New York City),* 1932–35, 16 × 24 cm
Fogg Art Museum, gift of Bernarda Bryson Shahn, P1970.2828

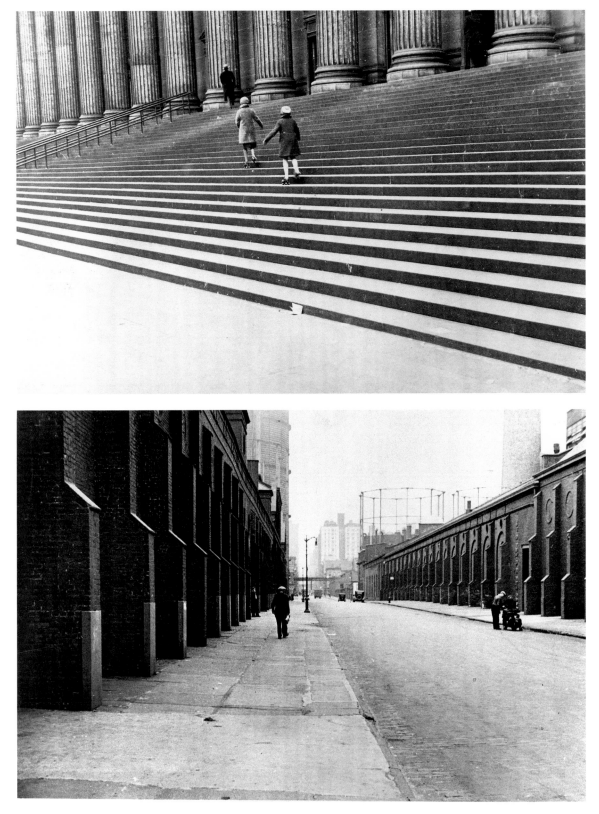

89. *Untitled
(New York
General Post
Office, Eighth
Avenue and
Thirty-third Street,
New York City)*
1932–35
15.9 × 22.4 cm
Fogg Art Museum,
gift of Bernarda
Bryson Shahn,
P1970.2782

90. *Untitled
(East Twelfth Street,
New York City)*
1932–35
16.1 × 24.6 cm
Fogg Art Museum,
gift of Bernarda
Bryson Shahn,
P1970.2470

217

91. *East Twelfth Street,* 1946, Tempera on paper, 55.9 × 76.2 cm
Curtis Galleries, Minneapolis, Minn.

Artists' Protest

During the Depression, protest marches and picket lines filled the streets and squares of lower Manhattan. Large crowds regularly assembled in City Hall Plaza, as well as in Union Square, the epicenter of the radical labor movement in America, to demonstrate for government relief programs, better working conditions, and social justice. Shahn joined in these events as part of a cadre of leftist artists who considered themselves "workers," creating art for the masses. He also included images of civic dissent in his art, as evident in the lively gouache *Demonstration* (1933) (cat. 93), from *The Mooney Case* (1932–33), a series of paintings documenting the infamous 1916 trial of the radical labor leader Tom Mooney. Throughout the 1930s, the international workers' movement exalted Mooney as a political martyr, and in *Demonstration,* Shahn celebrated the solidarity of a group of agitators. He based the scene on a newspaper photograph depicting Communist demonstrators at a 1932 May Day parade in Union Square (cat. 94).

At this time Shahn also became active in the Artists' Union and the Artists' Committee of Action, progressive cultural organizations modeled on trade unions. Shahn often photographed his comrades and other agitators at May Day parades, demonstrations for expanded government art projects, and protests against censorship and international fascism. To emphasize the cadence of the marchers, Shahn would move in and out of the crowds, creating images that evoked the dynamism of these public spectacles. He also made animated street portraits of his compatriots: Bernarda Bryson, Stuart Davis, Roselle Springer, Stephen Dimitroff, Boris Gorelick, David Smith, Moses Soyer, and Max Spivak. A number of these photographs appeared as illustrations in *Art Front,* the magazine of the Artists' Union and Artists' Committee of Action that was edited by Shahn and his peers. Shahn also focused his camera on bystanders, capturing the suggestive gestures and bemused expressions of the people watching the marchers with their elaborate banners and placards. These vivid protest photographs illustrate the artist's activist response to the Depression-era conditions he chronicled in New York's neighborhoods.

Shahn's support for organized labor featured prominently in his work into the 1940s, when he was the lead graphic artist for the Congress of Industrial Organizations' Political Action Committee. There he created a series of "get out to vote" posters, including *For All These Rights We've Just Begun to Fight* (1946) (cat. 104). This bold color lithograph portrays a defiant marcher enveloped by banners emblazoned with slogans from Roosevelt's 1944

Economic Bill of Rights speech, in which the president outlined a list of workers' rights. *For All These Rights,* appropriately based on a photograph Shahn made during an Artists' Union protest in the fall of 1934 (cat. 103), attests to how the artist's formative experiences in the radical artists' movement in New York City shaped his later art and his lifelong commitment to political activism.

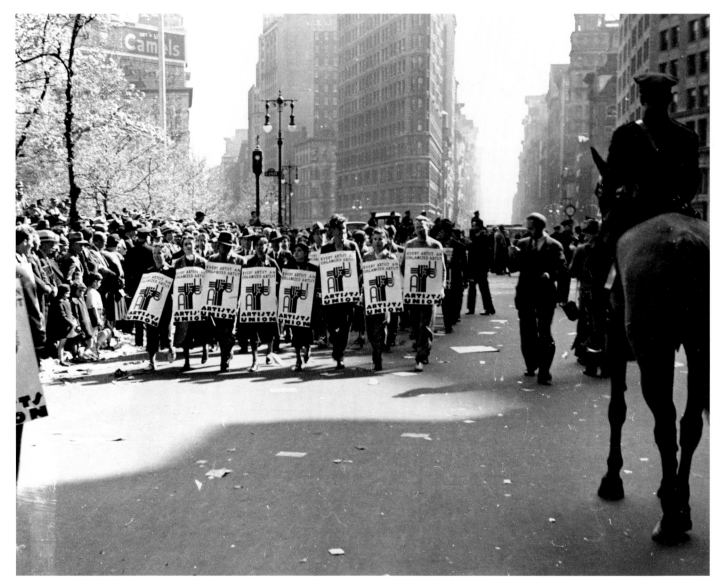

92. Lou Block, *Untitled (Ben Shahn photographing Artists' Union demonstrators, May Day Parade, New York City),* 1 May 1935, 25.1 × 34.6 cm
Photographic Archives, University of Louisville, Kentucky

93. *Demonstration,* 1933, from *The Mooney Case,* 1932–33
Gouache on paper mounted to masonite, 40.1 × 56.3 cm
Collection of Judith Shahn and Ezra Shahn

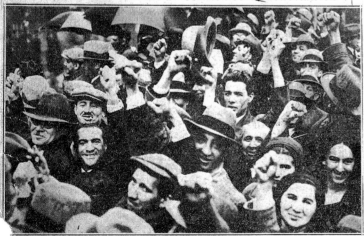

A STUDY IN EXPRESSIONS AT COMMUNIST DEMONSTRATION

A closeup of part of the demonstrators at Union Square yesterday. *TELEGRAM MAY 2, 1932* Associated Press Photo.

94. Associated Press Photo, "A Study in Expressions at
Communist Demonstration," *New York Telegram,* 2 May 1932
Newspaper clipping, 10.5 × 15 cm
Source File, "May Day," Shahn Papers

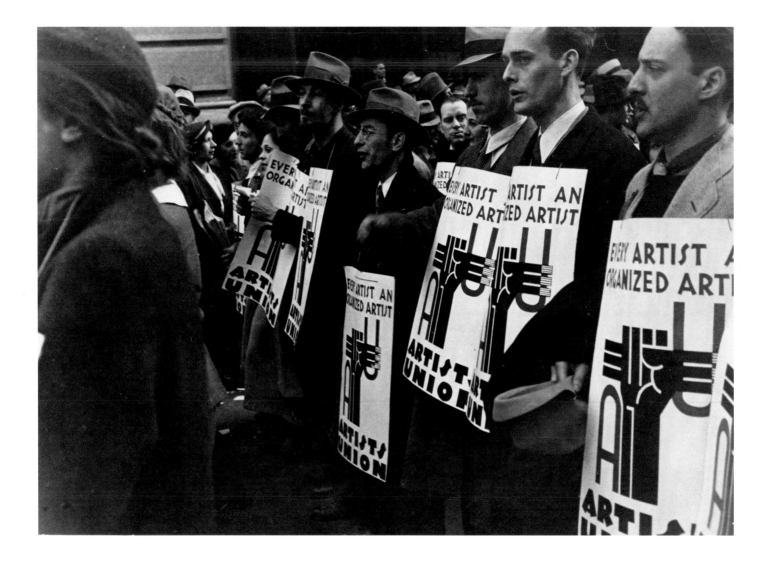

95. *Untitled (Artists' Union demonstrators, May Day Parade, New York City),* 1 May 1935, 16 × 23.2 cm
Collection of Judith Shahn and Ezra Shahn

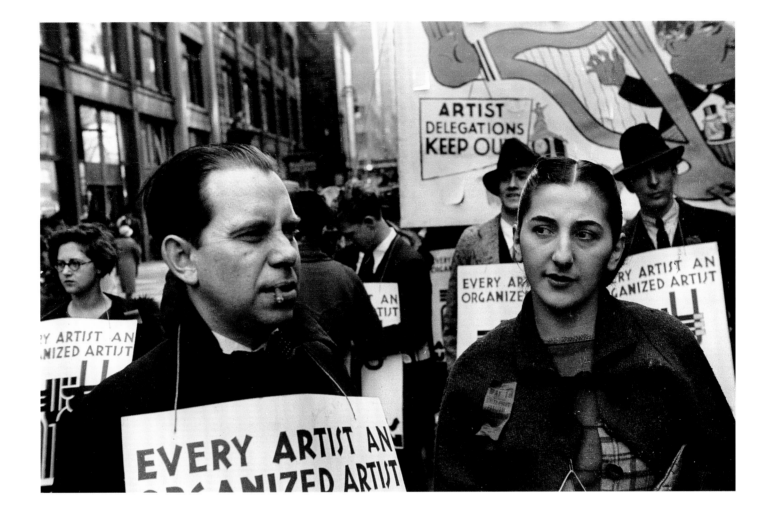

96. *Untitled (Stuart Davis and Roselle Springer, May Day Parade, New York City),* 1 May 1935, Modern print from an original negative
Fogg Art Museum, gift of Bernarda Bryson Shahn, P1970.3921

97. Lou Block, *Untitled
(Artists' Union demonstrators,
May Day Parade, New York City)*
1 May 1935, 26.8 × 34.9 cm
Photographic Archives,
University of Louisville,
Kentucky

98. Lou Block, *Untitled
(Artists' Union demonstrators,
May Day Parade, New York City)*
1 May 1935, 27 × 32.2 cm
Photographic Archives,
University of Louisville,
Kentucky

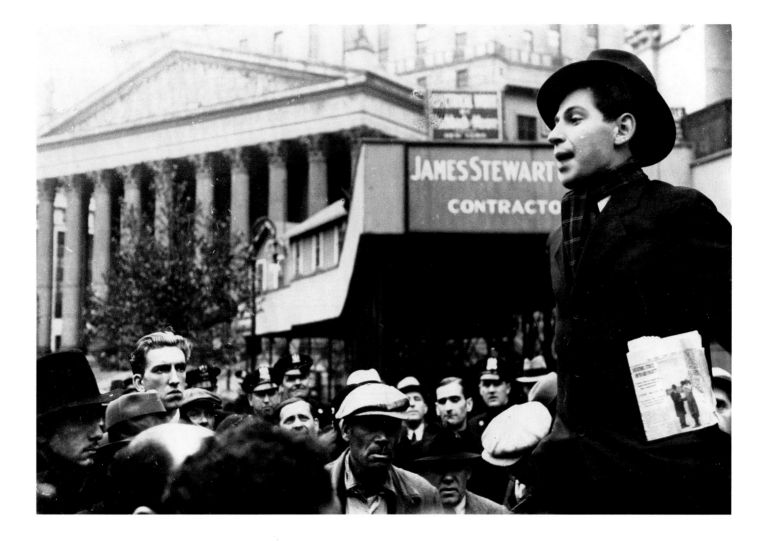

99. *Untitled (Max Spivak, Artists' Union demonstration for relief jobs and a municipal art gallery,*
Centre Street Courthouse, New York City), 27 October 1934, 11.7 × 17.2 cm
Fogg Art Museum, gift of Bernarda Bryson Shahn, P1970.198

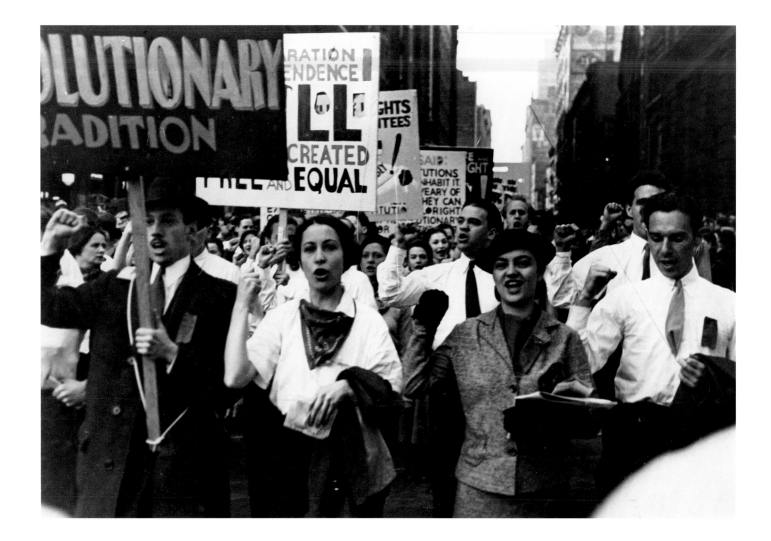

100. *Untitled (Theatre Union demonstrators, May Day Parade, New York City)*, 1 May 1934, 15.2 × 22.7 cm
Fogg Art Museum, gift of Bernarda Bryson Shahn, P1970.2818

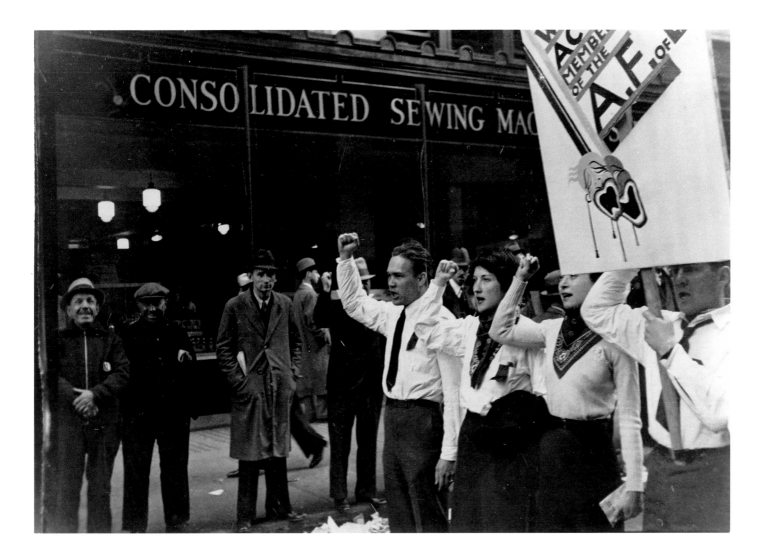

101. *Untitled (Theatre Union demonstrators, May Day Parade, New York City),* 1 May 1934, 16.2 × 24.7 cm

Fogg Art Museum, gift of Bernarda Bryson Shahn, P1970.2912

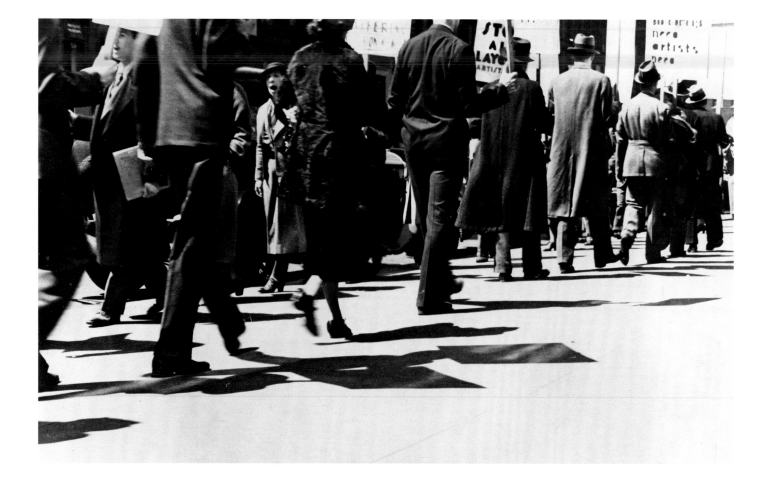

102. *Untitled (demonstrators, New York City),* 1934–35, 15 × 24 cm

Fogg Art Museum, gift of Bernarda Bryson Shahn, P1970.2992

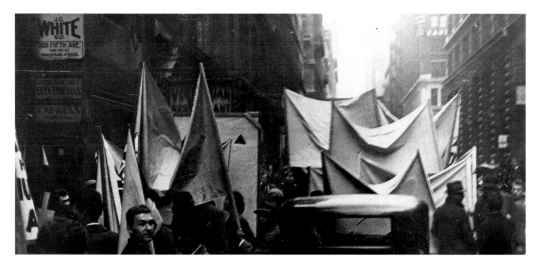

103. *Untitled (Stephen Dimitroff, Artists' Union demonstration for relief jobs and a municipal art gallery, New York City),* 27 October 1934
8 × 17.8 cm
Fogg Art Museum, gift of Bernarda Bryson Shahn, P1970.2909

104. *For All These Rights We've Just Begun to Fight,* 1946, Lithograph in color, 73.6 × 98.4 cm
Fogg Art Museum, gift of Ben Shahn, M13342

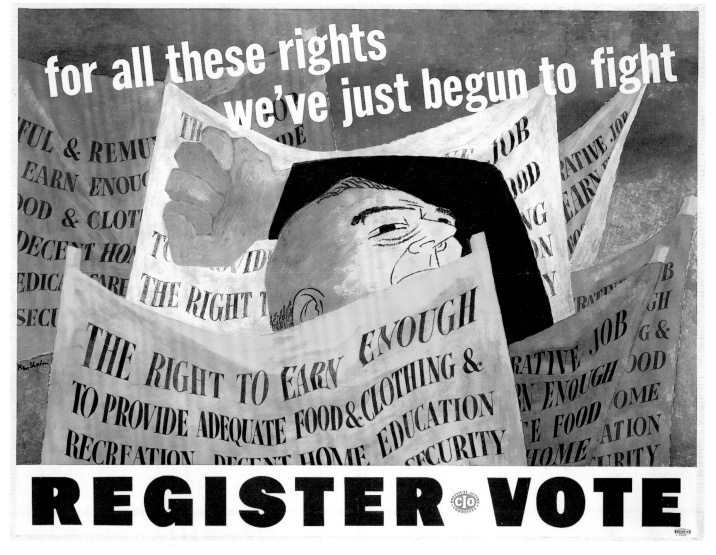

Rikers Island Penitentiary Mural Project

From the spring of 1934 through the winter of 1935 Shahn worked on an ambitious public art project—a mural design for the newly constructed penitentiary on Rikers Island, a four hundred–acre plot of land situated in the East River, between Queens and the Bronx. Shahn collaborated with the painter and photographer Lou Block, and the Temporary Emergency Relief Administration provided funding. Choosing a long corridor in the main building as his site, Shahn developed a didactic scheme on the hotly debated issue of prison reform. Block, meanwhile, designed a series of panels about religious charity for the penitentiary chapels (see fig. 49). In preparation, the two artists studied law and penology and drew on the expertise of local sociologists and prison officials. They also visited correctional facilities in and around New York City. Shahn photographed inmates at the model reformatory in New Hampton and the antiquated, overcrowded Blackwell's Island Penitentiary on Welfare Island (renamed Roosevelt Island in 1973), just south of Rikers Island. Although Shahn had used photographs to help prepare for his Prohibition mural studies, this was the first instance of his making photographs as a primary research tool for a mural painting.

Shahn's studied depictions of prison life impart a very different character from the scenes he created more surreptitiously on the sidewalks of New York. To photograph within penal institutions Shahn was required to obtain permission from a number of authorities, as well as the prisoners themselves. In such a controlled setting it was impossible to work unnoticed. Photographing the convicts directly and without the use of his angle viewfinder, Shahn recorded gregarious young men who posed for his camera, as well as prisoners absorbed in thought, reading newspapers, even creating art. He also focused on inmates learning useful trades: masonry, metalwork, and farming. These images are engaging portraits, depicting inmates as wayward sons and brothers. As a believer in prison reform, Shahn thus rebuked the prevalent "rouges' gallery" classification of criminals, seeking instead to reveal how prisoners deserved assistance and rehabilitation.

Shahn's photographs profoundly informed his designs for the Rikers Island Penitentiary mural (cat. 122). The artist incorporated his views of prison architecture and translated his images of prisoners at work and leisure into his mural study. For instance, a number of the young men who posed so willingly at the New Hampton reformatory populate scenes in the mural that delineate the social benefits of providing inmates with education, vocational training, and medical care. In contrast, the destitute men the artist had photographed on the sidewalks of Manhattan formed the basis for the opposing portions of the

mural, which illustrated how poverty and desperation lead to crime—circumstances the artist had witnessed firsthand. In spite of the extensive support Shahn's commanding mural design received at City Hall and the municipal Department of Correction, the conservative Municipal Art Commission dismissed the proposal in February 1935. The rejection immediately became a cause célèbre. Although frustrated that his mural would never be executed, Shahn developed through this project a manner of using his own camerawork that would affect his artmaking for years to come.

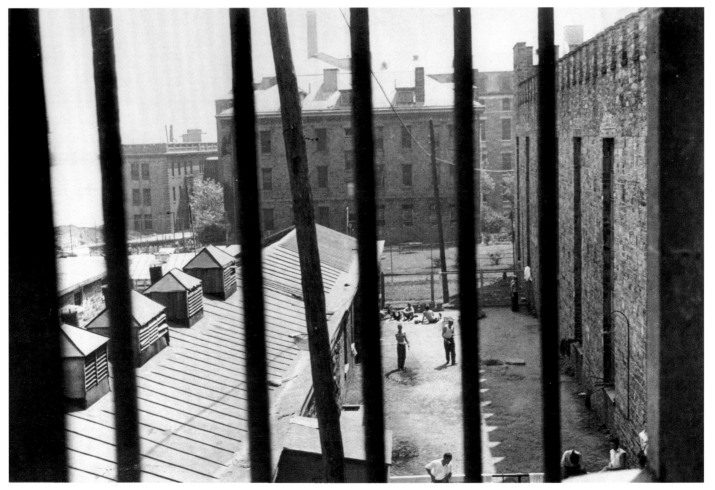

105. *Untitled (Blackwell's Island Penitentiary, Welfare Island, New York City)*, 1934, 14.9 × 22.9 cm
Photographic Archives, University of Louisville, Kentucky

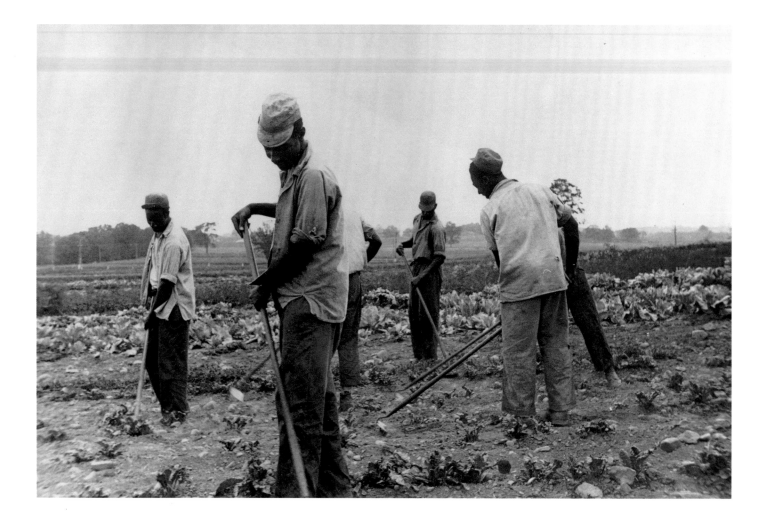

106. *Untitled (New York City Reformatory, New Hampton, New York),* 1934, 15.9 × 23.2 cm
Photographic Archives, University of Louisville, Kentucky

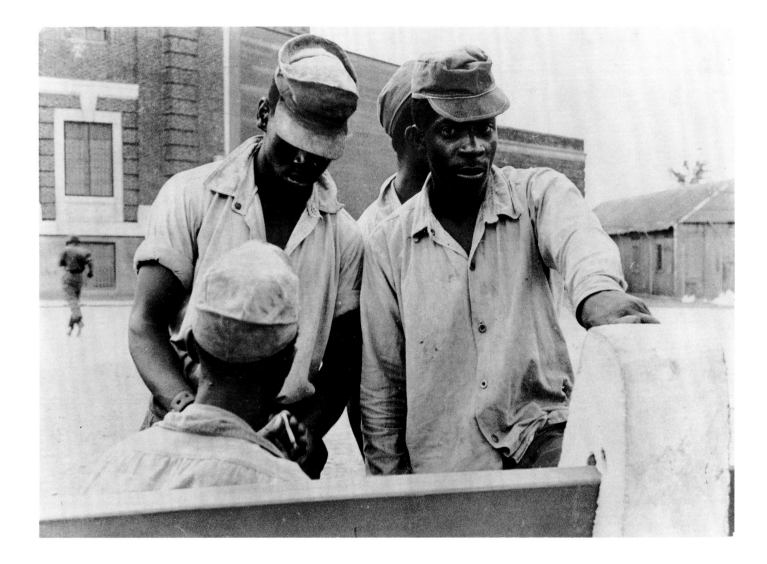

107. *Untitled (New York City Reformatory, New Hampton, New York)*, 1934, 15 × 22.7 cm
Howard Greenberg Gallery, New York City

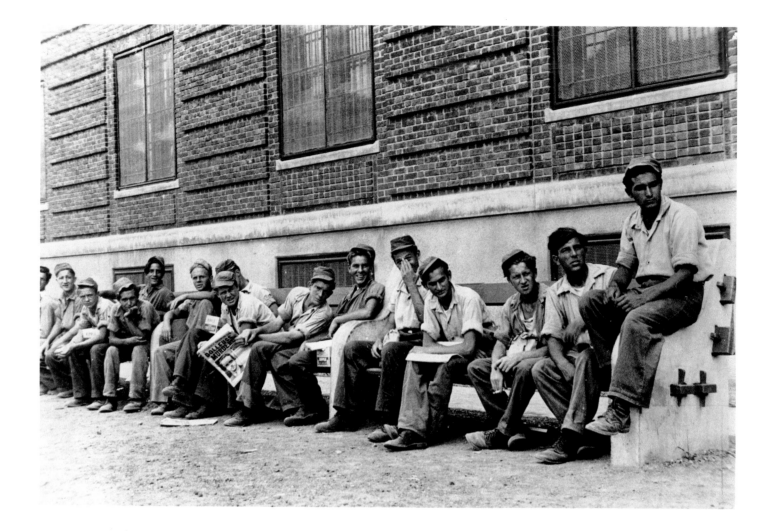

108. *Untitled (New York City Reformatory, New Hampton, New York),* 1934, 15.7 × 23.8 cm
Howard Greenberg Gallery, New York City

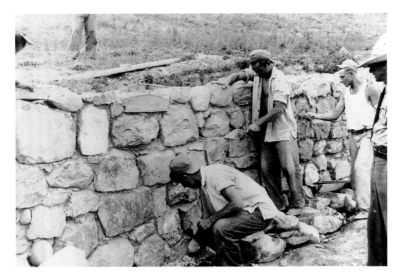

109. *Untitled*
(New York City Reformatory,
New Hampton, New York), 1934
15.9 × 23.8 cm
Photographic Archives,
University of Louisville,
Kentucky

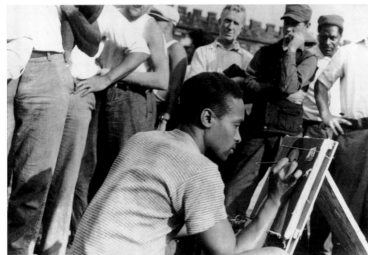

110. *Untitled*
(Blackwell's Island Penitentiary,
Welfare Island, New York City)
1934, 15.9 × 23.5 cm
Photographic Archives,
University of Louisville,
Kentucky

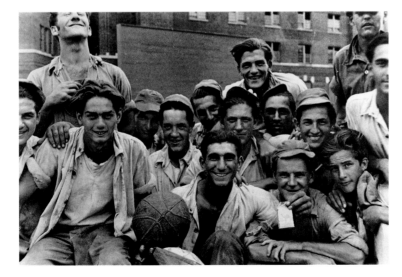

111. *Untitled*
(New York City Reformatory,
New Hampton, New York), 1934
15 × 22.8 cm
Terry Dintenfass Gallery Inc.,
in association with
Salander O'Reilly Galleries,
New York City

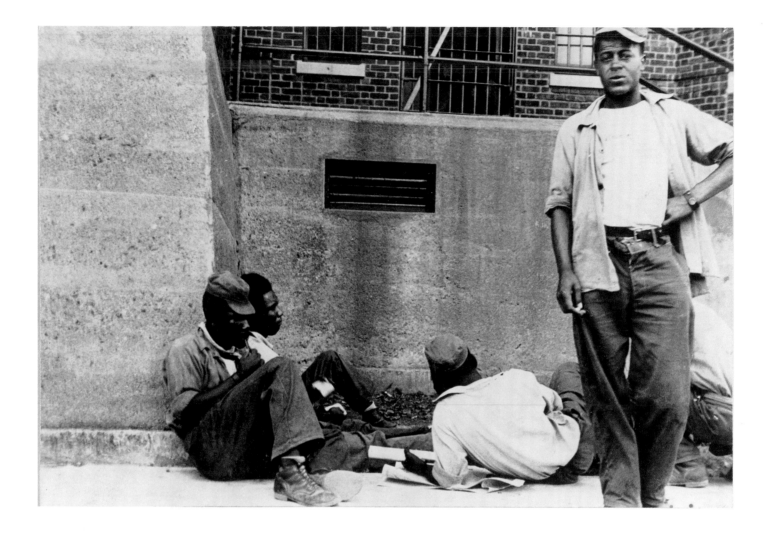

112. *Untitled (New York City Reformatory, New Hampton, New York),* 1934, 15.9 × 23.8 cm
Source File, "Punishment," Shahn Papers

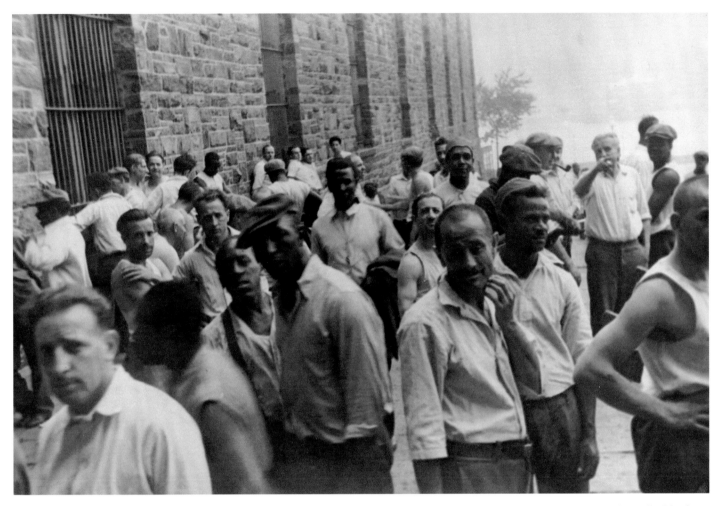

113. *Untitled (Blackwell's Island Penitentiary, Welfare Island, New York City),* 1934, 15.9 × 23.2 cm
Photographic Archives, University of Louisville, Kentucky

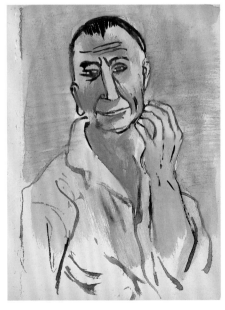

114. *Untitled (sketch for the Rikers Island Penitentiary Mural),* 1934–35, Watercolor and gouache, 17 × 13 cm
Estate of Ben Shahn

237

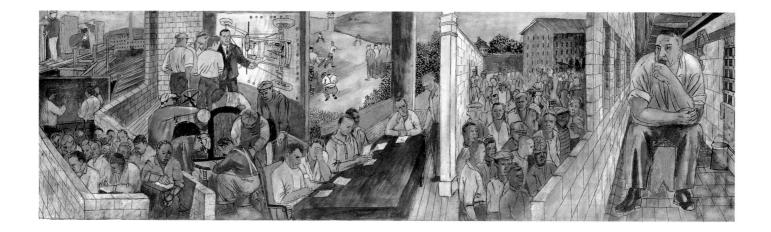

top

115. *Untitled (study for Rikers Island Penitentiary Mural, panel for east wall)*, 1934–35
Tempera on paper mounted to masonite, 26.5 × 83.9 cm
Collection of John Horton

bottom

116. *Untitled (study for Rikers Island Penitentiary Mural, panel for west wall)*, 1934–35
Tempera on paper mounted to board, 26.7 × 92.7 cm
Art Fund, Friends of the Wichita Art Museum, Wichita Art Museum, Kansas

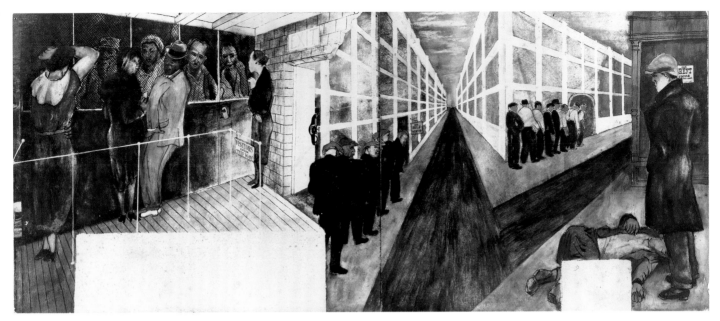

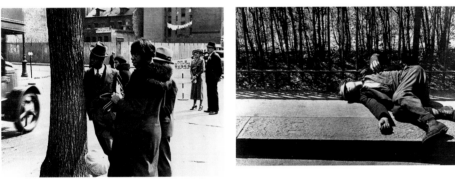

top
117. Two copy photographs of Shahn's Rikers Island Penitentiary
Mural Study, panel for east wall, 1934–35, 18.4 × 21.2 cm
Collection of Bernarda Bryson Shahn
Photographs may be by Walker Evans

bottom left
118. *Untitled (New York City),* 1932–34, 17.7 × 24.2 cm
Fogg Art Museum, gift of Bernarda Bryson Shahn, P1970.2997

bottom center
119. *Untitled (probably Fourth Avenue, New York City),* 1932–34, 15.7 × 23 cm
Fogg Art Museum, gift of Bernarda Bryson Shahn, P1970.2865

bottom right
120. Mounted newspaper clipping, c. 1930–35, 18.2 × 12.6 cm
Clippings File, Shahn Papers

121–22. Rikers Island Penitentiary, unfinished mural study, 1934–35

Reconstruction by Deborah Martin Kao; computer imaging by Michelle Tarsney, Kao Design Group, 1999

Shahn's didactic mural in support of progressive penal reform programs was to be painted on the walls of a cavernous hallway that led to the prison's chapels. The corridor measured 100 feet long by 18 feet wide and provided 12 feet of continuous wall surface above a tiled dado for the proposed fresco. Shahn's design for this government-funded public works project, rejected by the conservative Municipal Art Commission in February 1935, was never executed. These computer generated images project what Shahn's impressive mural would have looked like in situ had it been painted according to his gouache studies.

Program

North Wall

Centre Street Courthouse

Police lineup

Bridge of Sighs and unemployment lines

East Wall: The Archaic Penal System

Cell block in an unsanitary prison

Idleness and the milling about of prisoners

Public whipping in Delaware

Dreary, unproductive labor

Southern prison camps and chain gangs

Prisoners' lock-down after 5:00

Prisoners in troubled sleep

Overcrowded dormitories

Restrictions on visitors

Release of prisoners, with an intimation of a return to crime

West Wall: The Reformed Penal System

Portrait of prison reformer Thomas Mott Osborne

Self-government of prisoners for minor infractions

Outdoor recreation

Prisoners receiving elementary schooling

Prisoners receiving vocational training

Modern medical services

West Wall: Missing Scenes

Prisoners weaving and playing musical instruments

Former inmates finding productive labor

South Wall: Missing Scene

Shahn considered depicting the Statue of Liberty, a Janus Head, or a prisoner breaking free of his chains. He settled on moving the portrait of Thomas Mott Osborne to the south wall as an "apotheosis" for the mural scheme.

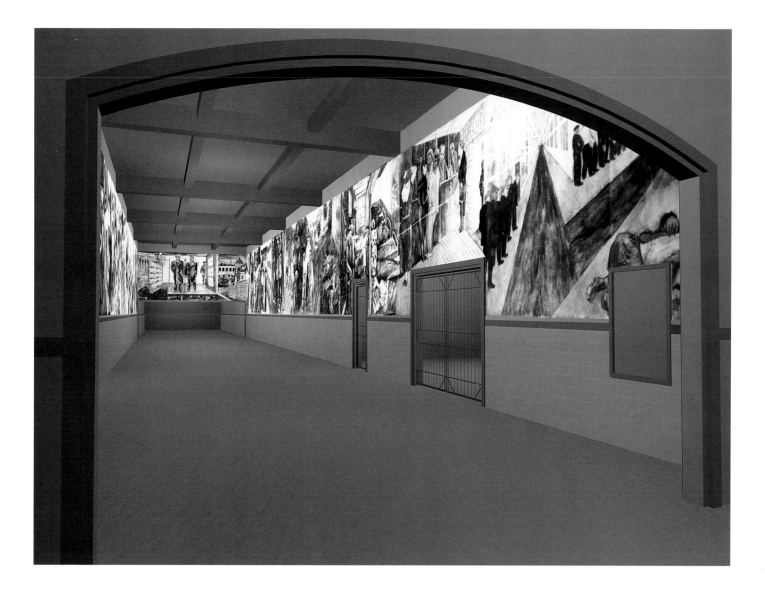

Contemporary American Photography

In late September 1935 Shahn left New York to work for the Resettlement Administration in Washington, D.C. This position gave him the opportunity to travel throughout the American South until early November, photographing scenes of rural poverty that exposed him to a far different world from the one he had known in New York. The following spring Shahn began preparing for a government-funded mural, his first since the rejection of the Rikers Island Penitentiary project. The mural was commissioned for a public community center at Jersey Homesteads (later Roosevelt), New Jersey, a New Deal settlement for Jewish immigrant garment workers who were relocated from Lower East Side tenements. In April 1936 Shahn returned to New York to research material related to this project at the public library, the headquarters for the Associated Press, and the offices of the *Jewish Daily Forward* newspaper. While in New York he visited the Lower East Side and made what proved to be one of his most consequential rolls of film (cat. 123). From the negatives on this roll, Shahn would create a focused body of work that included such iconic commentaries on Depression-era New York as *Bowery* (cat. 128) and *East Side Merchants* (cat. 136).

Because the majority of Shahn's New York negatives were posthumously cut apart into individual frames, this intact roll constitutes one of the few remaining early examples of the artist's working process as a street photographer. The roll begins with an array of affectionate portraits of Shahn's first two children, Judith and Ezra, whom he visited on occasion after the dissolution of his marriage in 1935. Subsequent images indicate how, as the artist moved through the streets of the Lower East Side, he made numerous exposures of merchants and storefronts that captured his interest. He particularly delighted in the handpainted signs in store windows, and he celebrated the distinctive lettering as a type of authentic folk art. Once in the darkroom, Shahn made prints from nearly all the frames on this roll, experimenting at length with cropping, dodging, and burning the images to create "finished" works of art.

This roll also contains a concentrated number of frames depicting window displays of Yiddish books, prayer shawls, tombstones, and kosher food—objects of religious ritual that reminded the artist of his own upbringing. Shahn's interest in urban Jewish life stemmed most immediately from his research into immigrant Jewish labor. Yet it was also the result of a deep concern for the fate of his culture at home and abroad, as indicated by his participation in the First American Artists' Congress Against War and Fascism held in New York City in February 1936. Throughout his career Shahn would revisit the Jewish

themes in these special photographs, using them as the basis for major paintings, including *New York* (1947) (cat. 135) and *Sound in the Mulberry Tree* (1948) (cat. 139), both of which commemorate aspects of the Jewish experience in modern times.

In the midst of photographing Jewish subjects on the Lower East Side, Shahn paused to document the window display of a commercial photography studio (cat. 140). Four years later this prosaic scene of family portraits and wedding pictures provided the source for the remarkable tempera *Photographer's Window* (1939–40), which Shahn also referred to as *Contemporary American Photography* (cat. 141). Although at first sight the painting seems to be a close visual transcription of the source photograph, Shahn in fact made a number of subtle modifications. Most significant, he interspersed among his painted renditions of the posed studio portraits several representations of poor rural sharecroppers, miners, and tenant farmers based on his RA/FSA photographs (cats. 142, 143). Shahn thus set up juxtapositions between the urban working class and the rural poor, and between commercial and documentary modes of portraiture. *Photographer's Window* stands as a summation of Shahn's allegiance to and simultaneous questioning of the ideals of documentary "truth" that were so pivotal to New Deal thought.

123. *Untitled (New York City),* April 1936, Modern print from original negatives
Fogg Art Museum, gift of Bernarda Bryson Shahn, P1998.135.1–35

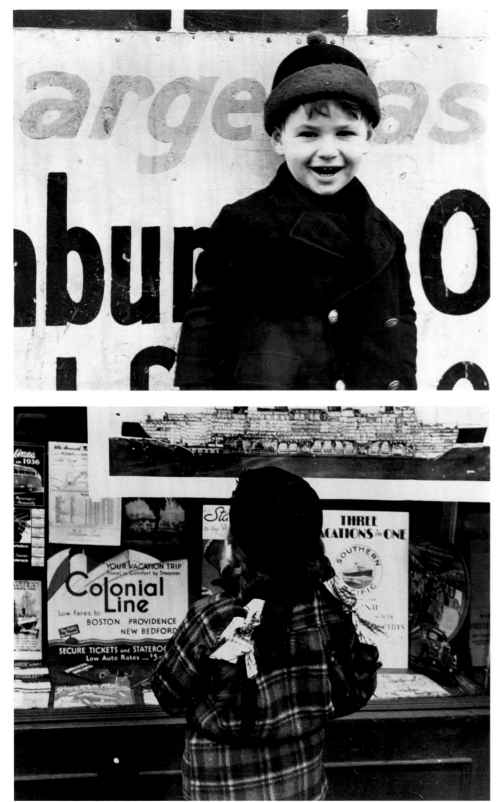

124. *Untitled*
(Ezra Shahn, New York City)
April 1936, 18.7 × 24.1 cm
Collection of Judith Shahn and
Ezra Shahn

125. *Untitled*
(Judith Shahn, New York City)
April 1936, 19.2 × 24.2 cm
Fogg Art Museum, gift of
Bernarda Bryson Shahn,
P1970.193

126. *Bowery*
(New York City)
April 1936
15.8 × 23.5 cm
Shahn Papers

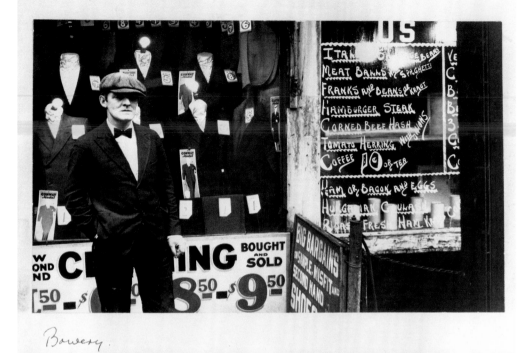

127. *Untitled*
(Bowery, New York City)
April 1936, 19.4 × 24.9 cm
Fogg Art Museum, gift of
Bernarda Bryson Shahn,
P1970.197

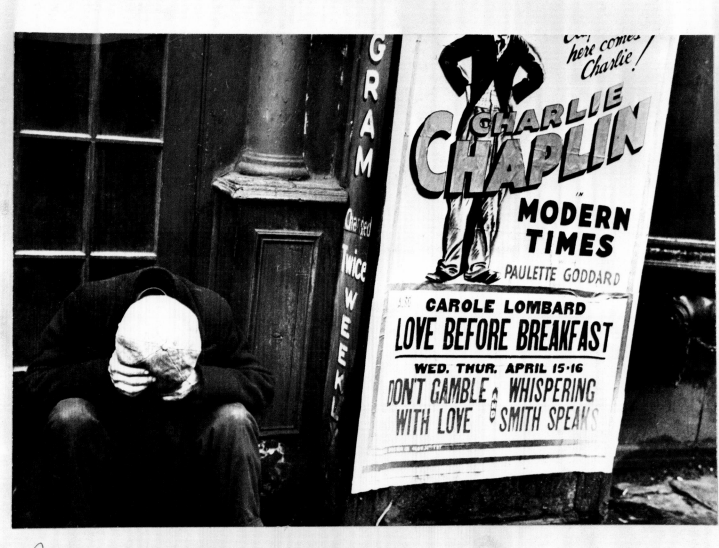

Bowery

128. *Bowery (New York City),* April 1936, 16 × 24 cm
Fogg Art Museum, gift of Bernarda Bryson Shahn, P1970.2809

129. *Untitled (Lower East Side, New York City),* April 1936, 19.5 × 25 cm

Fogg Art Museum, gift of Bernarda Bryson Shahn, P1970.3141

top left
130. *Untitled*
(Lower East Side, New York City), April 1936, 19.7 × 24.7 cm
Fogg Art Museum, gift of Bernarda Bryson Shahn, P1970.3124

top right
131. *Untitled*
(Lower East Side, New York City), April 1936, 19.7 × 24.6 cm
Fogg Art Museum, gift of Bernarda Bryson Shahn, P1970.2480

bottom left
132. *Untitled*
(Lower East Side, New York City), April 1936, 19.6 × 25 cm
Fogg Art Museum, gift of Bernarda Bryson Shahn, P1970.2989

bottom right
133. *Untitled*
(Lower East Side, New York City), April 1936, 19.7 × 24.8 cm
Fogg Art Museum, gift of Bernarda Bryson Shahn, P1970.2928

134. *Untitled*
(Lower East Side,
New York City)
April 1936
16 × 23.8 cm
Shahn Papers

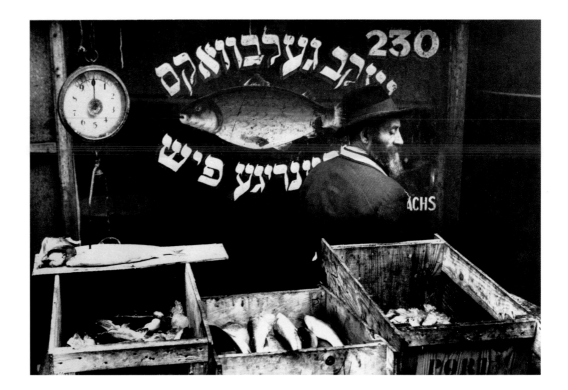

135. *New York,* 1947
Tempera on paper mounted
on panel, 91.4 × 121.9 cm
The Jewish Museum,
New York City

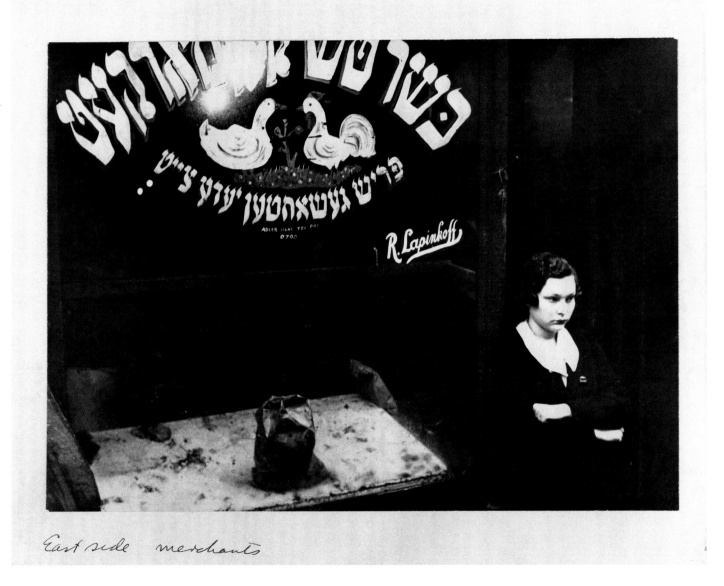

East side merchants

136. *East Side Merchants (Lower East Side, New York City),* April 1936, 16.3 × 23 cm
Fogg Art Museum, gift of Bernarda Bryson Shahn, P1970.3143

137. *Greenwich Village
(New York City)*, 1932–35
15.7 × 24 cm
Shahn Papers

138. *Untitled
(Lower East Side,
New York City)*
April 1936
19.7 × 24.6 cm
Shahn Papers

139. *Sound in the Mulberry Tree,* 1948
Tempera on canvas mounted to panel
121.9 × 91.4 cm
Smith College Museum of Art, Northampton, Mass., purchased in 1948

140. *Untitled (Lower East Side, New York City)*, April 1936, 19.6 × 24.8 cm
Fogg Art Museum, gift of Bernarda Bryson Shahn, P1970.2944

141. *Photographer's Window*
1939–40, Tempera on paper
mounted to board, 61.3 × 82.5 cm
Hood Museum of Art,
Dartmouth College, Hanover,
N.H., bequest of Lawrence
Richmond, Class of 1930

left
142. *Untitled (children of a Rehabilitation client, Maria Plantation, Ozarks, Arkansas),* October 1935, 18.5 × 24.5 cm
Fogg Art Museum, gift of Bernarda Bryson Shahn, P1970.3165

right
143. *Untitled (Sam Nichols, tenant farmer, Boone County, Arkansas),* October 1935, 19.5 × 24.7 cm
Fogg Art Museum, gift of Bernarda Bryson Shahn, P1970.3174

Appendix: Contemporary Documents

BEN SHAHN'S NEW YORK

Harlan Phillips:
Interview with Ben Shahn, 1965

I had a very curious upbringing. My father [Joshua Hessel Shahn] was a woodcarver, as were my grandfather and uncles. One was an engraver who worked for the American Bank Note for forty-five years. I have that kind of background and have no use for people who at the end of a day didn't have something really tangible to show for it. I still have that, at the end of the day, what can you show for your work? It was bred into me.

I was born in Russia, and I came here when I was almost nine [in 1906].[1] I had a lot of schooling but of a unique kind—the Bible and so on. Anyway, I hadn't been here less than maybe a year when I was suddenly aware of the whole business of the *Mayflower* and ancestry. I had never thought of ancestry. I had two sets of great-grandparents, so I thought I had plenty of ancestry. There were grandparents, endless uncles and aunts, but not ancestry—and I craved it a little.

I began to ask my father, "How could I establish ancestry?" I had lived with my grandfather [Wolf-Lyeb (or Lion) Shahn] for three years because my father, who had been a socialist, had been sent away [to Siberia] and then escaped [to Sweden, England, and then South Africa]. So I didn't see him for three years. My mother [Gittel Lieberman Shahn] and we three children [the artist and his two younger siblings Philip and Hattie] stayed with my grandfather [in Vilkomir (now Ukmergé), Lithuania]. My grandfather was a woodcarver, and he had a half-a-dozen or eight people who worked for him doing baroque carving. That was my father's work too. So I began to probe. I said to my father,

"What did your grandfather do?" "He was a woodcarver like my father." I said, "Do you know what his grandfather did?" I was looking for a *Mayflower,* you see. My father drew very naturally, as did my grandfather. He could draw anything, just as some people can with no training. He drew a man hanging on a gibbet when I asked about my great-great-grandfather. I said, "What's that?" My father said, "He was a horse thief. Only what you do counts, not what your ancestors did."

Many years later [1940–42] when I was working on the [*Meaning of Social Security*] mural in Washington, D.C., a woman was nagging me, sort of baiting me about the subject I was painting—workmen in a government building. "It's Communistic," she said. One day I decided I couldn't take this. Generally she used to wait to nag me until I was off the scaffold. But this time she said, "My ancestors fought in the Battle of Lexington. I'll see that this kind of work doesn't . . . "I picked up a big pot of paint and said, "Look, lady, my ancestors fought in the Battle of Jericho, and if you don't get the hell out of here, I'll pour this on you." I just couldn't take it anymore. She ran. She had on a little mink jacket, I remember. That was the last I saw of her.[2]

I had to learn early on to negotiate as an artist. [In 1926] when I was quite a youngster, an admirer of my work suggested I visit Frank Crowninshield of *Vanity Fair,* the magazine of the time. Frank apparently did not share the view of my admirer, who was a good friend of his, so Frank got rid of me by sending me to Eugene O'Neill, who quickly got rid of me by sending me to Robert Edmond Jones, who got rid of me by sending me down to the Provincetown Playhouse where they gave me a job.[3] I had thought, gee, if you're good, people will come to you. Unfortunately, I was wrong.

I came back from Europe in 1929 a week before the market crashed and until then had total security. I was a

Unless otherwise noted, original spelling and punctuation were retained throughout this appendix.

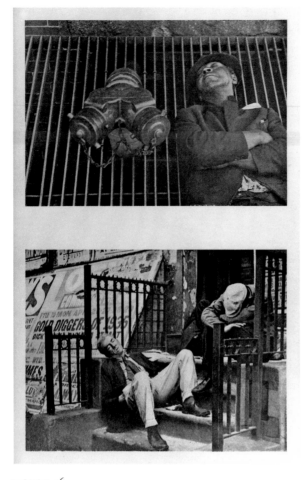

FIGURE 46
Ben Shahn, *Untitled (Bowery, New York City)*
1932–35 (top)
Hans Groenhoff, *Untitled (New York City)*
1935–38 (bottom)
In Cecil Beaton, *Portrait of New York*
(1948, originally published in 1938 as
Cecil Beaton's New York)
22.2 × 14 cm
Taller Archive

trained commercial lithographer, and I thought I could always get a job with the union. When I came back, there weren't any jobs, and my knees shook. They said, "Even if there were a job, you won't get it, Ben. You've been away from your table for four years, but the guys that have been sticking with the table are going to get it." Like that. I had

this wonderful sense that I am a craftsman, I can do this, and I can earn my livelihood. I came back with a baby—that was the other thing. It was a terrifying experience.[4]

In 1931 I got a call from the union about a job, and I came in from Brooklyn and got off at the City Hall station. There was a demonstration going on at City Hall and, frankly, I wasn't too hip to these things. These guys had signs. They said they wanted rent, and I thought, "They're weak! Who the hell is going to do this? How can the government pay your rent?" I got curious and wanted to get closer, and I got hit on the shoulder by a club. There was a little pushing, an absolute accident, you know.[5] I went on to this place where the union sent me, and they told me to come in for work the next Monday. A foreman sensed my situation, and he slipped me ten bucks to help me out until I began work. I bought two dollars' worth of apples. I went up and down the street and got big bags of them. And I thought the Depression was over for me.

A lot of friends of mine who were university graduates but did not have jobs would hang out at the library all day. [Beginning in late 1930 or early 1931] I used to do the same thing. I'd just go up to that art room on the third floor [the Picture Collection, room 73] and get immersed in something obscure. If I had a dollar a day everything looked bright, because it covered the whole day including newspapers, cigarettes, breakfast, lunch, and dinner. After breakfast at the automat around the corner and buying cigarettes and a newspaper,[6] I had sixty cents left in my pocket, which was more than ample for dinner because we knew Italian families—four or five of us would arrange to have dinner with some family. We'd pay forty cents each, and that almost fed a family down in the Village. A lot of lovely families were glad to have us, and we had a real home meal with them. One day, coming toward me was a friend who I knew was going to tap me for a loan. I couldn't give him the dime, and if I gave him the half-dollar, there'd be no dinner. I was fondling these two coins in my pocket when he rushed toward me and said, "Hey Ben, do you need money? I just got six dollars from the *New Republic.* I sold something to them." I still blush inwardly to think of that.

We were in the same boat. One evening a group of my friends were at my place on [23] Bethune Street in the Village.[7] A number of them had jobs. They taught or were lawyers or something, or had jobs with law firms and were probably earning thirty bucks a week. It was black Sunday night, because I didn't have a cent in my pocket. I wanted to

face Monday with five bucks. I brought out a portfolio of gouaches, and I said I'd sell any three for five bucks, just pick out any three. And I didn't have a taker, except one guy was ready to take one for two bucks. I said, "No, you've got to take three." He didn't take it. Although times were grim we laughed a lot too. Sometimes we would scrape together a dollar and a half among us all, and we'd have a wonderful spaghetti dinner. It was still during Prohibition and I knew a store where they'd give you half a gallon of homemade wine for fifty cents. You could even get anchovies and make it real fancy.

When the banks closed we were heating by gas, and it was running to about forty dollars a month with Walker [Evans] sharing the cost. The gas company said they were going to shut it off. It was grim. That was the terrible winter of '32–'33. So we went all over the city, and we collected close to ninety dollars—we were three months in arrears. I had the ninety dollars, and was going down to the Edison Building there in Union Square [Fourteenth Street and Irving Place]. As I walked down Bethune Street and up Eighth Avenue, I saw at the first newsstand: "Banks Closed." Well, they couldn't shut off the gas when the banks were closed, and I had ninety dollars. I got on the phone and called friends and asked them if they needed any money.

One day I was walking with Lou [Block] on East Fiftieth Street somewhere.[8] We passed a garage, and there was a brand new Rolls standing outside with a sign on it: For Sale. We asked how much it was, and they said it was five hundred dollars. Somebody had left it there and didn't pay for the garaging for over a year, so they wanted to get rid of it. Well, if somebody had said you could buy a Rembrandt for $500,000, it was parallel to that. Much as I would have loved to buy the Rembrandt, this was a red Rolls-Royce convertible. When people talk about that time—those who weren't touched by it you know—it's very hard for them to understand.

Well, I decided then that I would try to exhibit. I had never exhibited before. I went around to galleries. I can't go into the details of the two years of '30 and '31. But in [April] '32 [Diego] Rivera saw my work [twenty-three gouaches from *The Passion of Sacco-Vanzetti* at the Downtown Gallery] and invited me to work with him on the mural he was going to do in Rockefeller Center [*Man at the Crossroads Looking with Hope and High Vision to the Choosing of a New and Better Future*]. I was flattered. And I was on a salary. I was the rich guy on the block.[9]

FIGURE 47
Untitled (Judith Shahn, David Soyer, and Ezra Shahn, 333 West Eleventh Street, New York City), 14 July 1935
Brownie camera snapshot, 6.4 × 8.9 cm
Collection of Judith Shahn and Ezra Shahn

I had already gotten involved rather excitedly in mural work. The Modern Museum in [February] '32 invited a group of, I don't know, fifteen people to do sketches for an imaginary mural [*Murals by American Painters and Photographers*]. I thought they were going to try to find someone, or several of us, who would do murals for the new building they were constructing. They gave us a subject—they called it a postwar subject—to do a total sketch two feet by four feet and then pick up a detail four feet by eight feet.[10] I've written about it elsewhere, so I won't go into it because a great scandalous situation arose.[11]

I worked with Rivera from about March of '33 right until about November.[12] And then there was nothing else again. I often argued with Rivera. For instance, I felt that he was crowding his things too much, just cluttered, and I said so. He said, "Well, look around you. Do you see any space?" In a sense it's true, you know. As I look around now, I see those blueprint cabinets, the books over there, and if one were to photograph it, it would be a clutter. But I always felt that the role of the artist is to bring an order to disorder. We used to have some pretty strong arguments. I speak French fluently, and so we could converse. We'd be on the scaffold together for endless hours.

There are all sorts of concepts of seeing. If you were to

look at a single printed word and just focus on one letter, the rest is out of focus. So it's the same thing. You just focus in and out automatically. You either encompass a large area or you encompass a very tiny area. I felt that murals are visualizations of strong but simple ideas. They have to be that, just as simple as you can really make them. If they get too complex they are seen almost like billboards. They have to have that kind of simplicity. But then, that concept was in harmony with the work I'd been doing up until then. It was nothing more except to think of large spaces and the experience of being on a wall with Rivera for a number of months on another job.[13]

But nevertheless, when I finally got a wall—and it looked as if I'd never get one—I crowded it too much [*Jersey Homesteads Mural,* Roosevelt, New Jersey, 1936–38]. Being kept away from a wall for so long frightened me. The next mural I did was in the Bronx, and it was much quieter [*Resources of America,* Bronx General Post Office, 1938–39, with Bernarda Bryson]. It's like a silence in a musical composition where the next thing is so much more meaningful. I think it went even better than the one I did in the Social Security Building [*The Meaning of Social Security,* in the Wilbur J. Cohen Federal Building]. Then, later murals I did departed from that. You develop. Your ideas change, their influences. But I differed very strongly with Rivera on the kind of mind-made-up approach to things, that the workmen always had heavy wrists and that kind of nonsense. I couldn't go along with that. But I was very happy to work with him because I learned the trade. I learned the craft from him and that's all I wanted.

My friendship with Rivera ceased in the queerest way when the Rockefeller Center mural ended. I had a very big house, and in May [1933] Frida [Kahlo] and Diego came to live with me for a while [at 23 Bethune Street]. Then he went to the Hotel Brevoort.[14] We used to have these discussions, sometimes becoming rather violent about different approaches to what one's work should be. I admired him for the, I thought, kind of futile sacrifice he made. He was the supreme aesthetician while he studied in Paris. And he said, "Now I'm going to speak to the masses, and I must spell everything out." I thought that was over simplified, the approach. You read it like too many words, and I had infinitely more enthusiasm for [José Clemente] Orozco.[15]

Suddenly the federal government set up a project called the Public Works of Art Project, the PWAP. You could have a salary! I was on a salary for two weeks before I knew why.

I was so imbued with the idea of murals that I thought I would do a story of Prohibition, which had just gone out [5 December 1933]. [The art critic] Lloyd Goodrich, who was under Juliana Force [regional director of the PWAP and director of the Whitney Museum of American Art] at the time, said, "Go ahead with that." So we talked about the possibility of putting a mural in one of the city-owned restaurants in Central Park, Central Park Casino [Tavern on the Green] (cat. 73). Then in a couple of months the PWAP ended [June 1934]. Whang! Like that.

I remember the day the PWAP ended. I wandered about the Cooper Union Museum for some unearthly reason. I'd never been there. I saw fascinating things of decor of the eighteenth century, original sketches. But I associate it with that day of getting the pink slip. I was really into murals at that time. I'd made details of an imaginary mural in fresco. I had learned fresco from Rivera. [In the fall of 1934 and spring of 1935] I was teaching fresco [at the John Reed Club School of Art] to other people, people who had nothing to do except learn things. We were all in the same economic boat.

There used to be three blind musicians who went up and down Fourteenth Street, and I used to walk in front of them with the crowd, walking backward while sketching them (cats. 34, 35, 37). And I thought, "My God, I can't get all that detail, ever." I asked Walker if he would show me how to use a camera. He had always promised he would, but he never got around to it. One day he was invited to go on a yacht trip in the South Pacific [Tahiti]—he had some very nice connections. Lincoln Kirstein and I were helping him pack, and I remember we filled up one suitcase with telephone books.[16] We thought those might come in handy, just to be funny. We got him a cab, and I said, "Walker, you remember you promised to teach me how to photograph." He said, "Well, Ben, there's nothing to it: F/4.5 on the shady side, F/9 on the sunny side, twentieth of a second, hold your camera steady."

Then I began to photograph. My brother was a lawyer and an accountant. So I asked him to get me a camera. I'd seen one in a camera shop, a Leica for twenty-five dollars.[17] I said, "You get it for me; and if I can't get anything in a magazine off the first roll"—I was pretty cocky—"then I'll give it back to you." And I did. I got one in some theatre magazine [*New Theatre,* November 1934; see fig. 4].

I'd known Lou Block for several years, and Lou is very good at devising a project. He looked the situation over,

and he must have known that they were building this new Rikers Island Penitentiary.[18] He wrote the project up. It just made your mouth water when he wrote up a project, and it was inevitable that we would get it. We started on it under the state aegis; and we had the most incredible cooperation from Commissioner of Correction [Austin H.] MacCormick, an unusual man in a political job. He had been a professor at Dartmouth. [Mayor Fiorella H.] La Guardia became interested. Commissioner MacCormick would drive over with his three-hundred-foot Cadillac to this dingy little street we lived on, and all the kids would be so curious. La Guardia came down once or twice. We went to see him. Things were going along swimmingly.

We studied correctional institutions (cats. 105–13 and figs. 48, 82–89). We visited Sing Sing. We visited other penitentiaries and reformatories all over the state. I was really going on all cylinders, and I was just knocking out one foot after another of the sketches (cats. 114–17; figs. 78–81, 90). We were working in the same room [at 23 Bethune Street]. Lou sort of bent his work toward the idea I had.

Warden [Lewis] Lawes of Sing Sing was just full of clichés, having been around the Welfare Island prison [Blackwell's Island Penitentiary]. We saw criminals and they looked like criminals, by god. At Sing Sing they didn't look like criminals at all, and I commented on that to Lawes. So Lawes said, "Oh, well, we have all kinds here—bankers, doctors, lawyers, not enough of those, you know." He must have said that to everybody that ever came there. We got nothing from him at all.

We attended one parole hearing—not in Sing Sing—with [Audrey] McMahon.[19] I realized that those things are all arranged beforehand. The priest, the disciplinarian, and the doctor each gave his report on the kid. And they would ask him, "What are you going to do?" The kid would say, "I'm going to get a job when I get out" and so forth. One kid came in, and apparently he changed his mind and became honest. "What are you going to do when you get out?" He said, "Steal! What else can I do? Show me where I can get a job. And if I get a job, I get four bucks a week. How are you going to take a girl out on four bucks a week?" He was shaking when he made up his mind to be honest. The doctor was a sympathetic man and sort of grabbed his wrist and tried to quiet him. The parole was denied because he was being honest.

We also went to see the famous sociologist and penologist at Columbia [University], an old man then, Dean

[George W.] Kirchwey [former warden of Sing Sing]. We spent strange hours with him. We saw everybody that had anything to do with our subject.

The project had gone on for almost a year, from '34 into '35. They had assigned several assistants. One is now a big Hollywood guy [Michael Simmons]. I don't know what he does, producer or something. The other was the brother of Morris Kantor—Izzy [Israel] Kantor, I think his name was—a very gifted boy, crazy as hell but a very gifted boy.[20]

Jonas Lie was head of the [New York City Municipal] Art Commission. I did a caricature of him in *Art Front* [April 1935]. Even though I was riding high with our mural, I felt he was a menace. Well, he was so shocked at the kind of assignments and the way the work was going along so different from what he was used to having seen all the time that he made some crack like, "Let's not worry about those murals, there'll be plenty of whitewash." I then made a caricature of him looking like Patrick Henry, on the base of a statue with a brush that looked like the American flag and a bucket of whitewash (fig. 50).[21]

Then a situation developed where there was a question whether we would get to do the Rikers Island mural. Something had happened inside the inner sanctum of politics; and suddenly they said it's not to be painted. I never knew why. Well, it created quite a stir; and people [from the Museum of Modern Art and the College Art Association] decided to ask [forty] prisoners [from Blackwell's Island Penitentiary] whether they wanted the mural. Some psychologists [Harry Manuel Shulman] made up a questionnaire. It became a cause célèbre.[22]

And the irony of ironies occurred when the prisoners' reactions were counted. I remember one vividly: "Picture east wall, good; picture west wall, good; all pictures good"— 95 percent apparently favored it because I think they knew what was expected of them. Do you know, the next day the *Tribune* came out with the headline: "Ninety-five Percent of Prisoners Reject Mural" [*Herald Tribune,* 9 May 1935]. This was just fed right out of City Hall.

Then it was suggested that we go and protest the rejection of our mural at the courthouse in the old Customs Building—not the one that's down at the Battery, but the old Customs Building on Christopher Street [and Washington Street]. Lou and I went there, and I tell you I felt like Christ before the rabbis. These three judges, old and deaf, couldn't have us come too near them because it interfered with the dignity of the court. It was a hot, boiling day, one

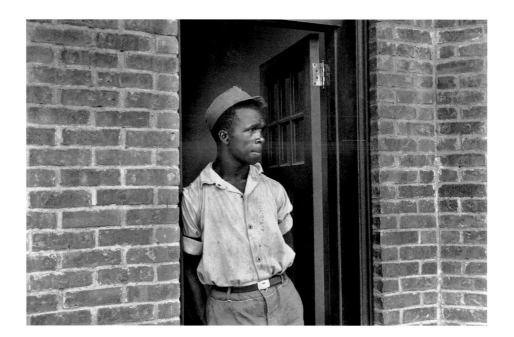

of those August days in New York. So they closed the windows—it was too hot, and they had to shift back and forth. There they were sitting in their judicial robes, listening, and I felt utterly hopeless. They hadn't the slightest interest, and one of them summed it up by saying very simply: "Look young man, if there was any money for painting, we'd paint the toilets first." That was that.

After the mural was rejected we even went to Coxsackie, up on the Hudson near Albany somewhere, where there is a reformatory [New York State Vocational Institution]. We spent a couple of days there, proposing the possibility of doing the mural—but all the time in my heart of hearts I knew that it was pretty hopeless.[23]

I was totally immersed in that subject, in every phase of it. I don't know how much more I would have done. I had finished my sketch about halfway when the thing was stopped. So I don't know just what would have come of it.

This is briefly the story of the Rikers Island mural. About two weeks later the WPA was formed, and I got a real job in the Resettlement Administration, and I left all my Rikers sketches. When the WPA was broken up, some junk dealer [Robert's Book Store, New York] bought all the sketches for weight.[24]

Then, when I worked for the Farm Security and the Resettlement Administration, that in itself was fantastic. [Rexford Guy] Tugwell came to see me [in September 1935]. Someone [Ernestine Evans] advised him that I might be good. Walker was already employed. Tugwell held out the following: "You get five dollars a day travel per diem, five cents a mile." I knew I could get my Ford running on a penny a mile, so I figured, my Lord, I'm in. He said, "Now, what do you want as salary?" I said, "Well, that's enough, thirty-five a week and mileage." He said, "No, no. That's just expenses." I nearly died. It was unbelievable.

Anyway, Tugwell said, "First we want you to go around the country for about three months, look at our projects and see, know what we're working with and about." Well, I had never traveled in America at all. I'd been to Africa [Algeria and Tunisia]. I'd been all over Europe [Italy, France, Spain, and briefly in Germany] but never in America.[25]

Off I went and, boy, that shook me up. I took a lot of pictures and photographed a lot and drew a lot. I realized that everything I had gotten about the condition of miners or cotton pickers I'd gotten on Fourteenth Street. I found realities there that I had no idea about.

I went to the mine country in West Virginia. There was a

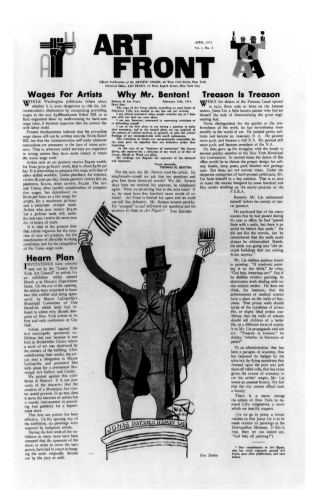

FIGURE 50
Jonas "Patrick Henry" Lie, 1935
In *Art Front* 1 (April 1935): 2
41.4 × 27.8 cm
Taller Archive

small strike going on, and I got to see the picket line there. So I fortified myself with a pack of Raleigh cigarettes because they're union made. I figure you can always start a conversation by offering a man a cigarette. There were a couple of guys in the picket line, and I picked a man that looked more sympathetic and offered him a cigarette. He said, "They're no damn good." I said, "They're union made." He replied, "The hell with that, I've been in the union thirty-five years," and he pulled out a pack of Luckies. Well, this was shocking. I found out that if you had a copy of *The Nation* with you, you might have been beaten up. And

We pick cotton

53

FIGURE 51

Untitled (cotton pickers, Alexander Plantation,
Pulaski County, Arkansas), October 1935
In Richard Wright, *Twelve Million Black Voices*
(New York, 1941), 53
25.4 × 17.2 cm

if you said a word against John L. Lewis, who was extolled in *The Nation,* you'd have been beaten up. This was the irony. These things shook me up no end.

Sometimes [RA] staff gave us a little trouble. When we got to Little Rock I had a letter of introduction to our regional director there, a guy by the name of O. E. Jones, and when I showed him my letter, he said, "What the hell are you coming down here for, making more trouble for us?" It was weird. This was our man you know. He was a big plantation owner. But these were realities I didn't know any-

thing about. I had thought that if a man works for this revolutionary agency he's going to have a heart of gold. I remember one regional director driving me around for a couple of days. And he said, "You ain't seen Niggers here, have yah? Well, the Niggers know that they ain't to be seen here after sunset." I also drove around with Brooks Hays who later became a congressman [in 1942] and then was kicked out [in 1958] because he took a fairly strong stand for integration.[26]

Anyway, I became acquainted with America. I came out to [Alexander Plantation, Pulaski County, Arkansas] to take photographs, and I knew I'd have to be there at 5:30 in the morning when the crew got together. The sun was low, just rising, and it was beautiful. They stood there, and they were singing of spiritual things. On the truck they put huge cans of water for when they'd get thirsty; and by eight o'clock, those cans of water were as warm as piss. At the end of the day, they'd get back to their company store where they started; and they'd drink three Cokes out of the sixty cents they earned in the twelve hours—five cents an hour. At one plantation, a guy stood with a shotgun to keep any other plantations from recruiting labor—in case he'd offer them six cents an hour. Those things I had no idea about, you know, and I have to see these things to understand them. I can't read too much about them. Afterwards I can read but not before.

To me, images are images. I don't care whether they're made with pen, pencil, or brush. They're images, and they can be moving or not. That's all there is to it.

NOTES

The interview took place in Roosevelt, N.J., on 3 October. The manuscript is in the Archives of American Art, Smithsonian Institution, Washington, D.C. We publish excerpts edited and annotated by Deborah Martin Kao and Jenna Webster.

1. The artist was born Benjamin Zwi (Hirsch) Shahn in Kovno (now Kaunas), Lithuania, 12 September 1898. He emigrated to the United States in June 1906 and obtained citizenship through the naturalization of his father on 17 March 1918 in Brooklyn. Shahn signed his passport in 1924 Benjamin Shan, the same name which appears in his grade school records. His brother Philip retained the spelling "Shan" for his entire life.

2. For an account of people observing Shahn as he painted his Social Security mural see Ada Rainey, "Art Spotlight of the Week on Murals," *Washington Post,* 28 September 1941, Art section, p. 6, Shahn Papers, 5024F256–5024F257.

3. Shahn also makes reference in this interview to his photo-

graphs being published by *Vanity Fair*. A search of *Vanity Fair* and its companion magazine *Vogue* for the years 1930 to 1936 revealed no photographs or other works by Shahn. According to Walker Evans, Shahn did work for *Vanity Fair* in the fall of 1933. See Evans to Leyda, 22 November 1933, Leyda Papers. According to Selden Rodman, in 1926 Crowninshield wanted to arrange an exhibition of Shahn's work at the Montross Gallery at 785 Fifth Avenue: Rodman, *Portrait of the Artist as an American: Ben Shahn, a Biography with Pictures* (New York, 1951), 135. Shahn agreed at first and then later refused, feeling that his work was "derivative" and not worthy of being exhibited. Undismayed, however, Crowninshield went on to arrange employment for Shahn in a Provincetown theater; Shahn's job included whistling in the jungle before the opening curtain of the theater's revival of Eugene O'Neill's *The Emperor Jones* (1921). While in Provincetown, Shahn became acquainted with the actors Charles Gilpin and Paul Robeson. Shahn discusses his work designing stage sets in a filmed interview of 17 February 1959 (Shahn Papers, 5023F1143–5023F1144).

4. Shahn and Tillie (Ziporah) Goldstein were married 8 August 1922 and moved to 150 Columbia Heights in Brooklyn Heights. In 1925 the couple traveled throughout North Africa and Europe (France, Spain, Italy), spending four months in Paris. When they returned to the United States they settled at 146 Willow Street, also in Brooklyn Heights, and spent summers in Truro, Massachusetts, where they maintained a cottage that they had purchased with their friend Dr. Iago Galdston. In 1928 the artist and his wife traveled abroad again, visiting Paris once more and also staying for a number of months in Algeria and Tunisia. When the couple returned to the United States in 1929 with their infant daughter, Judith Hermine, born in Paris on 14 July, they moved to 301 Hicks Street in Brooklyn Heights. The three resided at 23 Bethune Street in Greenwich Village beginning in early 1932. By November 1934 the artist, Tillie, Judith, and Ezra, who was born 12 November 1933, moved to 333 West Eleventh Street. However, Shahn continued to share a studio intermittently with Walker Evans, Lou Block, Jay Leyda, and Peter Sekear at 23 Bethune Street and then by July 1935 at 20–22 Bethune Street. When Shahn left New York for Washington in late September 1935, he and Tillie had separated. Ironically, in 1936 Tillie worked briefly for the Resettlement Administration in Jersey Homesteads, which Shahn visited in preparation for his mural there.

5. In an interview with Morris Dorsky, Shahn explained that the violence developed when a policeman was pursuing a journalist who was photographing the event (Dorsky, interview with Ben Shahn, Roosevelt, N.J., 4 December 1950, Taller Archive).

6. In a 1965 interview with WCBS-TV, Shahn remembered that his favorite automat was on Forty-second Street and Fifth Avenue.

7. Rodman writes that Shahn told him this incident took place at a party held by Shahn's friend Philip Van Doren Stern, who had proposed that the artist create ten lithograph illustrations for Thomas De Quincey's unfinished essay, "Levana and Our Ladies of Sorrow," a financially unsuccessful project that Shahn completed in 1931 (*Portrait of the Artist as an American,* 123).

8. Lou Block lived in this neighborhood during the 1930s.

9. In 1930 the radical social-activist attorney Phillip Wittenberg brought Shahn to the attention of Edith Halpert of the Downtown Gallery on 113 West Thirteenth Street. Halpert first included Shahn's work in a group exhibition; then in April 1931 she presented his paintings and drawings from North Africa in a one-man show. Shahn's work was featured in eleven solo exhibitions at the gallery over the course of his career. Shahn had met Wittenberg through Tillie, who was a friend of the lawyer's wife. Wittenberg, a close acquaintance of Halpert's husband Samuel, frequented theatrical and literary circles and also defended Diego Rivera in the Rockefeller Center controversy.

Shortly before the Downtown Gallery showing of Shahn's work, MoMA held a major exhibition on Rivera (23 December 1931 to 27 January 1932). According to Morris Dorsky, Rivera visited the Downtown Gallery with John A. Dunbar, a member of the MoMA Advisory Committee, the Saturday before the exhibit of Shahn's *The Passion of Sacco-Vanzetti* (5–17 April 1932) opened. See "The Formative Years of Ben Shahn: The Origin and Development of His Style" (M.A. thesis, New York University, 1966), 95. For Rivera's account of his visit to the exhibition see Diego Rivera, "The Revolutionary Spirit in Modern Art," *Modern Quarterly* 6 (Autumn 1932): 56. Lou Block claimed that Shahn and Rivera first met at a Christmas dinner party that Lou's brother Harry, a senior editor for Alfred E. Knopf, threw for Rivera and the artist Miguel Covarrubias. See Harlan Phillips, interview with Lou Block, Louisville, Ky., 31 May 1965. Covarrubias often visited Rivera and his assistants while they worked on the Rockefeller Center mural.

10. The exhibit, arranged by Lincoln Kirstein, was held at the Museum of Modern Art, New York, 3–31 May 1932. Rivera may also have seen Shahn's work at this exhibition. According to Rodman, Shahn received a congratulatory telegram from Rivera (109). MoMA was preparing to open at its new location at 11 West Fifty-third Street, and *Murals by American Painters and Photographers* was one of the first exhibitions in the new quarters. Entries in the MoMA exhibition were considered examples of the types of work that could decorate the new Rockefeller Center. The large panels measured more than 2 meters high by close to 1 meter wide, while the smaller studies measured about 54 centimeters high by more than a meter wide.

11. Shahn refers here to an infamous incident in which MoMA officials attempted to reject his Sacco and Vanzetti mural designs as well as works submitted by Hugo Gellert and William Gropper on the grounds that they satirized contemporary figures. Under the threat of a boycott by the artists and with the support of Kirstein, the works were installed. Shortly after *Murals by American*

Painters and Photographers opened, the disputed works were separated from the rest of the exhibit and installed on the fourth floor. See Hugo Gellert, "We Capture the Walls! The Museum of Modern Art Episode," *New Masses* 7 (June 1932): 29; and Lincoln Kirstein, "Contemporary Mural Painting in the United States," *Hound and Horn* 7 (July–September 1932): 656–63.

12. Rivera received notification that his mural proposal for Rockefeller Center had been approved on 7 November 1932. He, his wife Frida Kahlo, and his assistants Ernst Halberstadt and Andrés Sánchez Flores did not arrive in New York City to begin the mural until 20 March 1933. Rivera and his helpers, including Shahn, Ramon Alva, Lucienne Bloch, Lou Block, Stephen Dimitroff, Art Niendorf, Hideo Noda, and Clifford Wight, had to work extremely quickly to have the mural ready by May Day, when the artists hoped to unveil it.

13. Beginning in July, Rivera used leftover funds from the Rockefeller Center mural to execute his mural *Portrait of America* on twenty-one portable panels in a ramshackle building on West Fourteenth Street that housed the New Workers' School. Shahn and Block helped construct the heavy supports for the panels, which weighed about three hundred pounds each. Walker Evans and Jay Leyda photographed the mural on 21 July; Evans documented the work again in early August, and his photographs were published in Rivera's book *Portrait of America* (1934). Rivera finished the project by September and then worked for several months on smaller fresco panels at the International Workers' School, after which he left New York. He donated the New Workers' School frescoes to his friend (and future biographer) Bertram D. Wolfe, who was a cofounder of the Mexican Communist Party and directed the New Workers' School in a building he owned. When the panels were removed from the Fourteenth Street building, thirteen were installed at the International Ladies' Garment Workers' Union at Unity House in Forest Park, Pennsylvania; fire destroyed these panels in 1969. The remaining panels reside in private collections, including the collection of a former Mexican president, Luis Echeverría.

14. Situated among modern apartment buildings in Greenwich Village, the Hotel Brevoort, at Eighth Street and Fifth Avenue, was known for its distinguished intellectual and cosmopolitan clientele. Following the covering of the Rockefeller Center mural Rivera and Kahlo stayed briefly with Shahn while they searched for a residence close to the New Workers' School. Hideo Noda also lived with Shahn (Morris Dorsky, interview with Ben Shahn, Roosevelt, N.J., 27 October 1951, Taller Archive).

15. Throughout the 1930s Orozco lived intermittently in New York City. Shahn could have seen Orozco's murals at the New School for Social Research and at numerous exhibitions featuring his work.

16. According to an entry in Kirstein's diary, on 30 December 1931 he, the photographer Paul Grotz, and Shahn packed a movie camera and lightbulb, a New York telephone directory, and toilet paper into Evans's suitcase (cited in James R. Mellow, *Walker Evans* [New York, 1999], 146). Paul Grotz remembered being with Shahn as Walker gave his instructions (Belinda Rathbone, interview with Paul Grotz, New York, 1 March 1990).

17. For more on Shahn's Model A Leica see the Note to the Reader and George Gilbert, "35-mm," *Collecting Photographica: The Images and Equipment of the First Hundred Years of Photography* (New York, 1976), 134–46. We are grateful to Kevin Dacey, an assistant in the Department of Photographs at the Fogg Art Museum, for his research of this material.

18. Block and Shahn considered doing a prison mural as early as August 1933.

19. Audrey McMahon, editor of the art journal *Parnassus,* was the executive secretary of the College Art Association and directed the art unit of New York's Emergency Relief Administration (ERA), later the Temporary Emergency Relief Administration (TERA). As the head of the WPA Art Project in New York City and the regional director for New York State and New Jersey projects, McMahon oversaw Shahn and Block's work on the Rikers Island mural.

20. For Shahn's commentary on this statement by Jonas Lie, see Edward Alden Jewell, "In the Realm of Art: Diverse Mural Projects," *New York Times,* 19 May 1935, 9.

21. During the course of the Rikers Island project, Lydia Nadejena, who wrote for *Parnassus,* and Joseph Vogel were also assigned as assistants.

22. Shulman wrote extensively on the relation between social welfare and crime. See Harry Manuel Shulman, *Slums of New York* (New York, 1938).

23. In June 1935 Block and Shahn also suggested executing the mural at Elmira, Woodbourne, and Walkill prisons. In the collection of the Fogg Art Museum are a series of photographs (prints and negatives) of a ferry and a lawn party that Shahn may have made during this trip.

24. The government warehouse storing easel paintings from the Federal Art Project auctioned WPA paintings by the pound as "used canvas." The proprietor of Robert's Book Store obtained the lot, which weighed approximately a ton, in December 1943 and resold the canvases for three to five dollars each. See "End," *Art Digest* 18 (15 February 1944): 7. Shahn's clipping files also contain an article by Burt Schorr entitled "Art Works Produced Under Federal Programs in 1930s Are Neglected," from the *Wall Street Journal* (undated), Shahn Papers, 5024F1205 and 5024F1206.

25. In late September 1935, Shahn and Bernarda Bryson traveled throughout the South, beginning in coal-mining country (West Virginia, Kentucky, Tennessee). They continued on into Arkansas, Louisiana and Mississippi. Shahn and Bryson returned to Washington, D.C., on 8 November. Precise dating of the photographs from this trip is problematic since no itinerary exists and

the Historical Section developed film in large batches. For analysis of their trip see Susan H. Edwards, "Ben Shahn: New Deal Photographer in the Old South" (Ph.D. diss., City University of New York, 1996). Also see Carl Fleischhauer and Beverly W. Brannan, eds., "Appendix: The FSA-OWI Collection," *Documenting America, 1935–1943* (Berkeley, 1988), 330–42.

26. Stryker to Shahn, 7 October 1935, Shahn Papers, D147F503. Shahn met (Lawrence) Brooks Hays when he was holding a series of legal and administrative posts in RA/FSA offices in Arkansas. In 1957 the moderate Hays, strongly opposed to Jim Crow laws, played an integral role in easing the process of integration in Little Rock, hoping to establish a pattern for solving the nation's racial problems. After serving for sixteen consecutive years in the House of Representatives, Hays was defeated for reelection in 1958.

Diego Rivera:
Foreword to *The Mooney Case,* 1933

Lithographic workman, former student of biology, a man absorbed in the interests of his own class and in its defense, Ben Shahn is a typical case of the true modern artist and one of those individualities that may well assume greater importance, now that the agglomeration of ninety million men in North America is beginning to feel imperatively the necessity of finding an autonomous cultural expression that will serve it as a vehicle of unification.

Racial multiplicity gives the society of the American continent a universal physiognomy; by immense majority it has a worker-peasant social structure; from all its historical antecedents it has inherited a petit-bourgeois education. Contemporary American artistic expression must contain and give voice to these circumstances.

No other painting demonstrates this fact more clearly than that of Ben Shahn. It contains all the technical assets of French bourgeois art as well as naiveté of the "American Folk Art" style, and the broken chiaroscuro and confusion of the world city of New York. A judge's head and the trousers of one of Ben Shahn's personages in his paintings are in themselves a complete portrait of the social environment in which the life of this painter has developed.

Ben Shahn has humanized the technical methods of the Paris painters. Someone has called the modern French painters "dehumanized." In reality, they are profoundly human, only the humanity they express is a decadent one.

Ben Shahn has discovered the just note for his work now that his subject matter is the struggle of the proletarianized American petit-bourgeois intellectual against the degeneration of the European bourgeoisie transplanted on this continent. His ability and his esthetic qualities are magnificent, as witness the fact that he is accepted by the most sophisticated connoisseurs of art as well as by the masses of workers.

Also, the case of Ben Shahn demonstrates that when contemporary art is revolutionary in content, it becomes stronger and imposes itself by the conjunction of its esthetic quality and its human expression. To the extent that it answers the demands of the collective spirit, the collectivity will respond by according success to the painter. It demonstrates as well that once art is set in this road, it acquires a progressive rhythm identical with that of its epoch. Hence, Ben Shahn's series on the Mooney Case is even stronger and of finer quality than his Sacco-Vanzetti paintings.

The English esthete, John Ruskin, said many years ago, something to the effect that lilies and peacocks are beautiful without serving any utilitarian purpose. Some time later, the great painter, Picasso, added: "Art is twice beautiful because it is useless." But we painters of the people of the American continent proclaim: "Whatever is not five times useful is not beautiful."

NOTES

Rivera's commentary on *The Mooney Case* was published in a brochure in conjunction with the exhibition of the series at the Downtown Gallery, New York, 2–20 May.

Jean Charlot:
"Ben Shahn: An Appreciation," 1933

It is sometimes perplexing to come face to face with the opinions that contemporaries of past periods had of their artists, and to check up on the final allotment of fame as ratified by posterity. Gigantic figures, pricked, dwindled like balloons, while from some corner obscurely related to fine arts, a fashion-plate designer like Moreau-le-jeune, a newspaper reporter like [Constantin] Guys, emerge as the indisputable mouth-pieces of their epoch. Thus, on the ground of experience, we may prophesy the deflation of our own giants of modern art, and start hunting through improbable corners of garrets and cellars for more authentic geniuses dyed deep enough to suit the taste of our grandsons.

FIGURE 52
Apotheosis panel from
The Mooney Case, 1932–33
In Jean Charlot, "Ben Shahn,"
Hound and Horn 6
(July–September 1933):
639

THE SUPREME COURT OF CALIFORNIA MOONEY TOM MOONEY'S MOTHER
APOTHEOSIS BEN SHAHN
(Panel in Tempera)

Why is it that contemporaries of the artists usually guess wrong as to their respective merits[?] We associate the idea of greatness with the term "old masters" and those are for us elders with long beards who live and work in an ivory tower suggested by the museum atmosphere in which their pictures are now buried. We forget that those old masters were young, and that they achieved international fame only by clinging tenaciously to their own earthly boundaries and mental idiosyncrasies. Thus Brueghel, after a trip to Italy at the time that Michael Angelo was painting the Sistine, came back home steeped deeper than ever in the atmosphere of his own Dutch peasantry and his distaste for the Spanish invaders. Siding with one's own moment, country, party or hamlet, diving into the social turmoil, using pencil and brushes to club your opponents is paradoxically one of the surest ways to remain in posterity's consciousness as a master whose work did transcend all limitations of time and space.

We can safely look at Ben Shahn as a most valuable witness to our epoch. Both his language and subject matter are unmistakably contemporary. He is indeed a painter of historical tableaux as much as Emmanuel Leutze or the Baron Gros, and if his pictures are so dissimilar from theirs, it is further proof of how genuinely Shahn is of his time. The sources of Shahn's art, that is, the technical sources, its grammar, are to be found in this school of Paris whose aims differed so entirely from his own. Flippant [Raoul] Dufy and Catholic [Georges] Rouault contributed indirectly to his vocabulary those broad washes of gouache which in an apparently accidental way create the volumes, but not this tense, grimy city atmosphere which remains peculiarly his. On this loosely brushed background a line as keen as the sharpest silver-point superposes its own version of the subject, sometimes in agreement with the mass modelling, but more often unbinding itself from it and creating a version of its own. It is a palimpsest, two texts perceived simultaneously, whose concordancies and discrepancies create a third image, forcefully dynamic, which is the picture.

Much of Shahn's plastic is explainable by his aims. Being a story-teller, his source material consists mainly of newspaper reports, his models being the photographs of rotogravure sections and tabloid sheets. Degas also used photographs, but depurated [purified], stylized, lifted to the plane of his art. Shahn, on the contrary, delights in what is peculiarly accidental, cynical, and ungentlemanly in camera work. The gymnastics of inhibition by which we immediately substitute for any given spectacle a more anthropomorphic version in which hands and heads will be given the leading role, do not fool the camera, nor Shahn. For them a man, however intellectually eminent, will exist mainly

through the bunch of folds and creases which are his clothes, his buttons, his shoe-laces, his grotesque shadow on a brick wall, the baroque mouldings on the arm of this chair, while his mouth and eyes may be summed up by three inconspicuous slits. Such an ousting of our lawful vision is a slap to the highly orderly and satisfying implications that this vision symbolizes. Yet the more one grows accustomed to this new version of the world, the more one is able to perceive in it a new order. The overgrown canine teeth of Governor Rolph [*Governor James Rolph, Jr., of California,* 1932, from *The Mooney Case,* 1932–33], the bittersweet dimple at the corner of Mooney's mouth are enough to reassure one that this apparently mechanical vision is as heavily loaded with moral values as the more conservative and antiquated version.

NOTES
The essay first appeared in *Hound and Horn* 6 (July–September 1933): 632–39.

John Boling: "The Face of a City," 1934

From Russia comes a small book of photographs of Paris which ought to stir up excitement among our commercial and arty-minded camera men. Ilya Ehrenbourg, its author and one of the great continental reporters of our time, for years has been living in Paris; here he wrote many of his novels and magnificent reports, here he witnessed the feverish pulse and changing scene of a city which produced a Zola and Jean Jaurès, a Murger and an American Left

Bank.[1] Ehrenbourg may have seen [Eugène] Atget's classic photographs depicting the provincial aspects of the metropolis, the tender poetic prints which glorified the petit-bourgeois *colorit* [nuance, shade] of the outskirts for the painters of twenty years ago; perhaps he has seen the modernistic spiralbound book [*Paris de Nuit (Paris by Night),* 1933] with the preface by Paul Morand presenting Brassaï's [Gyula Halász] spectacular show of 60 photographs. "Paris de Nuit," dramatically exposing the mysterious quality and pictorial originality hidden beneath the growing shadows of metropolitan nights; and he surely must have seen the hundreds of pictures which the Hungarian photographer [André] Kertész made of Paris: sensitive types and characteristic details, the shifting traffic and picturesque streets and corners, photographed expressly for publication in breezy newspapers and lengthy feature magazines.

But all these books and photo magazines presented only part of the vast panorama, all these camera men did not include the penetration and analysis which Ehrenbourg regarded [as] vitally important today. They applied the modern photo technique for an antiquated outlook on life; they used every known trick of camera and lighting for surface pictures without aim nor discretion. Nowhere could one find an expression of the social background which is called propaganda nor that of the sociological implications bound to reveal more than rotogravure pages allow to reveal. Nowhere was evident the convincing momentum and absolute strength of the camera which can unify a group of individual shots to an extraordinary manifestation of the contemporary scene.

Equipped with a Leica camera and angle viewfinder,[2]

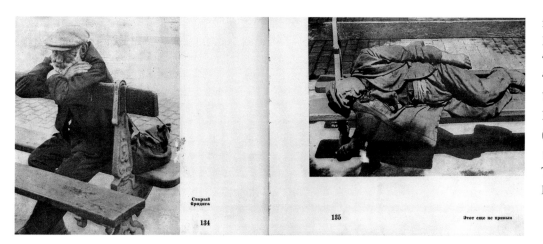

FIGURE 53
Ilya Ehrenburg,
"An Old Vagrant" (left);
"This One Still Hasn't Gotten
Used to It All" (right)
In *Moi Parizh (My Paris)*
(Moscow, 1933), 134–35
15.1 × 36.6 cm
The Fine Arts Library,
Harvard College Library

Ilya Ehrenbourg set out to rediscover a city that has been far too much romanticized and surrounded with a halo of pseudo-artistry. This book gives us a cross-section of the little joys and large miseries of the proletarized middle-class and labor population; and its lasting fascination is undoubtedly due to the fact that Ehrenbourg has been able to catch the most intimate gestures and expressions of these people fully unaware of the camera. Nothing is posed nor strikingly "pictorial," nowhere an aesthetic or artistic strain of photo montage or angular distortion,—nothing much happens in these pictures although each one tells a complete story in itself. This and the shockingly true and human insight make the perusal such an exciting experience. This unpretentious book has the rare quality of a movie in slow motion tempo recorded in natural sequence. Here groups of workmen gather for a glass of beer, the old women sit before the crumbling façades of their houses and stare indifferently into an empty future, the children play in the gutter, the crippled and drunkards sit and lie on benches and pavement and dope off their fate allotted them by our present society. And all around swirls the life of the street: sidewalk restaurants and carousels, open dance plateaus and performing athletes, pushcarts, show windows, flower vendors and gypsy fortune tellers. Ehrenbourg does not contrast the wretched machine slave against the deluxe glamor of Gay Paree. He does not crash the gates of the factories to glorify the machine, which is the same in Russia as in France, he only shows the life-withered faces and figures in their off hours, the burdened carriage of body and mind, the broken spirit of infinite despair.

It is astonishing indeed how little cognizance has been given the camera as a powerful historic recorder of the times. Marked and expanded in literature as the *Age of Transition,* what a wealth of material for myth-exploding "stills" offers photography in giving reality to what the inner eye may see. Except for the sudden boom our publishers respirated into complications of ready material into sentimental and lop-sided surveys of "only yesterdays," little encouragement has come forth to present in graphic terms what hundreds of print-pages cannot describe. And even among compilations the publishers missed the most interesting of all: a panorama of *Twenty Years of World History,* published three years ago in several European countries.[3]

The tragic case of our camera men is tied up with their complete surrender of heart and soul to advertising. A wealth of knowledge and experience, ability and talent is being used up for posed fear pictures propagating a particular brand of toilet paper or into most intricate lighting technique to make a can of beans look like a bowl of crystals. The art of photography has been limited by advertising to the creative urge of distorting a car into a super-long body, stamina-inflated tires and the durability of an armored tank; the photographer's conception of beauty has been pressed into the catalogues of model exchanges standardized by moneyed clients as typical of the average taste of the average buying public.

The others went aesthetic and acquired a "romantic" way of surveying the scene or, at best, they somersaulted into technical bravados of surréalist abstractions. Dr. Erich Salomon probably took the finest pictures the Leica camera has as yet produced, but his ambition was to become the "candid" recorder of the snore and sneeze diplomats and society ladies and he snapped them chewing spaghetti or dissipating in boredom. Remie Lohse was propelled by sophisticated magazines and photo connoisseurs into public life as "The Big Miniature Man," but he only advanced to an uninspired vulgarization of perfectly lighted strip acts and hot-cha parades of Harlem night clubs and Broadway burlesques.[4]

And Walker Evans, most brilliant and sincere among the younger photographers, when he was commissioned by the New York T.E.R.A to make a photo report of relief work was confined to the uninteresting task of reproducing images of social workers in their various activities, of workmen engaged in obviously trumped-up jobs, of recording the machinery of relief, just as a commercial photographer in an advertising agency is required to record the machinery of salesmanship. We have not seen these pictures, but we saw a few stirring and true records of misery and depression which were done collaterally. Some publisher, if not the T.E.R.A. itself, should have commissioned Evans—and it is not too late—to accomplish this important job for which he has shown passion and ability.

So it must be stated that most of the document pictures do not come from our photographers; they are an accidental by-product of the newsman. Conscious of the lack of material and tremendous range of photographic expression, the Film and Photo League has gathered a number of militant photographers [including Ralph Steiner, Leo Seltzer, Leo Hurwitz] and newsreel men [Jay Leyda, Tom Brandon, Samuel Brody] to collective action. They were sent out to cover lynch trials and strike bombardments, hunger marches and N.R.A. [National Recovery Act] pa-

rades; and photo exhibits of the social scene have been arranged with many outsiders participating.[5]

Strangely enough, we can find a full-grown collection of document pictures not by the photographers, but by painters like Reginald Marsh, Denys Wortman, Ben Shahn and others. Marsh uses much of the photo material for his luscious figures and blank faces of Fourteenth Street crowds and Burlesque audiences; Denys Wortman found infinite source material for his daily Metropolitan Movies cartoon, without using it with sympathy to the working class; and Ben Shahn, who will be remembered for his series of gouaches depicting the Sacco and Vanzetti case, is working at present on a mural for one of New York's prisons (cats. 121–22). Whatever this may point out, it seems certain that our painters, inspired and influenced by mural painting[,] which is collective work and meant for mass inspection, are many steps ahead of our photographers in recognition of the camera as a powerful medium of expression.

Ehrenbourg's record of the social strata of a city is significant today, for it clearly shows that the camera eye stands before the lens, that a social consciousness is needed to produce a picture revealing the rotating kernel of our cultural labyrinth.

Indeed, a great deal of credit must be given to the Russian Ilya Ehrenbourg[,] who has caught the breath of a typical French city as few photographers ever have. In not one of these photos does he succumb to the classic Russian technique of symbolizing events with the enlarged features of face and body shot from below, nowhere can one trace back the German influence of technical sharpness and geometric-exact composition which allows but little range for emotional modulation. Despite the poor reproduction, one can easily see the splendid composition Ehrenbourg found for this monochromatic group of photos and a pictorial depth of character reminiscent of the Scotch master [David Octavius] Hill. It is to be hoped that this book will soon find an American publisher and that our photographers will be inspired if not commissioned to start work on a series of books recording the background of American life today whose repercussions will be heard tomorrow.

NOTES

This article, annotated by Jenna Webster, is a review of Ilya Ehrenburg's *Moi Parizh (My Paris)* (Moscow, 1933); it first appeared in *New Masses* 12 (18 September 1934): 26–27. The critic

John Boling also wrote for *Art Front. Moi Parizh* was never published in America.

1. Ehrenburg, who lived in Paris with few interruptions from 1924 to 1940, found a place among other émigrés during this time and hosted visiting Soviet writers and artists.

2. It is possible that Ehrenburg used a Russian copy of the Leica known as an FED. For an illustration of the FED see George Gilbert, *Photographica: The Images and Equipment of the First Hundred Years of Photography* (New York, 1976), 137. Companies in the United States, England, Italy, and Japan made copies of the Leica as well. We are grateful to Kevin Dacey for researching this material.

3. Boling refers here to *1910–1930: Zwanzig Jahre Weltgeschichte in 700 Bildern* (Berlin, 1931), with photographs by Sandor Marai and Laszlo Dormandi.

4. Remie Lohse's photographs appeared frequently in *Vanity Fair* and other popular magazines. Erich Salomon practiced photojournalism in Germany in the 1920s and 1930s.

5. The Workers' Film and Photo League was established in December 1930 in the tradition of the Workers' International Relief, a proletarian organization founded in 1921 by the Communist International. The Film and Photo League, as it was known beginning in 1933, provided a forum for leftist photographers and filmmakers to exchange ideas, take classes, and protest for the causes of the working class. Because of dissension and general disorganization among the filmmakers, the league dissolved in September 1934. A number of the filmmakers formed Nykino, a section of the Theatre of Action, while some of the still photographers organized what became known in 1936 as the Photo League.

Walker Evans:
Slide Lecture, Fogg Art Museum, 1969

I'm full of the subject of Ben Shahn because I knew him awfully well for years and years, way back.[1] I haven't rehearsed the idea of speaking about Shahn. But I want to unburden myself with some ideas I had about this man whom I thought so much of. I used to fight with him and love him and go through all the emotional upheavals that close friends produce.

The Leica camera came out about 1925, and I remember that it fascinated Shahn. He got hold of one somehow, and he knew I knew something about it so he asked me how it worked. He was just like a child with the thing. He couldn't stop shooting pictures.

I would note how quick he was on his feet and what a witty eye Shahn had to whip out this kind of camera and to

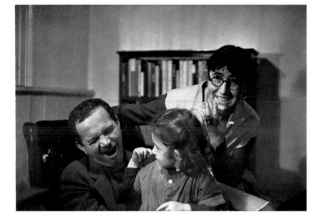

FIGURE 54
Walker Evans, *Ben, Tillie, and Judith Shahn,*
23 Bethune Street, New York City, 1933–34
10 × 14.5 cm
The Museum of Modern Art, New York,
gift of the photographer

sort of shoot from the hip in a second. It is interesting, just as a footnote, that Shahn's work represents pioneering documentary photography. Now you've all seen oceans of it, but this is one of the early examples, and Shahn had that kind of an eye and enthusiasm and energy about it.

Shahn and I both discovered a gadget that fitted on the Leica camera which isn't used very much anymore. It was a right-angle viewfinder. It's really a periscope in horizontal form. We photographed people unobserved through this thing. We felt perfectly guiltless about doing this because we, in the amplitude of our youth, believed we were working in the great tradition of [Honoré] Daumier and the *Third Class Carriage.* And we didn't care how we bothered people if we got a picture. I mean we certainly weren't going to hurt them. I think they knew that. Anyway this is a stolen picture with one of those little spies.[2]

Shahn was anxious in his photography to keep away from so-called coarse, artistic work. Cotton does have a great design to it which he probably couldn't resist appreciating and recording. The fantastic shapes of the bags are the result of his sophistication about design. But that is also a documentary photograph.[3]

This is the work of an artist with a practiced eye, and at the same time it has that atmosphere. That is New York, the Lower East Side, which was so rich in those days in food for the eye. Shahn and I and several other artists used to hang around a great deal just soaking that up and getting the atmosphere of life in the Lower East Side of New York, particularly in the summertime. It was like being in Naples.

Shahn photographed with great response and great feeling. That was his trademark. I regarded him as a humanitarian par excellence. This image almost looks like a Shahn painting—his great sense of lettering, his response to the vernacular. His design in that picture is remarkable. I really love that thing. I wish I'd done it.

We liked Henri Cartier-Bresson very much. He was a rather dreamy kind of person. He and his sister were quite well known as odd and lovely characters around the Village.[4] During the Depression he was being fed by the birds it seemed; we all were, as a matter of fact. That was a curious atmosphere, which is now a past dream to me, but the idea of living without money now seems so odd that it's hard to even speak about it. And people don't believe that this was possible. When I say "without money," I mean, people like Cartier and Shahn and myself and a dozen others, who all knew each other [including Lucienne Bloch, Bernarda Bryson, Stefan Hirsch, Hans Skolle, Moses Soyer], living in the Village not only didn't have jobs but we couldn't get jobs. And this really helped our work. But what did we eat? That's another matter. For one thing, you were young enough and healthy enough to skip an awful lot of meals. But for another thing I remember those famous grocery boxes that came around and somebody got one, usually by some sort of handout by an organized and bureaucratic office somewhere which none of us went near. It was shared. And so, as far as I can remember, there we were, living for quite a period as artists, as artists without regular sustenance.[5]

I don't think you can say whose eye influenced whose. The advent of the miniature camera with its maneuverability was a very important factor here. We were all reacting against "artistic photography," which wouldn't dream of using a little instrument like a miniature camera. You had to have a great big view camera with a tripod to be a serious photographer, and Bresson and myself and a few others I can hardly remember did break that tradition down.[6] We were working—Shahn too, as you can see—in what seemed a furtive way compared to the standard artistic salon photographer at the time.

As to whether photography influenced Shahn's painting,

I do mean to suggest so, particularly in the snapshots of the boys playing handball (cats. 11, 13, 14). I feel that as in the case of Degas, it wasn't the diagram but by the element of the snapshot, the rest in motion, which you see in, let's say, horses in pictures, jockeys mounting horses and dashing off, in Degas. That wouldn't have been done without photography. You probably know Degas was also quite a photographer.

I think Shahn looked at photography, to use a rather trite phrase, as grist to his mill. He got a wonderful chance to use his eye with a new medium, and some of it could go into painting and some of it could be photographs unto themselves. This man was tremendously productive and creative and busy and energetic, and he just sailed into photography as he sailed into anything else. Some of it came out in paintings, and some of it stayed as photographs. I watched him operate. He was a voracious kind of a fellow, a glutton for work and terribly stimulating. Because he was so hopped up all the time, you got very stimulated when you were in his presence. If he came into the room, you'd start to get tired.

I parted company with Shahn on political scores and decided to pay no attention to his political career. I wanted to ignore it, and I succeeded. I did not know what Shahn was up to, and I didn't want to think about it. And as I say, I had terrible fights with him. He didn't like my brand of left political thinking, and I didn't like his. It happens all the time. So we just agreed that we loved each other but could not stand each other politically.

NOTES

The lecture was given on 13 November in conjunction with the exhibition *Ben Shahn as Photographer,* 29 October–14 December 1969, at the Fogg Art Museum, Cambridge, Mass. We publish excerpts edited and annotated by Deborah Martin Kao and Jenna Webster.

1. Evans and Shahn met around 1929 at the Brooklyn Heights home of the patron and art collector Dr. Iago Galdston, who was also an amateur photographer. Galdston's wife, Theresa Wolfson, was a high school friend of Tillie Shahn's and knew the artist's parents and siblings well.

2. The right-angle viewfinder was also known by the brand-name "Winko." See Willard D. Morgan and Henry M. Lester, eds., *The Leica Manual* (New York, 1935), 41.

3. Evans was referring to the series of RA/FSA photographs Shahn made in October 1935 of cotton pickers at the Alexander Plantation in Pulaski County, Arkansas.

4. Following a year spent in Mexico, Henri Cartier-Bresson arrived in New York in early 1935 and quickly joined the city's bohemian circles. His friends included Lincoln Kirstein, the photographer and filmmaker Ralph Steiner, the painter Pavel Tchelitchew (who greatly admired Shahn), the poet and filmmaker Ben Maddow, the composer Nicolas Nabokov, and the photographers Helen Levitt and Carl Van Vechten.

5. For a discussion of the poverty in which Evans lived during the 1930s, see James R. Mellow, *Walker Evans* (New York, 1999), 126, 196, 202. According to Lou Block no one in the Bethune Street studio knew whether Evans was eating. Block explained that Evans "managed to get film and paper but food often had to be forgotten" (in F. Jack Hurley, *Portrait of a Decade: Roy Stryker and the Development of Documentary Photography in the Thirties* [Baton Rouge, La., 1972], 46).

6. The term "view camera" refers to a cumbersome camera that often uses a tripod and requires negatives that are the same size as the ground glass (4 × 5 in.; 8 × 10 in., etc.); these are frequently contact printed rather than enlarged. The view camera is the opposite of the miniature camera.

ARTISTS' PROTEST

Stuart Davis: "The Artist Today: The Standpoint of the Artists' Union," 1935

This article deals with the artistic, the social, and the economic situation of the American artist in the field of fine arts, regarding the situation in the broadest possible way, and does not intend to stigmatize individuals except as they are the name-symbols of certain group tendencies.

The most superficial contact with artists makes it clear that the artist today is in a state of confusion, doubt, and struggle. He is not alone in his plight but has the respectable company of business men, chambers of commerce, politicians, congresses, presidents, and supreme courts. In short, the artist participates in the world crisis.

The immediate past of the American fine-artist was briefly as follows—he came in general from families of the lower middle class who could afford to send their children to art school, in many cases to European schools. These schools were, in their nature, schools of the middle class, and it is also generally true that the art taught in these schools was oriented towards the middle class. Consequently the work of the future artists was supposed to be absorbed by that class through the appropriate commercial

FIGURE 55
Lucienne Bloch
*Untitled (Ben Shahn with his camera,
Artists' Union demonstration for
relief jobs and a municipal art gallery,
New York City),* 27 October 1934
Detail from *Art Front* 1
(January 1935): 4
6.2 × 9.6 cm
Taller Archive

channels. This does not mean, of course, that the middle class as a whole were art patrons; it means that the upper strata of the class, who were the wealthy art buyers, still retained their lower middle class psychology and were qualitatively one with the class as a whole in culture.

Thus the artist exercised his talents within the framework of the middle class culture. Still-lifes, landscapes, and nudes were the chief categories of subject matter, and the artists competed freely against each other for originality within this framework of subject material. In addition, there were of course the different schools of theory and method such as the impressionists, the post-impressionists, the Cézanneists, the Cubists, the *Surrealists,* and always the reactionary Academy in different forms. The commercial contact of the artist was through the art dealer and gallery and the private patron, as well as the museum, which is really a collective of art patrons conditioned by the art dealer.

It follows, then, that the artist of the immediate past was an individualist, progressive or reactionary, in his painting theory, working within the framework of middle class culture with a subject matter acceptable to that culture and marketing his product through channels set up by the middle class. His economic condition in general was poor and he was badly exploited by art dealer and patron alike.

For those unaware of this exploitation, I will briefly specify. The dealer opened shop with a free choice of the field for his stock in trade. His stock cost him nothing but promises, and these promises were not promises to pay, but promises of a vague future of affluence to the unorganized and wildly competing artists. In many cases the artists were actually forced to pay gallery rent, lighting and catalogue and advertising costs in return for the promises of the dealer. In addition, commissions of from a third to a half and more were charged for sales. In the few cases where certain artists were subsidized by dealers the situation was not different in kind but only in degree. What resulted? In each gallery two or three artists emerged as commercial assets to the dealer, and at that point a certain character was given to the gallery. This character was the result of the planning of the one-man and group exhibitions around the works of the artist that time had shown to be the easy sellers. The body of artists of the gallery were used chiefly for window dressing and quantitative filler. In addition, the dealers carried variously old masters, early American, folk art, etc., which they bought at bargain prices and sold at enormous profit, frequently to the exclusion of the work of the contemporary artists they were supposedly marketing. Art for profit, profit for everybody but the artist. With the art patron and museum the situation is similar, free choice without responsibility, but there is the additional feature of

social snobbery. Artists are subsidized with the hope of financial gain on a statistical basis; a number are picked for low subsidy with the hope that one of them will bring home the bacon financially speaking. There is also the desire of the patron to be regarded as an outstanding person of culture among his fellow traders, social snobbery, or, in cases of extreme wealth, the ability of the patron to add the prestige of charity to the excitement of gambling. For these reasons the term "badly exploited" surely applies directly to the artist.

This is a factual description of the social-economic relation of the artist body to society as a whole in the immediate past, and of course today as well.

Today, however, there are certain developments which are peculiar to the time and which directly affect the artist in his social-economic relations. They are: (1) Federal, State, and Municipal Art Projects; (2) street exhibitions and art marts [such as the Washington Square Outdoor Show]; (3) the Mayor's Committee of One Hundred in New York City (fig. 56), appointed over the protests of the artists, whose supposed function is the creation of a Municipal Art Center; (4) suppression and destruction of murals, as in the case of Diego Rivera [*Man at the Crossroads Looking with Hope and High Vision to the Choosing of a New and Better Future,* 1932–33, Rockefeller Center], [David] Alfaro Siqueiros [*Tropical America,* 1932, Plaza Art Center, Olvera Street, Los Angeles], and Ben Shahn [Rikers Island Penitentiary mural, 1934–35], and the Joe Jones affair in Missouri;[1] (5) gallery rackets, self-help plans, such as the Artists Aid Committee in New York, artists and writers dinner clubs, five and ten dollar gallery exhibitions, etc.;[2] (6) a rental policy for all exhibitions as adopted by the American Society of Painters, Sculptors and Gravers, and the refusal of museums and dealers to accept it; and (7) the organization of the Artists' Union of New York and the "firing" of members for organizational activities on the projects.[3]

These events and others are not isolated phenomena peculiar to the field of art. They are reflections in that field of the chaotic conditions in capitalist world society today. The artist finds himself without the meagre support of his immediate past and he realizes now, if not before, that art is not a practice disassociated from other human activities. He has had the experience of being completely thrown overboard and sold out by art dealer and patron, and his illu-

sions as to their cultural interests are destroyed. He realizes now that the shallowness of cultural interest of his middle-class audience was retroactive on his own creative efforts, resulting in a standard of work qualitatively low from any broad viewpoint. Looking about him, he sees sharp class distinction, those who have, and those (the great majority) who have not. He recognizes his alignment with those who have not—the workers.

With these realizations the artists of New York have taken certain actions. They organized the Artists' Committee of Action and undertook a struggle for a Municipal Art Gallery and Center, administered by artists. Mass meetings and demonstrations were held. The mayor of the city, [Fiorello H.] La Guardia, refused to see their delegations, gave them the run-around and finally appointed a Committee of One Hundred to plan a municipal gallery and center [6 July 1934]. This committee was appointed without consulting the artists and is composed for the most part of names of socially prominent people who have no conception of the problems involved. Their first act was to hold an exhibit in a department store, their idea of solving the artists' problem [*Lower New York Art Council* exhibition, March 1935, Hearn's Department Store, Union Square]. Most of those invited to exhibit withdrew their work from the walls on the opening day in protest, and the whole story with photographs, phoned in to papers by reporters on the spot, was killed in the press because the department store was a big advertiser. After this farcial first step the Committee of One Hundred went into temporary retirement and is now planning some summer festival, another attempt to give the present administration of the city credit for patronizing the arts without doing it.

The formation of the Artists' Union[4] over a year ago is an event of greatest importance to all artists. With a present membership of thirteen hundred artists, the Union invites all artists to membership, and locals in other cities are being formed. The most direct action taken by the Union has been on the Municipal Art Projects. Over three hundred art teachers, painters, and sculptors are employed, a small fraction of those needing employment.

Those employed have the necessity of proving themselves paupers before they are eligible and after employment are often badly misplaced in regard to their best abilities. All organization by the artists on these projects is frowned upon by the administration, which subscribes to the ancient adage that paupers cannot be choosers. The ad-

ministration is wrong; paupers today can choose when they are organized, and through their Artists' Union they have won some rights, have had "fired" members reinstated, and through their picket lines have shown the authorities that they are not to be kicked around at will. They fight steadily for increase in projects, against lay-offs, against time and wage cuts, for genuine social and unemployment insurance, for trade union unity, against the degrading pauper's oath on the projects, and for free expression in art as a civil right. Through their struggles in the Artists' Union the members have discovered their identity with the working class as a whole, and with those organized groups of artist-craftsmen such as woodcarvers and architectural modelers and sculptors in particular. With this realization a morale has developed which grows in spite of the efforts of the administration and its agents to break it. Exhibitions of the work of the members of the Union during the past winter showed a quality comparable in every way with the gallery exhibitions. This quality will change and improve, for reasons I will give later. The Artists' Union has an official organ, *The Art Front,* which has been widely hailed as the most vital art magazine in the country, with critical articles of high quality. The slogan of the Union, "EVERY ARTIST AN ORGANIZED ARTIST" means something which no artist can afford to disregard (see figs. 68–69). Negotiations are now under way for the entrance of the Union into the American Federation of Labor.[5]

The question of the civil right of free expression is a vital one today for the artists. It affects his life as a man and as an artist. Fascism is a powerful trend in the current political world set-up. Fascism is defined by the Methodist Federation for Social Service as "the use of open force (against the workers) by big business." We have seen it at work in Germany and Italy, and one of its first acts is the suppression of freedom in the arts. Schools are closed; artists, scientists, and intellectuals are driven into exile or thrown into concentration camps. Culture in general is degraded and forced to serve mean and reactionary nationalistic ends, and the creative spirit of the artist is crushed ruthlessly. Such trends exist in this country, as any newspaper reader knows, and already individuals and small groups have committed Fascist-like acts of suppression, for ideological and political reasons. The destruction of the Rivera mural, the Siqueiros murals in Los Angeles, the suppression of the Ben Shahn and Lou Block mural for Riker's Island Penitentiary in New York by Jonas Lie of the Municipal Art Commission are ex-

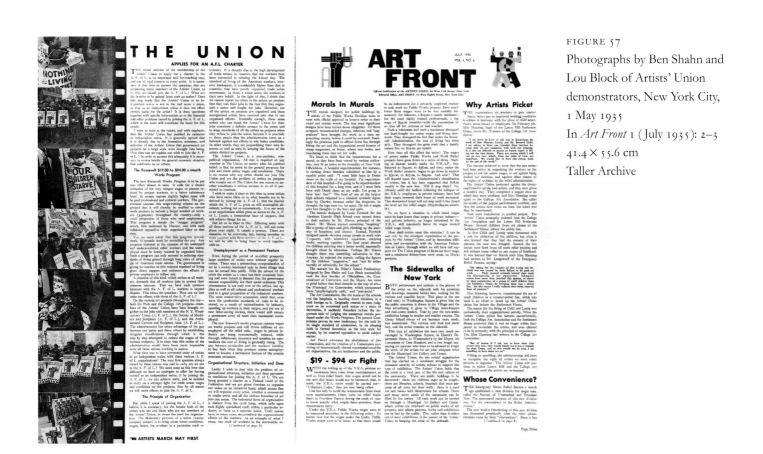

FIGURE 57

Photographs by Ben Shahn and
Lou Block of Artists' Union
demonstrators, New York City,
1 May 1935
In *Art Front* 1 (July 1935): 2–3
41.4 × 55.6 cm
Taller Archive

amples. No artist can afford to remain complacent in the face of these and a thousand other similar cases, nor can he feel that they do not concern him directly. Organization by the artists and coöperation with the organized workers is the only method to fight these attacks on culture.

The question of quality interests artists. They say, "Yes, we agree with your ideas of organization, but what standards have you? We can't have everybody in a Union who calls himself an artist. We have a standard and we resent the implication that our standard of quality is unimportant in the type of organization you say is necessary for artists." The answer to this point is as follows: A work of art is a public act, or, as John Dewey says, an "experience." By definition, then, it is not an isolated phenomenon, having meaning for the artist and his friends alone. Rather it is the result of the whole life experience of the artist as a social being. From this it follows that there are many "qualities" and no one of these qualities is disassociated from the life experience and environment that produced it. The quality standard of any group of artists, such as the National Academy of Design for example, is valid for the social scheme of

that group only. Its "world validity" depends precisely on the degree to which the life-scheme of the group of artists is broad in scope. We have, therefore, little qualities and big qualities. Any artist group which seeks to isolate itself from broad world interests and concentrates on the perpetuation of some sub-classifications of qualitative standard is by definition the producer of small quality. For such a group to demand that all artists meet this static qualitative concept is of course absurd. Art comes from life, not life from art. For this reason the question of the quality of the work of the members of the Artists' Union has no meaning at this time. The Artists' Union is initiating artists into a new social and economic relationship, and through this activity a quality will grow. This quality will certainly be different from the quality standard of any member before participation in union activities and will take time to develop. As the social scheme of the Union is broad and realistic, directly connected to life today in all its aspects, so we confidently expect the emergence of an aesthetic quality in the work of the members which has this broad, social, realistic value. Therefore, an artist does not join the Union merely to get a job; he

277

joins it to fight for his right to economic stability on a decent level and to develop as an artist through development as a social human being.

NOTES

This article first appeared in *American Magazine of Art* 28 (August 1935): 476–78, 506. It has been annotated by Jenna Webster.

1. Joe Jones and a group of other artists created a mural in a studio of an abandoned courthouse used by the Unemployed Art Class in St. Louis. When the mural, a scene of a Mississippi levee, was unveiled, authorities threatened to destroy the work, claiming that it incited social unrest, particularly among African Americans. Because of the boisterous protests by Jones and his supporters, however, the mural was saved. See "To Those Protesting the Rockefeller Destruction," *New Masses* 10 (6 March 1934): 6; and Orrick Johns, "St. Louis Artists Win," *New Masses* 10 (6 March 1934): 28.

2. D. G. Plotkin, director of the Artists' and Writers' Dinner Club in New York, endeavored to create a gallery where artists could sell their work free of charge. Members of the Artists' Union and the Artists' Committee for Action viewed Plotkin's plans as an affront to their efforts to establish a municipally supported gallery.

3. Davis refers in part to the case of Bernard Child and his fiancée Florence Lustig, two artists on relief projects who because of tardiness were fired from their TERA-administered College Art Association teaching jobs at the Lenox Hill Settlement House in New York. The Artists' Union argued that the dismissal occurred because of the teachers' activity within the union. See "Cracking Down," *Art Front* 1 (May 1935): 2; "Why Artists Picket," *Art Front* 1 (July 1935): 3. Child rallied members of the Artists' Union to protest with their spouses and children at the College Art Association and the Settlement House. Ralph Pearson, artist, art critic, and lecturer at the New School for Social Research, was dismayed by Child's zealous response, and he wrote to Shahn, whom he greatly admired, and asked him to mediate the dispute, which Pearson believed discredited the Artists' Union (Ralph Pearson to Shahn, 31 May 1935, Shahn Papers, 5006F747).

4. An asterisked footnote reads: Address: 60 West 15th Street, New York City.

5. In July 1935 the Artists' Union applied for but did not receive membership with the American Federation of Labor (AFL); it became part of the Congress of Industrial Workers (CIO) in February 1938. See Gerald M. Monroe, "The Artists Union of New York" (Ph.D. diss., New York University, 1971), 187–95.

opposite, top left
FIGURE 58
Untitled (Civil Works Administration demonstration, New York City),
February–April 1934
Modern print from an original negative
Fogg Art Museum, gift of
Bernarda Bryson Shahn,
P1970.3892

opposite, top right
FIGURE 59
Untitled (May Day Parade, New York City), 1 May 1934
Modern print from an original negative
Fogg Art Museum, gift of
Bernarda Bryson Shahn,
P1970.4080

opposite, center left
FIGURE 60
Untitled (Moses Soyer, Artists' Union demonstration for relief jobs and a municipal art gallery, New York City), 27 October 1934
Modern print from an original negative
Fogg Art Museum, gift of
Bernarda Bryson Shahn,
P1970.3908

opposite, center right
FIGURE 61
Untitled (Boris Gorelick, Artists' Union demonstration for relief jobs and a municipal art gallery, Centre Street Courthouse, New York City), 27 October 1934
Modern print from an original negative
Fogg Art Museum, gift of
Bernarda Bryson Shahn,
P1970.3924

opposite, bottom left
FIGURE 62
Untitled (Artists' Union demonstration for relief jobs and a municipal art gallery, Centre Street Courthouse, New York City), 27 October 1934
Modern print from an original negative
Fogg Art Museum, gift of
Bernarda Bryson Shahn,
P1970.3923

opposite, bottom right
FIGURE 63
Untitled (Artists' Union demonstration for relief jobs and a municipal art gallery, Foley Square, New York City), 27 October 1934
Modern print from an original negative
Fogg Art Museum, gift of
Bernarda Bryson Shahn,
P1970.3926

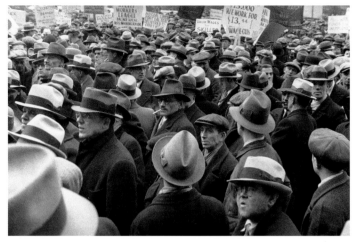
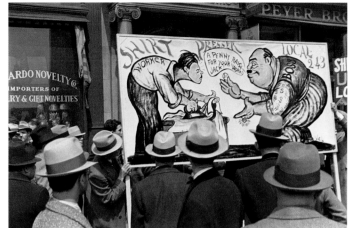

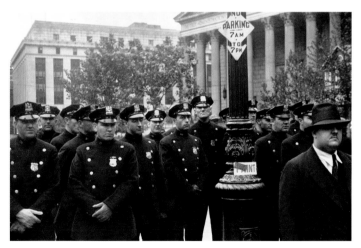

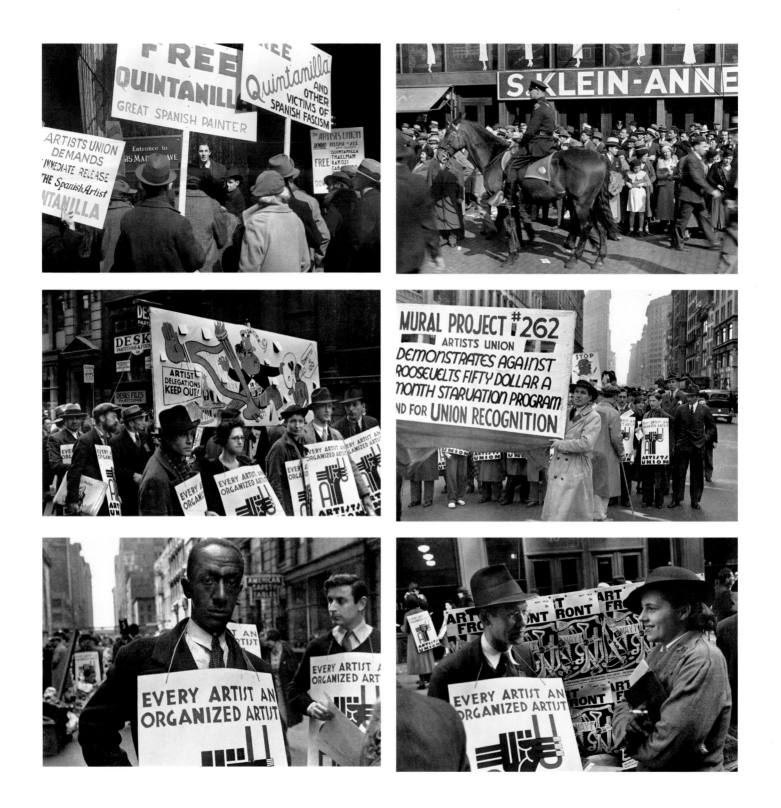

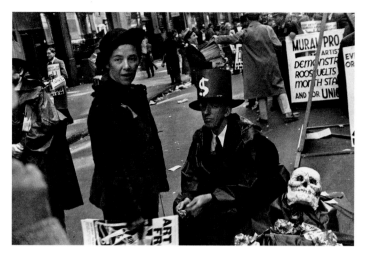 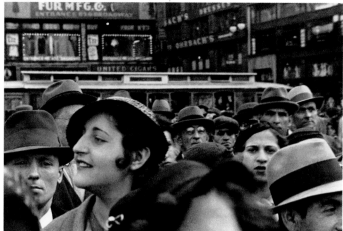

opposite, top left

FIGURE 64

Untitled (Artists' Union demonstration, New York City), 1934–35

Modern print from an original negative

Fogg Art Museum, gift of Bernarda Bryson Shahn,

P 1970.3953

opposite, top right

FIGURE 65

Untitled (Union Square, New York City), probably 1 May 1934

Modern print from an original negative

Fogg Art Museum, gift of Bernarda Bryson Shahn,

P 1970.4086

opposite, center left

FIGURE 66

Untitled (Artists' Union demonstrators, May Day Parade, New York City), 1 May 1935

Modern print from an original negative

Fogg Art Museum, gift of Bernarda Bryson Shahn,

P 1970.4071

opposite, center right

FIGURE 67

Untitled (Artists' Union demonstrators, May Day Parade, New York City), 1 May 1935

Modern print from an original negative

Fogg Art Museum, gift of Bernarda Bryson Shahn,

P 1970.3997

opposite, bottom left

FIGURE 68

Untitled (Cecil Gaylord, May Day Parade, New York City), 1 May 1935

Modern print from an original negative

Fogg Art Museum, gift of Bernarda Bryson Shahn,

P 1970.4023

opposite, bottom right

FIGURE 69

Untitled (Artists' Union demonstrators, May Day Parade, New York City), 1 May 1935

Modern print from an original negative

Fogg Art Museum, gift of Bernarda Bryson Shahn,

P 1970.4003

above left

FIGURE 70

Untitled (Bernarda Bryson and other Artists' Union demonstrators, May Day Parade, New York City), 1 May 1935

Modern print from an original negative

Fogg Art Museum, gift of Bernarda Bryson Shahn,

P 1970.4022

above right

FIGURE 71

Untitled (Union Square, New York City), probably 1 May 1935

Modern print from an original negative

Fogg Art Museum, gift of Bernarda Bryson Shahn,

P 1970.3895

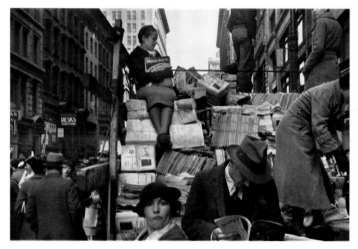

THE EDITORS ARE WORRIED

FIGURE 72
Untitled (May Day Parade, New York City), 1 May 1935
Modern print from an original negative
Fogg Art Museum, gift of Bernarda Bryson Shahn,
P1970.4025

FIGURE 73
Untitled (May Day Parade, New York City), 1 May 1935
Modern print from an original negative
Fogg Art Museum, gift of Bernarda Bryson Shahn,
P1970.3726

FIGURE 74
"The Editors Are Worried," 1935
Ink on paper, 24.1 × 17.1 cm
Collection of Bernarda Bryson Shahn

Ben Shahn: Notes for *Art Front*, 1935

The aim of *Art Front* is to draw artists to the Union, to give them an economic orientation, to bring them close to the revolutionary movement.

It has been admitted that to do this *Art Front* must be so broad in its scope as to interest artists not yet acquainted with the revolutionary movement, and must be high enough in quality to command the respect of artists on the merits of its contents.

We have succeeded in winning the co-operation of artists and writers of some following, and have utilized some of the members of the union for work on the magazine. We need to draw in a still greater number of artists of recognized merit, and we need to use and develop Union members much more than we have succeeded in doing.

Since it is necessary to change both the format and the price under any circumstances, we should if possible make the change to interest more artists and to utilize more talent.[1]

TO PUT OUT THE MAGAZINE IN COLOR
LITHOGRAPHY: means

1. That we put in the hands of the artists a means of doing original work for large scale production. In black and white all drawings must be reproduced on zinc plates which lose the quality of the original drawing. In this way we naturally interest more artists in working for the magazine.

2. A magazine containing a number of original color lithographs is considerably more interesting to the artist or other person who buys than one with zinc reproductions.

3. Such a magazine has not been published in America since the times of Puck, and Leslies, which during their time were the most popular and politically powerful magazines.

4. The unusual character of the magazine in color will cause it to echo farther than a magazine of the familiar Masses [*New Masses*] format can reach.[2]

5. More copies are sold of magazines which charge over 15c than those which charge under that.[3]

6. The newsstands prefer to handle a magazine which costs more than five or ten cents because they get more profit on them. Such magazines are better displayed th[a]n the 5 and 10 cent ones.[4]

7. The *New Theatre* in changing its format lost only ten % of ten thousand circulation. The new format was begun at the beginning of the summer season, and the loss is attributed to the usual seasonal drop.[5] The Editor [Herbert Kline] advised that we charge 15c whether we print the mag. in black or color.

8. The Editor of *New Theatre* was so enthusiastic about the idea of a color mag. with original lithographs that he immediately began to make plans to put out a special edition of *New Theatre* in color.

NOTES

The notes, annotated by Jenna Webster, were originally typewritten in the late summer or early fall of 1935. They are located in the Shahn Papers, 5006F726. For related handwritten notes see Shahn Papers, 5006F727–5006F737.

1. Some of the format changes Shahn suggested appeared in the November 1935 issue of *Art Front*.

2. In September 1953 *New Masses* announced the change from a monthly to a weekly format. The first weekly issue did not appear until 2 January 1934.

3. At the time Shahn composed this document, *New Theatre* was either considering raising its price or had just done so: after lengthy consideration, the editors changed the price from ten to fifteen cents in July 1935. *Art Front* continued to cost five cents through November 1935; beginning in December it was ten cents. *New Masses* had raised its price on 8 October 1935. Newspapers like the eight-page *Daily Worker* cost three cents, as most broadsheets did, and five cents for the fourteen-page Sunday edition.

4. According to Herbert Kline, the editor of *New Theatre,* only 2,200 of the magazine's 8,500 monthly copies were sold on newsstands. The majority of the issues were sold through theatre groups and agencies. See Herbert Kline to Jay Leyda, undated [Fall 1934], Leyda Papers. *Art Front* probably had similar distribution ratios.

5. *New Theatre* first began using color covers in July 1934, at the same time increasing the page layout from approximately twenty-four pages to thirty-four. *New Theatre,* originally entitled *Workers' Theatre* (the name changed for the September–October 1933 issue), had already switched from typewritten to typeset pages for the January 1934 issue.

New Theatre was the organ of the League of Workers Theatres (a section of the International Union of the Revolutionary Theatre), the Workers Dance League, and the Film and Photo League. On 27 January 1935 delegates from the National Film and Photo League designated *Filmfront* the organization's official publication. *Filmfront,* a semimonthly of stapled mimeographed sheets, appeared irregularly with a few hundred copies per issue from 24 December 1934 to 15 March 1935. During this time, however, *New Theatre* continued to publish articles on theoretical and technical aspects of film, as well as information pertaining to the various splinter groups of the Film and Photo League, including Nykino. In March 1937 the magazine changed its name to *New Theatre and Film.*

RIKERS ISLAND PENITENTIARY MURAL PROJECT

Lou Block and Ben Shahn:
Memorandum to Mayor Fiorello H.
La Guardia on the Projected Murals for
the Rikers Island Penitentiary, 1934

The plan for this series of murals was originally to present a history of penology, setting forth the bad features of archaic penal methods and also visualizing the entire trend toward reform. At the beginning of research and after conversations with Commissioner [Austin H.] MacCormick, Dean [George W.] Kirchwey, Mr. [William B.] Cox[, executive secretary] of Osborne Association, and Warden [Lewis E.] Lawes, we abandoned the idea of dealing with the history of penology. We felt that the murals would have more force if they treated only with prisons of our own time, both of an unenlightened nature and those which have been administered by individuals who believe in the need for penal reform.

The corridor for which these murals are intended is about 100 feet long by 18 feet wide and the available space for painting above a tiled dado is about 12 feet. As you enter the corridor facing toward the chapel entrance, the left hand wall deals with those prisons which are still administered under methods which leave very little to which the inmate can look forward. In the sketches which you have, this wall begins with a cell block indicating the filing cabinet nature of this type of institution. This permits no possible chance for individual treatment or rehabilitation of the prisoner. It is also intended to indicate the over-crowded unsanitary conditions which exist in these prisons.

The new arrangement for this wall will present the police line-up and various phases of routine prior to conviction as the opening panel (see fig. 78). The succeeding panels on this wall carry through the different types of penal institutions and methods which have not encountered the influence of reform. The chain gangs of the South, institutions in which no work is provided for the inmates, and a survey of similarly unenlightened institutions are portrayed. For the sake of brevity and to help you identify the various panels, the following list gives you the order in which they will appear:

Police line-up
Cell block in an unsanitary prison
Idleness and the milling of prisoners
Public whipping
Dreary, unproductive labor

FIGURE 75

Sloan and Robertson,
Architects' Rendering,
Rikers Island Penitentiary,
completed in 1934
In *Condensed Report of the Art
Commission of the City of New York,
1930–1937* (New York, 1938),
p. 86, pl. 38A
8.3 × 11.2 cm

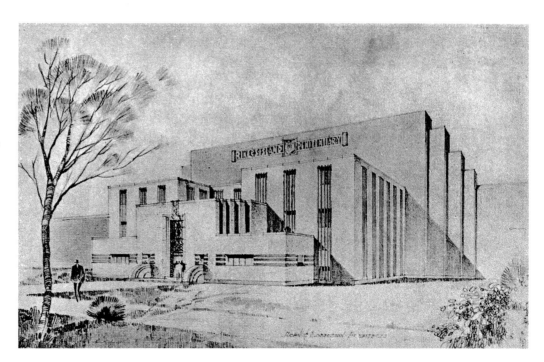

Southern prison camps

Prisoners after 5 o'clock in their cells

Over-crowded, unsanitary dormitories

The restrictions on visiting, with a metal screen between prisoner and visitor

The release of the prisoner and an intimation of a return to crime

The wall over the chapel entrance contains a symbolic figure of Thomas Mott Osborne pointing the way toward proper prison methods. Behind him is a repetition of the theme of the dreary round of prisoners in dark prison corridors. The long right hand wall contains the positive activities of institutions which are administered under more enlightened methods. The introduction into prisons of schools for illiterates, facilities for teaching trades with well equipped shops and civilian instructors, outdoor recreation, and work under healthful conditions are shown on this wall. There is also visualized the entirely modern medical service which now pertains in the newer institutions[,] assuring the inmates of proper medical and surgical care, and also going into the more involved branches of psychological treatment. Also included are suggestions of the possibility for individual avocation among the inmates.

The wall over the exit door is to contain an apotheosis of both walls. Existing conditions such as the difficulties facing a man released from prison; unemployment; the hostility of the public to an ex-convict; and similar circumstances make any summation hard to arrive at. What we would like to suggest is the possibility of a full realization of reform direction as it affects a convict both in prison and after his release, reacceptance without stigma by society, the opportunity for employment, and a general readjustment calculated to prevent a return to crime.

This wall is still in a tentative state, however, and we are hoping in additional talks with Commissioner MacCormick to develop this theme to its most logical form. We would also like to point out that these murals are not directed to the inmates of the penitentiary but, in accordance with the plan of Commissioner MacCormick, are intended to visualize for visitors, especially visiting penologists and students of sociology, the problems which have been set forth in this series of murals.

NOTES

The letter, written 6 December and dated 10 December, is in the Block Papers.

FIGURE 76
P. L. Sperr, *The Frame Work for the New Prison on Rikers Island,* 18 September 1931
Milstein Division of United States History, Local History and Genealogy, The New York Public Library, Astor, Lenox and Tilden Foundations

Stuart Davis:
"We Reject"—The Art Commission, 1935

The large mural designed by Ben Shahn and Lou Block for the Riker's Island Penitentiary was rejected by the Municipal Art Commission on the ground of "psychological unfitness." This stupid and irresponsible decision is the more easily understandable when we recall that it is Jonas Lie, painter member of the Commission, who is behind the ultimatum—at least according to his own boasts in the *New York Times* of May 9th.[1] We suggest that while the Commission was thinking along the line of "psychological unfitness," it might have done well to look to its own painter member. For, wherever particularly stupid and reactionary acts are committed in regard to art matters, one seldom has to look far to find the person of this back-slapping, handshaking, pot-boiling President of the National Academy of Design. But more of this later. Let us accept the decision at its face value, and examine the validity of its claims.

"Psychological unfitness" is the reason given for rejection. Disregarding the role adopted by the Art Commission in overstepping its function as an art jury, and handing down decisions in the field of psychology, we must simply state that the charge is decidedly untrue. Even were it true,

then, included in the indictment, along with the painters Shahn and Block, would be Mayor LaGuardia and the Commissioner of Correction, Austin H. McCormick.

The ideology and pictorial appropriateness of these murals were not worked out in the isolation of the artists' studios. From the time the project was approved [on May 12, 1934] by the Mayor and Commissioner, the artists spent months of research and consultation with authorities in the field, meanwhile developing their compositions. They read and thoroughly acquainted themselves with penology in its historical and theoretical aspects. They conferred with Dean Kirchwey, one-time Warden of Sing-Sing, and with the present Warden, Lawes. They were given freedom to sketch and photograph in many prisons and were in regular contact with Commissioner McCormick as the work progressed.

From the foregoing it becomes clear that the artists were in possession of authentic factual material and informed critical opinion. When the sketches were complete, they were thoroughly approved by the Commissioner. They were then submitted to the Mayor, who pronounced them "a swell job," and said, "They will be a credit to my administration." It is important to note there that the approval of the Commissioner and the Mayor was not merely an expression of satisfaction with the artistic merit of the murals,

FIGURE 77

Lou Block, *Untitled
(prisoners unloading potatoes,
Rikers Island Penitentiary,
New York City),* 1934
15.6 × 22.9 cm
Photographic Archives,
University of Louisville,
Kentucky

but was precisely a statement of approval as to their appropriateness and "psychological fitness" for the place which they were designed, the Riker's Island Penitentiary.

The murals were first rejected by the Art Commission in February [1935], although at that time no announcement was made of the decision.

In an effort to have the case reconsidered on the submission of additional evidence as to their psychological fitness, a poll of opinion among prisoners on Welfare Island was taken. Commissioner McCormick selected a group of forty prisoners which he considered representative of the prison population. The nature of the test was suggested by Dr. Schulman [Harry Manuel Shulman], criminal psychologist and head of the Hawthorne School for Boys. The sketches and some enlargements were placed on exhibition and were carefully inspected in turn by small groups of the forty chosen for the test, until all had had an opportunity to form an opinion. They were then asked to answer the following four questions in writing.

1. What do you think of these pictures?

2. How do you feel about having them on the walls of a new prison?

3. In your opinion, what will other men here think about it?

4. Visitors will also go through the halls. Of what interest do you think these pictures will be to them?

Now carefully note the following: Of the entire answers, 97 were favorable, only 10 were unfavorable, 22 were indifferent and 31 were left answered. There is no question here as to the definitely favorable reaction from this representative group of the prison body. Yet, in the face of this, the Commissioner made a public statement to the press on May 9th to the effect that, although the replies were favorable, he had decided afterward that the sketches would probably have a bad psychological effect on the prisoners. In view of the fact that the conditions of the test were the Commissioner's own, it looks as though, in this particular game, only the house had a chance to win.

On the same day, May 9th, the old reactionary, Lie, blew off some steam to the press. In the *New York Times* he is

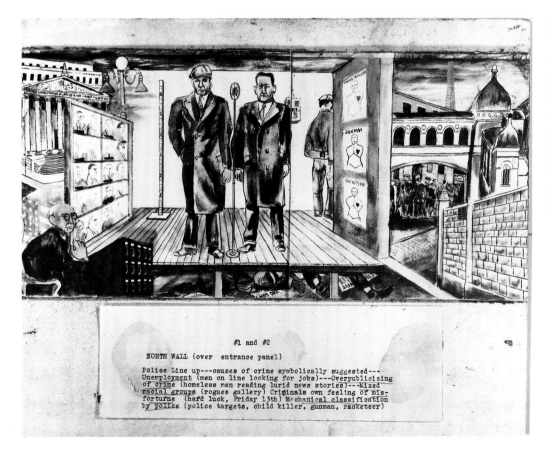

FIGURE 78
Two photographs mounted to board documenting a panel of Shahn's Rikers Island Penitentiary mural study, north wall, 1934
23 × 31.9 cm
Photographs may be by Walker Evans
Collection of Bernarda Bryson Shahn

quoted as saying that an effort is being made to inject anti-social propaganda into paintings paid for as relief work by the government. In view of the simple facts of the case as stated above, Lie has apparently convinced both the Commissioner and the Mayor that they were conspiring with the artists to spread anti-social propaganda. Thus Lie must indeed have power to be able to make such charges against two of the highest city officials—and make them like it.

At this point I think it is in order to give a brief description of the content of this "anti-social" mural as it was worked out by the artists with the co-operation of Commissioner McCormick and the approval of the Mayor.

The murals are designed to occupy two opposing walls of a long corridor leading to the prison chapel. There are also designs for the short end walls of the corridor. The purpose of the mural is to show what has been done in penal administration and reform, and to show the advances in modern penology, by contrasting this with the old methods of segregation and punishment. The subject matter is treated realistically, as opposed to a decorative or symbolic treatment.

Over the door at one end—the police line-up, the first introduction of the criminal to the penal system, is represented. Starting from there, on the left wall is portrayed the course his imprisonment may take if the undirected "social revenge" system of penology is in effect. On the opposing wall are contrasted the methods of prison organization which are the product of the modern penological practice, whereby the prisoner is treated as a member of society who must be saved for proper life as a citizen on his release. On the two walls we see opposed to each other the Southern prison camp and the modern prison farm where the men do healthy, constructive work. Opposed to the scenes in old prisons with their horrors, are shown the sanitary conditions now more and more coming into being in prisons under modern penological supervision, where adequate hospitalization and X-ray therapy are used to correct the physical handicaps that lead to crime. The wall over the chapel door summarizes the two long walls.

This very briefly, is the ideological content of the mural. Artistically, the work is unquestionably of a high order. Stefan Hirsch, mural painter and instructor at Bennington College, has written of them: "The walls (on which the murals are to be placed) are too long to put one single composition on them and still have the painting seen in one glance. . . . The obvious thing to do was to divide the walls into panels of equal size. Shahn, however, never does the obvious: he created narrower and wider panels which lend the wall a certain rhythm, and force the onlooker to step from panel to panel with renewed interest all the time. To increase this effect he uses what I would call an 'open and shut' composition. I mean by that the use of a scene with deep perspective, such as an outdoor scene in one panel and in the next an indoor scene with limited depth of perspective. This creates a dramatic change for the eye as it wanders from panel to panel and, to my knowledge, is a completely new device in modern art. . . . When I say panel, I use this term only for lack of a better one, because the various scenes are very ingeniously played into each other without any sharp break and yet with a definite change of subject, mood and emphasis. The occasional change of scale of the figures from one scene to the next enlivens the composition and forces the onlooker to take each scene on its own merits, so to speak, without being definitely conditioned by the preceding one. . . . They are conceived in color from the very outset, not, as most murals, in black and white. This is one reason why 'they don't look better in photographs than in color.' . . . Moreover, there is no violence in the color, but rather a great and earthy solidity, a certain reticence that does not try to beguile with brilliance, but attempts to convince with simple statement. . . . He has taken a firm stand regarding the old rule that a mural must always be flat, and not 'tear holes in the wall.' This rule is an invention of non-painters, and is not borne out by the history of art in the western world. It happens only through the use of a mathematically deliberate perspective that the illusion of the hole in the wall is created, while an unphotographic perspective rather symbolizes than creates actual space, and is therefore not apt to destroy the architectural qualities of a room. . . . Of course, all these devices would not mean very much to me, if they were not behind a new and great visual conception of the world, as they are indeed in Shahn's designs. It is very hard to put one's finger on the subtleties of the artist's genius and for that reason I have dwelt too long, perhaps, on the craftsmanship in this work. I don't think I'll have to point out the keen characterization in all the figures and the remarkable incisiveness of the stories told, the blending of economy with realism in all the details, and the evocative quality of many of the objects represented. I consider this work of art the most important thing since Orozco's frescos at Dartmouth."[2]

Just where the "anti-social" factor in these murals enters is difficult to see, but I suspect that it creeps in in the super

heated and fascistically inclined imagination of Mr. Jonas Lie. If we remove Mr. Lie from the scene, the anti-social element evaporates. The murals are devoted to telling the story of improvement and the need for further improvement in prison conditions, and are a support and a record of all the constructive efforts that have been made along these lines.

In using his position on the Art Commission to stop these murals, Jonas Lie has, I believe, satisfied a personal animosity, and at the same time has put himself forward in the press as the patriotic Boy Scout, always there to do his deed for home and country. Lie's charge of "anti-social content" is a lying charge, and he knows it, yet this man of mean ambitions is actually in a position to pass judgment on the work of artists. Rover Lie, the Watch Dog, his bark is loud against (other) foreigners to show how dearly he loves the country of his adoption.

A few anti-social acts of which Mr. Lie himself can boast are the following: The bailing out of jail for $500.00 of the vandal [John] Smiuske, who threw paint remover and set fire to a painting which satirized the New Deal (in Tarrytown, August 31, 1934);[3] enthusiastic approval of the destruction of the [Diego] Rivera mural [*Man at the Crossroads Looking with Hope and High Vision to the Choosing of a New and Better Future,* 1932–33] by [Nelson A.] Rockefeller in Radio City; statement before the Society of Mural Painters that he had passed mural paintings on the art projects "with a smile, but there is an awful lot behind that smile," because many of them were "going into old decrepit buildings that are coming down anyway," and besides, "whitewash is cheap," statements that he dislikes mural painting in general; statements of revulsion and contempt for modern art in general; and expressions of disapproval of government-sponsored mural projects—all of which must be judged by him as painter-member of the Art Commission.

By these and by other anti-social and anti-cultural words and behavior, Jonas Lie has proved himself unfit to hold a seat on the Municipal Art Commission, or to hold any public office, for that matter, outside that of a Fascist Censor. For these reasons the artists of New York are demanding his immediate removal from the Art Commission, as a menace to art, and as a person antagonistic to the civil rights of Americans. Further, we demand that the Commission as now constituted be replaced by one elected by a democratic vote of delegates representing all the organized bodies of artists of New York City—a Commission which

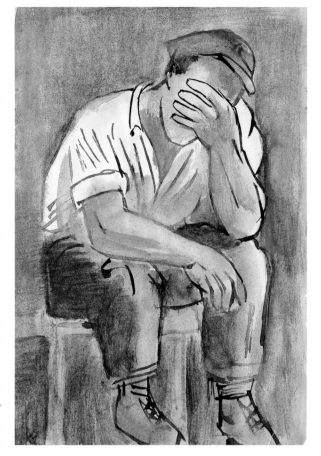

FIGURE 79
Page from *Rikers Island Penitentiary mural project sketchbook,* 1934–35
Watercolor and gouache
17 × 13 cm
Estate of Ben Shahn

will truly represent the artists, which will be aware of the problems confronting artists, and capable of judging art on its own merits.

NOTES

This article, which has been annotated by Jenna Webster, first appeared in *Art Front* 1 (July 1935): 4–5; see fig. 26. Austin H. MacCormick's name is misspelled throughout.

1. See Jonas Lie, "'Anti-Social' Move Seen in Relief Art," *New York Times,* 9 May 1935.

2. Davis quotes a letter Stefan Hirsch wrote to Audrey McMa-

hon in support of Shahn's mural. See Stefan Hirsch to Audrey McMahon, 25 January 1935, Shahn Papers, D147F630–D147F635. José Clemente Orozco painted the fresco *The Epic of American Civilization* (1934) for the Dartmouth College Library.

3. Davis refers to an incident in which John Smiuske, a twenty-six-year-old house painter, threw varnish remover on a painting that satirized President Roosevelt and his family exhibited in the Westchester Institute of Fine Arts. Smiuske also struck a match to the work, thus destroying it. Jonas Lie furnished the five hundred dollars in bail, exclaiming, "I was outraged over the caricature, and admired the youth for his courage and for having been aroused by so cowardly a portrayal" ("Jonas Lie Aids Man Who Ruined a Mural," *New York Times,* 5 October 1934, 25). For more see "Vandalism and Jonas Lie" and "Jonas Lie and Property Rights," *Art Front* 1 (November 1934): 3.

Philippa Gerry Whiting: "Speaking About Art: Riker's Island," 1935

In the past two years an effort has been made by Federal and State Governments to enroll artists as workers and collaborators, rather than to ignore them as the purveyors of graceful and whimsical entertainment to the elect. There has been much loud-voiced opposition to this interesting social change, but the opposition can, in large part, be ignored because the reasons behind it are so open and obvious. There are the mural painters who formerly had a corner on a small and lucrative market and who wish to keep that market undisturbed, and there are the easel painters who have been reared to think of art as delicate, exclusive, and frequently remunerative, and who fear the invasion of a new spirit. In general, the opposers have been exponents of the tried and true, and these gentlemen have never welcomed the vitality of change.

However, this fertile and healthy new relationship between artist and government, or artist and people, has very probably come to stay, and it has already proved certain things: that an artist does better work when he is painting for a definite audience, that he is able to work in harmony with other people and adapt himself to specific needs, that he is profoundly interested in the civilization of which he is a part. I know of no artist who has had this experience who yearns to return to his previous condition of proudly isolated starvation.

New York City has worked with its artists for a longer time than the Federal Government, and state funds are still being used for the employment of artists, under the administration of the College Art Association.[1] Recently a case has arisen in New York which is of the utmost importance not only in itself but in its bearing upon all governmental activities in the arts. This is the rejection by the Municipal Art Commission of the mural sketches by Ben Shahn and Lou Block for the Riker's Island Penitentiary.

The creation of these sketches was carried out in precisely the manner advocated by the Federal Government in its most important mural commissions. From start to finish, the artists worked in collaboration with trained penologists, in particular with New York's Commissioner of Correction, Austin H. McCormick; Dean Kirchwey, former Warden of Sing-Sing; and the present Warden, Mr. Lawes. They made an exhaustive study of penology, its history and theory, and they were able, with the coöperation of the Commissioner, to sketch and photograph in prisons of all types—a most unusual privilege. As a result of their research they prepared a written outline of their plans for the murals, and this outline was carefully considered by the Commissioner, who offered excellent suggestions and corrections. The work of preparing the sketches proceeded, with frequent consultations with Commissioner McCormick, who remained very enthusiastic and at no time questioned the fitness of the murals for the walls on which they were destined to be placed. He made it plain, however, that since the murals were not merely decorative, since they dealt with important social problems, his approval would have to be sustained by Mayor La Guardia. The sketches eventually reached the Mayor, who said that they were a "swell job" and that they would be "a credit to his administration."

The subject matter of the murals having been judged by the proper authorities, they were submitted to the Municipal Art Commission,[2] whose function is to pass on aesthetic quality. They were turned down by the Art Commission, on grounds of "psychological unfitness" to be seen by prisoners. Their aesthetic merit was unquestioned. In the effort to have the case reconsidered on the basis of their psychological fitness, a poll of inmates of Welfare Island [Blackwell's Island Penitentiary] was taken under the direction of Commissioner McCormick. The Commissioner selected forty representative prisoners, and they were given a test suggested by Dr. Schulman [Shulman], criminal psychologist. The sketches were placed on exhibition and were viewed carefully by the prisoners in small groups. There was a brief explanation:

"Here is a set of pictures showing the good and bad sides of prison life. The small ones are sketches and the large ones will give you some idea of how it will look on the wall. This is planned for a mural in one of the halls of a brand new and modern prison building. The artists would like to know what you think of these pictures." And the following four questions were written on large blackboards:

1. What do you think about these pictures?

2. How do you feel about having them on the walls of a new prison?

3. In your opinion what will other men here think about it?

4. Visitors will also go through the halls. Of what interest do you think these pictures will be to them?

The replies of the prisoners will be better understood if a short description is given of the theme of the panels. They are intended to portray what has been done in penal reform and modern administration (Riker's Island Penitentiary is the last word in intelligent prison construction, includes modern hospitalization, up-to-date sanitation, recreational facilities, facilities for vocational training, etc.), as contrasted with the old methods of segregation, idleness, and social vengeance. Over the door, the first introduction of the criminal to the penal system is depicted—the police line-up. On the left wall is shown the course that his imprisonment might take under the calculated cruelty of the past, the methods which commit him to a life of crime; on the right the means by which social rehabilitation is being effected in the best prisons today. The final panel summarizes the two walls.

Out of a possible total of one hundred and sixty answers, ninety-seven were favorable, ten unfavorable, twenty-two indifferent, and 31 left blank. Several of the prisoners gave one blanket answer for the four. There is thus no question of the definitely favorable reaction. One cannot help being glad for the circumstances which gave the prisoners a chance to speak for themselves; the responses have an interest far beyond their immediate purpose. In education and capacity for expression they range all the way from the men who said, "I believe that it shows it care for the unploy as they dont have to sleep in the streets if they have no home, but its hard on the one who have people to come over to see them in cages like a monkey," and "It look Verry Bad to see what has hapen in the buy gone days, but—to see the change the state has, it is good to hange on the walls of the new prison," to the author of "Upon the walls of a

FIGURE 80

Page from *Rikers Island Penitentiary mural project sketchbook,* 1934–35

Ink, 17 × 13 cm

Estate of Ben Shahn

new prison they would be a memorial to the spirit of reform from barbarism . . . the reform which is gradually being introduced in prisons will eventually absolve the state from its former policy of creating habitual criminals."

Chief objection to subject matter was that the prisoner sees enough of prison as it is: "I think the fellow inmate should have some thing to forget his surroundings rather than have some thing to remind him of the place he inhabits. The paintings them selfs are very good. They should have a painting reminding him of a gay time making him want to git."

And one man was not to be cajoled at all: "My opinion

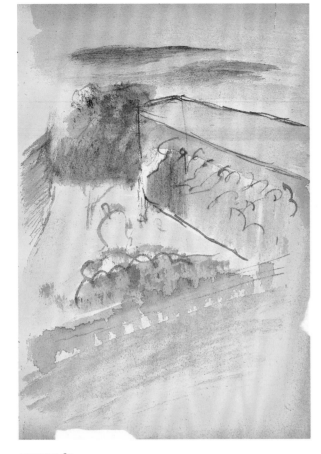

FIGURE 81

Page from *Rikers Island Penitentiary mural project sketchbook,* 1934–35
Watercolor and ink, 17 × 13 cm
Estate of Ben Shahn

about the pictures. I am not interested in them. Perhaps some prisoners and visitors may think a great deal of them. The only things I am interested in while behind the cold bars is English Arithmetic. In further more when the 26 of April comes I dont care for my face to see a prison any more nor pictures."

Majority opinions:

"I think that having them within our view we would realize that the Prison administration of today is really trying to assist us in starting over honestly."

"I cannot speak for the other fellow as for my self I think they will make a great improvement on one mind."

"They are beautifully painted. . . . Visitors will bee willing to help, put the plans over."

"It would be a good idea because it make the people have a lot of faith in the new Prison and when your people write to you you can tell them about it and it will make them feel more better."

"I am very much interested in pictures. And by having them on the Walls will make one feel more at home. I will be glad if the privileges is granted."

"To have them to view each day would be to me a constant reminder of where I am and would create a very strong desire in me to be a free man again."

It is apparently insurmountably difficult to appraise "psychological" factors. In any case the fact that three-fourths of the answers were clearly favorable, and that the test was his own, did not, in the eyes of the Commissioner, constitute "psychological fitness." Which puts the test down as a waste of time except as it makes interesting reading. The sketches for the Riker's Island murals are still in the artists' studios. They are, potentially, one of the most important mural achievements of a period which is using the mural as never before in this country. They have proved themselves in every possible way, and they will be carried out on twentieth-century New York walls when the New York City administration decides to accept the coöperation of its artists and its prisoners in building a finer social order.

NOTES

This article, annotated by Jenna Webster, first appeared in *American Magazine of Art* 28 (August 1935): 492–96. Philippa Gerry Whiting, an associate editor of the magazine, had read Stuart Davis's "'We Reject'—The Art Commission" in advance of its publication. She immediately wrote to Shahn, asking him for photographs of his mural sketches so that she could defend them in *American Magazine of Art*. Like Davis, Whiting misspells Austin H. MacCormick's name throughout.

1. Following the stock-market crash in 1929, a number of organizations began providing select New York City artists with much-needed financial assistance. The most important of these charities was the Gibson Committee, which, in August 1931, raised more than twenty million dollars to be administered by the Emergency Work Bureau. In September 1931 the Temporary Emergency Relief Administration, established by the New York state legislature, replaced the Gibson Committee in providing funds for the Emergency Work Bureau. Shortly thereafter, in 1932, the College Art Association began collaborating with the Gibson Committee. Wealthy individuals, of whom Gertrude Vanderbilt

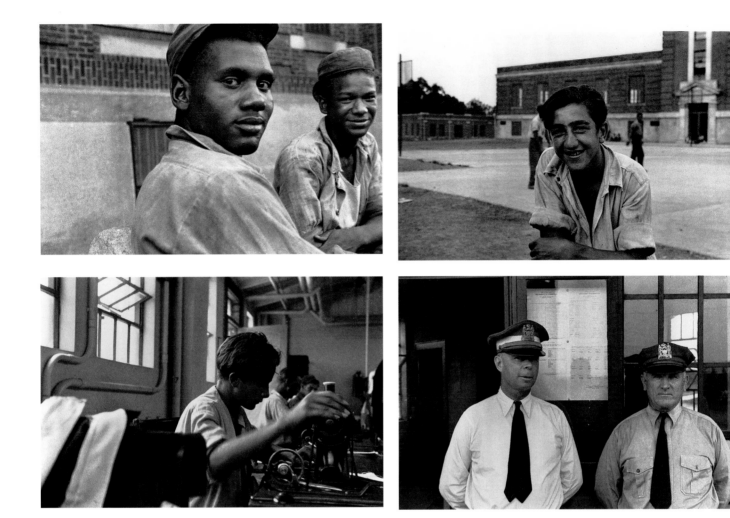

top left

FIGURE 82

Untitled (New York City Reformatory, New Hampton, New York), 1934

Modern print from an original negative

Fogg Art Museum, gift of Bernarda Bryson Shahn,

P1970.4162

top right

FIGURE 83

Untitled (New York City Reformatory, New Hampton, New York), 1934

Modern print from an original negative

Fogg Art Museum, gift of Bernarda Bryson Shahn,

P1970.4157

bottom left

FIGURE 84

Untitled (New York City Reformatory, New Hampton, New York), 1934

Modern print from an original negative

Fogg Art Museum, gift of Bernarda Bryson Shahn,

P1970.4148

bottom right

FIGURE 85

Untitled (New York City Reformatory, New Hampton, New York), 1934

Modern print from an original negative

Fogg Art Museum, gift of Bernarda Bryson Shahn,

P1970.4155

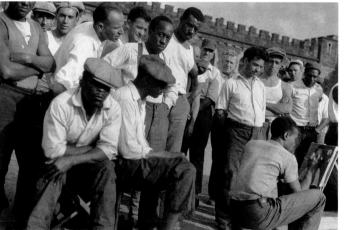

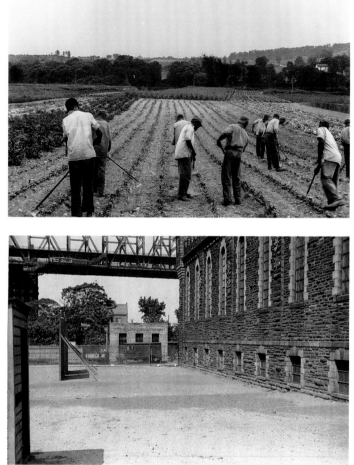

top left

FIGURE 86

Untitled (New York City Reformatory, New Hampton, New York), 1934

Modern print from an original negative

Fogg Art Museum, gift of Bernarda Bryson Shahn,

P1970.4169

top right

FIGURE 87

Untitled (New York City Reformatory, New Hampton, New York), 1934

Modern print from an original negative

Fogg Art Museum, gift of Bernarda Bryson Shahn,

P1970.4187

bottom left

FIGURE 88

Untitled (Blackwell's Island Penitentiary, Welfare Island, New York City),

1934

Modern print from an original negative

Fogg Art Museum, gift of Bernarda Bryson Shahn,

P1970.4193

bottom right

FIGURE 89

Untitled (Blackwell's Island Penitentiary, Welfare Island, New York City),

1934

Modern print from an original negative

Fogg Art Museum, gift of Bernarda Bryson Shahn,

P1970.4111

Whitney is most famous, initiated relief projects as well. The Gibson Committee found Shahn employment as a window dresser, a job he declined. See Harlan Phillips, interview with Ben Shahn, Roosevelt, N.J., 3 October 1965.

2. An asterisked note reads: Jonas Lie, then painter member, has since resigned.

I. N. Phelps Stokes and Philippa Gerry Whiting: Letter to the Editor and Rebuttal, *American Magazine of Art,* 1935

Lugubrious and Unpleasant
Sir:

My attention has been called to an article in the August issue of your magazine, in which the writer, Miss Philippa Whiting, an associate editor, criticizes the action of the Art Commission of the City of New York in rejecting the murals painted for the Riker's Island Penitentiary by Ben Shahn and Lou Block, two artists employed on a PWA [Public Works of Art] project under the auspices of the College Art Association. These paintings, which were submitted in elaborate sketch form, depict and contrast prison life of the past with that of the present, and, in the opinion of the Art Commission, to say the least, are lugubrious and unpleasant to look upon.

The article in your magazine, and a very similar one, upon which it is evidently based, in the July issue of *Art Front,* published by the Artists' Union, accuse the Art Commission of having "turned down the designs on the grounds of psychological unfitness," and your article adds: "their aesthetic merit was unquestioned." The article concludes: "The sketches for the Riker's Island murals are still in the artists' studios. They are, potentially, one of the most important mural achievements of a period which is using murals as never before in this country. They have proved themselves in every possible way, and they will be carried out on twentieth century New York walls when the New York City administration decides to accept the coöperation of its artists and its prisoners in building a finer social order."

In fairness to the Art Commission and to Commissioner McCormick I wish to point out that the designs were disapproved by the Art Commission for one reason—and for one reason only—because every member of the Art Commission who was present when the submission was acted upon believed that, artistically, and in other respects, most of them were unsatisfactory and unsuitable for the location for which they were intended and submitted—the main corridor leading to the chapel of the penitentiary, where they would be seen at frequent intervals, not only by the prisoners themselves, but by visitors to the penitentiary, a decision in which the Commissioner concurred.

It should also be recorded that the Art Commission expressed its willingness to consider the use of some of the sketches for less public portions of the penitentiary.

REBUTTAL

Readers will welcome Mr. Stokes' frank explanation of the point of view of New York's Municipal Art Commission in regard to the Riker's Island murals. It is important in supplementing the data on the project given in the note in the August issue of this magazine—data which was based on the official report of the artists in question to the College Association, which administers New York State relief for artists. No doubt this report was available also to Mr. Stuart Davis who wrote the July article in *Art Front.*

The Art Commission, then, did not balk at the "psychological unfitness" of the murals, but turned them down for one reason and only one: because "artistically, and in other respects most of them were unsatisfactory and unsuitable for the location for which they were intended and submitted. . . ." If we consider this statement, "artistically," "in other respects," "most of them," and the matter of location, the Art Commission becomes involved at once in at least four reasons, but it is impossible to agree or disagree with the Commission as to the "other respects," because these are not defined. The same difficulty obtains with "most of them." We are left, therefore, with the fact that the sketches were rejected as artistically unsuited for the location intended.

To reject murals on these grounds is a perfectly proper exercise of the functions of the Municipal Art Commission, and their decision can be disagreed with but not objected to. However, there are one or two points in this case that are still not clear. If the reason for rejection was as stated above, why did it occur to anyone to give a test to forty representative prisoners at Welfare Island, to determine their reaction to the murals? The Commission surely does not need to have its aesthetic judgments confirmed by forty Welfare Island prisoners. In this case they were not confirmed. The prisoners liked the murals. Perhaps the test was negative: if the prisoners were favorable, then the Municipal Art Com-

FIGURE 90
Page from *Rikers Island Penitentiary mural project sketchbook,* 1934–35
Ink, 17 × 13 cm
Estate of Ben Shahn

mission felt that it had been right in declaring them artistically unsuitable. It seems that before the test was given, it should have been made quite clear what it was intended to prove.

The second question that naturally arises is the matter of location. Mr. Stokes thinks that it should be recorded that the Commission is willing to have some of the sketches used in "less public portions of the penitentiary." This is a very interesting suggestion. The Commission apparently feels that the murals are not just aesthetically unsuitable, but are suitable to be seen by a smaller number of people. It is not explained whether this smaller number is to comprise

prisoners, or visitors, or a limited number of the two together. The possibilities of this method of appraising works of art are exciting, if somewhat complicated. We may see the days when paintings will be classified according to their numerical appeal, and artists will submit a choice of sketches suitable to be seen by twenty, fifty, and a hundred people respectively.

It is obvious that a mural which is suitable for a hospital may not be suitable for an indoor skating rink—that audiences differ in kind. But in this case, they would differ in number, or in frequency. It would be interesting to know how a mural which is bad when seen by five people can be good when seen by one—unless the one is a different kind of person from the five.

NOTES
The letter and rebuttal first appeared in *American Magazine of Art* 28 (October 1935): 635–37. I. N. Phelps Stokes was the president of the New York City Municipal Art Commission. Once again, MacCormick's name is misspelled.

THE POLITICS OF MEDIA

Richard Doud:
Interview with Ben Shahn, 1964

I became interested in photography in the early thirties when I shared a studio with Walker Evans [at 20–22 and 23 Bethune Street in Greenwich Village], and found my own sketching was inadequate. I was at that time very interested in details. I remember I was working around Fourteenth Street, and a group of blind musicians were constantly playing there (see cats. 33, 34, 37).[1] I would walk in front of them and sketch, and walk backwards and sketch, and I found it was inadequate. I knew Walker had a Leica. So I asked my brother [Philip Shan] to buy me a camera because I didn't have the money for it. It was a second hand one and cost all of twenty-five dollars. He bought me a Leica and I promised him—this was a kind of bold promise—I said, "If I don't get in a magazine off the first roll you can have your camera back." My photographs were published in a magazine, a theater magazine [*New Theatre,* November 1934; see fig. 4].

Now, my knowledge of photography was terribly limited. I thought I could always ask Walker to show me what to do—it was a kind of an indefinite promise that he made.

One day [30 December 1931] when he was going off to the South Seas and I was helping him into his taxi, I said, "Walker, remember your promise to show me how to photograph?" He said, "Well, it's very easy Ben—F/9 on the sunny side of the street, F/4.5 on the shady side of the street. For a twentieth of a second hold your camera steady," and that was all. This was the only lesson I ever had. Of course I realize that photography is not the technical facility as much as it is the eye—the decision that you make the moment you snap the shutter. I was primarily interested in people, and people in action, so I did not photograph buildings for their own sake, or a still life, or anything like that.

Then in [September] 1935, someone [Rexford Guy Tugwell] came down from the Farm Security—it was then called the Resettlement Administration. I had been recommended by Ernestine Evans, who was on the planning board and had recommended Walker Evans. I was brought in, not in the photographic department at all, but on a thing called the Special Skills [Division]. I was to do posters, pamphlets, murals—propaganda in general.[2] To me the word "propaganda" is a holy word when it's something I believe in.

I came down to Washington with a chip on my shoulder, and Roy Stryker [head of the Historical Section of the Information Division] was just another bureaucrat to me, but I realized very soon that without Roy the photographic project would have died. I was so interested in photography that I really would have preferred to work with Stryker than with my department. The amusing thing was that Walker Evans would have preferred to work with my department, rather than with Stryker. He didn't get along too well with Stryker for one reason or another.

It was suggested that I first take a trip around the country in the areas in which the Resettlement Administration worked—to see what it's all about. I tell you, that was a revelation to me. Before then all my experience had been European. I had studied in Europe [France, Italy, and Spain] for four years and my knowledge of the United States came via New York and mostly through Union Square. When I began to go out into the field it was a revelation. I did take my camera along, as I felt there wouldn't be enough time to draw the things I wanted. I did some drawing and a lot of photography, but I was not part of Stryker's outfit at all. However, I presented my photographs to him as a gift with my negatives. For that reason, I also could access the facilities to print them.

I used a camera that didn't have an interchangeable lens [a Model A Leica with a fifty millimeter lens], so it was much flatter, and I could put it in my back pocket. I got to be fast enough to work from a moving car. My wife [Bernarda Bryson] would do the driving. She was very understanding of the whole thing and just as enthusiastic about it as I was, so that we'd retrace steps, sometimes five hundred miles if I needed something to fill in. If I'd missed it, back we'd go. We had a little Model A Ford that we knocked around in. It gave us no trouble, but it didn't have much speed, so going back six hundred miles meant almost three days.

When I traveled throughout the United States I didn't have a penny. It was the middle of the Depression. I couldn't get as far as Hoboken at that time. I thought I'd never get out of New York again. The present seemed to be hopeless. It was a really tough time, and when this idea came along to wander around the country a bit for three months I just nearly jumped out of my skin with joy. And not only that, they were going to give me a salary too! I just couldn't believe it. I went and found things that were very startling to me.

I remember visiting the communities that the Resettlement Administration had built [Red House, West Virginia; Tygart Valley Homesteads, Elkins, West Virginia; and West Moreland Homesteads, Pennsylvania]—I found them impossible to photograph.[3] Neat little rows of houses—this wasn't my idea of something to photograph. I had the good luck to ask someone, "Where are you all from?" When they told me, I went down to a place called Scotts Run [West Virginia], and there it began.[4] I realized then that I must be on my own. From there I went all through Kentucky, West Virginia, down to Arkansas, Mississippi, and Louisiana—I covered the mine country and the cotton country. I was terribly excited about it and did no painting at all during that time. I thought photography would be the career for the rest of my life.

[In October] I did a series of photographs on a Saturday afternoon in a small town [Huntingdon] in Tennessee of a medicine man (fig. 91). He had a little ventriloquist dummy, and a Negro to help him and so on. It was Saturday. I don't think there were ten cars in the square—only mule-drawn carts. This was 1935! It was incredible to see.

When I was in the mine country, I think it was Kentucky, there was a local strike taking place. It was being picketed, and I thought, "Now how do you get into a conversation with a union picket? You offer him a union made cigarette."

DOCUMENTARY
PHOTOGRAPHS
FROM THE FILES OF THE RESETTLEMENT ADMINISTRATION

A COLLEGE ART ASSOCIATION EXHIBITION

FIGURE 91

Untitled (medicine show, Huntingdon, Tennessee)
October 1935
Cover of pamphlet for the exhibition
*Documentary Photographs from the Files of the
Resettlement Administration,* College Art
Association, December 1936, WPA Federal
Art Project Gallery, New York City
27.6 × 10.6 cm
Taller Archive

In December 1936 Peter Sekaer assembled this exhibition,
which included works by Shahn, Paul Carter, Walker
Evans, Theodore Jung, Elmer Johnson, Dorothea Lange,
Carl Mydans, and Arthur Rothstein. Rexford Tugwell, who
resigned as director of the Resettlement Administration
the same month as the exhibition's opening, wrote a brief
introduction: "In these photographs there is expressed a
vital relation to contemporary life which has always been
an essential factor of any art expression." Shahn had
designed similar exhibits of Resettlement Administration
photographs earlier that year in conjunction with a
Democratic convention.

So I bought a pack of Raleighs, and I offered him one, and
he said, "No, I don't smoke that awful stuff," in stronger
language than that. "I've been in the union for thirty years,
and I won't smoke that," and he offered me a non-union
cigarette. This was startling to me. As was the fact that
John L. Lewis was a god of theirs at this time, and you didn't
dare say a word against him. But if you had a copy of *The
Nation* with you, I think they'd run you out of town. It was
an incomprehensible conflict.

I went down to Plaquemines Parish, below New Or-
leans. We went through an area of the trappers who refused
to be farmers. It was beneath their dignity. They'd stamp
out anything green because their whole dignity rested on
trapping, not on soil, you see. I stayed with some families
and got to know them. We still remember their names; my
wife can tell endless stories.[5]

I used what is called an angle viewfinder on an ordinary
Leica. The angle viewfinder lets you look off in another di-

rection when you focus, so it would take away any self-
consciousness people have. So, most of my pictures don't
have any posed quality, and this was a very helpful thing in
the whole quality of my work, this angle viewfinder. When I
was first in Louisiana some kids didn't know if it was a cam-
era or a machine gun. When I went back there on an extra
little trip two years later in 1937, they said, "Ha, you work
for *Life Magazine.*" *Life* had already come out in 1936, and
they have become very sophisticated, but in the early days
they were not.[6] There are so many gadgets on cameras now
that people abandon these simpler instruments. I didn't
even use a light meter. I used my own judgement. So, I
missed a lot of things.

I remember traveling around in Arkansas with [the
Democratic] Senator [Joseph Taylor] Robinson, and I told
him about this little angle viewfinder trick.[7] He felt very
much part of it and helped me take pictures of people un-
beknownst to them. On another occasion when I was in

Kentucky, the Sheriff came along and just took me by the arm: "No photographing in post offices." A post office had been held up in Paducah and someone had come in with a camera and sort of cased the joint. Well I was very amused by this. I had credentials that I hadn't shown. I wanted to see how far this would go. So, he took me to some justice, and I showed him my credentials, and while he was reading me the riot act I kept photographing him with this angle viewfinder.

I was very fond of the German film called Perutz Peromnia, which has a very fine grain and is very slow. I remember spending the whole evening at some dance hall and not getting a single thing. If I'd used a faster film I probably would have gotten it, but I had a great deal of faith in that film. Sometimes I got things that I never dreamed I'd get. There was one photograph that I'm very proud of [*Untitled (Child of Fortuna Family, Hammond, Louisiana),* October 1935]. It's been reproduced a lot (see fig. 93). There is a little girl, sort of very meager looking tragic eyes, and she was walking through the hallway of her home and there was a huge reproduction of Raphael's Holy Mother [*Terranuova Madonna*]. I held the camera in hand for about ten seconds, and I got it. My hands are pretty steady.

I was quite a purist about it when some of the people began to use flash. I thought it was immoral. I'll give you a reason why. You come into a sharecropper's cabin, and it's dark. A flash destroyed that darkness. It is true that a flash would actually illuminate the comic papers they paste on their walls, but this wasn't the impact it had on me. It was the darkness, the glistening of the eyes, the glistening of a brass ornament on top of a big bed, a glass, a mirror that would catch light. I wanted very much to hold on to this. Now, that's a matter of personal judgement, whether you divulge everything or whether things are kept mysterious as they are viewed.[8]

In Arkansas I saw a family who were so miserable that it was unbelievable. The child was holding some ragged doll and looked as horribly ragged as the doll [*Untitled (Mulhall Children, Ozark Mountaineer Family, Arkansas)*; see figs. 93, 107]. It was an unbelievable situation. When we were in the Ozarks, the families there were on total relief—you couldn't get a work project for them because they had no vehicles and they lived twenty miles apart so you couldn't pick them up for a day's work. I'd come to one family and the house was immaculate. Another one was completely impossible. I thought, "There is difference in people"—differences in

FIGURE 92
Unknown artist (possibly Jack Delano),
*Untitled (caricature of Ben Shahn with his
right angle viewfinder),* c. 1959
Drawing, 22.2 × 14.2 cm
Roy Emerson Stryker Collection,
Photographic Archives, University of
Louisville, Kentucky

people and their attitude and the respect they had for themselves. This is something I would not have believed because I felt that two families earning the same amount of relief would be equal, but it just didn't work that way. For a period of almost seven or eight years after, the experiences that I went through then were the basis of most of my work. So, I can't say enough about what it did for me.

FIGURE 93

Photographs by Ben Shahn,
1935, and Dorothea Lange, 1936
In "The Living Theatre,"
New Theatre and Film 4
(April 1937): 24–25
31.2 × 47.2 cm
The Harvard Theatre Collection,
The Houghton Library

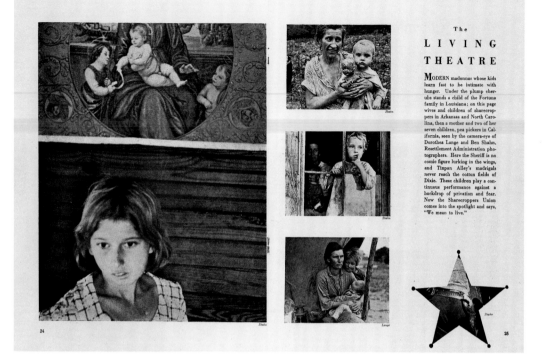

I recognized that our function was to convince our congressmen and senators that this Resettlement Administration was a necessary thing—and without convincing the public you can't convince a congressman either.[9] I felt it was essential to get our stuff out to publications and exhibits. I designed a number of exhibits for state fairs [in 1936]. Big things, we had the photographs blown up enormously. The whole idea was to impress the public and our government of the need for this. So, if you want to call that exploiting, I guess it was exploiting the deterioration of the South.

Walker Evans loved the South, particularly the antebellum architecture, and I think Roy was rather disaffected by Walker's direction. He thought perhaps Walker ought to do more of the kinds of things I was doing—people and movement and so on and so forth.

In the beginning there were no instructions, but later on it became a little bureaucratic. Roy would assign books to be read. I confess on my first trip I took a lot of books along, particularly books that were published in Chapel Hill, a series of sociological studies of the problem of cotton and so on.[10] That was completely on my own. I think I would have resented having someone tell me what book to read. It's a little bit like my inability to read a guidebook before I get

anywhere. I can read it after I've been there, and by the same logic I refuse to accept any technical stunts from anybody. I refused to learn more than I knew, and I confess I missed a great deal. I missed a great deal when I traveled by not reading the guidebook.

I used to talk to Roy about the photographs we were taking. When he wanted us to photograph eroded soil, I'd say, "Look Roy, you're not going to move anybody with this eroded soil. But the effect that eroded soil has on a kid who looks starved—this is going to move people." At that time Dorothea Lange's work was sent in, and her photographs were a revelation for Roy. You had to get close to people. Statistics meant nothing. Six million were unemployed. Oh, it meant something, but not if you told the story of just me. [In October 1936] I started to do a movie [*We Are the People*] on this very subject with Walker Evans and the money ran out. I just have a way of being fairly honest with myself and particularly in admitting my own inadequacies. I was thirty-five by that time [Shahn was actually thirty-eight], and I thought, "Look you can't start in the movies at thirty-five. Your esthetic arteries are hardened. You've got to be in there at eighteen. This is a cooperative business, a collaboration business, and you've been a lone wolf all your life." I

just faced it and stepped away from it. It was that kind of a serious decision to make. But to me it's the greatest medium there is today, it's total. We use all our senses, and when it's good it's terrific. When it's bad of course, it's also very bad.[11]

Roy had this remarkable facility of listening to people who he respected, and it became part of him, became part of his critical judgement as well. After I had worked there for awhile I had a strict advantage over everybody else there: a) they had not worked for him. b) my work was included in the first *U.S. Camera Annual* [1935] (fig. 95).[12] That made a terrific impression.

My negatives, I know, were very uneven and real trouble for the printer. In the beginning I would insist on printing my own stuff, and then when so many photographs were being made they had to bring in some printers.[10] I would give the printers the quality of the thing I wanted and they would put it in the file so when they had a call for it they would reproduce it. They were much better printers than I was. They could reproduce it exactly.

In the summer of 1938 [July and August], I went on Mr. Stryker's payroll at about half the salary I was getting before to cover what he called "the harvest" in central Ohio. It was just as vague as that: to do the harvest. At first it seemed so completely different from the South and from the mine country. It was neat, clean and orderly, and I didn't think it had any photographic qualities. At first I said, "Well, I can't do anything about it," and then one day it sort of came to me. I felt it after about two weeks, so I called Roy and I said, "I'll take the job." I stayed about six weeks and worked day and night. It was entirely different than in the South or in the mine country, wherever you point the camera there is a picture. In Ohio you had to make some choices. It was a little more difficult, but I think I did a nice job photographing the actual harvest, as well as the Sunday activities. I covered a lot of the church functions, and I went out to a resort called Buckeye Lake.

I must tell you something very amusing about the man who wrote *Middletown* [Robert S. Lynd and Helen Merrell Lynd, 1929]. He heard that I was going to Ohio, and he asked Roy if I would also be aware of the impact that women's clubs have had on the whole social structure. I was so amused that I wrote to Roy and said, "If you will send me a psychologic lens and philosophic film" (fig. 97).

Then there was the auction of a farm near Columbus, Ohio, which had its tragic overtones. There was a baby car-

FIGURE 94
Willard D. Morgan, letter to Ben Shahn,
12 August 1936
25.4 × 19.8 cm
Shahn Papers

riage, and the children for whom that baby carriage was bought were now grandparents themselves. I looked at it almost like a movie script except they were stills. I'd first go out and photograph all the signs on telegraph poles and trees announcing this auction, then get the people gathering, all kinds of details of them, and then examining the things, and the auctioneer, and so on and so forth. Those six weeks when I was out in Ohio was the only time I was directly under Roy's employ. To everybody's amazement I resigned because so many people were trying to get into it. My wife and I had a big mural to do [*Resources of America*, Bronx General Post Office, 1938–39], and photography ceased to interest me. Suddenly, just like that, I felt I would only be repeating myself and stopped it dead.

83

FIGURE 95

Untitled (Bowery, New York City), 1932–34

In *U.S. Camera Annual* (1935): 83

29.8 × 22.3 cm

Taller Archive

U.S. Camera Annual was published in
conjunction with the yearly traveling
exhibition *U.S. Camera Salon,* which
opened at Rockefeller Center in New York
City. It was there that Willard D. Morgan,
who worked for the Leica corporation and
arranged for publication of Leica guidebooks
and photographic annuals, first saw Shahn's
New York photographs. Morgan was so
impressed that he sought to include the
artist's RA/FSA photographs in various
Leica Annuals and traveling exhibits
throughout the 1930s.

I felt the whole social impact of the Depression, and I
felt very strongly about what the Resettlement Administra-
tion was trying to accomplish. I felt completely in harmony
with the times. I don't think I've ever felt that way before or
since. Totally involved, I thought nothing of working
through the night to print stuff or make posters or what
have you. It was a total commitment.

The only criticism I had later was that we were pho-
tographing just one side of America, the real poverty-
stricken. We photographed a pregnant woman standing in a
doorway or someone looking out of a window many, many
times. But how about the family who had just bought a new
set of furniture from Sears and Roebuck? How about this
nice little middle class street? This is hard to do. There
should be a photographic project for documenting society
at all times—during periods of miserable depression as well
as periods of affluence.

What I think was very beautiful about this thing was our
sense of unity as a group. Leica people used to put out an
annual every year, you know, and they wanted to give each
one of us awards, and we said, "No, give it to the outfit, the
photographic division." It was an esprit de corps. It was
very beautiful. It was pure. There was no competition fi-
nancially. I was so impressed with the work we were doing.
We were hypercritical of each other in a very decent way.
When a man returned from the field we'd look at the work.
We'd criticize each other very genuinely and never offen-
sively. And we would avoid all tricks—angle shots were just
horrible to us.

I was very involved ideologically in photography, and I
arranged an exhibition at the College Art Association [in
conjunction with a Democratic convention, 1936]. I picked
the photographs for the first exhibition, which was to be in
New York. That's the first time people in New York became
aware of it. I think it revolutionized photography—or at
least one aspect of photography.

To me there are two areas of photography. There is the
kind of thing Paul Strand or Walker Evans does with an
eight-by-ten camera, divulging textures and details the
human eye almost can't see. Evans made one of the best
photographs of the Depression with an eight-by-ten cam-
era. It was of some bum asleep in a beautiful doorway [*South
Street, New York,* 1932]. Then there is the thing [Henri]
Cartier-Bresson does of people in movement. Those are the
two great directions for me. A third one has come up now,
which is abstract, but it doesn't move me very much.

FIGURE 96
Untitled (central Ohio),
summer 1938
In Federal Writers'
Project, *The Ohio Guide*
(New York, 1940), n. p.
20.2 × 25 cm

FIGURE 97
Roy Stryker,
letter to Ben Shahn,
2 August 1938
25.5 × 20.5 cm
Shahn Papers

The things I photographed I did not think of so much as documents for myself. A lot of paintings came out of my work in photography over the years. I thought of it purely as a documentary thing, and I could argue rather violently with photographers who were interested in print quality, which bored me. I felt the function of a photograph was to have it seen by as many people as possible, and newspapers and magazines are one of the best ways. Naturally things printed in a magazine won't have the photographic quality of the photograph itself. But I felt that the image was more important than its print quality.

The fact that newspapers and the AP [Associated Press] began to borrow Resettlement Administration photographs and send them around the country was one of those weird accidents, because normally the average photo editor is not going to go to a government agency for good photographs. Well, our photographs were used a good deal. Archibald MacLeish, who was then the editor of *Fortune,* was doing one of those enormous studies on the use of land. And someone suggested that he might look at our photographs. I don't think he was very excited about the idea. When we sent him our photographs—we sent down a big portfolio—he said, "I'm abandoning my text, I'm using just your photographs, and I'll write a single line sound track for it." The book is called *Land of the Free* [1938], and I think it was the first book that came out with our photographs (see fig. 107). *Home Town: The Face of America* [by Sherwood Anderson, 1940] and *Twelve Million Black Voices* [by Richard Wright, 1941] (see fig. 51), both of which Ed[win] Rosskam chose the illustrations for, used our photographs too.

On the other hand, in Switzerland, somebody got a hold of our photographs, and they published practically a whole issue of a magazine with them. They did a beautiful job showing how democracy helped itself when it's in time of trouble. The same pictures were used by some Italian magazine during the very height of Mussolini's time to show how democracy can deteriorate.[14] Photographs can be used both ways. There is no doubt about it. It's the caption and the juxtaposition of pictures. I don't think an image is an adjunct to the caption. It's like saying that the cello is an adjunct to the orchestra or the other way around, that the orchestra is an adjunct to the cello. It depends how you use them and how you put them together.[15]

When they did the picture of the Okies, the movie of Steinbeck's *Grapes of Wrath* [1940], our photographs were used for setting up all sorts of scenes. When I saw it, I recognized it immediately. They've been used all over, and they've been stolen, you know. Photo agencies copied them and sold them. I've seen photographs of mine in magazines with other captions under them (fig. 98). You couldn't do anything about it because it was public domain. The government made them available. *Life* and *Look* used them. Margaret Bourke White and her husband at the time, Erskine Caldwell, did *You Have Seen Their Faces* [1937]. It was an inadequate copy of our work really. It didn't have the particular dedication that ours had. It was a commercial job you know.[16]

Stryker contributed an incredible amount to the project. He was the one who was constantly up on Capitol Hill making it possible for us to go out in the field. Roy was essentially a teacher. He had to fight for a budget all the time. I remember they had to drop a man because they didn't have enough money, and they went through the file and counted the photographs. Walker Evans, who had the least number because he is such a perfectionist, was the one who was dropped, and I thought that was insane. This is the way the government runs things; it's what they call quantity control instead of quality control. Roy was heartbroken but he had to let Walker go. He felt terrible about it.

I confess that Roy was a little bit dictatorial in his editing, and he ruined quite a number of my pictures, which he stopped doing later. He used to punch a hole through a negative.[17] Some of them were incredibly valuable, which he didn't understand at the time. For instance, I was in Marked Tree, Arkansas [in October 1935], and there was tension breaking out there, and it was really ugly. I photographed the front of a store where they, with Bon Ami, had marked the price of things. Later on during the war when I was doing some work for the OWI [Office of War Information], I wanted to show what happened to prices (the prices were fantastically low at that time), and I went to look for that negative, and he had punched a hole through it. Well, I shot my mouth off about that. He learned then not to do that because this was an invaluable document of what life was like in 1935, and when I was looking for it in 1943 or 1944 it didn't exist anymore.

Historically the Resettlement Administration photographic file is incredible. Years later [1944–46] I was working for the CIO doing some pamphlets (fig. 99), and I sent my assistant to find some pictures at the New York Public Library—which had a complete file of most of our photo-

graphs—and she brought back some of my pictures. They'd been borrowed a lot, and they were all frayed and looked as if they had been taken about fifty years ago. Romana Javitz who runs the Picture Collection in the New York Public Library has an incredibly wonderful imagination and exercises no editorial comment on the two or three million pictures they have there. They [RA/FSA photographs] have value for someone, for something at sometime. They become more and more valuable as time goes on.

In 1955 [Edward] Steichen put on a show in the Modern Museum [Museum of Modern Art, New York City] called *The Family of Man,* a photographic exhibit. An art critic [Aline B. Saarinen] wrote a very snide article about it, consoling the artists about the crowds that were waiting to get in—that they shouldn't be disturbed by that because, "This concerns itself with the outer world, but you artists concern yourself with the inner world." I was pretty burnt up about this silly review so I called the art editor and said, "Would you give me a column or two so I can answer this?" And he said he would, and it was published [13 February]. I generally never engage in any kind of polemics with an art critic on my own work, but I thought this was as good an opening as any. You can look it up in the *New York Times* because I went into this pretty thoroughly.[18]

There is among photographers a kind of self-consciousness of wanting photography to be an "art," you know, the "art of photography" and so on, and I get kind of tired of that. Photography is a mind, an eye, but not an art. The word "art" has never really been defined so you can't argue about it. But so many photographers have a sense of inadequacy. I have friends come in and talk about photography, and they can get mystical in ascribing to it certain qualities that it hasn't got. It's a reflective image, which we have the good fortune to have the mechanics to hold.

I felt I had more control over my painting than I did over photography. Extraneous material entered that I couldn't control in photography, except in very few instances where I felt there was a total picture. Some time ago [1960], we [the artist, his wife, and Dr. and Mrs. Sidney Spivack] went to Asia, and I took a camera along. I did hundreds of photographs of details of the sculpture, the temples and so on. But no more people. I found it was gone. It happens to people, a certain interest leaves them. I still love to look at photographs, but I couldn't do it myself anymore.[19]

NOTES

The interview took place in Roosevelt, N.J., on 14 April. The manuscript is in the Archives of American Art, Smithsonian Institution, Washington, D.C. We publish excerpts that have been edited and annotated by Deborah Martin Kao and Jenna Webster.

1. In his 1969 slide lecture at the Fogg Art Museum, Walker Evans recollected that the blind accordion player was an "infa-

OUT IN THE COUNTRY—U. S. A.—Millions of Americans go abroad every year to see the "quaint sights and people," little realizing, apparently, that right in their own back yard the sights and people are 100 per cent quaint as well as 100 per cent American. Above, left, are mountain folk snapped in Shenandoah National Park, Va. Next are two miners at Jenkins, Ky., taking time off for lunch; the grime of their trade is much in evidence. A child of a North Carolina sharecropper appears wistful and a bit sad. The last picture in the top panel, taken by a Resettlement Administration candid cameraman, shows a familiar rural type. He is Postmaster Brown, at Old Rag, Va. The lower panel shows an unemployed trapper of Plaquemine Parish, La. (left). It is the job of the Administration to "resettle" such men whose industry, like all others, has been hit by the depression. A workman in an old and glamorous business (center)—the Mississippi River boatman. This deckhand is on a vessel docked at Memphis, Tenn. Last, three Creole girls of Louisiana, with melody in their faces. Note the unusual stringed instrument. Beauties of this type are common in Louisiana.

FIGURE 98

Photographs by Ben Shahn and other RA/FSA photographers, 1935 In "Truly Rural America That Faces Resettlement," *Washington Post,* 4 March 1936 27.1 × 43 cm Taller Archive

mous" figure in the environs of Union Square. Lou Block also photographed this street performer on occasion: see Block Papers.

2. Shahn was appointed an Associate Art Expert on 16 September 1935 and began his trip through the South shortly thereafter with Bernarda Bryson. The pair returned to Washington on 8 November. Less than a year later, on 16 October 1936, the Special Skills Division designated Shahn an Associate Technical Advisor. He later held the position of Senior Liaison Officer. Bernarda Bryson was appointed Junior Art Expert in 1935 and Junior Technical Advisor on 16 October 1936.

3. Evidence suggests that Shahn only made photographs in West Moreland Homesteads. He may also have toured and photographed Cumberland Homesteads, Tennessee, at this time. In 1937 Shahn photographed Penderlea Homesteads, North Carolina, and Skyline Farms, Alabama. In the fall of 1941 he photographed the Shenandoah Homesteads in Elkton, Virginia, as part of a commemorative book project begun with Inslee Hopper (see fig. 36).

4. An alternative spelling of "Scotts Run" includes an apostrophe. Named after the eighteenth-century military captain David Scott, this area of West Virginia was also referred to as "Scott Run."

5. See captions by Bernarda Bryson Shahn in Hank O'Neal, *A Vision Shared: A Classic Portrait of America and Its People, 1935–1943* (New York, 1976), 33–36.

6. In 1937 Shahn's friend Willard D. Morgan wrote the artist on several occasions from *Life*'s New York offices requesting RA/FSA images.

7. Although Robinson, the Senate majority leader, staunchly supported President Roosevelt, he strongly opposed the local striking farm workers' union. Shahn and Bernarda Bryson accompanied Robinson for several days and then parted company with him, preferring to explore Arkansas on their own.

8. Evidence suggests that when Shahn photographed in Ohio in the summer of 1938 he did in fact use a flash. See Roy Stryker to Shahn, 2 July 1938, Shahn Papers, 5007F140; Stryker to Shahn, 10 July 1938, Shahn Papers, 5007F142. The images Shahn made in Ohio of interiors seem to confirm this. Shahn may have also used a wide-angle viewer at this time as well. See Stryker to Shahn, 26 July 1938, Shahn Papers, 5007F146.

9. During 1934 and 1935 Shahn, an editor of *Art Front* and an active member of the Artists' Union, demonstrated with his colleagues against what they perceived as censorship on the part of New Deal art programs. After Shahn began working for the Resettlement Administration in September 1935, however, his politics shifted, and he became one of the most vocal advocates of government art projects. In addition to the posters, pamphlets, and photographs Shahn made for the Resettlement Administration (and later for the Farm Security Administration), the artist performed a number of administrative duties as well, including ensuring that the display and reproduction of agency photographs would not compromise the New Deal agenda that he supported. For instance, when the photographer Barbara Morgan wanted to use RA/FSA photographs for an exhibition at the Second American Artists' Congress (17–19 December 1937) in New York, Shahn warned her that the images could not be used in ways that might criticize the government's programs (Shahn to Morgan, 21 January 1937, Shahn Papers, D146F50).

10. Shahn refers to studies being done by the social science research center at the University of North Carolina, Chapel Hill. For examples of their publications see Ben F. Lemert, *The Cotton Textile Industry of the Southern Appalachian Piedmont* (Chapel Hill, 1933); W. T. Couch, ed., *Culture in the South* (Chapel Hill, 1934); W. W. Alexander, Edwin R. Embree, and Charles S. Johnson, *The Collapse of Cotton Tenancy* (Chapel Hill, 1935), Rupert Vance, *Regional Reconstruction: A Way Out for the South* (Chapel Hill, 1935). For other texts Shahn may have used see Susan H. Edwards, "Ben Shahn: A New Deal Photographer in the Old South" (Ph.D. diss. City University of New York, 1996), 54–55. Edwards has reason to believe Shahn was reading studies by Howard Washington Odum and Arthur Raper.

11. For drafts of the shooting script for this project see Shahn Papers, 5016F859–5016F970.

12. For a review of this issue, see Beaumont Newhall, "Photography, 1935," *American Magazine of Art* 29 (January 1936): 54, 64, 66.

13. During the earliest period of Shahn's employment with the RA/FSA, he sent ten rolls of film that he made in the South to be developed at Willoughby's, at 110 West Thirty-second Street, New York City. See Willoughby's Packing Slip, Shahn Papers, 17 October 1935, D147F506. Shortly thereafter, however, Shahn began using the RA/FSA facilities. There is an envelope from Willoughby's in the Shahn collection at the Fogg Art Museum. Bernarda Bryson Shahn remembers helping Shahn print photographs in a darkroom in a converted mansion on Massachusetts Avenue in Washington, D.C. See Deborah Martin Kao and Jenna Webster, interview with Bernarda Bryson Shahn, Roosevelt, N.J., 20 January 1997.

14. Shahn was probably remembering the Nazi journal *Germanische Leithefte,* which, according to correspondence in Roy Stryker's papers, obtained the photographs directly from the RA/FSA. Penelope Dixon located this text. See Dixon, *Photographers of the Farm Security Administration: An Annotated Bibliography, 1930–1980* (New York, 1983), xix, 208.

15. The 1939 *U.S. Camera Annual* exemplifies both sides of this phenomenon. The publication overprinted RA/FSA photographs with a wide variety captions written by visitors to the International Photographic Salon in April 1939 at the Grand Central Palace in New York. The captions varied from "Long live Roosevelt!" to "Nazi propaganda!" Edward Steichen, in his essay on RA/FSA photographs for the volume, similarly emphasized the contradictory ways in which photographs could be read.

16. For a discussion of the publication of RA/FSA photographs see F. Jack Hurley, *Portrait of a Decade: Roy Stryker and the Development of Documentary Photography in the Thirties* (Baton Rouge, La., 1972), 122–46.

17. Stryker's staff sometimes punched holes in thirty-five millimeter negatives, which were then referred to as "killed." See Carl Fleischhauer and Beverly W. Brannan, "Appendix: The FSA-OWI Collection," in Fleischhauer and Brannan, eds., *Documenting America, 1935–1943* (Berkeley, Calif., 1988), 338–40.

18. Saarinen's review and Shahn's response are reprinted below.

19. Shahn produced hundreds of photographs during his travels through Asia. This body of work, which is in the collection of the Fogg Art Museum, in fact contains many wonderful portraits.

John D. Morse: "Henri Cartier-Bresson," 1947

Like a great many people who saw the exhibition of photographs by Cartier-Bresson at the Museum of Modern Art during March, I came away with a number of them stamped more clearly in my memory than anything else I had seen in the museum that day (except Henry Moore's *Shelter Drawings.*) So, never having been sure what made a good photograph good, and never having got any satisfactory answer to this question from the experts on photography, it occurred to me to ask Ben Shahn about it. The photograph people admire his prints (the Ohio "American Guide Series" is filled with them)[1] as much as the painting people admire his painting, so I thought he might supply the answer to my question. He did, and it has little to do with the usual terms of photographic criticism: focus, shutter, aperture, composition, etc.

"You presuppose technique in a photographer," said Shahn, "just as you presuppose it in a musician, or a painter. Lots of people have it. But technique is not what makes Bresson's photographs memorable. Bresson likes people. That's really all there is to it. That's why he photographed the onlookers at the coronation, when everybody else was photographing the coronation itself.

"Or the Mexico series [1934]. Most people photograph the picturesque—the markets, the costumes, and so on. Bresson photographed the girls in the red-light district, not as Mexican practitioners of the oldest profession, but just as people. His genuine sympathy for people is what makes these photographs memorable. He is never mean. Even in the picture called *Picnic* [1936–37], the one with the fat woman on the sand, he is sympathetic. Most people would have made fun of her.

"Of course his photographs have form, composition, contrast, and all that. Bresson is also a painter, so that's what you'd expect, or what you might presuppose, as I said. But the thing that makes them memorable is the content. To me, he is supremely the artist when he is looking for his subject. The rest is mechanical. The feeling for the subject and the ability to know just when to press the shutter—that is not mechanical. To find the extraordinary aspect of the ordinary—that's what Cartier-Bresson does.

"The emphasis among most photographers in this country has always been on form. Our first photography club called itself 'The Circle of Confusion.' Its members talked about lenses, scope, speed, print quality, and I don't

Letter 1 (Figure 100):

PM 5 cents NEW YORK DAILY

27 Sixth Avenue, BROOKLYN, N.Y. Sterling 3-2501

June 13, 1940

Ben Shan
Jersey Homesteads
Hightstown, New Jersey

Dear Ben Shan:

I don't know whether you have heard of the exciting new newspaper PM that 's appearing on the newsstands June 18, but I am assuming that you have. PM Weekly, the Sunday edition of PM, is going to carry two pages which we will call "News of Photography" -- not for photographers but to tell the reading and picture-looking public something about photography, photographs, and photographers. We hope to educate our readers, but without boring them, or even letting them know they are being educated.

We know that a lot of painters also take photographs, either for photography's sake or for use in their work. In our issue of June 30, we thought it would be interesting to carry two pages of photographs by painters. Beside each one we will place a painting of a painting by the same artist. We will be interested to see whether the same quality emerges in the photographs which we find in the paintings. Does the choice of subject, or approach in the photograph bear a relation to the painting? Of course we don't know just what we'll find until we have a sampling, but we think it will be entertaining.

If you think this a good idea and are willing to cooperate with us, we'd like to have photographs of a few of your paintings. And, we'd like to have glossy prints of several of your photographs, whichever you select, of course, but enough to give us some choice. The more you send us the better we'll like it. If you have no glossy prints and it would take some time to make them, would you send us the negatives? We will make our own prints and return the negatives to you immediately. Whether you send negatives or prints, we'll return them all to you and until we do, we will take the very best care of them and keep them under lock and key.

Will you send the photographs as soon as possible? We have a dead line early in the week preceding June 30, and there is a lot of work to be done after the photographs arrive.

We hope very much that you will participate because we want to make the pages as good as they can possibly be.

Sincerely,

Ann Henry

Letter 2 (Figure 101):

Jersey Homesteads
Hightstown, New Jersey
June 17, 1940

Ann Henry
c/o PM
New York City 27 Sixth Avenue Brooklyn N.Y

Dear Miss Henry:

In response to your good idea for showing whatever relationship exists between a painter's painting and his photography, I am sending you some photographs of paintings from a recent show of mine, and in addition a number of prints of photographs in which you may find a similar approach.

As to the questions you raise - whether the painter takes photographs for photography's sake, or for use in his own work - in my own case, I've never taken a picture for photography's sake, but always for my own use. On several occasions I have gone out to do documentary photographic studies for Resettlement (Farm Security) but in these pictures my point of view was always the same as though I were making paintings.

In the package which I'm sending you are:
1, 14 photographs of paintings.
2, 34 glossy prints of New York City subjects.
3, 83 photographs done for the Resettlement Administration. The latter are not glossy prints, but in case you wish to use them you can obtain glossy prints by requesting them from:

 Roy E. Stryker, Chief
 Historical Section
 Farm Security Administration
 Washington, D.C.

The prints can be ordered by the numbers penciled on the backs.

In case you wonder at the number of prints I have sent, I had previously promised Mr. Gus Peck, of your staff, a number of my photographs. I wonder if I may ask you to be responsible for them.

Yours very truly,

FIGURE 100
Ann Henry, letter to Shahn, 13 June 1940
25.4 × 19.8 cm
Shahn Papers
Throughout the 1940s Shahn continued to submit his photographs for publication in newspapers and journals. The newspaper *PM's Weekly,* which crusaded against big business, racism, and anti-Semitism, sought out Shahn's work on occasion, particularly for photo spreads in its sixty-four-page Sunday edition. In June, the newspaper's picture editor, Ann Henry, wrote for permission to publish Shahn's photographs and paintings in a special feature on "photographs by painters." Shahn submitted his work, including many photographs taken in New York, but the feature was canceled, and the images were never published.

FIGURE 101
Letter to Ann Henry, 17 June 1940
25.4 × 19.8 cm
Shahn Papers

FIGURE 102

Unknown photographer,
*Untitled (Ben Shahn, son Jonathan,
and daughter Susan),* c. 1941
From modern chromogenic
print, 7.62 × 12.7 cm
Taller Archive

FIGURE 103

Photographs by Shahn and other
RA/FSA photographers, 1935–40
In "The Small Town," *PM's
Weekly,* 13 October 1940, 48–49
36.6 × 56 cm

know what all. I still don't know the language very well (see fig. 40).

"There are any number of conditions under which you take a picture—the place, the people, why you were there, why you stood where you did instead of on any of a thousand other spots. But in the 'Annual' published by *U.S. Camera* the only questions asked of photographers are: camera? aperture? speed? (Shahn confessed that since he never keeps account of these details he once made up some completely impossible figures, which were solemnly published.)[2]

"Because concern with content has been so rare among our photographers, a show that has nothing else but content, and such human content as this one, is bound to be a memorable experience."

NOTES

This review of *The Photographs of Henri Cartier-Bresson,* Museum of Modern Art, New York, 4 February–6 April 1947, first appeared in *Magazine of Art* 40 (May 1947): 189.

1. Federal Writers' Project, *The Ohio Guide* (New York, 1940); see fig. 96.

2. In *U.S. Camera Annual* (1935); see fig. 95.

Nancy Newhall: "Ben Shahn," 1947

Why do the paintings of Ben Shahn appeal so strongly to photographers? Is it because he uses a camera to make the sketches from life on which he bases his paintings? Many other painters do the same without arousing photographers to such a pitch of excitement. Or because he made a brief but important contribution, along with Dorothea Lange and Walker Evans, to the early style of the FSA photographic project? His work with the Leica is good but not as distinguished as Cartier-Bresson and Helen Levitt.

Shahn is not a "photographic" painter in the usual art-critic sense of a dead and embalmed illusion. His nervously incised contours are far more important than chiaroscuro, which he uses only for dramatic effect. His color is free, as pink automobiles and crimson tree trunks abundantly testify, and recently, as in the ghostly gold in *Cherubs and Children* 1944 and the strange compelling scarlet of *The Red Stairway* 1944, it becomes a dominant theme in itself. A comparison of his original photographic perception with the finished painting reveals how much better he is as painter than photographer. In his photographs he does not

work for the most expressive moment; he snaps an interesting but incomplete idea, usually an architectural setting with suggested placements of figures. His painting is to him what the climax of a series is to the miniaturist or the print visualized on the final ground glass image to those who use large cameras.

Why then does he arouse such photographic emotions? First of all, I think, because he deals with the same problems, themes, and concepts as we do. He has not evaded actuality but penetrated it. He uses its very look and feel—I almost said sound and smell—in translating it into intensely poetic images. He sees people in the streets and backlots and fields with the same deep perspectives and split second tensions as Cartier-Bresson and Helen Levitt. He uses architecture and signs as Walker Evans, Berenice Abbott, and many other photographers do. He has an uncanny sense of detail and its connotations. James [Thrall] Soby, in his valuable monograph [1947], first of the American series of Penguin Modern Painters, quotes Shahn as saying, "There's a difference in the way a twelve-dollar coat wrinkles from the way a seventy-five dollar coat wrinkles, and that has to be right." Soby comments on the feet in his paintings—and once you have noticed them, they become an obsession—children's sneakers, working boots, the middle aged shoes in that weird dance of the *Churchgoers* [*Myself Among the Churchgoers,* 1939; Introduction, cat. 2]. Not only the clothing, but the outline and action of every figure is that of an individual we have seen.

Perhaps his most amazing use of detail is more cinematic than photographic, though it can be found in the work of people as apparently diverse as [Edward] Weston and Cartier-Bresson. This might be dubbed the psychological time-bomb; in *Pacific Landscape* 1945, a canvas full of insistent pebbles make[s] you blink before you discover a man lying on the beach and gradually realize there is blood seeping from him. There is a variation on this effect that resembles a double-exposure: in *Ohio Magic* 1945 (cat. 84), we see a street with a bus on it and in a corner window a boy looking out. Then vague shadows materialize like a frightening dream into an implacable brick wall.

Such interchange of themes and concepts between painting and photography is not new. It has a lineage extending back through the camera obscura and the camera lucida to the Renaissance, when painters began employing such instruments to help them construct the deep perspectives consonant with the expanding world of their time.

Ben Shahn, a social-minded painter, now shares his fame with Ben Shahn, the social-minded artist-photographer

BEN SHAHN, one of the country's leading "social" painters had shot only two rolls of film on his new 35 mm. camera when he received his first photographic assignment—to tour the poverty-gripped areas of the South to record on film what he saw. His pictures will undoubtedly cause some controversy among photographers but the fact remains that they have won for Shahn a reputation as a brilliant "social" photographer.

"But even now," says Shahn, "I am not what you'd call a photographic technician. I am only interested in photography as a means of documentation and to make notes for future paintings. Since I take pictures of what I like to call the obvious, I avoid shooting with filters

and I stick to straight printing. I have, however, equipped my camera with an angle viewer so subjects do not know when they are being photographed.

"Here, then, is significant evidence that a photographer need not be a technician. Shahn, in taking pictures, has proven himself to be as fine an artist with his camera as he is with his brush.

"What I try to shoot is the ordinary in an extraordinary manner, extraordinary only because it's so rarely done deliberately. It's called 'documentary' which I suppose is all right."

Ben Shahn did shoot in an extraordinary manner his photographs have appeared in leading photographic magazines in America and Europe and side by side with his paintings they hang (Continued on page 97)

WHILE ON ASSIGNMENT to make camera tour of impoverished communities in the South, Ben Shahn took this picture of negro mother and child living in squalor in French quarter outside New Orleans. Because he was shooting for realism he used no filters or any trick devices to glamorize his pictures.

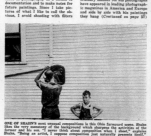

ONE OF SHAHN'S FAVORITES—He was attracted by these three visitors to a county fair in Ohio. In this case the photograph is art itself. "I would never be moved to use it in a painting," says Shahn, "because a painting could not be more effective. The faces are what particularly interested me."

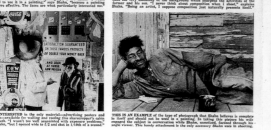

ONE OF SHAHN'S most unusual compositions is this Ohio farmyard scene. Shahn likes the very monotony of the background which sharpens the activities of the farmer and his son. "I never think about composition when I shoot," explains Shahn. "Being an artist, I suppose composition just naturally presents itself."

SHAHN WAS INTERESTED in the only material—advertising posters and catalogue covers—available for walling and roofing this sharecropper's cabin home in the South. "I wasn't too well acquainted with exposure problems," says painter Shahn, "but I opened wide to f/2 and shot at 1/10th of a second."

THIS IS AN EXAMPLE of the type of photograph that Shahn believes is complete in itself and should not be used in a painting. In taking this picture his wife engaged the subject in conversation while Shahn, unnoticed, focused through his angle viewer. This handy attachment is the only accessory Shahn uses in shooting.

SHAHN LIKES to refer to this kind of photograph when he paints. He used this one for a mural in an office building. "In photography," says Shahn "I'm interested in recording only essentials—the unessentials I crop in painting. If my photographs have what is called composition, then that is so much velvet."

THIS SHOT illustrates Shahn's contention that often a photograph is superior to a painting as a means of convincing documentation. What the camera can do for painter is to arrest split second action. It reveals how different are actions of man pitching hay than those, for example, of a man handling coal shovel.

COTTON PICKERS in Louisiana were photographed and later included by Shahn in a mural. "I took the picture to get important details," says Shahn. This is one of a group of photographs that have established him as a "social minded" photographer. Pictures like this add to America's cultural history.

THIS CHURCH in a small Ohio town is just like 99 out of a 100 small town churches. To Shahn it was so obvious that it cried out to be taken. Shahn says, "Shots like this record these essential details of form that you think you'll remember but don't . . . important details I like to put into my paintings."

IF A PICTURE makes you acutely aware of something you've known all your life then the man with a camera is more than a good photographer . . . he's an artist. This is an example and it, like so many other Shahn photographs, served to suggest background for one of his paintings (next page, bottom row, center).

IMPACT OF SMALL dark figures against tall bare wall appealed to Shahn the artist. He took this shot because it suggested an idea for a painting. Note that same quality which attracted him to shoot this scene is caught in his painting (next page, bottom row, right). The background has been changed somewhat.

30
31

THIS PAINTING by Shahn like others on this page were suggested by his photographs which appear on previous page. In this painting Shahn has included wheel of hay wagon which can be seen in background of photograph.

TO DRAMATIZE this painting of a cotton picker Shahn borrowed details from a photograph he had taken in Louisiana. Note how he has combined the boy's costume and the woman's stooped figure.

EXAGGERATION OF SIZE of cotton worker's hand suggests heavy toil. This is a section of mural Shahn painted. He referred to photograph (top, left, previous page) for details of action his camera recorded.

BACKGROUND FOR this painting was borrowed from photo of church. Shahn added people to suggest Sunday morning activity in small town. Photographer (left) is Shahn himself.

ANOTHER EXAMPLE of how Ben Shahn has used something his camera and divulged to help him in painting. In this painting he included in background a string of low class dwelling he had photographed in Ohio community.

COMPARE THIS PAINTING with the photograph on page 30. This is the same scene except for some changes in the background. " . . . to present relationships of color and tone in most dramatic way," says Ben Shahn.

FIGURE 104

"Photos for Art"

In *U.S. Camera* 9 (May 1946): 30–32

Each page: 34.2 × 26.5 cm

Since 1839 many painters have made creative use of photographic concepts—Degas of instantaneous photography, Marcel Duchamp of stroboscopic, for example—and many more, such as Gauguin and Toulose-Lautrec, have worked from photographs. This vast and exciting field is still shunned by all but one or two art-historians and art critics. The insult still contained in the word "photographic" when hurled at a painter implies the same kind of creative impotence and superficial imitations as the word "pictorial." James Soby, Director of the Shahn exhibition, is to be congratulated for the role he has long played in helping establish a more profound evaluation of the relation between painting and photography.

NOTES

This review of *Ben Shahn: Retrospective Exhibition of Paintings, Drawings, Posters, Illustrations and Photographs,* Museum of Modern Art, New York, 30 September 1947–4 January 1948, first appeared in *Photonotes* (November 1947): 3.

Clement Greenberg: "Art," 1947

Ben Shahn's gift, though indisputable, is rarely effective beyond a surface felicity. What his retrospective show at the Museum of Modern Art (through January 4) makes all too clear is how lacking his art is in density and resonance. These pictures are mere stitchings on the border of the cloth of painting, little flashes of talent that have to be shaded from the glare of high tradition lest they disappear from sight.

Shahn first came to notice as a "socially conscious" painter, working in that routine quasi-expressionist, half-impressionist illustrative manner derived from Cézanne, [Maurice de] Vlaminck, and other pre-cubist French artists, examples of which year in and year out fill the halls of the Whitney, Carnegie, and Pepsi-Cola annuals and the show-rooms of Associated American Artists ([Aaron] Bohrod, [Alexander] Brook, [Arnold] Blanch, [Edmond] Bouché, [Lamar] Dodd, [Guy] Pène du Bois, [Maurice] Sterne, etc., etc.). Shahn appears to have been momentarily successful within the very narrow limits of this style: thus in the gouache *Walker Greets the Mother of Mooney* [from *The Mooney Case,* 1932–33] a real instinct for pictorial unity imposes itself on tawdry color and banal drawing. But his real originality, such as it is, emerges only with the entrance of the influence of photography, a medium he has practiced in

addition to painting. It was the monocular photograph, with its sudden telescoping of planes, its abrupt leaps from solid foreground to flat distance, that in the early 1930's gave him the formula which remains responsible for most of the successful pictures he has painted since then: the flat, dark, exact silhouette placed upstage against a receding empty, flat plane that is uptilted sharply to close the back of the picture and contradict the indication of deep space. [Giorgio de] Chirico is felt here.

Some striking pictures issue from this formula. They are all in tempera, which lends itself best to Shahn's precise contours and extremely simple color sense; among them are the *Handball* of 1939 (fig. 38), the *East 12th Street* of 1947 (cat. 91) and the *Ohio Magic* of 1945 (cat. 84). The influence of the photograph, with its startlingly irrational unselectivity of detail, is also applied to advantage in the *Self-Portrait Among Churchgoers* of 1939 (see Introduction, cat. 2).

On the whole Shahn's art seems to have improved with time. The later pictures become more sensitive and more painterly. That his "social consciousness" has at the same time become less prominent does not, in my opinion, play much of a role here; it is simply that Shahn gains better control of his medium as he goes along. Yet there has been a certain loss of vigor. Nothing improves upon or repeats the shock of *Handball.* There is an attempt to strengthen and vary color, but to little avail. Shahn, more naturally a photographer than painter, feels only black and white, and is surest of himself when he orients his picture in terms of dark and light. All other chromatic effects tend to become artificial under his brush.

This art is not important, is essentially beside the point as far as ambitious present-day painting is concerned, and is much more derivative than it seems at first glance. There is a poverty of culture and resources, a pinchedness, a resignation to the minor, a certain desire for quick acceptance—all of which the scale and cumulative evidence of the present show make more obvious. Yet Shahn has a genuine gift, and that he has not done more with it is perhaps the fault of the milieu in which he has worked, even more than his own.

NOTES

This review of *Ben Shahn: Retrospective Exhibition of Paintings, Drawings, Posters, Illustrations and Photographs,* Museum of Modern Art, New York, 30 September 1947–4 January 1948, first appeared in *The Nation* 165 (1 November 1947): 481. Courtesy Getty Research Institute, Research Library, 950085.

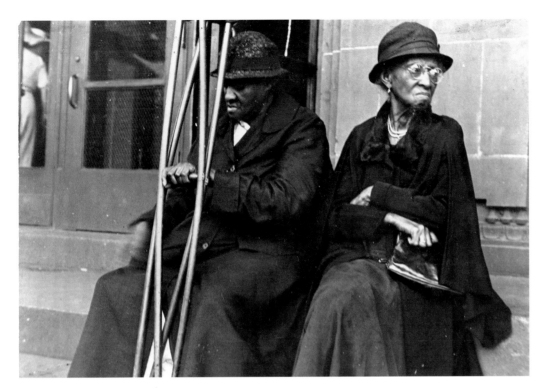

FIGURE 105
Untitled (Welfare Hospital, Welfare Island, New York City), 1934–35
15.1 × 22.7 cm
Fogg Art Museum, gift of
Bernarda Bryson Shahn,
P1970.3593

FIGURE 106
The Meaning of Social Security,
mural in progress, west wall,
Social Security Building
(now Wilbur J. Cohen Federal
Building), 1940–42
National Archives and Records
Administration, Record Group
121

Aline B. Saarinen:
"The Camera Versus the Artist," 1955

The current exhibition at the Museum of Modern Art packs a terrific emotional wallop. It is a show not of paintings but of photographs: Edward Steichen's tremendous "Family of Man" exhibition, consisting of over 500 photographs of man's moods from birth to death. Its impact is so forceful, in fact, that it raises a nudging question: has photography replaced painting as the great visual art form of our time?

Once the question is allowed admittance, instances come to mind that accelerate an affirmative answer. Which are the unforgettable images of our age? What more poignantly represents the nightmare of the atomic bomb than the photograph of the crying little girl alone in the desolate, bombed landscape of Nakasaki? Is the fall of France more penetratingly etched on memory than in the photograph of the middle-aged bourgeois Parisian with tears streaking his face? And in this show, does not the photograph of the soldier saying good-bye to his little boy unveil a universal truth about war?

More arguments rush forward to defend this young art form. Granting that all art is an expression of a response to life and a communication of emotion, is it not true that photography makes itself immediately intelligible and that its statement is undeniably universal? Conversely, has not painting become so introverted, so personal, so intellectualized that it has lost both its emotion and its power of communication?

The argument needs testing. Let us try a sobering question or two. Suppose one had to choose between saving the life work of the ten best painters and the ten best photographers of our time? One pauses. Picasso's "Guernica" [1937], Matisse's "La Danse" [1909–10] come to mind. Horror of man's inhumanity to man; the apotheosis of joyousness. Mondrian; Miro; Leger. Surely one would have to save the work of the painters in such a choice.

The Artist's Vision

They are the ones who have invented a whole way of seeing for our age. Their statements have irrevocably influenced our life. And no matter how debased and vulgar their color and form may have become in the ad and the automobile, their vision has still directed almost everything we

see and use. Moreover, through their work we are reminded, as in a Francisco Boromini church or a Beethoven symphony, of the dignity of man, for it is in his personal creativeness that he most triumphantly asserts this fact.

So we must save the work of the ten great painters. But now suppose we have to choose between all the rest of the paintings of our time and all the rest of the photographs. The answer is easy. Let us save the photograph. For surely as against the mass of the painting, derivative or tentative, the photographs in this totality have a validity, a directness and a powerful statement that the paintings lack.

Suddenly the smoke clears. The answer is apparent. Painting is in our time, as it always has been in the hands of its giants, a great and strong means of expression. But photography is the marvelous, anonymous folk-art of our time. Test this further. Steichen made his show from over 2,500,000 prints that were submitted by professionals and amateurs in sixty-eight countries. Suppose the Museum had invited paintings on the same basis. The thought of what the 500 objects would look like is appalling.

This sort of speculation and the Steichen show make another point about painting and photography eminently clear. And that is the distinction between the two visual forms.

A painting, however realistic, is always an abstraction. A photograph, no matter how abstract, is always basically actual. The painter starts with an empty canvas and creates an image, seen or imagined. The photographer starts with the finished image and creates by selectivity.

Recently, as Steichen points out, certain photographers borrowed the artist's *concept,* playing up form and fragment as an abstraction, submerging subject-matter to composition.

One of the fascinating aspects of the "Family of Man" show is that it is composed almost entirely of those photographs which capitalize on the special and peculiar virtue of the camera: what Steichen calls "the swiftness of seeing," the ability to fix an exact, transitory instant. This is photography at its purest best.

Conversely, one need only think of how banal the moving photograph of the flag-raising at Iwo Jima became when it was cast into bronze sculpture to see that the plastic arts, too, are weakened when they trespass into the area of another medium.

That each of the art forms of painting and photography is most forcible and effective when it is truest to itself is perhaps the lesson of the "Family of Man" which painters

should take most to heart. Let them not resent the fact that his folk-art, as all folk-art always is, is replete with easily assimilable emotional impact. Let them instead be reinforced in their conviction that they have no *responsibility* toward depicting the outward appearance of the world or even finding the "hidden significance in a given text." Theirs is the prerogative to invent and create the image and to write the text which conveys the significance.

But let them also be reminded by this exhibition that communication of emotion is at the basis of any art.

NOTES

This review of Edward Steichen's exhibition *The Family of Man,* Museum of Modern Art, New York, 1955, first appeared in the *New York Times,* 6 February 1955, sec. 2, p. 10.

Ben Shahn:
"In the Mail: Art vs. Camera," 1955

To the Art Editor:

This is to take some exception to your review entitled "The Camera versus the Artist" which discusses the magnificent photographic exhibition arranged by Edward Steichen at the Museum of Modern Art and called "The Family of Man."

One would not ordinarily feel it necessary to express his disagreement with such a discussion. However, in this case, I feel that the assumptions made actually do a great disservice to both art and photography, and that perhaps one should make some sort of comment about them.

Your reviewer, Aline Saarinen, was greatly affected by the exhibition even though it stands in exultant contradiction to every precious principle which she and the majority of other art writers have laboriously hung about the neck of art across a decade of literary effort.

In order to reconcile the contradiction between, on the one hand, the precious principles, and on the other, the undeniable impact of Steichen's great assemblage, it became necessary for the reviewer to do some fine scalpel-work upon those Siamese twins—art and photography. With the separation accomplished we are presented with two curious anomalies—photography emerges as "folk-art," but "responsible," while art remains art, but is warned that if its meanings become too "easily assimilable" it may fall into the category of folk-art, God forfend!

Easily Recognizable

A few days ago [3 February] The Times reproduced a painting by El Greco showing the body of Christ received in the arms of Mary [*Pietà*]. The meaning of the work is so easily assimilable that not even a single line of art comment is required for full comprehension. Is El Greco, then, a folk-artist?

The reviewer, it seems to me[,] presses upon the artist a *responsibility* more onerous than any he has ever yet had to bear—namely the warning that responsibility may not be for him. Has it ever occurred to Mrs. Saarinen that perhaps the artist *wants* to be responsible? Is he not human? Does he not share the great common experiences of man? Has he not witnessed death and tragedy and birth? And is he, by some grievous miracle, exempt from the ordinary human reactions to such experience?

A further *responsibility* which your reviewer presses upon the artist is the injunction not to depict the outward appearance of the world. Must one then cease to admire [Jacques Louis] David because one loves [Paul] Klee? Must one reject Praxiteles in order to appreciate [Isamu] Noguchi?

A third *responsibility* placed upon the artist in this review is the prohibition against "trespassing" upon that area which is the proper preserve of photography. To this, one can only answer that there is no area anywhere that does not rightly belong to both painting and photography, provided the able painter or photographer sees in that area the making of a great symbol.

Obviously such efforts to exempt the artist from responsibility are only an attempt to make him feel free. That is not necessary. The artist who has great powers will feel free whether anyone "frees" him or not. But art, quite like small children, must have some structure of discipline to be able to grow. Without discipline, both atrophy.

Defense of Photography

On behalf of the photographer I would take issue with the term "folk-art." Photography is a very highly developed art and keenly sophisticated. Both qualities are just the opposite of the earnest awkwardness and simplicity of folk-art.

I feel that the status of painting as an art is a higher one than that of photography not because the one is responsible, the other irresponsible, but simply because painting is able to call much more out of the artist himself, and is able to contain a fuller expression of the artist's own capacities than is photography.

FIGURE 107

Untitled (children of the Mulhall family, Ozarks, Arkansas),
October 1935
In Archibald Macleish, *Land of the Free* (New York, 1938), 45–46
23 × 35.6 cm

45

Not from the brittle orchards: barren gardens:
Dog-run houses with the broken windows:
Hen-shat houseyards where the children huddle
Barefoot in winter: tiny in too big rags:
Fed on porkfat: corn meal: cheap molasses:

Fed on famine rations out of fields
Where grass grew taller than a child could touch once

But let us also note that it is not at all surprising that the public turns to the Steichen show with such undivided enthusiasm. The reason is, I am sure, that the public is impatient for some exercise of its faculties; it is hungry for thinking, for feeling, for real experience; it is eager for some new philosophical outlook, for new kinds of truth; it wants contact with live minds; it wants to feel compassion; it wants to grow emotionally and intellectually; it wants to live. In past times all this has been largely the function of art. If art today repudiates this role, can we wonder that the public turns to photography; and particularly to this vivid show of photographs that have, it seems, *trespassed* into almost every area of experience.

NOTES
Shahn's response to Saarinen's review "The Camera Versus the Artist" first appeared in the *New York Times,* 13 February 1955, sec. 2, p. 15.

Archibald MacLeish: Foreword to *The Photographic Eye of Ben Shahn,* 1975

There are more ways than one to paint that self-portrait of the artist as the artist which so obsesses our self-conscious age. The artist can face himself in a glass mirror, as Vincent [van Gogh] did, and paint the image, mutilated ear and all. Or he can face the world and paint what there reflects his expectation. Ben Shahn painted a reflecting world.

Whenever I think of him, now that he is dead, I see that bombed-out building he painted in 1945 [*Liberation*] with its bedroom wallpaper naked to the blasted sky and the pale little sad-faced girls on their rope ladders, whirling like archaic angels round and round the light pole in the ruined street—the light pole that has pierced the frame above the picture.

It was always the ruined city he was painting: the city ruined by war, ruined by greed, by hatred, by viciousness, injustice; modern metropolis, urban America. But with Ben Shahn the ruin was never the subject: it was only the scene. It was the landscape, and the landscape was peopled with figures—redeemed by its humanity. It was the gutted house where the whirling girls on those rope ladders—meant, one sees now, for escape from conflagration, from disaster—used those tragic instruments for toys, for play, for soaring

flight. What reflects the artist in this picture is not the rubble or the broken walls: any man who lived this century can paint a shattered house. What reflects the artist is the towering pole and the three, free figures circling in the air.

This is true reflection. Ben Shahn's was an inhabited world and what inhabited it was not death, despair, frustration, impotence. What inhabited it was man—mankind: those possibilities. I know this, and not only from his pictures. One winter morning in the year of Shahn's Charles Eliot Norton Professorship at Harvard [1956–57] I set out to find him in his [fourth floor] studio at the Fogg. It was a room at the top of the building protected from intrusion by back stairs and crooked corridors where the painter was to paint secure from trespass and I approached it with a sense of guilt. I could have saved myself my careful qualms. When I came to the door it was wide open and the room was full of the winter smell of undergraduates. There was hardly a square foot of the floor left free to walk on and as for Ben, though he was painting it was not in lonely silence. He was shouting at the room with his back to it: questioning and answering his questions for himself; pronouncing judgment and refuting with a brush stroke.

I saw then how it was with him: how he found himself in the world and worked in it. He was not and never could have been that private painter who stands outside his picture and looks in. He was that rarer artist who is himself a figure in the scene. *Myself Among the Churchgoers* [1939] (Introduction, cat. 2), he called a painting from about the time of these photographs. *Myself Among the Living* he might have called the photographs themselves. It would have placed him where he wanted to be placed—where he belonged— not only in the ruined city but among the human throngs who still can hope there and still live.

NOTES

This foreword was first published in *The Photographic Eye of Ben Shahn*, ed. Davis Pratt (Cambridge, Mass., 1975), v–vi.

Davis Pratt: Preface to
The Photographic Eye of Ben Shahn, 1975

Ben Shahn was little known as a photographer, even to a public familiar with his paintings and graphic work, until the 1969 exhibition *Ben Shahn as Photographer* at the Fogg Art Museum. The exhibition attempted to place Shahn, a sensi-

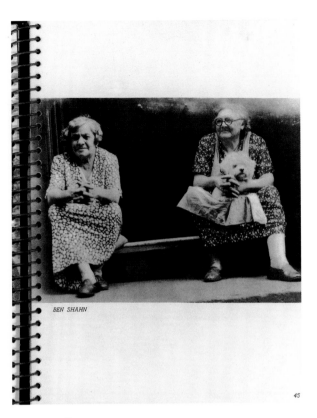

BEN SHAHN

FIGURE 108

Untitled (Lower East Side, New York City),

1932–34

In *U.S. Camera Annual* (1936): 45

29.8 × 22.3 cm

Taller Archive

tive photographer, in proper perspective and to reflect his consummate skill in the medium. Shahn was more concerned with content in a photograph than with technical qualities; the latter, he felt, had been greatly overemphasized. "When you spend all day walking around, looking, looking, looking through a camera viewfinder, you get an idea of what makes a good picture. What you're really doing is abstracting the forms" (1944).[1]

Ben Shahn was a photographer as surely as he was a graphic artist and painter. He never wholly accepted photography as art, however, and the "whole artistical approach to photography," as he put it, was alien to him.[2] Often he expressed an ambivalence about the medium: "I am only interested in photography as a means of documentation and

FIGURE 109

Ben Shahn and one of his RA/FSA
photographs at *The Bitter Years* exhibition,
The Museum of Modern Art,
New York City, 1962
In "A Backward Look at *The Bitter Years,*"
St. Louis Post-Dispatch, 4 November 1962
12.6 × 11.4 cm
Shahn Papers
*The Bitter Years, 1935–1941: Rural America
as Seen by the Photographers of the Farm Security
Administration,* arranged by Edward Steichen
and held at MoMA in 1962, was one of the
last major exhibitions to include Shahn's work
during his lifetime. Davis Pratt, who became
the curator of photography at the Fogg Art
Museum and arranged the first retrospective
of Shahn's photographs in 1969, worked with
Steichen as a picture research assistant.

to make notes for my future paintings" (1946); "I felt the
function of a photograph was to be seen by as many people
as possible. I felt the image was more important than the
quality of the image—you understand?" (1964).[3] Photography was a creative medium as far as the mind was concerned, but expressively it could never attain the stature of
painting.

Certainly Shahn was not the first painter to make use
of photography: one recalls Degas, Cézanne, [Thomas]
Eakins, and [Charles] Sheeler, among others. Often he
would use a reversed photographic print as a model for a
painting or drawing, and some of his photographs are
clearly "notes for future paintings." Others as social documents stand on their own. Shahn's vision as a painter surely
had an influence on his photography. In a 1946 interview he
said: "I am a social painter or photographer. I paint or photograph for two reasons: either because I like certain events,
things, or people with great intensity or because I dislike
others with equal intensity. . . . But frankly, I find difficulty
in making distinctions between photography and painting.
Both are pictures." His widow, Bernarda B. Shahn, has
written: "He felt that photography was a great and valid
form of expression. . . . He believed in photography used to
record. . . . He believed very much in its power to discover
and reveal."[4]

Although he had long been interested in photography, it
was not until 1932, when he was thirty-four, that Shahn,
having received a new Leica from his brother, began to
photograph seriously. He learned much of his craft from his
friend Walker Evans, the photographer; they shared a flat in
Greenwich Village and often spent time together in Truro
on Cape Cod. Recalling those early days, Walker Evans said:
"Ben was a born graphic artist and craftsman. It wasn't very
difficult to teach anyone as bright and gifted as that—a very
gifted artist—really a poet."[5]

Shahn had also met the young French photographer,
Henri Cartier-Bresson, whose first exhibition at the Julien
Levy Gallery in New York in 1933 impressed him deeply.
Cartier-Bresson's genuine sympathy for people and his remarkable skill in crystallizing momentary aspects of reality
had a pervading influence on Shahn's work. Other photographers whom he admired were Mathew Brady, [Eugène]
Atget, and Lewis W. Hine, whose compelling documentary
photographs of child labor and slums are well known.

During the years from 1932 to 1935 Shahn familiarized
himself with the capabilities of the 35-millimeter camera.

FIGURE 110

Jacket design by Shahn for *The Thirties, with Love,* to be written by Roy Stryker (never completed), c. 1960

10.8 × 24.2 cm

Roy Stryker Collection, Photographic Archives, University of Louisville, Kentucky

He was in the vanguard of those photographers in America in the early thirties who used miniature cameras for creative professional purposes. He was attracted to the convenience and unobtrusiveness of the small camera. Often he used a right-angle view finder, which made formal composition difficult and sometimes resulted in severed heads and bodies; however, this device permitted him to record his subject unaware and added a powerful spontaneity to his pictures. He appreciated the camera's ability to record swiftly moving events: "What the photographer can do that the painter can't is to arrest that split second of action in a guy stepping onto a bus, or eating at a lunch counter" (1944). And he was intrigued by the accidents of design that occur when one uses a small camera. As Ron Hill points out in an unpublished thesis, "With a rangefinder camera, the image . . . the photographer focuses on is not exactly the same image the camera is seeing . . . Consequently, it is not until he views the print that he becomes truly aware of the design seen by the lens."[6]

In 1934 and 1935 Shahn and a painter friend, Lou Block, collaborated on the Rikers Island Penitentiary mural project, which unfortunately was never accepted. To make studies for those murals, they photographed extensively on New York's Lower East Side, documenting street life, including labor demonstrations. Later they photographed life in several prisons in New York State. These photographs often lack an intimacy with the subject matter that was to become so apparent in his later work. Many have the feeling of sketches made in haste, but some were quite successful as early attempts at image sequencing.

From 1935 to 1938 Ben Shahn worked for the Farm Security Administration as an artist, designer, and photographer along with Walker Evans, Dorothea Lange, Russell Lee, Carl Mydans, John Vachon, Arthur Rothstein, and others. Often he traveled with his wife, Bernarda. Their mission was to photograph what F.D.R. referred to as "one-third of a nation ill-housed, ill-clad, ill nourished." Later they also photographed government homestead projects and made sociologically oriented studies of American small town life. Shahn took over six thousand photographs in the South and Middle West. Roy Stryker, who headed the pro-

gram, has recalled his impressions of Shahn's work during this period: "I was taken by Ben's photos because they were so compassionate. Ben's were warm. Ben's had the juices of human beings and their troubles and all those human things. You sensed all those things."[7] Shahn earlier had said, "We had only one purpose—a moral one, I suppose. So we decided: no angle shots, no filters, no mattes, nothing but glossy paper. But we did get a lot of pictures that certainly add something to the cultural history of America."[8]

Shahn's vision was deceptively simple and direct. Often he effectively employed cinematic sequencing techniques in photographing people or events. Viewed side by side, the images read like a film strip, with long shots, medium close-ups, and extreme close-ups from several different angles bringing the viewer into intimate contact with the subjects. In a 1964 interview [with Richard Doud], describing an auction he had once photographed, he said: "I looked at it almost like a movie script. . . . I'd first go out and photograph all the signs on the telegraph poles and trees announcing this auction, and then get the people gathering, and all kinds of details of them, and then examine the things, and the auctioneer, and so forth."

His early FSA photographs stress a frontality of subject matter and a flatness of space which heighten the graphic impact, as in a poster. With superb intuitive skill, he organized his subjects in relation to their surroundings and within the spatial confines of the photographic frame.

Shahn's comments in 1944 on his FSA experience are revealing: "We tried to present the ordinary in an extraordinary manner. But that's a paradox, because the only thing extraordinary about it was that it was so ordinary. Nobody had ever done it before, deliberately. Now it's called documentary, which I suppose is all right. . . . We just took pictures that cried out to be taken."[9]

Shahn's serious involvement with photography was relatively short. When he left the FSA in 1938 he ended his extensive use of photography, although he continued to use photographs in conjunction with his paintings and graphic work. In 1964 he wrote: "In 1959 my wife and I went to Asia, and I took a camera along to do what I had done years ago—photograph people. I could not get interested in it. I took hundreds of photographs of details of sculptures and monuments. We were in Indonesia. We were in Cambodia, and I did endless photographs of details—the temples and so on. But no more people. I found it was gone. I still love to look at photographs of people, but I couldn't make them myself any more."[10]

In studying several thousand of Shahn's photographs, one is struck by his remarkable achievement. As the images in this book attest, the photographic eye of Ben Shahn reflects a compassionate concern for humanity. One's confrontation with these photographs is more than a neutral experience; their impact continues to be felt long after the first encounter.

NOTES

This preface was first published in *The Photographic Eye of Ben Shahn,* ed. Davis Pratt (Cambridge, Mass., 1975), vii–xi. We identify the quotes where possible below.

1. Shahn, quoted in John D. Morse, "Ben Shahn: An Interview," *Magazine of Art* 37 (April 1944): 136–41.

2. We have been unable to identify the source of this statement.

3. Shahn, quoted in "Photos for Art," *U.S. Camera* 9 (May 1946): 30 (see fig. 104); Richard Doud, interview with Ben Shahn, Roosevelt, N.J., 14 April 1964. Excerpts from the Doud interview are reprinted above.

4. Shahn, quoted in "Photos for Art," 30, 57; Bernarda Bryson Shahn to Davis Pratt, 17 August 1969, Department of Photographs, Fogg Art Museum.

5. Davis Pratt, interview with Walker Evans, Niantic and Old Lyme, Conn., 24 September 1969.

6. Shahn, quoted in Morse, "Ben Shahn," 139; Ronald Hill, "Responsive Images: The Photographs of Ben Shahn" (Senior Thesis, Harvard University, 1975), 4–5. Ellipses are Pratt's.

7. We have been unable to identify the source of this statement.

8. Shahn, quoted in Morse, "Ben Shahn," 139.

9. Shahn, quoted in Morse, "Ben Shahn," 139.

10. See Doud, interview with Shahn. In fact Shahn produced many portraits, especially of children, during his travels (which actually took place in 1960) through Indonesia, Thailand, Japan, New Zealand, Australia, Hong Kong, Vietnam, and South Korea.

Selected Bibliography

This bibliography contains recommended sources for the general reader. For a comprehensive listing of works by and about Ben Shahn see Stephen Lee Taller, "Selected Bibliography," in Frances K. Pohl, *Ben Shahn: With Ben Shahn's Writings*, 158–67. The Stephen Lee Taller Ben Shahn Archive at the Fine Arts Library, Harvard College Library, also contains an exhaustive database of sources.

Aaron, Daniel. *Writers on the Left: Episodes in American Literary Communism*. New York, 1961. Rev. ed. 1992.

Abbott, Berenice. *Changing New York*. New York, 1939.

Alland, Alexander, and Felix Riesenberg. *Portrait of New York*. New York, 1939.

Allen, Frederick Lewis. *Since Yesterday: The Nineteen-Thirties in America, September 3, 1929–September 3, 1939*. New York, 1940.

Allen, Frederick Lewis, and Agnes Rogers. *Metropolis: An American City in Photographs*. New York, 1934.

Amishai-Maisels, Ziva. "Ben Shahn and the Problem of Jewish Identity." *Journal of Jewish Art* 12–13 (1986–87): 304–19.

Anreus, Alejandro, et al. *Ben Shahn: The Passion of Sacco and Vanzetti*. Exh. cat., Jersey City Museum, New Jersey, forthcoming.

Anreus, Alejandro, Diana L. Linden, and Jonathan Weinberg, eds. *The Social and the Real: Political Art of the 1930s in the Americas*. Princeton, forthcoming.

Baigell, Matthew, and Julia Williams, eds. *Artists Against War and Fascism: Papers of the First American Artists' Congress*. New Brunswick, N.J., 1986.

Beachley, DeAnna E. "Ben Shahn and Art as Weapons for Decency." Ph.D. diss., Northern Arizona University, 1997.

Beaton, Cecil. *Cecil Beaton's New York*. New York, 1938. Reprinted as *Portrait of New York*, 1948.

Ben Shahn, Voices and Visions. Exh. cat., Santa Fe East Galleries, New Mexico, 1981.

Ben Shahn in Ohio, the Summer of 1938. Exh. cat., Cultural Arts Commission, City of Upper Arlington, Ohio, 1988.

Berger, Maurice. *FSA, the Illiterate Eye: Photographs from the Farm Security Administration*. Exh. cat., Hunter College Art Gallery, New York, 1985.

Bolton, Richard, ed. *The Contest of Meaning: Critical Histories of Photography*. Cambridge, Mass., 1989.

Bryson Shahn, Bernarda. *Ben Shahn*. New York, 1972.

Cahill, Holger, and Alfred H. Barr, Jr., eds. *Art in America in Modern Times*. New York, 1934.

Carlisle, John. "A Biographical Study of How the Artist Became a Humanitarian Activist: Ben Shahn, 1938–1946." Ph.D. diss., University of Michigan, 1972.

Chevlowe, Susan, et al. *Common Man, Mythic Vision: The Paintings of Ben Shahn*. Exh. cat., Jewish Museum, New York, 1998.

Curtis, James. *Mind's Eye, Mind's Truth: FSA Photography Reconsidered*. Philadelphia, 1989.

Daniel, Pete, et al. *Official Images: New Deal Photography*. Washington, D.C., 1987.

Denning, Michael. *The Cultural Front: The Laboring of American Culture in the Twentieth Century*. New York, 1996.

DiBiaso, Jay Richard, et al. *Ben Shahn: The Thirties*. Exh. cat., Williams College Museum of Art, Williamstown, Mass., 1977.

Dorsky, Morris. "The Formative Years of Ben Shahn: The Origin and Development of His Style." M.A. thesis, New York University, 1966.

Edwards, Susan H. "Ben Shahn: New Deal Photographer in the Old South." Ph.D. diss., City University of New York, 1996.

———. "Ben Shahn: The Road South." *History of Photography* 19 (Spring 1995): 13–19.

———. "Ben Shahn and the American Racial Divide." *Tamarind Papers* 17 (January 1998): 77–85.

———. *Ben Shahn and the Task of Photography in the 1930s*. Exh. cat., Hunter College Art Galleries, New York, 1995.

Evans, Walker. *American Photographs*. New York, 1938.

———. "The Reappearance of Photography." *Hound and Horn* 4 (Oct.–Dec. 1931): 125–28.

Federal Writers' Project. *New York City Guide*. New York, 1939. Reprinted as *The WPA Guide to New York City: The Federal Writers' Project Guide to 1930s New York*. New York, 1992.

———. *New York Panorama*. New York, 1938. Reprinted as *New York Panorama: A Companion to the WPA Guide to New York City*. New York, 1984.

Fleischhauer, Carl, and Beverly W. Brannan, eds. *Documenting America, 1935–1943*. Berkeley, Calif., 1988.

Footner, Hulbert. *New York, City of Cities*. New York, 1937.

Greenfeld, Howard. *Ben Shahn: An Artist's Life*. New York, 1998.

Guimond, James. *American Photography and the American Dream*. Chapel Hill, N.C., 1991.

Hambourg, Maria Morris, Jeff L. Rosenheim, et al. *Walker Evans*. Exh. cat., Metropolitan Museum of Art, New York, 2000.

Harris, Jonathan. *Federal Art and National Culture: The Politics of Identity in New Deal America*. New York, 1995.

Hills, Patricia. *Social Concern and Urban Realism: American Painting of the 1930s*. Exh. cat., Boston University Art Gallery, Massachusetts, 1983.

Howe, Irving. *A Margin of Hope: An Intellectual Autobiography*. New York, 1982.

Katzman, Laura. "The Politics of Media: Ben Shahn and Photography." Ph.D. diss., Yale University, 1997.

———. "The Politics of Media: Painting and Photography in the Art of Ben Shahn." *American Art* 7 (Winter 1993): 61–87.

Kazin, Alfred. *A Walker in the City*. New York, 1946. 2d ed. 1951.

Kleeblatt, Norman, and Susan Chevlowe, eds. *Painting a Place in America: Jewish Artists in New York, 1900–1945*. Exh. cat., Jewish Museum, New York, 1991.

Levine, Lawrence. "American Culture and the Great Depression." *Yale Review* 74 (Winter 1985): 196–223.

Levitt, Helen. *A Way of Seeing*. New York, 1981.

Linden, Diana L. "The New Deal Murals of Ben Shahn: The Intersection of Jewish Identity, Social Reform, and Government Patronage." Ph.D. diss., City University of New York, 1997.

Livingston, Jane. *The New York School: Photographs 1936–1963*. New York, 1992.

Marquardt, Virginia Hagelstein, ed. *Art and Journals on the Political Front, 1910–1940*. Gainesville, Fla., 1997.

Mellow, James R. *Walker Evans*. New York, 1999.

Miranda, Manuel Fernandez. *Ben Shahn: Dibujos y fotografías de los años treinta y cuarenta*. Exh. cat., Salas Pablo Ruiz Picasso Museum, Madrid, 1984.

Morse, John D., ed. *Ben Shahn*. New York, 1972.

Natanson, Nicholas. *The Black Image in the New Deal: The Politics of FSA Photography*. Knoxville, Tenn., 1992.

Newhall, Beaumont. "Documentary Approach to Photography." *Parnassus* 10 (March 1938): 3–6.

O'Connor, Francis V., ed. *The New Deal Art Projects: An Anthology of Memoirs*. Washington, D.C., 1972.

Park, Marlene, and Gerald E. Markowitz. *New Deal for Art: The Government Art Projects of the 1930s with Examples from New York City and State*. Exh. cat., Gallery Association of New York State, New York, 1977.

Pells, Richard H. *Radical Visions and American Dreams: Culture and Social Thought in the Depression Years*. New York, 1973. Rev. ed. 1998.

Phillips, Sandra S., and Maria Morris Hambourg. *Helen Levitt*. Exh. cat., San Francisco Museum of Modern Art, 1991.

Platt, Susan. *Art and Politics in the 1930s: Modernism, Marxism, Americanism*. New York, 1999.

Pohl, Frances K. *Ben Shahn: New Deal Artist in a Cold War Climate, 1947–1954*. Austin, Tex., 1989.

———. *Ben Shahn: With Ben Shahn's Writings*. San Francisco, 1993.

Pratt, Davis, ed. *The Photographic Eye of Ben Shahn*. Cambridge, Mass., 1975.

Prescott, Kenneth W. *Complete Graphic Works of Ben Shahn*. New York, 1973.

Rathbone, Belinda. *Walker Evans: A Biography*. Boston, 1995.

Rivera, Diego. *Portrait of America*. New York, 1934.

Rodman, Selden. *Portrait of the Artist as an American: Ben Shahn, a Biography with Pictures*. New York, 1951.

Schwartz, Lawrence H. *Marxism and Culture: The CPUSA and Aesthetics in the 1930s*. Port Washington, N.Y., 1980.

Seldes, Gilbert, ed. *This Is New York: The First Modern Photographic Book of New York*. New York, 1934.

Shahn, Ben. *Love and Joy About Letters*. New York, 1963.

———. *The Shape of Content*. Cambridge, Mass., 1957.

Soby, James Thrall. *Ben Shahn*. New York, 1947.

Solomon-Godeau, Abigail. *Photography at the Dock: Essays on Photographic History, Institutions, and Practices*. Minneapolis, 1991.

Stange, Maren. *Symbols of Ideal Life: Social Documentary Photography in America, 1890–1950.* New York, 1989.

Stott, William. *Documentary Expression and Thirties America.* New York, 1973. Rev. ed. 1986.

Susman, Warren. *Culture and Commitment, 1929–1945.* New York, 1973.

———. *Culture as History: The Transformation of American Society in the Twentieth Century.* New York, 1984.

Tagg, John. *The Burden of Representation: Essays on Photographies and Histories.* Amherst, Mass., 1988.

Todd, Ellen Wiley. *The New Woman Revised: Painting and Gender Politics on Fourteenth Street.* Berkeley, Calif., 1993.

Trachtenberg, Alan. *Reading American Photographs: Images as History, Mathew Brady to Walker Evans.* New York, 1989.

Tyler, Francine. "Artists Respond to the Great Depression and the Threat of Fascism: The New York Artists' Union and Its Magazine 'Art Front' (1934–1937)." Ph.D. diss., New York University, 1991.

Ware, Caroline. *Greenwich Village, 1920–1930: A Comment on American Civilization in the Post-War Years.* Boston, 1935. Rpt. Berkeley, Calif., 1994.

Weiss, Margaret R., ed. *Ben Shahn, Photographer: An Album from the Thirties.* New York, 1973.

Wenger, Beth S. *New York Jews and the Great Depression: Uncertain Promise.* New Haven, 1996.

Westerbeck, Colin L., Jr. "Ben Shahn, Artist as Photographer." *Connoisseur* 212 (October 1982): 100–104.

Westerbeck, Colin L., and Joel Meyerowitz. *Bystander: A History of Street Photography.* Boston, 1994.

Whiting, Cecile. *Antifascism in American Art.* New Haven, Conn., 1989.

Yochelson, Bonnie. *Berenice Abbott: Changing New York.* New York, 1997.

Acknowledgments

We would like to thank the National Endowment for the Humanities, for recognizing the importance of foundational research on Ben Shahn's New York photographs. Without their generous support, the exhibition and catalogue of *Ben Shahn's New York: The Photography of Modern Times* would not have been possible.

The following institutions kindly agreed to loan works by Shahn from their collections: Ben Shahn Papers, Archives of American Art, Smithsonian Institution, Washington, D.C.; Curtis Galleries, Inc., Minneapolis, Minn.; The Fine Arts Library, Harvard College Library, Cambridge, Mass.; Fine Arts Museums of San Francisco; Fogg Art Museum, Harvard University Art Museums, Cambridge, Mass.; Fred Jones Jr. Museum of Art, University of Oklahoma, Norman; Hood Museum of Art, Dartmouth College, Hanover, N.H.; The Jewish Museum, New York; Museum of the City of New York; Museum of Contemporary Art, Chicago; Museum of Fine Arts, Boston; Neuberger Museum of Art, State University of New York, Purchase; Philadelphia Museum of Art; Photographic Archives, University of Louisville, Kentucky; Smith College Museum of Art, Northampton, Mass.; Stephen Lee Taller Ben Shahn Archive, the Fine Arts Library, Harvard College Library, Cambridge, Mass.; and the Wichita Art Museum, Kansas. Numerous individuals also kindly made their private collections available to our project: Alice E. Davenport, Rolf Fricke, John Horton, Jack Naylor, Bernarda Bryson Shahn, Ezra Shahn, and Judith Shahn. The generosity of these people and institutions enabled us to present Shahn's New York photographs and related artwork to audiences in the greater Boston area, Washington, D.C., New York City, and Chicago.

We are particularly grateful for the enthusiasm of our colleagues at the museums that are hosting *Ben Shahn's New York*. Special thanks are owed to Jay Gates, director, Eliza Rathbone, chief curator, and Elizabeth Hutton Turner, curator, at the Phillips Collection, Washington, D.C.; Lynn Gumpert, director of the Grey Art Gallery, New York University, New York; and Kimberly Rorschach, director of the David and Alfred Smart Museum of Art, University of Chicago.

Many scholars helped refine our ideas as this project took shape. Beverly W. Brannan, Lawrence Levine, Frances K. Pohl, and Alan Trachtenberg of our advisory committee guided us with their command of American culture and Shahn's art. We are especially indebted to the experts whose scholarship on Shahn enriched our understanding of the artist: Alejandro Anreus, DeAnna E. Beachley, Susan Chevlowe, Morris Dorsky, Susan H. Edwards, Howard Greenfeld, Diana L. Linden, and Kenneth W. Prescott. For intellectual inspiration, we are also indebted to Carl Chiarenza, Merry Foresta, Edward Grazda, Ellen Handy, John T. Hill, Patricia Hills, Jenna Weissman Joselit, Judith Keller, Garnett McCoy, Virginia Mecklenburg, Gerald M. Monroe, Nicholas Natanson, Mary Panzer, Sandra S. Phillips, Jules Prown, Belinda Rathbone, Jeff L. Rosenheim, Joel Snyder, Maren Stange, Sally Stein, Diane Tepfer, Ellen Wiley Todd, Anne Tucker, Elizabeth Hutton Turner, Colin L. Westerbeck, Bonnie Yochelson, and Rebecca Zurier.

We benefited immensely from the encouragement of Shahn's family and his many admirers. During the course of our research, members of the artist's family graciously gave their time and shared their recollections. Bernarda Bryson Shahn inspired us with her charm, intelligence, and humor. Judith Shahn, Ezra Shahn, Jonathan Shahn, and Jeb Shahn offered memories and kindly agreed to loan cherished works from their collections. We feel blessed to have known the late Dr. Stephen Lee Taller, who amassed an archive of research material on Shahn that represents a major resource. We owe thanks as well to Dolores Taller and to Roia Ferrazares, whose patience with our many questions was deeply appreciated.

Judith Metro and Susan Laity of Yale University Press, Evelyn Rosenthal of the Publications Department at the Harvard University Art Museums, and Marsha Pomerantz edited this catalogue with consummate wisdom and insight. The elegant design represents the standards of quality held

Acknowledgments

by all those at Yale University Press, with whom we were honored to work.

Numerous individuals gave unhesitatingly of their time in order to support our efforts: Ellen Agnew; Lucienne Allen; Malu Nay Block; Kathleen Gill Bowman; Sarah Cash; Chanda Chapin and Terry Dintenfass of Terry Dintenfass, Inc., in association with Salander O'Reilly Galleries; Lisa Dittrich; John Donovan; John Erdman; Howard Greenberg of the Howard Greenberg Gallery; Jonnie Guerra; Timothy C. Harte; Nicholas Jenkins; Archy Lasalle; Peter Lynch; Kathryn H. Mackey; Richard L. Menschel; Terry Moody; Kathy and Jim Muehlemann; Claudia Roth Pierpont; Herbert and Patricia Pratt; Eric M. Rosenberg; Gary Schneider; Joel Snyder; Anita Solow; Susan Stevens; Yoshiko Wada; Gina Werfel; and Caroline Cunningham Young. The project was further enriched by the special talents of Michaela Alan Murphy, Dorothy C. Munson, and Doug Munson of the Chicago Albumen Works, Housatonic, Mass.; Lee Ewing, Washington, D.C.; Stephen Sylvester and Robert Zinck of Imaging Services, Harvard College Library, Cambridge, Mass.; William Carner of IT Imaging Services, University of Louisville, Kentucky; Thomas J. McDunnough III, Washington, D.C.; and Kenneth Martin Kao and Michelle Tarsney of Kao Design Group, Somerville, Mass.

Archivists and curators at many institutions greatly facilitated our research: Anne Louise Bayly, Robert Brown, Susan Carey, Elizabeth Joffrion, Judith Throm, and Richard Wattanmaker of the Archives of American Art, Smithsonian Institution; at the Harvard College Library, Amanda Bowen, Martha Mahard, Katharine Martinez, and Abigail Smith of The Fine Arts Library, Annette Fern of the Theatre Collection, and Jeffrey Horrell, librarian of Harvard College; Bonnie MacAdam at the Hood Museum, Dartmouth College; Bernard F. Reilly, Jr., formerly of the Library of Congress; at the University of Louisville, James Anderson, Delinda Buie, and Amy H. Purcell of the Photographic Archives, Ekstrom Library, and Gail Gilbert of the Margaret M. Bridwell Art Library; Jeff L. Rosenheim and Doug Eklund at the Metropolitan Museum of Art, New York; Rona Roob, formerly of the Museum of Modern Art Archives, New York; Lynn Bodner of the Municipal Art Commission, New York; archivists at the National Archives and Records Administration in College Park, Maryland; Thomas McCarthy, New York City Department of Correction; Karen Nickeson of the Dance Collection at the New York Public Library for the Performing Arts; Peter Filardo of the Tamiment Institute Library, New York University; and Richard Field of the Yale University Art Gallery, New Haven, Conn.

The success of *Ben Shahn's New York* depended upon the unwavering support of James Cuno, Elizabeth and John Moors Cabot Director of the Harvard University Art Museums. We feel privileged to have worked under his extraordinary leadership. Many current and former staff members at the Art Museums also contributed to our project. Kevin Dacey, an assistant in the Department of Photographs, provided insight and untold hours of support in critical areas. The innovative research strategies of Michael Dumas were immensely helpful. We remain grateful to both Kevin and Michael for their unfailing sense of humor. The goodwill of our colleagues Marjorie B. Cohn, Alvin L. Clark, William W. Robinson, and Miriam Stewart in the Agnes Mongan Center for the Study of Prints, Drawings, and Photographs was always deeply appreciated. Craigen Bowen, Anne Driesse, and Betty Ann Murphy prepared the art and emphera for the exhibition, which Danielle Hanrahan and her staff expertly installed. Maureen Donovan and Rachel Vargas contributed considerable logistical support, as did Francine Flynn, who carefully oversaw the exhibition tour. Others deserving mention are Frances Beane, Richard Benefield, Kristen Burger, Kim Cafasso, Erika Enright, Kate McShea Ewen, Chelsea Foxwell, Elizabeth Gombosi, Elizabeth Hansen, Margaret Howland, Lee Mandell, David Mathews, Janet Mullen, Edward Saywell, Kerry Schauber, Stephanie Schilling, Abigail Smith, Lynne Stanton, Ann Starnbach, Emily Trespas, Mary Ann Trulli, Rebecca Wright, and Corinne Zimmerman.

Finally, all who admire Shahn's photographs are indebted to the artist's widow, Bernarda Bryson Shahn, and the late Davis Pratt, the first curator of photography at the Fogg Art Museum. Bryson Shahn cherished her husband's photographs and sought to ensure their preservation. Pratt, early in his career, marveled at the inventiveness of Shahn's "photographic eye" and recognized the importance of keeping intact this unique and comprehensive collection. Owing to the foresight of these two individuals, the photographic work of one of twentieth-century America's most fascinating and prolific artists is available to generations. We salute Bernarda Bryson Shahn and Davis Pratt for their prescience.

Permissions and Photo Credits

Photographs by Ben Shahn in the collection of the Fogg Art Museum, Harvard University Art Museums, Cambridge, Mass., © President and Fellows of Harvard College.

Statements and works of art by Ben Shahn (excluding photographs in the collection of the Fogg Art Museum) © Estate of Ben Shahn/Licensed by VAGA, New York, N.Y., and the owners or custodians as indicated.

Items in the Ben Shahn Papers, Archives of American Art, Smithsonian Institution, Washington, D.C., courtesy Ben Shahn Papers, Archives of American Art.

Items in the Margaret M. Bridwell Art Library, University of Louisville, courtesy Collection of the Margaret M. Bridwell Art Library, University of Louisville, Kentucky.

Items in the Roy Emerson Stryker Papers, Photographic Archives, University of Louisville, courtesy Photographic Archives, University of Louisville, Kentucky.

Items in the Stephen Lee Taller Ben Shahn Archive, Fine Arts Library, Harvard College Library, Cambridge, Mass., courtesy of The Fine Arts Library, Harvard College Library.

Copyright holders are as listed in the captions. The illustrations and manuscripts listed below are reproduced with permission from or courtesy of the following:

Fig. 5 © Walker Evans Archive, The Metropolitan Museum of Art, New York.

Fig. 6 Marian Seldes.

Fig. 7 © Berenice Abbott/Commerce Graphics Ltd., Inc.

Fig. 15 © 1933 Henri Cartier-Bresson; Magnum Photos, Inc.

Fig. 17 The Museum of Modern Art, New York; Whitney Museum of American Art, New York; Teresa Heinz.

Fig. 19 Roderick S. Quiroz and the Estate of Prentiss Taylor.

Fig. 20 Bank of Mexico, Trustee of the Diego Rivera and Frida Kahlo Museums Trust; Peter A. Juley and Son Collection, National Museum of American Art, Smithsonian Institution.

Fig. 21 Old Stage Studios.

Fig. 22 Ralph Steiner Estate.

Fig. 23 Collection of the City of New York; Art Commission of the City of New York; Private Collection, Japan.

Fig. 24 *Daily News*.

Fig. 25 Fox Movietonews, Inc.

Fig. 26 © Estate of Stuart Davis/Licensed by VAGA, New York, N.Y.

Fig. 27 E. E. Cummings Copyright Trust.

Fig. 35 Miguel Covarrubias Foundation.

Fig. 46 (Groenhoff) Black Star Publishing Co., Inc.

Fig. 51 John Hawkins and Associates, Inc.

Fig. 52 Mrs. Dorothy Zohmah Charlot and the Dorothy Z. Charlot Revocable Trust; Harry and Brigitte Spiro.

Fig. 53 Central State Archive of Literature and Art, Moscow.

Fig. 54 © Walker Evans Archive, The Metropolitan Museum of Art, New York.

Fig. 55 Old Stage Studios.

Fig. 75 Department of Correction, New York City.

Fig. 94 Lloyd Morgan.

Fig. 98 © 1936 *The Washington Post*.

Fig. 99 American Federation of Labor and Congress of Industrial Organizations.

Fig. 103 Ralph Steiner Estate.

Fig. 107 © 1938, renewed 1966 by Archibald MacLeish. Reprinted by permission of Houghton Mifflin Co. All rights reserved.

Fig. 109 © 1962 *St. Louis Post-Dispatch*.

Cats. 121, 122 Collection of the City of New York; Art Commission of the City of New York; Private Collection, Japan.

Laura Katzman, "The Politics of Media: Painting and

New York/Art Resource, New York: cat. 135.

New York Public Library, New York: fig. 76.

Philadelphia Museum of Art: cat. 17.

Smith College Museum of Art (Stephen Petergorsky), Northampton, Mass.: cat. 139.

Visual Image Presentations, Bladensburg, Md.: fig. 106; cat. 15.

Walter Rosenblum, Long Island City, N.Y.: fig 8.

Wichita Art Museum (Dimitris Skliris), Wichita, Kans.: cat. 116.

Index

Page numbers in *italics* refer to illustrations. Unless otherwise indicated, all works are by Shahn. Shahn's untitled works are listed by the titles used by the authors.

DATE			

$50.00